FIN DE SIÈCLE

FIN DE SIÈCLE

Shearer West

THE OVERLOOK PRESS

Woodstock · New York

PICTURE ACKNOWLEDGEMENTS

All pictures courtesy of The Bridgeman Art Library except: 2. e.t.archive; 4. Artothek/Alte Pinakothek, Munich; 10. Giraudon/Bridgeman Art Library; 16. Giraudon/Bridgeman Art Library; 19. The Trustees of the British Museum; 20. e.t.archive; 24. e.t.archive; 25. The Trustees of the British Museum; 30. Board of Trustees of the National Museums & Galleries on Merseyside (Walker Art Gallery, Liverpool); 32. Mansell Collection; 33. Mansell Collection; 39. Mary Evans Picture Library; 40. Mary Evans Picture Library; 42. Giraudon/Bridgeman Art Library; 44. Board of Trustees of the National Museums & Galleries on Merseyside (Lady Lever Art Gallery, Portsunlight); 45. Board of Trustees of the National Museums & Galleries on Merseyside (Walker Art Gallery, Liverpool); 49. Staatliche Museen zu Berlin – Preussischer Kulturbesitz Nationalgalerie; 51. The Trustees of the British Museum; 54. Herbert F. Johnson Museum of Art, Cornell University; 56. e.t.archive; 59. Colorphoto Hinz Allschwil-Basel/Kunstmuseum Basel.

Please note: every effort has been made to trace the copyright holders of material in this book. The Publishers apologize if any material has been included without permission and would be pleased to hear from anyone who has not been consulted.

First published in the USA in 1994 by
The Overlook Press
Lewis Hollow Road
Woodstock, New York 12498

Library of Congress Cataloging-in-Publication Data

West, Shearer
 Fin de siècle: art and society in an age of uncertainty/Shearer West.
 p. cm.
 Includes bibliographical references.
1. Art, European. 2. Art, Modern–19th century–Europe. 3. Art, Modern–20th century–Europe. 4. Art–Europe–Psychology. 5. Art and society–Europe–History–19th century. 6. Art and society–Europe–History–20th century. 1. Title.
N6460 1890.W47 1994
709'.03'4–dc20

ISBN: 0-87951-519-8 93-4945
 CIP

Printed and bound in Hong Kong by Dah Hua Printing Co.

CONTENTS

TO NICK, FOR A NEW BEGINNING

PREFACE AND ACKNOWLEDGEMENTS

This is not intended to be a conventional history of art, but a history of culture, with art as its emphasis. I have not spent time going over old ground: relating the story of art's development through the phases of Impressionism, Neo-Impressionism, Symbolism, Art Nouveau and Modernism. This has been done countless times in the past, and both its merits and its fallacies have been outlined by other scholars in this field. Instead, I have attempted to isolate late nineteenth-century themes and examine how these themes affected cultural production – especially the production of art.

The daunting nature of this task became apparent to me at a very early stage, and I think it is important to make the limitations and possible problems of my own approach clear from the beginning. The majority of this book is concerned with the late nineteenth and early twentieth centuries: for my purpose the *fin de siècle* is a generation – roughly 1870–1914, rather than simply the last decade of the nineteenth century. Obviously, I was limited in the extent of my coverage, and I made the (perhaps arbitrary) decision of confining myself mainly to Europe and to two-dimensional art. Other countries, such as America and Australia, and other media, namely architecture and sculpture, receive some consideration, but I have not devoted as much attention to them as to painting and graphic art in Europe. I do not wish to be guilty of tokenism, but I felt an allusion to these other countries and forms of art would indicate the rich array of sources available to the historian of this period; whereas extensive coverage would lead to a diffusion of my argument.

This book is intended for both scholars and students. For the former, I have based my discussion largely on primary sources, and for the latter I have attempted to present the material in an accessible, yet challenging, way. For both, I hope I have stimulated debate, rather than prescribing a dogmatic reading of the period. In writing a book with such a wide, and potentially diverse, appeal, I have doubtless left myself open for criticism from both camps. I have limited the number and extent of my footnotes to make for easier reading, but I have filled in the gaps through an annotated bibliography. Unless otherwise indicated, translations from French, German and Italian are my own, and I take full responsibility for their occasional clumsiness.

Scholars will note that this book does not engage directly with the theoretical debates that have made art history such a fascinating discipline over the last few years. This omission is not due to a rejection of theoretical complexities – quite the contrary. It seems to me that the ultimate justification for theory is practice, and I have endeavoured to present the results of my own investigations, rather than entering directly into the debate about what art history should be.

The book is organized thematically. The first chapter (Fin de Siècle Art) serves the same purpose as the first part of Konrad Swart's *The Sense of Decadence in Nineteenth-Century France* (1964). I have examined the idea of an approaching *fin de siècle* in its historical context. As Swart's argument was constructed on historical lines, mine is concerned with cultural artefacts and how they relate to

millennial concerns from the late Middle Ages until the end of the eighteenth century. Subsequent chapters focus exclusively upon the period 1870–1914, and in them, I have isolated what I consider to be the most essential social and political themes which have a bearing on European art of that age. Chapter 2 (Degeneration), Chapter 3 (Anarchy), and Chapter 4 (Anxiety) analyse the social and political spheres within which artists were working. In these chapters, the idea of a decaying and dying society is seen against the intensification of extremist political agitation as well as the rapid and disruptive growth of cities. Chapter 5 (Androgyny) and Chapter 6 (Icons of Womanhood) direct the argument to the ways in which the lives of men and women were altered in the late nineteenth century, and how these changes found their way into art. Chapter 7 (The Inner Life) carries the investigation into the spiritual conflicts of an age which was ostensibly (but not actually) agnostic. The final chapter (Regeneration) brings the discussion full circle by considering how a society which perceived itself to be degenerate saw the means for its own renewal. In this chapter, the millennial themes considered in Chapter 1 return to enrich our understanding of the agitated and somewhat hysterical perspective of some individuals at the approach of the First World War. A planned 'Postscript', looking ahead to the year 2000, was thankfully dropped. I am not a journalist nor an astrologer, and I fear my predictive faculties are not as acute as is required for such forecasting. However, what became apparent to me in the course of researching this book was just how chillingly familiar many of the *fin de siècle* arguments about gender, politics, society and religion actually are. If, through reading this book, anyone feels that their understanding of the 1990s is enhanced by an exploration of the 1890s, I will think that my work was worthwhile.

I would have liked to have spent many years researching and writing this book, but in the short time in which I was eating, drinking and dreaming *fin de siècle*, I have accumulated a number of debts of thanks, which I now wish to repay. I owe special thanks to Tracey Smith at Bloomsbury, who was not only an enthusiastic and supportive editor throughout the project, but who also came to be a good friend. Much of my gratitude is due to Leicester University. The Leicester University Research Board provided part of the funds for an essential trip to Central Europe. My colleagues in the History of Art department created a stimulating intellectual atmosphere conducive to research and writing; I thank them (in alphabetical order): Joan Crossley, Thomas Frangenberg, Phillip Lindley, Margaret Lintern-Ball, Marsha Meskimmon, Brenda Tracy, Nicholas Watkins, Hazel Williamson and Alison Yarrington. Participants in the Leicester University Urban History Centre Seminar provided very useful comments on a version of Chapter 4. My students, as usual, gave me the opportunity to discuss and expand my ideas, and to revise them in light of their feedback.

In London, the staff of the British Library were always helpful and cheerful, despite a period of industrial dispute which has both upset and demoralized them. They made writing this book a real pleasure. My deep personal thanks go to the Reverend Dr Peter Galloway and Lesley Stevenson, who provided homes in London when they were desperately needed. Lesley Stevenson also read and commented on the text, and I am especially grateful for her many helpful suggestions and an acute eye for inaccuracies. Any errors which have crept into the final text are entirely my own responsibility.

Above all, I wish to thank my husband, Nick Davidson, who provided a constant remedy for the frequent dips in my confidence, and whose scrupulous intellect and lively discussion stimulated ideas which would otherwise have remained in embryo.

CHAPTER 1
THE *FIN DE SIÈCLE* PHENOMENON

Disasters, catastrophes and fears that the world will come to an end are concerns which have governed human behaviour and have found their expression in art and literature for centuries. Observers who promote a cyclical view of history avoid emphasizing catastrophes, but proponents of a teleological perspective see an ultimate conclusion to all things in the progress of the world and the universe. The term 'fin de siècle' originated in a play of 1888 by two obscure Parisian writers, but the name came to be applied to a cultural malaise in late nineteenth-century Europe. In its strictest sense, 'fin de siècle' referred not just to the fact that the nineteenth century was drawing to a close, but it signified a belief on the part of the literate and voluble bourgeoisie that the end of the century would bring with it decay, decline and ultimate disaster. This prevalent attitude did not simply sweep across the world unaided. To speak of a 'fin de siècle phenomenon' does not suggest that a free-floating *Zeitgeist*, or 'spirit of the times', theory is an adequate explanation for its prominence. Social and political factors obviously governed such a sustained 'feeling', and the growth of mass communications facilitated the spread of these ideas. Late nineteenth-century Europe was unquestionably invaded by *fin de siècle* culture – by art and literature which self-consciously promoted the themes of decadence and death. Paradoxically, the very internationalism of this 'fin de siècle' ideology stimulated a greater sense of self-awareness and even affectation in the citizens of Europe and America.

This internationalism was the most unusual aspect of nineteenth-century *fin de siècle*, for the characteristics of the phenomenon were present in other centuries and equally found their expression in art. In order to understand the nature of the late nineteenth-century developments, it is instructive to look back at European history to see points of tension in which similar perspectives were of general concern and consequently affected the subject-matter of art. The idea that the world would come to an end did not always relate to the approach of a century's end, but otherwise the characteristics of the *fin de siècle* phenomenon remain similar throughout history. An understanding of the sociological aspects of this apocalyptic perspective will illuminate the means by which artists realized a prevailing feeling of cultural decline.

The first quality which distinguishes the *fin de siècle* phenomenon is an awareness of time and future – an idea that events are moving towards a final conclusion, and that nothing is happening without a purpose. Coupled with this is a period of change, disaster or progress. Changes can be social, economic or political; disasters tend to be unexpected; and progress undermines the stability of an old order and familiar patterns of life. Violent change could result in a pessimistic view of the future, but conversely, those who witnessed floods, plagues, wars or persistent crop failure could reassure themselves with the thought that the old, sick world was being wiped out to be replaced by a newer, more perfect world. This rationalization of disaster may have provided an explanation for a beleaguered population, but it equally promoted utopian visions.

The most extreme expressions of the *fin de siècle* phenomenon came in the form of millenarian prophecies.[1] Although the term millennium has been used generally to refer to a period of 1000 years, its religious connotations are much more precise. According to interpretations of the Book of Daniel, the Gospel according to St Matthew and the Revelation of St John the Divine in the Bible, the end of the world will be preceded by a number of important events. Firstly, the sins of mankind will bring on a time of turmoil:

> For nation shall rise against nation, and kingdom against kingdom: and there shall be famines and pestilences, and earthquakes in divers places. All these are the beginning of sorrows (Matthew 24: 7–8).

According to Christian writers, these disasters would herald the Second Coming of Christ, which would in turn induce a millennium, or a period of 1000 years in which life would be happy and prosperous. At the end of this period, the Antichrist would appear, and this would signal the apocalyptic battle between Christ and Antichrist, followed by the end of the world and the Last Judgement. At the Last Judgement, all the dead would be raised and ultimately judged by God as suitable for heaven or hell:

> There shall be a time of trouble, such as never was since there was a nation . . . And many of them that sleep in the dust of the earth shall awake, some to everlasting life, and some to shame and everlasting contempt (Daniel 12: 1–2).

The exact order of these events varied, and medieval theologians and prophets further transformed or elaborated the myth according to their own obsessions or interests. The most notable of these prophets were the tenth-century French monk Adso, whose *Libellus de Antichristo* consolidated millenarian theories of the Antichrist, and the twelfth-century prophet Joachim of Fiore, who invented his own history of the world which embraced such millenarian beliefs. For many centuries millenarianism was largely a Christian concern, but from the late eighteenth century onwards – when the incursion of rationalism and empiricism threw such cosmological beliefs into doubt – the millenarian myth became absorbed into more secular views of history. Marx's theory of historical materialism, which culminates in a perfect communist society, was only one of many secular distortions of millenarian utopianism. Millenarian myths were consistently altered or adapted to suit the specific concerns of the time. As millenarians tended to believe that change was imminent and inevitable, interpretations of current events in light of these beliefs could be very liberal. Generally, catastrophes and disruptions were seen to precede the millennium, and any hated or distrusted figure of power was construed as the Antichrist. Millenarianism in its widest sense is the most prominent aspect of the *fin de siècle* phenomenon.

In order to understand such ideas more fully, it is instructive to see how art responded to millenarian concerns, and the ways in which it absorbed both the apocalyptic visions of prophets and the political subtexts underlying the response to disaster. Among the most immediate and accessible of cultural artefacts, visual art is the sphere where social and political tensions are most cogently expressed. Through paintings, prints and sculptures it is possible to detect the latent anxieties springing from the *fin de siècle* experience. Of course, artistic production did not always accompany millenarian agitation. Before the thirteenth century, artistic expressions of the Last Judgement or the end of the world were confined to tombs and cathedral sculpture, and they

did not necessarily relate to any specific upsurge of millenarian prophecy. In some respects, this lack of expression may have resulted from the fact that medieval millenarian movements were largely agrarian and confined to the peasant population, who had little opportunity for visual expression of their concerns.

However, the patrons of art – who included the Church – were not always immune to the natural and military catastrophes that created so much anxiety among the peasants. In 1348, the Black Death devastated Europe, and from this point onwards, millenarian subjects became more common in altarpiece painting.[2] Despite the innovations of Giotto, artists began to rely exclusively on an earlier symbolic, hieratic style in which human emotions were minimized in favour of a less realist but arguably more spiritual form of representation. Nardo di Cione and his brother Andrea di Cione (Orcagna) produced work of this type for the church of Sta Maria Novella in Florence. The careful naturalism and sensuous emotionalism of Giotto were eschewed in favour of a more formal and ascetic treatment. Nardo di Cione painted frescoes of the Last Judgement for the Church, and Orcagna produced an altarpiece, *The Redeemer with the Madonna and Saints*, which was linked to the theme of the frescoes by the inclusion of St Michael, who – according to Daniel and Revelation – weighed souls during the Last Judgement In both subject and style, Nardo di Cione and Orcagna seem to have been responding to the prevailing idea that God had passed judgement on the world and had found it wanting. The plague was seen as God's punishment for man's sinfulness, and fearful believers felt the need to compensate for God's wrath through a more subdued, penitent and spiritual life. The spiritual emphasis of the Sta Maria Novella paintings may well be in response to this new attitude.

The Black Death was an unexpected and devastating disaster which did not discriminate among its victims. A similarly indiscriminate calamity occurred in sixteenth-century Rome, when the armies of the Holy Roman Emperor Charles V sacked the city. Before, during and after the 1527 Sack of Rome, Northern Europe abounded with images from Revelation which referred obliquely or directly to the present condition of Rome. As the seat of the Papacy, Rome was the object of continual attention from the rest of Europe, and with the spread of Reformation ideas, the supremacy of the Pope and of Rome was beginning to be questioned. Charles V respected the Pope's spiritual authority, but hostility to the Papacy was facilitated in Europe by a plethora of reformist propaganda (much of it produced by followers of Martin Luther), which denounced the Pope as the Antichrist or the Seven-Headed Beast from Revelation, and presented Rome as the corrupt Babylon, the land of the Antichrist.[3] The invention of printing in the fifteenth century meant that such ideas could be widely disseminated through the medium of woodcuts; art thus played a major role in inciting the German population against the Pope and all he stood for. One of the most extreme examples of this phenomenon was the *Passional Christi und Antichristi*, published in 1521 and intended for laymen. This book has 13 illustrations representing the polarity between good and evil: good appears in the actions of Christ and evil in the corresponding actions of the Pope. For example, in one illustration Christ and his followers go on foot, whereas the Pope is carried in a sedan chair; in another, the Pope accepts the crown of temporal power, but Christ rejects it. Such simple, but unequivocal, messages reinforced millenarian belief and allowed observers to interpret the Sack of Rome as a fulfilment of the prophecy of Revelation.[4]

As Rome was such an important centre for Renaissance art, the Sack disrupted the continuity of artistic creation, but it also helped inspire a new artistic vision encouraged by Pope Clement VII, who had presided over the period of devastation. Clement's vision of the Sack as evidence of

divine wrath may have inspired him to commission Michelangelo to paint the Last Judgement in the Sistine Chapel. Although Michelangelo did not finish the work until 1541, well after the Sack, the ultimate purpose behind his painting was most likely related to it. Equally the work of Giulio Romano in the 1530s emphasized the extreme possibilities of cosmological disaster. Guilio's Palazzo del Té in Mantua, built for Federigo Gonzaga, includes a Room of the Giants which is decorated with bizarre and disturbing images of a battle between gods and giants (Figure 1). The sixteenth-century Italian artist and historian Giorgio Vasari attempted to sum up the impact of this room on the observer:

> No more terrible work of the brush exists, and anyone entering the room and seeing the windows, doors and other things so twisted that they appear about to fall, and the tumbling mountains and ruins, will fear that all is about to come about his ears, especially as he sees the gods fleeing hither and thither.[5]

The overwhelming image of chaos and ruination would have been especially pertinent to those observers who had been in Rome during or after the Sack. The imagery of universal forces in battle bore more than a coincidental relationship to Charles V's ambition to gather a Christian Europe under the banner of the Holy Roman Empire, and indeed Charles himself was one of the first visitors to the Palazzo del Té and the Room of the Giants.

Whether indirectly expressed in high art or overtly propagandist in popular prints, the themes of Last Judgement, Apocalypse and cosmological battle reflected prevalent concerns about political events or natural calamities in a number of different periods. But none of the examples considered so far actually fell at the end of a century. It seems that the feeling of finality which pervaded society during these periods of distress was not necessarily tied down to the calendar in any but a very general way. However, in examining the history of art before the nineteenth century, two periods stand out as representing all the features of the *fin de siècle* phenomenon, including the time in which they occurred. The 1490s and the 1790s were both characterized by a sense of disaster, change and apocalypse, and during both periods, a concomitant flourishing of the arts resulted in a widespread visual response to such troubles. These problems were not localized or regionalized, but affected the whole of Europe. Both periods witnessed a steady growth of political and/or religious conflict which began some time before the '90s and culminated in the early years of the century following. In the 1490s, European religious controversies exploded, presaging the Protestant Reformation, and in the 1790s the French Revolution inspired a wave of political unrest throughout Europe, which was eventually obliterated by the imperialism, then defeat, of Napoleon. It is worthwhile considering both of these periods in some detail to see how the salient characteristics of the *fin de siècle* phenomenon manifested themselves and how they were expressed in art.

As Johan Huizinga pointed out many years ago, fifteenth-century Europe saw the waning of the period referred to as the Middle Ages.[6] Despite the sweeping nature of Huizinga's theory, his understanding of the uneasy coexistence of a growing urban, mercantile society and an agrarian and ostensibly obsolete feudal culture isolated an important source of conflict. The spiritual obsessions of the medieval church were in some ways as strong as ever, but there was an increasing mistrust of the institution itself and its representatives. The Great Schism of the fourteenth and fifteenth centuries resulted in two popes, one in Rome, the other in Avignon; from 1409 to 1415 there were even three. The loyalties of European towns and villages were

consequently divided. In northern Europe by the fifteenth century, a sometimes intense but self-defensive religious piety accompanied a growing concern with new methods of money-making centred predominantly in Netherlandish towns such as Ghent and Bruges, the seat of the Duke of Burgundy. Traditional altarpiece painting came to embody these tensions, so that familiar motifs were transformed in the hands of artists such as Robert Campin, Rogier van der Weyden and Jan Van Eyck. Van Eyck's *Madonna with Chancellor Rolin* (Figure 2) epitomizes the schizophrenic split between unabashed mercantilism and devout piety. The Chancellor was from humble origins, but managed to rise to an important position in the court of Philip the Good, Duke of Burgundy. Rolin, who was not known for his scruples, eventually became wealthy, and Van Eyck's meticulously painted altarpiece is full of allusions to Rolin's wealth and status. However, these characteristics exist alongside more traditional symbols of spiritual humility. For example, Rolin, dressed in elaborate robes, sits as an equal with the Madonna, but the columns behind his head are decorated with scenes of Adam and Eve in the Garden of Eden; the inclusion of the Fall of Man indicates the sinfulness of all men, including the Chancellor himself. Also behind him, a lavish garden alludes to his wealth, while the enclosed garden is also a symbol of the Madonna's holy virginity. In the garden is a peacock, which represents both pride and immortality. This confusion of symbols is an apposite representation of the social and religious contradictions of the Burgundian Netherlands.

The growing tensions between old and new in the fifteenth-century North further led to obsessions with death and decay. These themes were expressed through popular books which counselled human beings on the 'proper' way to die. The *ars moriendi* or the 'art of dying' was a common topos of late fifteenth-century literature. In order to 'die well', people must keep thoughts of hell in their minds, for the fear of hell might prevent them from committing sins. Hieronymus Bosch's panel, for example, *Death and the Miser* (c. 1490, Washington DC, National Gallery Kress Collection) visualizes the *ars moriendi* by showing an avaricious man who lusts after money even on his deathbed. The same man who shovels coins into a bag held by a devil is still concerned with his wealth as he dies, despite the potential of salvation offered by the rosary in his hand and the radiant crucifix in the window. The theme of death obviously carried a specific and age-old Christian message, but the proliferation of such themes at the close of the fifteenth century reveals a perception not just of individual death, but of the death of a way of life.

Themes of death were not alone in reflecting the religious anxieties of the time. As with other ages of change and conflict, millenarianism was prevalent at the end of the century. Bosch's pessimistic view of man's ultimate sinfulness and damnation was combined in his works with millennial messages, as can be seen in two of his most famous altarpieces, *The Garden of Earthly Delights* and the *Epiphany Triptych*. His emphatic treatments of the Seven Deadly Sins and the tortures of the damned were addressed to a world that seemed to be consumed in evil. The closed wings of the *Garden of Earthly Delights* show us the world at the time of creation but before the Fall of Man. The inside central panel of the altarpiece (Figure 3) also seems to represent a paradise: here, a colony of men and women cavort in a lush tropical garden indulging in all manner of sexual activity with utter abandon. The late Wilhelm Fränger felt that this panel represented the beliefs of a millenarian cult called the Brothers and Sisters of the Free Spirit, who claimed that human beings could return to the blessed innocence of Eden before the Fall by refusing to be ashamed of nakedness and sexuality.[7] Although fascinating, Fränger's theory has little factual justification. It is more likely that Bosch was revealing a world which is superficially attractive, but nevertheless rife with sinfulness and corruption. Bosch thus played upon the belief

that sin often presented itself in attractive guises, but must be resisted at all costs. This cautionary interpretation is reinforced by the right panel of the alterpiece which represents the tortures of Hell, the final destination of sinful man. Although perhaps not as explicitly millenarian as Fränger supposed, *The Garden of Earthly Delights* points to the ultimate dangers of succumbing to worldly pleasures in an increasingly worldly age.

This is not to say that Bosch never explored millenarian themes, but his millennialism is pessimistic rather than utopian. He did not revel in the possibilities of the new and purer millennial kingdom but dwelt instead upon the period of disaster that would precede the millennium and God's judgement that would follow it. Echoes of these themes occur in his *Epiphany* triptych (*c.* 1510, Madrid Prado). The central panel of this work appears at first glance to be a traditional Nativity scene, with the three Magi presenting their gifts to the Christ child. But there are also some disturbing additions which have no precedent in the history of art. In a doorway behind the Christ child, a leering, half-naked figure looms ominously amidst a collection of grotesque companions. This strange supernumerary may well represent the Antichrist – his presence is certainly threatening rather than supportive, and what garments he wears are embroidered with various infernal creatures. The menacing presence of the Antichrist at Christ's birth is accompanied by portentous events occurring on the outer panels of the triptych. For example, in the background of the right panel, a woman and a man are attacked by wolves and a bear – a bizarre counterpoint to the birth of Christ, which traditionally represents the potential salvation of sinful man.

Given the religious tensions in northern European society during the late fifteenth century, the infiltration of millenarian themes into religious paintings is hardly surprising. With anxieties and religious unrest, the Book of Revelation and representations of the Apocalypse were increasingly popular, and in 1498 Dürer illustrated an edition of Revelation with fifteen woodcuts. His designs realized the visionary nature of the Biblical prophecy, and they were particularly pertinent in light of contemporary religious and social conflicts, as well as the continual threat of Turkish invasions. Dürer's art is more restrained than that of Bosch, but he appeared equally susceptible to the growing dichotomy between spiritual needs and the ability of the Church to fulfil them. His most famous self-portrait (Figure 4) was painted in 1500 – notably the beginning of a new century as well as a Holy Year – and could be seen as a response to the significance of the year: his formal, hieratic pose relates directly to representation of Christ as *Salvator Mundi*, or Saviour of the World. However, by depicting *himself* in such a guise, Dürer was being both bold and cynical and creating a confusion of roles unprecedented in medieval art. He thus not only acknowledged the new worth of the artist, but also minimized the hitherto unquestionable eminence of Christ in painting. The conflation of such worldly and otherworldly themes manifested prevailing uncertainties about the authority of religion.

When Luther posted his 95 theses to the door of the Castle Church at Wittenberg in 1517, the repressed tensions of the 1490s erupted and soon spread throughout Europe. *Fin de siècle* fears were realized by religious strife, peasant rebellions and military conflict. It would be difficult for us to imagine the imbalance that such a rift in the Church would have caused the people of sixteenth-century Europe; the very basis of life as they knew it was undermined and eventually destroyed. Something of the oddness of this feeling is captured by Holbein in his unusual portrait of two French ambassadors who visited England in 1533 (Figure 5). At this time, King Henry VIII was in the process of divorcing his wife, Catherine of Aragon, in order to marry Anne Boleyn. The Pope was opposed to this divorce, and eventually Henry – like some other European secular

leaders – found it expedient to use the name of the Reformation in order to break with the Roman church. The Act of Supremacy of 1534 made Henry himself head of the English church and sanctified his marriage with Anne Boleyn. Holbein's ambassadors arrived in England from Catholic France to attempt to prevent such a drastic rift from Rome. At first glance, this appears to be a rather innocuous portrait, but it is full of ambiguous and minatory symbols which reveal the sitters' (and Holbein's) concerns with the potentially disastrous results of the religious crisis. Partly concealed behind the curtain on the left is a crucifix, and amidst the objects on the table is a lute with a broken string, representing discord. Most bizarre of all is a skull cutting across the foreground of the painting. This cannot be seen at first glance, but it becomes visible when the observer changes position: the skull is a hidden image, but a familiar symbol of death. By concealing it within this portrait, Holbein is turning a mere likeness into an essay on religious discord and its ultimate result.

From the 1490s – when religious contention was no longer possible to ignore – until 1530 – when the tenets of the Lutheran church were standardized by the Augsburg Confession, northern art revealed the growing confusions between new worldly values and prevailing religious beliefs. But these tensions were not simply present in the North. Italy as well, although the seat of the papacy, was subject to *fin de siècle* anxiety, equally relating to an increasing dissatisfaction with the Church. The differences between painting in the North and in Italy were largely those of orientation. Northern artists still derived ideas, themes and inspiration from the art of the Middle Ages, whereas in Italy the renewed interest in classical learning that characterized one facet of the Renaissance provided wider possibilities. To some extent, Italian humanism paved the way for a more rigorous questioning of religious conventions, but as in the North, the old order did not simply disappear overnight. Italy too experienced a *fin de siècle* phenomenon in the 1490s.

This reaction was concentrated in Florence, the home of Alberti, Donatello, Ghiberti and Fra Angelico, and the seat of the early Renaissance. Florence had been peaceful and prosperous under the leadership of Cosimo de' Medici, who ruled from 1434 until 1464.[8] This long, stable period in Florentine history witnessed a flourishing of art, literature and philosophy, and created a calm atmosphere as well as a developed sense of civic harmony. Such feelings were consolidated under the leadership of Cosimo's grandson, Lorenzo de' Medici, called 'Il Magnifico', and the increasing confidence of Florentine citizens led to a greater assertion of their prominence among the Italian city-states. However, confidence, harmony and self-assertion were challenged when Lorenzo died in 1492 and was succeeded by his incompetent son Piero, whose policies disrupted the concord of Florentine society, especially as they coincided with the threat from the armies of the French King Charles VIII.

Charles VIII – like the later Holy Roman Emperor Charles V – saw Italy as a target for his expansionist policies. Charles threatened to invade Naples, and Florence too came under attack when Piero formed an alliance with Naples, despite the fact that Florence had hitherto been on good terms with France. Piero's actions created discontent among the Florentine patriciate who began agitating for a change of government. Such a change would have involved transforming oligarchic Florence into a republic, similar to Venice, in which a larger number of citizens would rule. In 1494, the Medici regime was finally overthrown and the French army marched into Florence. However, Charles was persuaded to leave Florence in peace due in part to the intervention of the Prior of San Marco, Fra Girolamo Savonarola.

Savonarola stimulated all the hopes and fears of Florentine citizens in the 1490s through his

skilful manipulation of millenarian myths, and his role in the conflicts that tore Florence apart contributed greatly to the *fin de siècle* phenomenon in that city. When Charles VIII's invasion seemed inevitable, Savonarola's fiery sermons became permeated with imagery from Revelation. Drawing on a traditional belief that a 'new Charlemagne' would enter Florence to signal its downfall, Savonarola told his congregations that Florence was about to undergo a period of disaster that would culminate in the end of the world. He warned them to prepare themselves for the *flagellum Dei*, or the punishment from God for their sins, and he claimed that the Antichrist would soon appear. Exhorting Florentines to repent their evil ways and lead a more ascetic life, Savonarola stimulated mass hysteria, epitomized by the 'burning of vanities', in which citizens piled up their trivial worldly possessions to be destroyed. Charles VIII's invasion seemed to be a fulfilment of Savonarola's prophecies, as he was seen at first to be an embodiment of the Antichrist. While Charles's armies were marching towards Florence, Savonarola was preaching doom to his congregation:

> O Florence, Florence, Florence, for your sins, for your cruelty, for your greed, for your lasciviousness, for your ambition, you have yet to suffer many adversities and much grief.[9]

However, by convincing Charles to turn away from Florence, Savonarola cast himself in the role of a saviour, and changed the tone of his subsequent sermons to a more optimistic note, stressing utopian themes. Florence thus became a city 'chosen by God' and destined to be 'the reformation of all Italy'. The new republican government was seen to be part of this scheme.

The subtle interpenetration of the religious and the political was enacted through the agent of millenarianism. Every event was taken as a fulfilment of a prophecy, and the dangerous power of Savonarola's influence eventually led to his excommunication in 1497, and torture and execution in 1498. He had stimulated the fears and hopes of Florentines during a period of strife, and he thus became the scapegoat of both political and religious leaders. His 'prophecies' had stirred both the wealthy and the poor, but the powerful very quickly began to distrust and fear his influence. The humanist philosopher Marsilio Ficino – who was at first persuaded by Savonarola's powerful messages – renounced the friar in the late 1490s by associating him with the Antichrist. Savonarola's millenarian discourse was thus ultimately used against him.

The congruence of political contention and artistic flourishing led to several expressions in art of the Florentine crisis, but these expressions (like Savonarola's prophecies) were often oblique or ambiguous. Although there is no real evidence that he was a *piagnone* (weeper), or follower of Savonarola, the artist Sandro Botticelli was obviously not immune to the influence of the friar.[10] Botticelli's paintings at the turn of the century reveal concerns which were prevalent in Florence at the time, and they contain millenarian imagery which was most certainly inspired by the prominence of such themes in Savonarola's preaching. Botticelli's unusual *Calumny of Apelles* (Figure 6) – which portrays an episode in the life of the Greek artist Apelles, in which the artist was falsely accused – was the first work to contain what may be an allusion to Savonarola. The Renaissance theorist Leon Battista Alberti had suggested that artists should attempt to realize this episode in painting, and Botticelli did just this in his work, which includes personifications of Ignorance, Suspicion and Calumny herself, who aggressively drags an innocent man before a docile judge. Among the allegorical figures is Remorse, who looks regretfully at naked Truth. Remorse is wearing a garment which has been identified as a Dominican robe, and significantly Savonarola was a Dominican. The dating of the *Calumny* is uncertain, but it was possibly produced

after Savonarola's excommunication, and may represent Botticelli's feeling that Savonarola was falsely accused of heresy.

However, this interpretation has been challenged, and the *Calumny* may be understood without reference to Savonarola at all. The same is not true of two paintings which contain explicit millenarian themes and thus implicit references to the charismatic preacher – the *Crucifixion* of *c.* 1494 (Boston, Fogg Art Museum) and the *Mystic Nativity* of 1500 (Figure 7) The *Crucifixion*, now in a ruined state, contains a unique combination of imagery that sets it apart from previous Crucifixion scenes. Here, there are both familiar and unfamiliar motifs. Mary Magdalen, often present at the foot of the cross, also weeps over Christ's death in this work, but the mysterious animal which rushes out of her cloak is unprecedented. Another odd motif is an angel on the right who slashes another animal with his sword. Rather than painting an anonymous city, Botticelli has taken pains to identify the city in the background as Florence: familiar landmarks are emphasized, namely the Duomo, the Palazzo della Signoria and the Baptistry. The sky is filled with God and angels, while the clouds harbour devils who throw burning torches. The painting represents a scene of calamity and devastation, but the obvious presence of Florence in the background makes the disaster more topical. As Ronald Lightbown has pointed out, the imagery of Botticelli's *Crucifixion* relates directly to the apocalyptic sermons of Savonarola.[11] The idea of Florence as a sinful city, destined for destruction, forms the subtext of this painting. The 'beasts' beneath the Crucifixion – possibly a fox and a wolf – symbolize violence, greed and fraud. Christ's Crucifixion was intended to redeem mankind from Original Sin, but the act was perpetuated by sinful men who were oblivious to Christ's divinity. Florence too, as Savonarola warned, was in danger of being dominated by vanity and spiritual blindness. The apocalyptic battle in the sky between angels and devils reinforces this interpretation. Significantly, the angels are armed with white shields on which are painted red crosses. These shields represent the coat of arms of the people (*popolo*), who had overturned the rule of Piero de' Medici in order to establish a more broadly-based republican government in Florence. One of Botticelli's most important patrons, Lorenzo di Pierfrancesco de' Medici, advocated the rights of the *popolo* against the tyranny of his own cousin, Piero. The *Crucifixion* thus contains mingled themes from politics and religion which are cast in an apocalyptic form reminiscent of Savonarola's sermons.

More global in its implications is one of Botticelli's last works, the *Mystic Nativity* (Figure 7). Although according to our modern calendar, the actual date of this work would have been March 1501, the Florentine dating system placed it during the last days of the Holy Year 1500. Just as the *Crucifixion* has both traditional and unusual symbolic features, so the *Mystic Nativity* is both familiar and unfamiliar. Nativity scenes were among the most common of Christian subjects, often including shepherds or the Magi, and occasionally introducing angels to emphasize the scene's holy nature. However, Botticelli's additions seem much more contrived and specific. Among the nativity and the adoration of shepherds, angels hold olive boughs and embrace human men while devils sink into earthly crevices behind them. On the roof of the stable more angels are kneeling and above them, in the golden dome of heaven, other angels sing praises to the Virgin Mary. The significance of these unprecedented characteristics can be determined by examining the inscription which Botticelli included on the top of the canvas:

This picture I, Alessandro, painted at the end of the year 1500, in the troubles of Italy, in the half-time after the time, during the fulfilment of the eleventh of John, in the second woe of

the Apocalypse, in the loosing of the devil for three and a half years. Afterwards he shall be chained according to the twelfth and we shall see him trodden down as in this picture.

At first glance, these words seem meaningless, but they are in fact rife with millenarian implications. Botticelli here signals the significance of the year 1500, and his reference to 'the half-time after the time' possibly refers to the year 1000 (literally the millennium) as 'the time', and the 500 years beyond that as the 'half-time'. He thus points to the numerological importance of 1500 which notably represents a culmination of 'the troubles of Italy'. The 'troubles' to which he refers are not simply Charles VIII's invasion and Savonarola's execution, but other subsequent calamities, including an invasion by the new French King Louis II in 1499 and the rise to power of the son of Pope Alexander VI, Cesare Borgia, who was looking to Florence as a potential place of conquest. Thus, according to Botticelli, the 'second woe of the Apocalypse' signifies this second French invasion. He also mentions the 'eleventh of John' and later 'the twelfth'. Both of these chapters in Revelation are significant to our understanding of the *Mystic Nativity*. The eleventh chapter of Revelation tells of the devastation of a 'holy city' for 42 months, and describes the accompanying 'woes'. The twelfth chapter speaks of a woman clothed in the sun, who gives birth to 'a man child, who was to rule all nations with a rod of iron', while the Archangel Michael repels a seven-headed dragon that threatens to devour the child:

> And the great dragon was cast out, that old serpent, called the Devil, and Satan, which deceiveth the whole world (Revelation 12:9).

The downtrodden 'holy city' may well be Florence, and the woman clothed in the sun symbolizes both the Virgin Mary and the Church itself.

The *Mystic Nativity* encapsulates these symbols in a recreation of the birth of Christ. The devils are defeated, while the angels rejoice at the holiness of Mary, or the Church, and the birth of Christ, the Saviour of mankind. Although essentially millenarian, the *Mystic Nativity* lacks the pessimism of the *Crucifixion* and looks forward to the reign of peace after the time of troubles. Botticelli's work thus embodies, in both a specific and a general sense, the universal fears and hopes of his age and country.

During such a period of disaster, hardship and political unrest, other artists turned to Revelation more directly as a source for millennial themes. Luca Signorelli's frescoes in Orvieto Cathedral are the most powerful uses of Revelation within the context of Savonarola's preaching. Signorelli began the cycle in 1499, after Savonarola's execution, but he did not finish it until 1503. During this period Cesare Borgia's power increased, and there may have been pressure from Borgia and the papal lobby to present Revelation in a way that would discredit the prophecies of Savonarola. Again Savonarola's adoption of millennial themes was ultimately exploited as propaganda against him. The powerful subjects of the Last Judgement, the Resurrection of the Dead, Paradise and the Damned Consigned to Hell were traditional themes of large-scale fresco painting, but Signorelli also introduced a subject hitherto confined to crude popular woodcuts – the Preaching of the Antichrist. In this part of the cycle the Antichrist performs a miracle by raising a dead man, while he preaches the second-hand words of a devil who whispers in his ear. In the background, soldiers raid a church and pile its contents near the Antichrist, and on the right and left, other soldiers torture innocent victims. By using such imagery, Signorelli has made several direct references to the woodcuts which accompanied printed versions of

Savonarola's sermons. Furthermore, the behaviour of the soldiers and the piling up of 'vanities' are more than coincidentally related to the events in Florence during the 1490s. Signorelli may have been responding to those enemies of Savonarola (as well as supporters of the Borgia Pope Alexander VI) who had accused the powerful Friar of being the Antichrist himself.

The crises of the 1490s, which induced a *fin de siècle* phenomenon throughout Europe, seem to have been predominantly religious, but given the all-encompassing temporal power of the Church in the late Middle Ages, it would be simplistic to suggest that political ideology was not equally characteristic of 1490s millenarianism. However, this political dimension was to be foregrounded in the second major European incidence of the *fin de siècle* phenomenon – the Revolutionary period of the 1790s. At this time millenarian tendencies were secularized, and utopianism and disaster were cast in terms of industrial or scientific 'progress'. Just as medieval spiritual values existed uneasily within the new mercantile secular world of the 1490s, so industrial innovations of the late eighteenth century drastically challenged the hegemony of the aristocratic élite throughout Europe. The American Revolution of 1776 was subsequently perceived in Europe as a forecast of the French Revolution which began in 1789, and like millenarian movements among the peasantry in the Middle Ages, these political events were initiated by oppressed or beleaguered groups of citizens.

In the late eighteenth century, the association of revolution with millennium was widespread, despite the minimized emphasis on religious or Biblical interpretations.[12] An engraving after Fragonard of Benjamin Franklin with a lightning bolt (*Au Génie de Franklin*, New York, Metropolitan Museum of Art) equates the rationalism and liberty that Franklin stood for with his success in harnessing a cosmological force through the lightning rod. Franklin thus becomes a type of harbinger of the new republican society. Equally during the French Revolution, images of the disgraced queen, Marie Antoinette, presented her as a beast or demon of the Apocalypse. In these respects, political sentiments were expressed through accessible millenarian imagery.

Both the positive and negative aspects of millenarianism appeared in a secularized form during the late eighteenth century. Jean-Jacques Rousseau's critique of civilization included a utopian vision of a morally perfect society – an idea that was embraced heartily in the 1790s. Rousseau believed that the natural goodness of man had been corrupted by the institutions of modern society, and he sought a theory which would allow the will of each individual to be given expression within a community. Rousseau's utopian notion of 'the people's sovereignty' helped pave the way for the republican ideals of the French Revolution. Conversely, the devastating domino effect of Revolutionary violence led to predictions of ultimate disaster, which seemed to be reinforced by 'natural' signs such as severe weather and crop failure. The initial optimistic response to the Revolution following the storming of the Bastille prison in 1789 was counteracted by the subsequent anarchy and bloodshed of the September Massacres (1792–3), the execution of King Louis XVI (1793) and the infamous Reign of Terror. The Englishman James Gillray represented the French libertarians, the *sans-culottes*, comically (and literally) 'without trousers', but seriously engaged in acts of cannibalism. Such behaviour exemplified English fears that French barbarism and social corruption would result in the destruction of 'civilized' society.[13] This theme was taken up by the English politician Edmund Burke, who wrote in 1796 that the world stood 'at the beginning of great troubles'.[14] His Biblical rhetoric articulated a widespread apocalyptic feeling.

As in the 1490s, a flourishing of the arts throughout Europe coincided with *fin de siècle* hopes and fears. From the 1760s onwards, a new focus on Gothic subjects expressed both a rational

contempt for superstition and a continued irrational fear of unknown forces. A declining belief in the real existence of demons freed artists to incorporate them unapologetically into non-religious art. The most famous such painting is Henry Fuseli's *The Nightmare* (Figure 8) which visualizes the disturbed imagination of a dreaming woman. An incubus and an unnatural horse externalize her hidden fears, and Fuseli's painting thus firmly places the origin of demonic superstition in the mind, rather than in the cosmos.[15] In a similar vein, Francisco de Goya's paintings of witches in the late 1790s are satirical, rather than serious. Spain was one of the last European countries in the eighteenth century to be influenced by Enlightenment thought, as the sustained power of the Catholic church prevented questioning of traditional religious belief.[16] The growing importance of empiricism during the reign of Charles III (1759–88) challenged the Church's long held authority. Even so, Goya's *Caprichos* of 1799 were suppressed because they presented priests as gluttons, lechers or creatures of the night. Gothic themes in art thus became the focal point of tensions between the rational world and the potentially irrational behaviour of man. The more ghoulish imagery of Gothicism made a further appearance in popular representations of the events of the French Revolution. James Northcote, for example, depicted the Bastille as a chamber of horrors filled with decaying corpses and obscure torture devices (engraved by James Gillray, 1790). In reality, the prison hardly lived up to such extreme descriptions, but they reinforced the symbolic nature of the Bastille as a product of *ancien régime* repression.

Artistic responses to the French Revolution were only rarely direct representations of actual events; more frequently, they embodied the political tensions which inspired the Revolution and were subsequently stimulated by it. These themes were cast in both classical and religious guises, and in some respects they echoed millenarian imagery, more notably characteristic of the art of the 1490s. Oblique and often ambiguous responses to pre-Revolutionary agitation characterized a number of paintings by the French artist Jacques-Louis David. David's *Oath of the Horatii* (Figure 9) was first exhibited in Rome in 1785, but when it was subsequently shown at the Paris Salon, it gained great critical and public attention. It was not so much David's skill as a painter or his cultivated neo-classical style that made the work such a success, but the theme of violent patriotism. The painting is set in the seventh-century BC, when Rome and Alba were moving towards war over agricultural differences; in order to settle their disagreements without wide-spread battle, three men from each side agreed to private combat. In the painting, the Roman Horatii make a pledge to their father to confront the Alban Curiatii. The conflict was complicated by the fact that there were intermarriages between the two factions, resulting in one of the Horatii murdering his sister for her continued devotion to an enemy of the Roman Republic. The republican themes in the painting were significant for France, where a new emphasis on the rights of man – liberty, property and resistance to oppression – was leading to agitation for an overthrow of the outmoded monarchy in favour of a more representative republican government. However, the work was exhibited at the Académie Royale – one of the bastions of *ancien régime* authority. The coexistence of a theme of liberty with a classical subject acceptable to the élite illustrates the tensions which characterized pre-Revolutionary society.

By casting contemporary themes in classical guises, David was both satisfying the conventions of the artistic establishment and universalizing the prevailing concerns with liberty and patriotism. In his 1793 painting *Marat Assassinated* (Figure 10), he also developed a religious subtext. Like many of his contemporaries, David considered Marat to represent the purest form of Revolutionary republicanism, and his portrait of the journalist who was murdered while lying in his bathtub has echoes of previous paintings of martyred saints, or even the *pietà*. Marat died for

his politics, just as saints died for their beliefs, and Christ died for the salvation of mankind. David's painting thus represents a revolutionary form of hagiography.

It was only a short step from these vague adaptations of religious themes to a use of millenarian imagery to represent the fears and hopes of revolutionary Europe. The later eighteenth century saw a revival of interest in John Milton's *Paradise Lost*, culminating in the opening of Fuseli's 'Milton Gallery' in London in the 1790s. The character of Satan in *Paradise Lost* was of particular interest to artists, because he was thrown out of heaven for challenging God, and thus represented rebellion against an established order. To the Romantics, Milton unintentionally made Satan a hero by presenting him as brave, noble and misunderstood in contrast to an uncompromising and doctrinaire God. Artists such as James Barry, himself a committed republican, saw Satan as an embodiment of the forces of rebellion and therefore represented him as heroic, idealized and monumental. The spiritual battle between God and Satan thus manifested the confrontation of the old world with the new – a theme which permeated the more explicitly millenarian poems and paintings of William Blake.

During the early years of the French Revolution, Blake, like Barry, believed that the events in France were of universal significance and would lead to a renewal of European society. Blake articulated these obsessions in a series of poems published in the 1790s which are known collectively as the 'Bible of Hell' or the 'Prophecies'. Blake's prophecies focus on several basic principles: firstly, his belief in the importance of liberty; secondly, his concern with man's spiritual struggle for redemption in a materialistic society; and thirdly, his idea that a disastrous obliteration of the old order was necessary before a new and better society could be achieved. The last of these theories was essentially millenarian. To Blake, the revolutions in America and France were the beginning of a universal spiritual struggle. As early as 1791, his *Marriage of Heaven and Hell* expressed the sentiment that struggle was necessary for advancement: 'Without contraries there is no progression'. Blake used the power of both words and images to relate his apocalyptic visions to the contemporary situation in Europe.

His poem of 1793, *America, A Prophecy*, tackles the subject of the American Revolution through a series of symbolic characters, including 'Albion's Angel', an embodiment of the English King George III, and Orc, who represents energy and rebellion. Orc is the child of Los and Enitharmon, who keep him bound until he escapes and wreaks havoc throughout the world, thus ushering in the Apocalypse. Blake's references to the Last Judgement in *America* are explicit:

> The Morning comes, the night decays, the watchmen leave their stations,
> The grave is burst, the spices shed, the linen wrapped up;
> The bones of death, the cov'ring clay, the sinews shrunk & dry'd
> Reviving shake, inspiring move, breathing, awakening,
> Spring like redeemed captives when their bonds & bars are burst.[17]

Here Blake uses the image of the dead awakening from the Last Judgement, but his language suggests that this awakening should also be seen as symbolic of liberty. The dead become the 'redeemed captives', by implication the repressed citizens of pre-Revolutionary society. The character of Orc, who represents the Revolution, is directly incorporated into the general millenarian theme of the work. When Albion's Angel, the embodiment of repression, speaks to Orc, he addressed him in the following way:

> Art thou not Orc, who serpent-form'd
> Stands at the gate of Enitharmon to devour her children?
> Blasphemous Demon, Antichrist, hater of Dignities,
> Lover of wild rebellion, and transgressor of God's Law.[18]

Orc thus becomes the Antichrist, and like many previous millenarians, Blake saw the Antichrist as heralding the end of an old, decadent world in order to make room for a new and better one.

The French Revolution created anxiety and discontent throughout Europe, and like the religious controversies of the late fourteenth century, many people feared that their hitherto stable world (whatever its faults) was about to be obliterated. Similarly, the conflicts of the 1790s spilled into the following century and culminated with a period of dramatic change. In this respect, the Protestant Reformation of the sixteenth century corresponds with the Napoleonic wars of the nineteenth. The anxieties of Europeans during the eighteenth-century *fin de siècle* were not ungrounded, but realized in the subsequent century. When memory of the French Revolution itself faded with the conquests of Napoleon, Blake's millennial themes became more interpretative than prophetic. His tempera paintings, *The Spiritual Form of Nelson Guiding Leviathan* (Figure 11) and *The Spiritual Form of Pitt Guiding Behemoth* (Figure 12), represent two of Napoleon's English antagonists – the Admiral and the Prime Minister – as angels from Revelation. Nelson thus becomes one of the angels destined to destroy the corrupt world, and his action of strangling a snake alludes to this violent, but crucial, responsibility.

Less overtly millennial but equally violent are Goya's paintings and engravings from 1808. Spain, like most of the rest of continental Europe, was subject to the imperialism of Napoleon. By 1808 not only had Napoleon's armies overrun the country, but his brother Joseph II had been crowned King of Spain. The resistance to Napoleon's political and military incursions came in the form of popular uprisings in individual villages, where the French armies were challenged by outraged Spanish citizens. One such uprising occurred on 2 May 1808, and the following day, French soldiers lined up the insurrectionists and shot them. Goya depicts this event in his painting *The Third of May* (Figure 13) in which the cold brutality of the French soldiers contrasts strikingly with the hysterical defencelessness of the Spanish peasants. The horror of the scene is conveyed through violent emotions rather than excessive gore, but it is no less effective for this subtlety. Goya's most chilling response to the subsequent years of civil conflict in Spain was his series of engravings, *The Disasters of War* (c. 1810–15), which were not published in full until 1863. If considered in relation to the millenarian concerns discussed in this chapter, Goya's engravings depart from the usual pattern. The frontispiece to the series, *Sad Forebodings of What is About to Happen*, carries with it echoes of apocalyptic prophecy, but the quality of Goya's pessimism is somewhat different. Like many millenarian subjects, these too are negative, but their sense of hopelessness is in response to the irrational behaviour of mankind rather than the overwhelming forces of natural or military catastrophe. Furthermore, Goya's pessimistic view of war does not allow any subsequent utopia or equitable Last Judgement. The plate *Nada* or *Nothing* sums up the bleakness and pointlessness of war, which ultimately results in losses on both sides. Any advantages inherent in conflict and man-made disaster are denied in Goya's provocative and disturbing series.

The fears of ultimate destruction that characterize Goya's work were appropriated as fantasies of destruction during the later nineteenth century, and it is here that the *fin de siècle* phenomenon appears in its most unequivocal manifestation. All of the factors discussed in this chapter also

dominate the 1890s, albeit in a unique and more widespread form. Although other elements should not be precluded, it could be said that the conflicts of the 1490s involved religion, whereas those of the 1790s concerned politics. In the 1890s, religion and politics did not disappear as sources of hope and anxiety, but the period was characterized by a greater self-examination and a more explicitly psychological perspective. By this time, large-scale religious millenarianism had virtually disappeared. No longer were writers and preachers talking so heatedly about the Second Coming of Christ, the Apocalypse, the Antichrist and the Last Judgement. However, the manifestations of millennial thinking still existed and indeed were inspired by the internationalism of the *fin de siècle* phenomenon. The power of this secularized millenarianism was strengthened by the growth of mass communication, which stimulated racism, nationalism and other forms of extremism on a vast scale. Self-awareness was encouraged through literature, and the visual arts played a role in both expressing old concerns and perpetuating new ones. Writers and artists represented the prevailing theme of declining civilization, and the end of the century increasingly came to be seen as the end of the world or the end of 'civilized' society.

Like previous *fin de siècle* phenomena, the concerns of the 1890s continued well into the following century. The pessimistic ennui of the 1890s was complemented in the early years of the twentieth century by a sense of millennial utopianism. Throughout Europe there was an awareness that a major war was inevitable and would be disastrous, but many observers also felt that a cataclysm was needed to wipe out the clinging remnants of a 'decadent' civilization. Fantasies of a utopian new world were stimulated by Freud's critique of neurotic urban society, as the commercial obsessions of the industrial age were seen to have drawn human beings away from necessary spiritual concerns. The models of decay and death, progress and renewal, were all present in the 1890s, but the dissemination of ideas on an international scale, as well as the hitherto unknown possibility of a world war, transformed these previously regionalized and religious themes into models of global significance.

NOTES

1. The best work on the subject of millenarianism in the late Middle Ages remains Norman Cohn, *The Pursuit of the Millennium* (London, 1970).
2. Millard Meiss, *Painting in Florence and Siena after the Black Death* (Princeton, 1951).
3. See Robert Scribner, *For the Sake of Simple Folk* (Cambridge, 1981), and his 'Popular Piety and Modes of Visual Perception in Late-Medieval and Reformation Germany', *Journal of Religious History*, 15, no. 4 (December 1989), 448–69.
4. See André Chastel, *The Sack of Rome 1527*, Eng. trans. (Princeton, 1983).
5. Giorgio Vasari, *The Lives of the Painters, Sculptors and Architects*, Eng. trans., 4 vols. (London, 1963), 3, 106. For Giulio Romano, see Frederick Hartt, *Giulio Romano*, 2 vols. (New Haven, 1958).
6. J. Huizinga, *The Waning of the Middle Ages*, Eng. trans. (Harmondsworth, 1987).
7. The most complete collection of Fränger's work on Bosch in English is *Hieronymus Bosch* (London, 1989).
8. Much of my discussion of Savonarola and Florence is based upon the argument of Donald Weinstein, *Savonarola and Florence: Prophecy and Patriotism in the Renaissance* (Princeton, 1970).
9. Quoted in Weinstein, *Savonarola and Florence*, 145.
10. For a detailed discussion of Botticelli's paintings, see Ronald Lightbown, *Sandro Botticelli: Life and Work*, 2 vols. (London, 1978), and for Botticelli and Savonarola, see Stanley Meltzoff, *Botticelli, Signorelli and Savonarola: 'Theologica Poetica' and Painting from Boccaccio to Poliziano* (Florence, 1987).
11. Lightbown, *Sandro Botticelli*.
12. For an exhaustive account of the Revolution and its aftermath, see Simon Schama, *Citizens* (London, 1989).
13. See David Bindman, *The Shadow of the Guillotine: Britain and the French Revolution* (London, 1989).
14. Edmund Burke, 'First of Letters on a Regicide Peace', in *The Works of the Right Honourable Edmund Burke*, volume 5: *Charge Against Warren Hastings Concluded: Political Letters* (London, 1868), 157.
15. See Nicolas Powell, *Fuseli 'The Nightmare'* (London, 1973), and Peter Tomory, *The Life and Art of Henry Fuseli* (London, 1972).
16. See Gwyn Williams, *Goya and the Impossible Revolution* (London, 1976).
17. 'America: A Prophecy', in Geoffrey Keynes, ed., *Blake: Complete Writings* (Oxford, 1989), 198.
18. Ibid.

CHAPTER 2
DEGENERATION

In the nineteenth century, the idea that modern civilization was moving towards an inevitable collapse emerged throughout Europe long before the 1890s. As early as 1834 Désiré Nisard's *Études de moeurs et de critiques sur les poètes latins de la décadence* looked for evidence of decline in the Latin language of the ancient world to create an analogy with the impoverishment of contemporary literature, and, by implication, the decay of social and moral values. Also in France, Thomas Couture's painting, *The Romans of the Decadence*, was the sensational picture at the 1847 Paris Salon. Although in many ways a traditional history painting with a classical setting and a moral purpose, this large canvas could also be read by contemporaries as a statement about Couture's own society. The excesses and debauchery of the decaying Roman empire stood as a sharp reminder that a once strong nation could be destroyed by its own indulgences and luxuries.[1]

As I have shown in my last chapter, these feelings of doom had a long genesis and were often used as a means of explanation or warning at times of social or religious crisis, war or economic collapse. However, in past centuries millenarianism, although widespread, generally occurred locally or regionally, rather than internationally. By the nineteenth century, the sense of disaster spread like a plague throughout the western world, fuelled by the growth of journalism and a larger circulation of published work. The prospect of an extended readership and the need to 'create' issues in order to satisfy this growing demand resulted in a wider comprehension of international concerns and a greater self-consciousness about the problems and potential of modern society. Holbrook Jackson, who lived through the 1890s, later reaffirmed the self-consciousness that dominated the period. He claimed that society anticipated the end of the century as an individual looks to an approaching birthday: an awareness that the event will come is accompanied by a knowledge of the changes that it will entail.[2] Thus French authors referred to '*fin de l'empire*' and '*fin de race*', and German writers chose titles that reinforced the finality of social development, such as Karl Kraus's *Die Letzten Tage der Menschheit* (*The Last Days of Mankind*) and Otto Weininger's *Über die Letzten Dingen* (*Concerning the Last Things*). The German scientist Max Nordau summed up the prevailing *fin de siècle* mood in emotive and almost mystical terms:

> The old Northern faith contained the fearsome doctrine of the Dusk of the Gods. In our days there have arisen in more highly-developed minds vague qualms of a Dusk of the Nations, in which all suns and all stars are gradually waning, and mankind with all its institutions and creations is perishing in the midst of a dying world.[3]

Nordau's hyperbolic assessment of the condition of society was part of his massive and influential volume *Degeneration*, originally published in German in 1892 and soon after translated

and circulated throughout Europe and America. Nordau's choice of the term 'degeneration', rather than 'decline' or 'decadence', was indicative of the interest in the relatively new fields of neurology, psychiatry and anthropology. In the work of the mid-nineteenth-century French psychologist, Bénédict-Augustin Morel, 'degeneration' was an organic disability with specific physiological and psychological manifestations, such as abnormal cranial or genital development, insanity, alcoholism and excessive sexual drive. He saw it as an inherited disorder that developed through several generations: the first was merely nervous, the second had specific central nervous system conditions such as epilepsy, the third was insane, and the fourth was lethally insane.[4] Ultimately, these 'degenerating' families became extinct. Morel's attempt to explain insanity by recourse to a physiological model was reinforced by the work of Charles Darwin, whose *The Origin of Species* (1859) attributed the development of animals to the process of evolution, where only the 'fittest' survived, and whose *Descent of Man* (1871) postulated a common ancestry for apes and men.

Such ostensibly scientific authority provided a rhetoric which could be exploited by writers like Nordau to condemn contemporary developments in the arts. In Nordau's view, Richard Wagner was suffering from 'persecution mania, megalomania, and mysticism', Henrick Ibsen was a 'malignant, anti-social simpleton', Friedrich Nietzsche wrote like 'a madman, with flashing eyes, wild gestures, and foaming mouth' and Émile Zola became a 'sexual psychopath'.[5] In an acerbic criticism of Nordau's book, George Bernard Shaw spoke of Nordau's 'trick of pointing out, as "stigmata of degeneration" in the person he is abusing, features which are common to the whole human race', and went on to assert, 'I could prove Nordau to be an elephant on more evidence than he has brought to prove that our greatest men are degenerate lunatics.'[6] Despite the common-sense eloquence of Shaw's observation, the model of degeneration proved seductive. The diagnosis appeared to be scientific, but it lacked the exactness of genuine scientific hypotheses, and so many of its 'symptoms' were based on subjective evidence. It thus allowed for a plurality of interpretations and was subject to the political, racial or class biases of the people who used the term. As late as 1937, the Nazis used 'degenerate' (*entartete*) to classify modern art which they felt denigrated the German race through its negative subject-matter, non-realist style, and the 'bolshevik' tendencies or Jewishness of its producers. What began as a term applied to insane individuals was quickly appropriated for all prominent social, moral and political concerns.

Within this discourse of degeneration, art had a prominent place. Critics pointed to recent developments in the style and subject-matter of paintings as evidence of social degeneracy; artists deliberately exploited the 'degenerate' aspects of society as a means of subverting the established order, and the history and purpose of art itself was seen through the evolutionary model of progress, decline and natural selection. The importance of art within this sphere has not been the subject of significant recent research. Writers have preferred to concentrate on specific movements such as Symbolism, Decadence and Aestheticism, rather than seeing these movements as part of a larger cultural paradigm. By examining the artistic manifestations within the wider context of degeneration theory, the significance of late nineteenth- and early twentieth-century developments in painting, sculpture and architecture becomes apparent.

Writers complaining about the degeneracy of society attributed much of this decline to the behaviour of individuals. The collapse of morality, the growth of pessimism and an increase in physical and mental disease were all read as symptoms of a declining species, and each of these concerns appeared in the style, subject-matter and development of art. Nordau isolated the first

of these issues – the contempt for traditional authority – as the most obvious stamp of a degenerate society.[7] He did not attribute loose morals to the growth in atheism or the European crises in Christianity, even though his own ethical stance – like that of many of his contemporaries – had its roots in the good/evil polarities of traditional Christian morality. The whole basis of this moral system had been challenged by Friedrich Nietzsche in works such as *Beyond Good and Evil* (1886), which did not become a popular text in German-speaking countries until the 1890s. Nietzsche's maxims used the format of Christ's Biblical parables, but he inverted their didactic intention in assertions such as 'To be ashamed of one's immorality: that is a step on the ladder at the end of which one is also ashamed of one's morality.'[8] Such paradoxes undermined the whole notion of 'right' and 'wrong', and while seeming to provide evidence for social degeneracy, they also opened up possibilities for new themes and styles in literature and art.

When Nietzsche wrote, 'There are no moral phenomena at all, only a moral interpretation of phenomena,'[9] he was not merely presenting a shocking paradox for its own sake. In its widest sense, Nietzsche's remark criticized the way morality was used by social institutions, but more specifically, he alluded to the perpetuation of ethical systems through the fictions of art and literature. Throughout Europe, art academies encouraged the notion that pictures should be painted in an elevated style, but one which was nevertheless true to nature, and that every picture should have both a story and a moral. Thus the moral purpose of a picture was inextricably bound up with its aesthetic qualities; truth to nature became the concomitant of a morally 'correct' subject matter. Changes in the purpose and practice of art came when artists began breaking away from the academy structures, setting up their own exhibitions and actively working against the academic principle of art as a form of instruction. With the advent of Impressionism in the 1860s, and Symbolist art in the 1880s, the aesthetic qualities of a painting began to be divorced from any moral purpose. Although contemporary critics often read narrative messages into Impressionist art, the Impressionists claimed to be presenting nature 'as it really appeared', rather than providing a narrative or a lesson. On the other hand, Symbolist artists advocated the presentation of subjective experience, divorced from any universal notion of human morality.

The way this change manifested itself can be demonstrated by comparing two paintings of similar subjects which reveal different styles and intentions. The Norwegian painter Edvard Munch's *Death in the Sickroom* (Oslo, National Gallery) of 1892 and *The Doctor* by the English artist Luke Fildes (1891, London, Tate Gallery) of the previous year both represent scenes of illness. Fildes's work was a great success when exhibited at the Royal Academy in 1891, and it inspired a plethora of comment and interpretation. Critics responded particularly to the narrative aspects of the painting, which shows a doctor watching over the sickbed of a dying child, whose parents are quietly despairing in the background. Such pathos characterized many Victorian narrative paintings, but observers went further in their eulogies about the role of the doctor as healer and selfless support in times of need. Fildes was tapping a universal theme, commensurate with the prevailing values of late Victorian society. He carefully constructed each section of the painting by setting up a model for the sickroom in his studio, thus creating a semblance of reality in the work itself. By contrast, Munch deliberately undercut any sense of realism in his *Death in the Sickroom* through his use of unsettling colours and shaky lines. Aside from the truth of the death itself, there is no narrative in Munch's painting, and we cannot reconstruct a 'story'. Instead, he foregrounded the emotions and isolation of the mourners, while relegating the deceased to the far background of the work. As in other sickroom scenes, Munch reportedly based this painting on his own youthful reactions to the death of his mother and sister, who both succumbed to

tuberculosis. By dispensing with conventional style, subject-matter and purpose, Munch's painting replaces ethical considerations with emotion, and points away from a rigid morality to a world of infinite possibility.

The most blatant rejection of established ethics can be traced in a commission intended to reinforce those very ethics. In 1894 the Ministry for Culture and Education in Vienna asked Gustav Klimt to paint a series of murals for the University. The general theme of the series was 'The Triumph of Light Over Darkness', and this was to be represented through images of the University Faculties of Philosophy, Medicine and Jurisprudence. These categories of learning were laden with tradition and respectability reaching back to the Middle Ages, but in each instance, Klimt's painting subverted conventional associations. Thus, Philosophy showed the world as an undifferentiated cosmos of lost individuals, rather than exemplifying Philosophy's role as a means of understanding the ethical, intellectual or aesthetic nature of the universe. Medicine was represented by a *femme fatale* with an entourage of nudes, alluding to healing only through the presence of a phallic snake – associated historically with the Greek healer Asclepius. Finally, Jurisprudence revealed not the justice of the law, but the injustice of slavery, with a group of sinister female judges overseeing a helpless chained male victim. The outrage expressed when Klimt's murals were shown publicly stemmed partly from the lubricious nudity, but more generally from the fact that traditional values were being ignored or overturned, challenging the conservative moral stance of *fin de siècle* Viennese society.

The abandonment of traditional moral concerns also led artists to explore themes and ideas which had previously been outside the realm of art. Artists associated with the Impressionist group were among those who claimed to be presenting an unbiased and non-didactic view of the contemporary world. They painted café life, street scenes, prostitutes and images of leisure which they presented as characteristic of modern life. However, by eschewing the moral nature of past art, the Impressionists and their followers implicitly rejected morality, and the subjects they selected exemplified the less salubrious aspects of modern existence.

Among the most popular Impressionist subjects, scenes of the café and the theatre reveal the interests of a more leisurely society. But these very aspects of leisure were isolated by some commentators as symptoms of social degeneration. Alfred Fouillée, for example, wrote of theatrical and cabaret performances as 'demoralizing spectacles', which are dangerous because they 'excite the passions of a people' thus leading to depression and nervousness.[10] Another 1890s writer saw the dances at the popular café concerts as similar to the frenzied moments of hysteric patients at the hospital of Salpêtrière where the famous physician Jean-Martin Charcot held the chair for nervous disorders.[11] Dancing could thus be seen as a modern form of madness.

Given these interpretations of public spectacle, a painting such as Seurat's *La Chahut* (Figure 14) which depicts the superficial frivolity of a can-can dance can no longer be understood merely as an experiment in Neo-Impressionist colour theory or even simply a jolly scene of leisure entertainment. The subject-matter itself would have been loaded with associations for the contemporary Parisian audience, and these associations could be linked with the notion of social degeneration. Impressionist artists approached this rather delicate subject-matter in a variety of ways. Renoir sugared the pill in his *Moulin de la Galette* (1876, Paris, Musée d'Orsay) by permeating the scene with a gentle light, thus softening the effect of the crowded café bar. By contrast, Toulouse-Lautrec emphasized the abnormal aspects of human behaviour brought forth in such settings. He painted a number of scenes of café life, but more interestingly, he produced posters to advertise popular nightspots such as the Moulin Rouge (Figure 15). Rather than seeking to

minimize the seedy, unnatural and emotionally unstable qualities of the café concert, Toulouse-Lautrec's posters heighten these characteristics. The very fact that this kind of sensational advertising was so popular indicates the growing attraction of the amorality promised by such pastimes.

Toulouse-Lautrec extended his repertoire to the depiction of prostitutes and brothel life, and he resided in Parisian brothels between 1892 and 1895 in order to study this life more closely. Although the 'degenerate' nature of café and leisure life was to a certain extent concealed in late nineteenth-century French paintings, Toulouse-Lautrec's motive in painting prostitutes in various stages of undress seems deliberately subversive. Sexual 'degeneracy' was widely discussed by writers throughout Europe. The Italian criminologist Cesare Lombroso pointed out in the 1880s that 'sexual crimes and crimes of fraud are the specific crimes of advanced civilization', and prostitution, although to an extent accepted and controlled, was perceived to be just such a 'sexual crime'.[12] More forthright than Lombroso was the Austrian psychiatrist Richard von Krafft-Ebing, whose popular *Psychopathia Sexualis* (1886) deemed any form of sexual behaviour outside monogamous marital relations as a symptom of potential or active degeneration. Krafft-Ebing agreed with Lombroso's assessment that sexual immorality was a specifically modern problem which both exacerbated and was exacerbated by the conditions of modern living:

> Periods of moral decadence in the life of a people are always contemporaneous with times of effeminacy, sensuality and luxury. These conditions can only be conceived as occurring with increasing demands upon the nervous system, which must meet these requirements. As a result of increase of nervousness, there is an increase of sensuality, and since this leads to excesses among the masses, it undermines the foundation of society – the morality and purity of family life.[13]

The contrast between conventional, effectively Christian, morality, and the ostensible amorality of paintings of prostitution and lesbianism produced by Toulouse-Lautrec is striking; indeed, Toulouse-Lautrec showed great curiosity about Krafft-Ebing's work when it was first published.[14]

A further step in this direction was taken by the Belgian artist Félicien Rops, whose work combined semi-pornographic views of women with anti-clerical satire, thus making the rejection of traditional morality explicit. In a later assessment of Rops, the Austrian art critic Hermann Bahr pointed out that the artist thought 'that the world is the work of the devil; that Mankind, who longs for the Good, is not released from the Devil's noose; he [Rops] expresses the dishonour and scandal of the worldly'.[15] Bahr summed up Rops's subversiveness concisely: 'He gives his atrocious, malicious, sinister thoughts, the purest and noblest form.'[16]

Themes associated with immorality and social degeneration can also be seen in paintings representing drinking, alcoholism and drug abuse – then considered both symptoms and causes of social decline. Nordau, Lombroso and Fouillée all isolated the widespread use of alcohol and drugs as problems of modern civilization, caused by a 'need for cerebral stimulation' which they felt characterized the degenerate individual.[17] Zola's novel *L'Assommoir* (1876) bluntly exposed some of the worst effects of alcohol abuse on the lives of individuals, while Edgar Degas (Figure 16), Edouard Manet and Jean François Raffaëlli all painted scenes of absinthe drinkers. As a relatively cheap and lethal alcoholic beverage, absinthe was accessible to the working classes, and, used in excess, it could ultimately lead to various forms of alcoholic insanity. Some art historians have claimed that these artists were simply painting what they saw, and that Degas, for

example, was more interested in the facial expression of the intoxicated and exhausted drinkers than in the act of drinking itself.[18] But this reading fails to take account of the meaning of such subject-matter within the context of late nineteenth-century theories of degeneration. The very choice of these themes constituted a statement, and the emphasis on aspects other than that of drinking was a way of making a difficult subject more palatable. When the English artist Dante Gabriel Rossetti painted a memorial picture of his wife, Elizabeth Siddal (Figure 17), he chose to obscure the fact that she had died of an overdose of laudanum (an opiate), but alluded obliquely to it by including in the painting a dove dropping a poppy into Siddal's hand. In each instance, these works reject the tenets of conventional morality characteristic of 'realistic' narrative painting in the academic tradition, and in each case these artists presented subject-matter which was regarded by a number of contemporaries as symptomatic of social degeneration.

Social degeneration was also seen in the increasing pessimism of much writing and art in the last half of the nineteenth century. The roots of this pessimism can first be seen in a growing interest in subjective experience, as opposed to the positivist ideology inspired by the commercialism of industrial society. Positivist thinkers believed that all knowledge rested in the observation of external phenomena, or the outside world, and they were therefore prone to accept only the perceptions of the senses as evidence of experience. Nietzsche attacked positivism for its limitations, but Nordau characteristically viewed the *rejection* of empirical understanding as degenerate. In terms of art, Nordau claimed that realistic art came directly from sense perceptions and idealistic art resulted from emotions detached from the world of the senses:

> Among thoroughly sane individuals the emotions originate almost solely from impressions of the external world; among those whose nervous life is more or less diseased, namely, among the hysterical, neurasthenic, and degenerate subjects, and every kind of lunatic, they originate much more frequently in internal organic processes.[19]

In other words, degenerate individuals are more likely to take a 'subjective' rather than 'objective' view of the world and life.

The effects of this philosophical subjectivism abound in art. In 1897, Gauguin painted his large *Where Do We Come From? Where Are We? Where Are We Going?* (Figure 18). Gauguin subsequently claimed that the work was painted from memory in a frenzy of despair shortly before an abortive suicide attempt, but the repetition of familiar motifs from previous paintings and a preparatory drawing suggest a much more carefully planned work.[20] Gauguin wished this canvas to be a summary of life experience, but he presented it in terms which were inaccessible to other observers. In a long letter of February 1898, he describes the painting in great detail, without so much as hinting at its meaning, and in a later letter to the art critic Charles Morice, he makes his orientation explicit by comparing his work to the art of the French academic painter Pierre Puvis de Chavannes:

> Puvis explains his idea. Yes, but he does not paint it. He is a Greek, whereas me, I am a savage, a wolf in the woods, without a leash. Puvis will entitle a painting 'Purity' and for the explanation, will paint a young virgin with a lily in her hand. Known symbols, therefore one understands it. Gauguin, to the title 'Purity', will paint a limpid landscape without the moral stain [*souillure*] of civilised man . . . There is a whole world between Puvis and me.[21]

Aside from a few obvious indications of birth, spiritual seeking and old age, Gauguin's work had little meaning for its viewing public, and the very existence of such patently private symbolism indicated that individual experience – rather than any universal meaning – was paramount.

The cult of subjectivism was encouraged by Arthur Schopenhauer's *The World as Will and Idea*. Although written in 1819, Schopenhauer's tract was only translated into French in 1886, and, like Nietzsche's works, it became a fashionable text in the 1890s. Schopenhauer saw the world as a mass of individuals whose wills were constantly clashing and who would never be able to understand or engage with each other. In Schopenhauer's world, love was a battle without winners and the only solace rested in a contemplative form of religious experience. This pessimism was also expressed in Rodin's *Gates of Hell*, which although originally intended as doors for the new Musée des Arts Décoratifs in Paris soon became a personal experiment. The original subject of Dante's *Divine Comedy* was abandoned in favour of themes based on Charles Baudelaire's collection of poems, *Les Fleurs du Mal*. Vestiges of Dante's *Inferno* remained, especially in the tympanum, which shows the damned being cast into hell, but Rodin replaced this specific literary subject with a more general appraisal of the human condition. In the chaotic and cluttered world of the *Gates of Hell*, love is reduced to a struggle for survival, and passion obliterates any possibility of reason.

The negative conception of life was also characteristic of numerous paintings produced from the 1880s onwards, particularly those which questioned the very meaning of life. To an extent, artists took on the role of philosophers and began painting pictures, or cycles of pictures, which examined global concepts. Life was seen as tragic and pointless, love was viewed as conflict rather than conciliation, and joy was banished. This pessimistic analysis of existence is epitomized by the 'blue period' paintings of Picasso. These works represent the destitute, the blind, the hungry and the insane, and their mood, colour and tone express the melancholy nature of life. Picasso's *La Vie* (1903, Cleveland Museum of Art), painted to commemorate the suicide of his friend, the artist Carlos Casagemas, includes themes of birth, love, despair and death. Like Gauguin's *Where Do We Come From?*, the exact meaning of this work is obscure, but its negativism is undeniable.

Individual philosophical paintings were less common than the picture cycle, including that of the English artist G.F. Watts, who wished to create a 'house of life' in which he could display his paintings. Although never realized, Watts's variations on the 'house of life' themes included a number of bleak visions such as *Hope*, which could just as easily have been called 'despair'. Hope is blind, and all but one of the strings on her lyre are broken. Watts represents Hope as fragile, helpless and reliant on the most tenuous of certainties, but at least he acknowledges her presence in the world.

By contrast, Munch's 'frieze of life' completely excludes hope from its sphere. Like Watts, Munch wished to exhibit a series of his paintings as a commentary on life and love. Begun in 1892, these paintings were first shown together in Berlin in 1902, and since Munch's death, they have been in the National Gallery in Oslo. Munch was interested in the whole question of human relationships, but he found the sentimental bourgeois interior scenes painted by his contemporaries a safe but ineffectual commentary on existence. He asserted: 'No more interiors should be painted, no people reading and women knitting. They should be living people who breathe, feel, suffer and love.'[22] Suffering dominates the series in works such as *Jealousy* (1893, Bergen, Rasmus Meyers Collection), based in part on a love triangle in which Munch was involved while living in Berlin. *Jealousy* shows Munch's erstwhile friend, the author Stanisław Przybyszewski,

whose gloomy expression dominates the foreground of the painting. Behind the jealous face, a man and a woman under an apple tree symbolize Adam and Eve and represent Munch himself and Przybyszewski's wife, Dagny, with whom the artist had an affair. The Norwegian playwright August Strindberg produced a prose-poem in praise of this painting, which contains an interesting slant, especially significant for the idea of degeneration:

> Jealousy, holy feeling of the soul's cleanness,
> which abhors mingling with one of the same sex, through
> the intermediary of another of the opposite sex.
> Jealousy, a legitimate egoism, descended from the
> instinct for survival, for myself and my race.[23]

Such a bizarre and seemingly inappropriate view of jealousy is coloured by the Darwinian notion of natural selection and preservation of the species. To Strindberg, Munch's paintings represented the struggle between man and woman which could be seen in currently popular anthropological terms such as cleanness, instinct, survival and descent. The 'fittest' survived, but it is survival – and not happiness – which dominates love, according to Munch.

Like the perceived collapse in moral values, the pessimistic view of existence perpetuated by artists at the turn of the nineteenth century reinforced the notion of degeneracy. The behaviour of individuals could also be read as retrogressive and effectively insane, and this interpretation was extended to ideas of sickness, family decline and extinction. Nordau referred to his whole analysis of degeneracy as 'our long and sorrowful wandering through the hospital',[24] and the issue of disease permeated late nineteenth-century literature, from Baudelaire's perverse poems, *Les Fleurs du Mal*, to Ibsen's Oswald Alving in *Ghosts*, who suffers from syphilis. In art, paintings of illness and death, such as Munch's *Death in the Sickroom* (1892, Oslo, National Gallery), expressed a horrified fascination with decay and disorder. The idea that one generation inherited traits from the previous generation was perpetuated by anthropological and psychological studies, which saw disease and insanity as being passed from parents to children. The idea of family decline contained in this notion is mostly expressed in literature by J.-K. Huysmans, whose notorious novel *A Rebours* (1884) concerns Jean Des Esseintes, the last representative of a diseased aristocratic family:

> The decadence of this ancient house was unquestionable, continuing regularly on its course; in this way the effemination of the men was accentuated; to finish off the work of ages, the Des Esseintes for two centuries intermarried, wearing out the remainder of their vigour in consanguinous unions.[25]

By extension, the sickness and degeneracy of individuals was perceived as merely a symptom of a comprehensive degeneracy of society and civilization as a whole. Here the anthropological model became more metaphorical than precise. The biologist Ernst Haeckel could thus analyse social structure as if it were composed of a series of cells:

> We can only arrive at a correct knowledge of the structure and life of the social body, the state, through a scientific knowledge of the structure and life of the individuals who compose it, and the cells of which they are in turn composed.[26]

Sickness of individuals and families was therefore seen as only one aspect of a sick civilization. Nietzsche's ironic comment, 'Madness is something rare in individuals – but in groups, parties, peoples, ages it is the rule',[27] later took on more serious forms. The sociologist Emile Durkheim attributed the increase in suicides in the 1890s to this wider social malady: suicide could not be attributed to individual insanity but to a flaw in the fabric of society which encouraged excessive individualism or immoderate self-sacrifice.[28] Durkheim's ostensibly scientific study was in reality a comment on what he saw as a diseased civilization. The same sort of observation was also made by Zola as early as 1880. In his novel, *Nana*, the eponymous prostitute dies of smallpox, which ruins the beauty she formerly employed to indulge her own greed and exploit the wealth and lust of high society. Zola's description of Nana's previously beautiful face as 'a charnel-house, a heap of pus and blood, a shovelful of putrid flesh' moralizes her disease, and he extends his metaphor: 'that ferment with which she had poisoned a whole people, had now risen to her face and rotted it.'[29] Significantly, while Nana dies, French soldiers are marching through Paris streets on the eve of the Franco-Prussian War: writing several years after the French defeat in this war, Zola could relate the collapse of French confidence to the previous excesses of a greedy mercantile society. Nana's own illness and death thus represented the sickness and degeneration of a whole nation.

Just as individual degeneracy was seen to manifest itself in moral decline, pessimism and inherited illness, so the degeneracy of society was interpreted in terms of racial purity and atavism, or reversion to primitive type. Suggestions that a modern civilization was in a state of decline required explanation, and writers turned to the changes wrought by the industrial revolution. Social degeneration was attributed variously to war, technology, the growth of cities and immigration. Most of these were specifically modern issues, but using the Darwinian model, observers suggested that the inability to adapt to rapidly changing conditions was resulting in a degeneration to primitive type. The more 'modern' the trappings of civilization became, the more 'primitive' members of that civilization were seen to be. Ultimately, the all-encompassing model of degeneration included the theory and history of art itself. Like society, the development of art was seen as a manifestation of progress and decline.

Before considering how the notion of degeneration was applied to the history and development of art, it is necessary to examine the application of degeneracy theory to civilization as a whole. A number of writers insisted on the detrimental effects of war to a civilized and efficiently functioning society. Both Nordau and Fouillée pointed to the debilitating consequences of war on the nerves of individuals;[30] war was seen to sap energy and break up the collective unity of the social order. In Havelock Ellis's utopian *The Nineteenth Century*, a wise man and a curious boy discuss the 'barbaric' period of the nineteenth century, presented by Ellis as being in the distant past. The dialogue which results offers a critique on European divisiveness in the nineteenth century, without suggesting any real alternative: 'Unlike previous ages, they lived under the double yoke and strain of a militant industrialism and the actual daily expectation of real warfare, and thus a constant strain of nervous tension existed among their populations.'[31] As well as conflict between nations, the growing problem of conflict *within* nations, or anarchy (see Chapter 3), intensified concerns about violence and its consequences. Inevitably, the whole idea of conflict was cast into biological terms by the French psychologist Paul Bourget, who, like Ernst Haeckel, compared society to an 'organism':

The individual is the social cell. In order that the organism should function with energy, it is necessary that the organisms composing it should function with energy, but with a

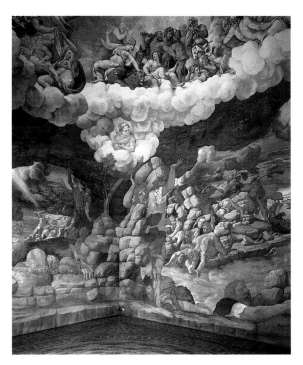

1 Giulio Romano, *The Room of the Giants* in the
Palazzo del Té, Mantua, Italy

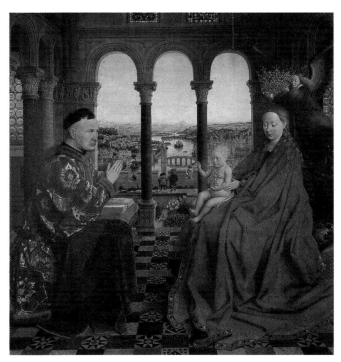

2 Jan van Eyck, *Virgin of Autun* (Madonna with Chancellor Rolin),
Louvre, Paris

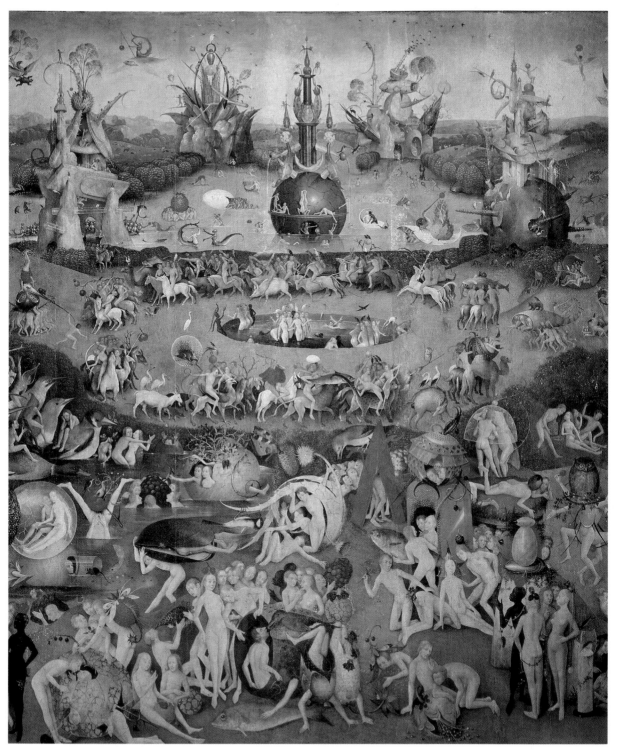

3 Hieronymus Bosch, *The Garden of Earthly Delights* (centre panel), *c*1505–10, Prado, Madrid

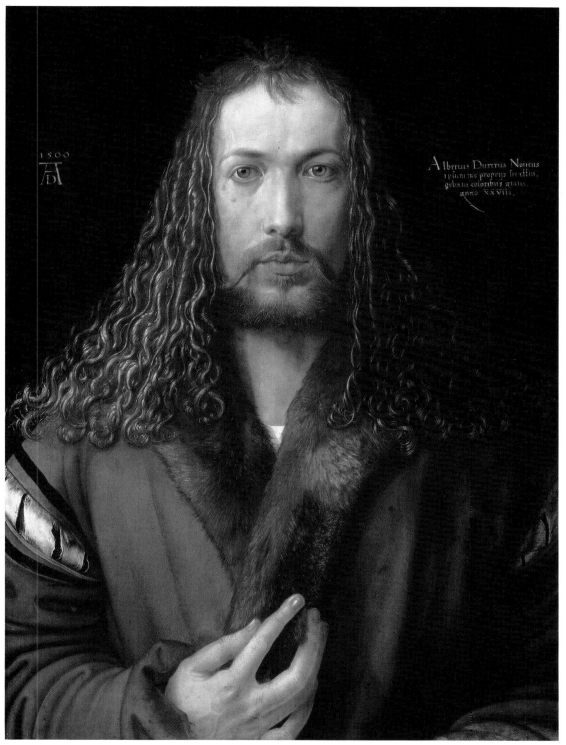

4 Albrecht Dürer, *Self Portrait*, 1500, Alte Pinakothek, Munich

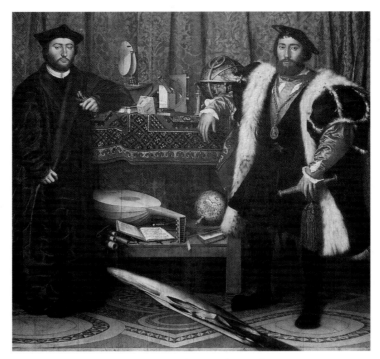

5 Hans Holbein, *The Ambassadors*, 1533,
National Gallery, London

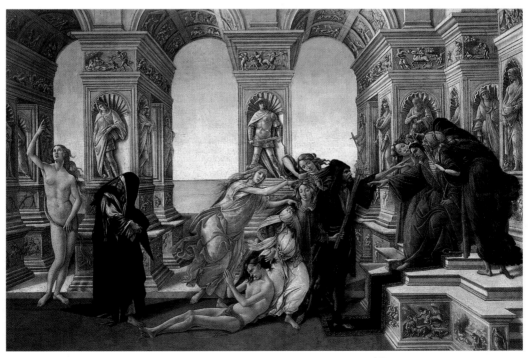

6 Sandro Botticelli, *The Calumny of Apelles*,
*c*1490, Galleria degli Uffizi, Florence

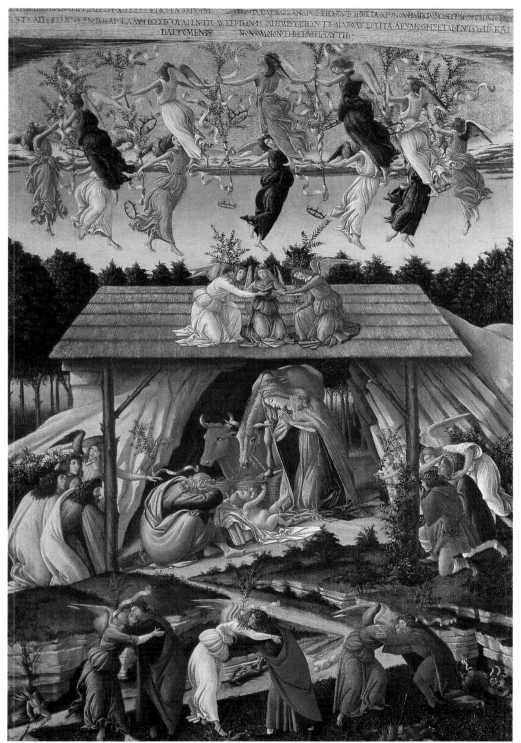

7 Sandro Botticelli, *Mystic Nativity*, 1500, National Gallery, London

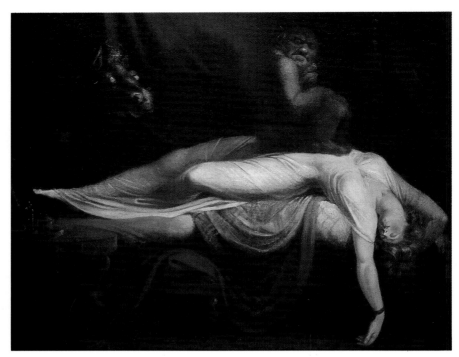

8 Henry Fuseli, *The Nightmare*,
Detroit Institute of Arts, Michigan

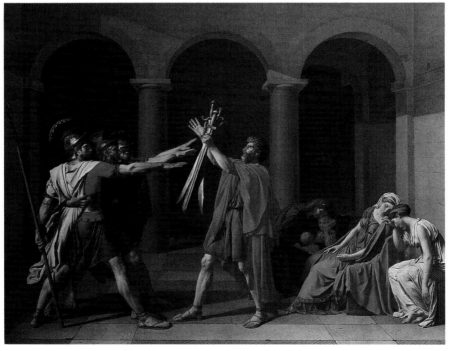

9 Jacques Louis David, *The Oath of the Horatii*, 1784,
Louvre, Paris

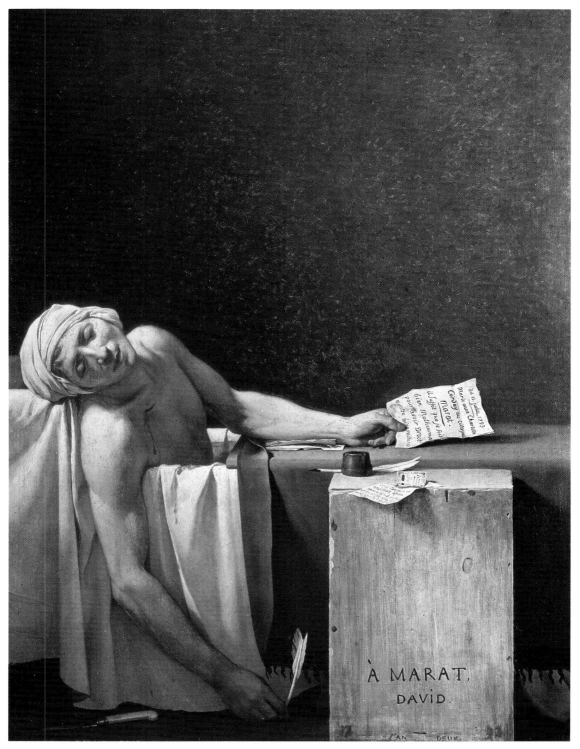

10 David, *Marat Assassinated*, 1793, Musées Royaux des Beaux-Arts de Belgique, Brussels

11 William Blake, *The Spiritual Form of Nelson Guiding Leviathan*,
Tate Gallery, London

12 William Blake, *The Spiritual Form of Pitt Guarding Behemoth*, 1808,
Tate Gallery, London

subordinate energy; and in order that these lesser organisms should themselves function with energy, it is necessary that their component cells should function with energy, but with a subordinate energy. If the energy of the cells becomes independent, the lesser organisms which compose the total organism will likewise cease to subordinate their energy to the total energy and the anarchy which is established constitutes the decadence of the whole.[32]

Thus anarchy and war were actions which went against the 'natural' development of the social organism.

This interpretation of war predominated in the 1880s and 1890s, but in France particularly it was possible to look back to the defeat of the Franco-Prussian war, as Zola had done, and to see in it evidence of social collapse. In art and literature, war was no longer so much an event to be glorified by revelling in the deeds of heroes, but became the subject of grim regret and cold-blooded analysis. The subject-matter of painting also revealed this shift in emphasis. Despite Goya's incisive *Disasters of War* series, much art of the past presented war as a necessary and even glorious part of civilization. By 1870, artists were no longer representing war in such a eulogistic manner. The Swiss painter, Arnold Böcklin, used a symbolist approach to the subject by presenting war as the Four Horsemen of the Apocalypse, riding furiously and breathlessly through the sky (*War*, 1896, Dresden, Staatliche Kunstsammlungen). In this painting, death, pestilence and disease, rather than heroic commanders, control the course of events. As far afield as Russia, the realist artist Vassili Vassilievich Vereshchagin painted an *Apotheosis of War* which summed up the savage Turkistan wars of 1867–70 through the motif of a pile of skulls. Vereshchagin's realist style is in direct contrast to Böcklin's symbolic mythologizing, but both artists arrived at the same interpretation. Even more seemingly 'realistic' than Vereshchagin, the English photographer Roger Fenton received a royal commission to photograph the British troops in the Crimea in 1855. Although Prince Albert limited Fenton's freedom by insisting on 'no dead bodies', photographs such as *The Valley of the Shadow of Death* (1855) deflated the more confident images Fenton produced there. Like Vereshchagin's skulls, Fenton's cannon balls litter the empty battlefield as a grim reminder of the impact of war.

Aside from war, the degeneracy of society was seen to rest in the growth of cities and the increase in technology. If war led to nervous tension, machines caused 'exhaustion'. Using the Darwinian paradigm, writers claimed that the development of cities had raced ahead of the ability of modern man to adapt. In attempting to adapt to such overwhelming and adverse social conditions, human beings were wearing themselves out.[33] According to some writers, the use of machines destroyed the traditional delicate balance between body and soul, and debilitated the body through its lack of use.[34] In a lecture on 'Degeneration Amongst Londoners' delivered to the Parkes Museum of Hygiene in 1885, James Cantlie attributed social degeneration to lack of exercise and sunshine ('Did you ever get sunburnt in London?' is one of his rhetorical questions). The ultimate result of such unhealthy living is a decline of the species: 'What I want to prove, if possible, is that a mere collection of human beings is enough, without manufactories' smoke, to render the air in such a condition that the families living in such an atmosphere dwindle and disappear from inability of continuance.'[35] Ironically, the city – which provided the most obvious evidence for scientific and technological progress in the nineteenth century – came to be seen as one of the causes of social decline (see Chapter 4).

Concerns about war, anarchy and the growth of cities were not without justification, and in retrospect, it is possible to recognize, and to an extent sympathize with, the fears of nineteenth-

century observers that such factors would ultimately destroy civilization. The other major cause of degeneration as perceived by *fin de siècle* observers – racial impurity – is less defensible. The concept of racial impurity was stimulated by an increase in immigration, fuelled by persecution and agrarian depression, which fed the growth of cities and was itself facilitated by modern rail transport. From the early 1880s, pogroms in Russia and Eastern Europe led to a large migration of Eastern European Jews, and at the same time, the promise of employment in cities drained the countryside throughout Europe. In Vienna, for example, the population between 1880 and 1900 grew by 130%, and many of these were working-class Czechs, whose sense of national identity was challenged by the Germanic bias of the Viennese Liberal government.[36] At the same time, other European countries, including England, were engaging in imperialistic campaigns to expand their empires in Asia and Africa. This increase in immigration and imperial expansion inspired paranoia in those who felt that racial mixing was a substantial threat to the continued 'health' of civilization.

Nietzsche was one of the earliest writers to express this paranoia. He claimed:

> The man of an era of dissolution which mixes the races together and who therefore contains within him the inheritance of a diversified descent, that is to say contrary and often not merely contrary drives and values which struggle with one another and rarely leave one another in peace – such a man of late cultures and broken lights will, on average, be a rather weak man.[37]

In its most invidious form, the anxiety about racial mixing could lead to an insistence on racial purity. Francis Galton, in his *Inquiries into Human Faculty* (1883), coined the term 'eugenics', which signified the improvement of a race by interbreeding the 'best' specimens of that race. When applied to human beings, this idea took on chilling implications: some people could be seen to be 'better' or 'purer' than others, and any mingling of an 'inferior' with a 'superior' race would weaken the superior one. Riddled with value judgements, eugenics and all it stood for engendered nationalist sentiment and horror of the effects of immigration. Fouillée applied such a principle to the issue of French degeneracy. He claimed that the delicately balanced mixture of Aquitainian, Celtic and Belgian racial qualities which constituted the French character was in danger of being destroyed by the influx of 'foreign elements'. According to him, among other factors, racial intermixing was resulting in a Darwinism in reverse ('*un darwinism à rebours*'), or a sort of *un*-natural *de*-selection of the species.[38]

Notions of race permeated literature at the end of the century, but in art their effects were somewhat less apparent. The very instability of the ideas behind eugenics did not lend themselves to artistic expression. However, one of the most famous paintings of the early twentieth century may be better understood within the terms of the arguments for racial purity. Picasso's *Les Demoiselles d'Avignon* (1906–7, New York, Museum of Modern Art) has long been recognized and explained as a 'turning point' in twentieth-century art. With its distorted forms and lack of conventional perspective, the painting has rightly been interpreted as a rejection of traditional artistic values reaching back to the Renaissance. The distorted faces of the prostitutes in the work were based partly on Picasso's observations of Iberian and African sculpture at the Musée du Trocadéro in Paris, and his use of such masks has generally been related to his obstinate rejection of western canons of beauty. Such observations are certainly valid, but a further understanding of Picasso's work can be reached by observing how he imposed African faces onto the bodies of western prostitutes. Here, both irony and contempt for traditional belief came to the fore. In *Les*

Demoiselles d'Avignon, Picasso created a virtual metaphor for degeneration. Prostitutes, perceived as one manifestation of modern moral degeneracy, are cast in the guise of a 'primitive' race. By turning such a representation into a work of art, Picasso's rejection of artistic and social convention becomes even more apparent. Degeneracy, moral decline and racial intermixing are combined to create an inverted vision of the classical Graces. Although many art historians would like to see Picasso as an artist somehow above the influence of cultural factors, his work can be better understood by considering it in relation to these very factors.

Most artists who used or were influenced by various forms of 'primitive' art regarded such work as somehow superior to the productions of western industrial society (see Chapter 8). However, observers who adhered to the degeneracy theory of civilization saw such reversion to primitive type as the ultimate evidence for the decline of society. The downfall of civilization was seen to be caused by war, industrialization and immigration, and the consequence of these effects was perceived to be an atavistic tendency in modern man. European observers saw retrogressive qualities in their fellow citizens: the increases in criminality, insanity and disease were all attributed to this perceived atavism. In reality, as Michel Foucault has shown, the proliferation of institutions such as psychiatric hospitals and prisons ironically *engendered* criminality and insanity, rather than providing the facilities to ameliorate an already existing condition.[39] Equally, the judgemental approach to atavistic or primitive tendencies allowed a society to classify 'outsiders' as manifestations of primitivism. Not only was the perceived inferiority of non-western peoples an incitement to western imperialist values, but children, Jews, women, homosexuals and the working class could all be looked upon as atavistic by the white male Protestants or Catholics who constituted the governments in Europe.

As in the notion of racial intermixing, atavism was not a concept concrete enough to find an obvious place in art, but artists did invent more oblique ways of expressing the prevalence of such theories through visual representation. This is the case in the work of Odilon Redon, who is primarily known for his nightmarish visions inspired by the bleak stories of Edgar Allan Poe (see Chapter 7). In 1883, Redon produced a collection of lithographs called *Origins*, the title of which makes a nod to Darwin's influential *The Origin of Species*. Redon was strongly influenced by his friend, the botanist Armand Clavaud, who encouraged him to study microscopic life forms. Among the illustrations in *Origins* (Figure 19, for example), 'When Life was awakening in the depths of Obscure Matter' shows a hybrid form which represents the beginnings of life as we know it. Such mutations abound in Redon's work, and they contain familiar features, but juxtaposed in unnatural ways. The title 'Origins' suggests the roots of civilization, but Redon's imaginary monsters bear enough resemblance to familiar animals and plants to indicate that the reverse could also be true. These creatures may represent 'origins', but they also represent 'reversions'. The theory of natural selection does not simply presuppose a strong species, but necessarily includes the existence of weak ones.

Atavism as a symptom of degeneration formed a more explicit theme in the theoretical writings of Adolf Loos, one of the earliest modernist architects. Loos was opposed to the revival of historical styles that dominated European architecture in the nineteenth century and he isolated one manifestation of this historicism in the passion for ornament in the design of architecture and decorative arts. Even more recent styles of architecture, such as art nouveau, were seen by Loos as invidious examples of ornamental obsession. In an influential essay, 'Ornament and Crime' (1908), Loos borrowed heavily from the criminological theories of Lombroso to propose that the excessive use of ornament exemplified social degeneracy. Loos admitted that primitive

societies employed ornament, citing the Papuan use of tattoos, but he pointed out that a modern society should have no need for such atavistic indulgences: 'The Papuan tattooes his skin, his boat, his rudder, in short, all that is within his reach. He is no criminal. The modern man who tattooes himself is a criminal and a degenerate.'[40] Loos extended his argument to suggest that an excessive concern with ornament led to a depletion of the energies of the work force: the sheer number of hours required to produce useless ornament engaged workers in exhausting and pointless activity which ultimately led to a decline in the strength of a nation. Loos believed that art needed to be purged of these atavistic influences in order to be both healthy and sane.

The range of examples used in this chapter has revealed the widespread nature of the concept of degeneracy, and the way this idea was used in relation to individuals and the society as a whole. Artists both responded to and reacted against the notion of degeneracy, and their style and subject-matter were often interpreted by observers as symptomatic of social decline. However, apart from the specific works of individual artists, the whole notion of art was subject to the theories of degeneracy which also informed the issues of politics, morality, race and civilization. First of all, some art was looked upon as evidence of degeneracy, and the creation in the 1880s of a semi-organized group of 'Decadent' writers and artists in England and France shows just how degeneracy could be ironically formalized. Secondly, some psychiatrists used the evidence of art in their investigations of individual degeneracy, and art thus played a passive role in the construction of notions of a degenerate type. Thirdly, the general concept of progress and decline was applied to the history of art, and by extension, Darwin's theories of species development and natural selection were also appropriated. In each of these ways, art itself became subsumed within the flexible and intangible discourse of degeneracy.

As early as 1767, an anonymous English sermon against the theatre, *The Stage, the High Road to Hell*, preached against the necessity for art in a civilized society:

All arts are proofs of the degeneracy of the human species; for if man had not, by the Fall, and its fatal consequences, forfeited his first exalted condition, he would never have occasion for invention to supply his wants, or education to remedy the imbecility of his nature.[41]

Although this author saw the arts as a consequence of Original Sin, Nordau implies the same viewpoint in his evaluation of the late nineteenth century, without recourse to such Biblical explanations. A similar notion was put forth by Ellis in his utopian critique of the nineteenth century. Too much literature (and by extension, too much art) was seen to be characteristic of an 'ill-adjusted culture', where the arts satisfy only the sick desires of 'a vast mass of emotionally starved and crushed human beings'.[42] Not only were the arts seen as products of a degenerate society, but according to Nordau, the artists themselves possessed these retrogressive tendencies:

Degenerates are not always criminals, prostitutes, anarchists, and pronounced lunatics; they are often authors and artists. These, however, manifest the same mental characteristics.[43]

The tendency of artists to organize themselves into groups was interpreted as evidence of their criminal potential; bohemian café life was thus seen as equivalent to Lombroso's criminal gangs.

Nordau's often excessive arguments here enter the realms of absurdity, but the idea that art and artists were corrupt and corrupting had a strong impact on social attitudes in the late nineteenth century.

Such interpretations could only be reinforced by the existence of a Decadent movement in literature and art. The very fact that this term could be used to characterize and circumscribe works of art suggests that writers and artists were formalizing their position as social outsiders and stimulants to social degeneracy. The term 'Decadent' is both meaningless and ironic. Literary theorists have long argued over its real meaning, the limits of its influence and its relationship with such movements as Symbolism and Aestheticism. The word had been used intermittently since 1834, but it only began to have a real impact when Théophile Gautier employed it to describe Baudelaire's poems in an 1868 edition of *Les Fleurs du Mal*. By the 1870s, the adjective 'decadent' had become a formal noun 'Decadence'. In France the term was used to describe writing, especially poetry, which was artificial, symbolic and subjective, using language in a perverse and evocative way and choosing subject-matter which was obscure or recondite. Huysman's novel *A Rebours* was called the 'Bible of the Decadence' because it was virtually without plot, and it outlined the bizarre experiments of a diseased aristocrat engaged in the exploration of his own physical sensations and mental anxieties. The Decadent aspects of the writing rested in both its subject-matter and the way in which that subject-matter was treated. Although the term was not generally applied to French art, Symbolist paintings by artists such as Gustav Moreau bore many of the attributes of Decadent literature. Through this process of formalization, the original meaning of the word 'decadence' was lost, and the launching of a review, *Le Décadent*, in 1887 turned what appeared to be an amoral and anti-social concept into something public and accessible.

In England, the Decadent movement was more closely tied up with art, and the connotations of the term came to be associated more directly with the theory of degeneration. Decadence was popularized by the writings of Walter Pater in the 1870s and 1880s, and it gained greater international prominence through the lecturing and 'life-style' of Oscar Wilde during that period. The writer Arthur Symons, in attempting to define this vague and insubstantial term, related literature of the Decadence to the fall of empires, the collapse of morality and disease – all of which were seen to be metaphors and manifestations of degeneracy:

> The most representative literature of the day . . . is certainly not classic, nor has it any relation with that old antithesis of the Classic, the Romantic. After a fashion it is no doubt a decadence; it has all the qualities that mark the end of great periods, the qualities that we find in the Greek, the Latin, decadence; an intense self-consciousness, a restless curiosity in research, an over-subtilizing refinement upon refinement, a spiritual and moral perversity. If what we call the classic is indeed the supreme art – those qualities of perfect simplicity, perfect sanity, perfect proportion, the supreme qualities – then this representative literature of to-day, interesting, beautiful, novel as it is, is really a new and beautiful and interesting disease.[44]

Symons's interpretation of Decadent literature could also be applied to the art of Aubrey Beardsley who was associated with the English movement. Beardsley's place in this phenomenon came through his role as art editor of the notorious periodical *The Yellow Book*. This journal, which ran from 1894 to 1897, was designed with a yellow cover to give it a greater resemblance to a

French novel, and it contained poetry, fiction and controversial articles about modern life. It is difficult today to understand why such a seemingly innocuous journal could have caused such outrage at the time, but this was due in part to the presence of Aubrey Beardsley's illustrations (Figure 20), which were consciously exaggerated and had implicit or explicit sexual or anti-clerical themes. What today could be called harmless 'camp' was seen as utterly subversive by many contemporary observers. The most common adjective applied to Beardsley and his work was 'unhealthy', and he was given satirical nicknames such as 'Wierdsly Daubery' and 'Awfully Wierdsley' by sceptical magazines like *Punch*. The seeming pointlessness of Beardsley's linear style, its detachment from reality and the casualness of his illicit scenes caused outrage among the prurient, but increased circulation of the *Yellow Book*.

The association between the Decadence – an arts movement – and degeneracy – a theory of social decline – became explicit in 1895 when Oscar Wilde was arrested for his homosexual activities. At the time of Wilde's arrest, he had a French novel under his arm, but witnesses identified this as a volume of the *Yellow Book*. Immediately a somewhat harmless rebellion against social conformity was seen to be a dangerous incitement to 'degenerate' activity, and Beardsley's prominent role in giving the *Yellow Book* its distinctive appearance was abruptly called to a halt when he was dismissed from his job. Coincidentally, 1895 was also the year in which the English translation of Nordau's *Degeneration* was published, and the connection between the Decadence and Nordau's own rather hysterical view of society was easily made. It is interesting to note that after Wilde's trial, the term 'Decadence' was less often used by artists and writers.

Given the nature of their themes and areas of interest, the arts could easily be identified as an incitement to subversive activity. But writers could also look to art to help them illustrate their own theories of degeneracy. This appropriation of art as example occurred in the work of the French psychiatrists, Jean-Martin Charcot and Paul Richer, whose *Les Difformes et les malades dans l'art* was written solely from the point of view of pathology. Charcot and Richer's interpretation of such varying phenomena as medieval grotesques and Velazquez's paintings of dwarfs rested entirely on their knowledge of hysterics and degenerates at the Salpêtrière Hospital. The authors contended that such 'deformities' in art were not products of the artist's imagination, but did, in fact, realistically represent some genuine psycho-physical disorders. They then went on to identify and classify these disorders by referring to the works of art themselves. Thus, paintings and sculptures were treated as if they were patients, and the authors applied the same kind of rigorous, albeit implicit, value judgements that characterize the pseudo-scientific writings on degeneracy. Thus 'idiots', hysterics, dwarfs and blind people were all lumped together as 'Nature's disinherited children',[45] and their conditions were subjected to a detached scientific analysis.

In a more general sense, the historical theories of progress and decline, degeneracy and natural selection, came to be applied to the history of art itself. From the time of Vasari's sixteenth-century *Lives of the Artists*, historians interpreted the development of art in terms of a steady rise towards perfection, followed by a decline to mannerism. Thus Giotto was seen as initiating a 'golden age' of art, which reached its peak in the work of Michelangelo, and dissipated in the imitative work of Michelangelo's followers. In the nineteenth century, Jacob Burckhardt's *Der Kultur der Renaissance in Italien* (1856–60) closely followed Vasari's model, but his work took on a new quality in relation to the concerns of the nineteenth century. More pertinently, the English writer John Addington Symonds produced an essay 'On the Application of Evolutionary Principles to Art and Literature' (1890) in which he used Vasari's vision of the history of art but cast it in

Darwinian terms of species progression. According to Symonds, art proceeds through three generations: youthful energy, perfection of type and continued use of type leading to degeneration. The original type is 'projected from the nation's heart', and this 'clearly marked type of national art, when left to pursue its course of development unchecked, passes through stages corresponding to the embryonic, the adolescent, the matured, the decadent, and the exhausted, which we are accustomed to regard as physiological'.[46]

However, Symonds did little more than graft a new anthropological model onto an already existing theory of historical progression. A more drastic step was taken by the German writer, Konrad Lange, whose prodigious two-volume study, *The Nature of Art*, took the next step by making art little more than one component in the development of civilization. As with most studies examined in this chapter, Lange's work pretended scientific objectivity, but it is loaded with thinly disguised value judgements. To Lange, there is both 'good' and 'bad' art, and form itself is 'an ethical postulate'. The moral rating depends upon how closely that art relates to the needs of a culture: 'Each art is good, which expresses, through evolutionary principles, the nature of art, that is, which corresponds to the aesthetic instinct of a civilization; each art is bad, which does not correspond with it.' In Lange's view, the establishment of civilization will naturally lead to the development of art, and the absence of art suggests destructive and atavistic tendencies. Equally symptomatic of cultural decline is an art which does not adhere strictly to a realistic portrayal of the natural world. To Lange, art has a purpose: it is an advanced form of play that allows human beings to learn about life and morality through conscious self-deceptions ('*bewusste Selbst-täuschung*'). Although people realize that art is only a substitute ('*Ersatz*') for life, it is important that it should be as close a substitute as possible. He even goes so far as to make up new words for how we perceive the arts, so that ornament becomes 'optical sense games', painting is 'picture-book looking' and the appreciation of sculpture is reduced to 'puppet-games'. Lange's persistent references to the words 'use' (*nutzen*) and 'need' (*brauchen*) gives art a referent which is more anthropological than aesthetic.[47]

The facility with which writers could expand such bizarre and often indefensible arguments was based upon the existence of new scientific and psychological models which could be used to endorse or validate the most tenuous of opinions. The problems of a new industrial age cannot be underestimated, and dissatisfaction with the darker sides of progress was rife. However, the means of expressing discontent changed as rapidly as society did. Local prejudices and superstitions were transformed into racial and global anxiety, and although Christian explanations were less frequently presented, the basic tenets of Christian belief were encompassed in the new scientific sphere. Art both responded to, and was subsumed within, this realm, and artists who broke away from conventions of style and subject-matter were accused of fostering degenerate tendencies. To the fanatical Nordau, art would have little purpose in the greater civilizations of the future: 'in the mental life of centuries far ahead of us, art and poetry will occupy but a very insignificant place.'[48]

NOTES

1. For the prevalence of such themes in nineteenth-century France, see Konrad Swart, *The Sense of Decadence in Nineteenth-Century France* (The Hague, 1964).
2. Holbrook Jackson, *The Eighteen Nineties* (London, 1913).
3. Max Nordau, *Degeneration*, Eng. trans. (London, 1895), 2.
4. Bénédict-Augustin Morel, *Traité des dégénérescences physiques, intellectuelles et morales de l'espèce humaine* (Paris, 1857).
5. Nordau, 171, 407, 416, 500.

6. George Bernard Shaw, *The Sanity of Art* (New York, 1908), 81, 101.
7. Nordau, 4.
8. Friedrich Nietzsche, *Beyond Good and Evil*, Eng. trans. (Harmondsworth, 1990), 95.
9. Ibid., 96.
10. Alfred Fouillée, 'Dégénerescence: Le Passé et le présent de notre race', *Revue des deux mondes*, 131 (1895), 821.
11. Supplement to the *Echo de Paris*, 9 December 1893, cited in André Fermigier, *Toulouse-Lautrec*, Eng. trans. (London, 1969), 80.
12. Cesare Lombroso, *Crime: Its Causes and Remedies* (Boston, 1911), 255.
13. Richard von Krafft-Ebing, *Psychopathia Sexualis*, Eng. trans. (Philadelphia and London, 1892), 6.
14. See Fermigier, 171.
15. Hermann Bahr, *Renaissance: Neue Studien zur Kritik der Moderne* (Berlin, 1897), 213–14.
16. Ibid., 215.
17. Lombroso, xxxiv.
18. See, for example, Theodore Reff, *Degas, the Artist's Mind* (London, 1976).
19. Nordau, 476.
20. See Gauguin's letter to Monfried, in Georges Wildenstein, *Gauguin* (Paris, 1964), 232.
21. Ibid., 233.
22. Quoted in J.P. Hodin, *Edvard Munch* (London, 1977), 50.
23. August Strindberg, 'L'Exposition d'Edvard Munch', *La Revue blanche*, 10, no. 72 (1 June 1896), 525.
24. Nordau, 536.
25. J.-K. Huysmans, *A Rebours* (Paris, 1978), 61.
26. Ernst Haeckel, *The Riddle of the Universe at the Close of the Nineteenth Century*, Eng. trans. (London, 1900), 8.
27. Nietzsche, 103.
28. Émile Durkheim, *Suicide*, Eng. trans. (London, 1952).
29. Émile Zola, *Nana*, Eng. Trans. (Harmondsworth, 1972), 470.
30. Fouillée, 814, and Nordau, 207.
31. Havelock Ellis, *The Nineteenth Century: A Dialogue in Utopia* (London, 1900), 146.
32. Paul Bourget, *Essais de psychologie contemporaine* (Paris, 1885), 24–5.
33. Nordau, 541.
34. Fouillée, 818–19.
35. James Cantlie, *Degeneration Amongst Londoners* (London, 1885), 13, 24.
36. These statistics are given in Monika Glettler, 'Minority Culture in a Capital City: the Czechs in Vienna at the Turn of the Century', in Robert Pynsent, ed., *Decadence and Innovation: Austro-Hungarian Life and Art at the Turn of the Century* (London, 1989), 49.
37. Nietzsche, 121.
38. Fouillée, 813.
39. See especially *Madness and Civilisation*, Eng. trans. (London, 1971), and *The Birth of the Clinic*, Eng. trans. (London, 1973).
40. Adolf Loos, 'Ornament und Verbrechen' (1908), in *Die Schriften von Adolf Loos: Trotzdem 1900–1930* (Innsbruck, 1932), 79.
41. Anonymous, *The Stage, the High Road to Hell* (London, 1767), dedication.
42. Ellis, 100.
43. Nordau, vii.
44. Arthur Symons, 'The Decadent Movement in Literature', *Harper's New Monthly Magazine*, 87, no. 522 (November 1893), 858–9.
45. J.-M. Charcot and Paul Richer, *Les Difformes et les malades dans l'art* (Paris, 1889), 44.
46. John Addington Symonds, 'On the Application of Evolutionary Principles to Art and Literature', in *Essays Speculative and Suggestive*, 2 vols. (London, 1890), 1:51–2, 72.
47. Konrad Lange, *Das Wesen der Kunst*, 2 vols. (Berlin, 1901), 1:14, 27; 2:39.
48. Nordau, 543.

CHAPTER 3
ANARCHY

Although rooted in the scientific thought of the late nineteenth century, theories of degeneration were laden with apocalyptic overtones; psychologists, biologists and cultural theorists saw political and social structures as heading inexorably towards the destruction of civilization. These doom-laden prophecies were applied equally to political systems and changes, and the term anarchy – in both its specific and general sense – was used to refer to the natural dissolution or deliberate destruction of institutions and traditions which many felt had held society together for centuries. Political extremism on both the left and right (see Chapter 8) followed in the wake of the failure of liberalism throughout Europe, and as part of this phenomenon, anarchism became a well-organized underground political movement in the 1880s and 1890s. There was often only a thin line between socialists and anarchists, although the former believed in a policy of state intervention which the latter decried. Both anarchist and socialist idealism proved attractive to artists, some of whom embraced leftist politics whole-heartedly, while others adopted such principles more loosely as a metaphor for their own rejection of authority. A disgust with the failure of liberal governments in the political sphere was matched in the aesthetic realm by a rebellion against art academies and traditional academic theory. Through the concept of anarchy, the political and the artistic intermingled, as artists created new styles and sought new subject-matter to express their dissatisfaction with industrial society or their desire for a utopian alternative. The ambiguities inherent in the political philosophy of anarchy were equally characteristic of *fin de siècle* art, and the complicated relationship between art and left-wing ideology in this period is significant for what it reveals about the interpenetrating discourses of culture and politics, 'high' and 'low' art, and the role of art in the life of the working class.

The growth of anarchy in the second half of the nineteenth century was surprisingly systematic, given the fact that its supporters were of diverse class and national origins, and many of its leaders were regularly imprisoned. However, the supporters of anarchy were united in their rejection of the parliamentary liberal governments which had fostered *laissez-faire* capitalism in the increasingly industrial European countries and in America. Anarchists were opposed to both capital and property, which they felt led to conflict between nations and individuals. Anarchists such as the Russian Prince Peter Kropotkin followed the eighteenth-century philosopher Jean-Jacques Rousseau in his belief that if people were left to their own devices, and not controlled by social and political institutions, their natural goodness would come forth. The anarchist view of liberty was essentially a communist one: human beings naturally wanted to live together in harmony and help each other, rather than compete and destroy. This positive conception of reality contradicted the ideas of Social Darwinists, who insisted that humanity was in a state of perpetual struggle. The French sociologist, Gustave Le Bon, asserted that 'Liberty is competition and incessant conflict, the mother of all progress, in which only the most capable can triumph,

and the weakest as in nature, are condemned to annihilation',[1] and the English political theorist David Ritchie exposed the ways in which Darwinian ideas were implicitly propping up a social order based on conflict:

> There can be no doubt that the formulae of Evolution do supply an apparent justification to the defenders of unrestricted *laissez-faire* and to the champions, more or less consistent and thorough-going, of existing inequalities of race, class and sex, and a plausible weapon of attack against those who look to something better than slavery or competition as the basis of human society.[2]

Darwinian theories could provide a defence of the established institutions of society, but they also justified the modern system of competitive capitalism as both an effect and a cause of 'progress' and 'civilization'.

The rebellion against political and economic systems encouraged by anarchists inevitably led to a reaction against anarchy by these 'Darwinian' writers. Often ignoring the ultimate goals of the anarchists, Social Darwinists focused instead on two aspects of the movement which they saw as essential manifestations of degeneracy: anarchist violence, and mass 'democracy'. Despite their ultimate aims for peace, many anarchists felt that, given the stranglehold of government institutions, the only way to attain their ends was by violence. From the 1870s, anarchist sympathizers began promoting acts of violence which were designed to overthrow repressive governments. In Italy, France, Russia, Spain and America, the aristocracy, the nobility and government officials were subjected to assassination attempts, and anarchist terrorism included a series of attacks on expensive restaurants, and other regular haunts of the bourgeoisie.

Such acts of violence led degeneracy theorists to condemn anarchy as an example of social atavism. Cesare Lombroso, despite his sympathy with many of the ideals of anarchism, referred to the more violent strain of anarchy as a manifestation of '*isteria politica*'.[3] Although Lombroso admitted that parliamentary systems of government were essentially 'dishonest', he claimed that these systems could and, indeed, should be changed by a slow evolution, rather than by a sudden revolution:

> There appears to be a clear distinction between revolutions, properly named, that are a slow, prepared, necessary effect – at the very most precipitated by some neurotic genius or some historical accident – and revolts or rebellions which are fruits of an artificial incubation, at an exaggerated temperature, of embryos predestined to die.[4]

Even the more balanced assessments of anarchism rarely avoided addressing the question of degeneracy. Lombroso's pupil Enrico Ferri also promoted the theory that such political crimes were 'manifestations of social pathology',[5] but he attributed the violence of anarchists to environmental factors, rather than to inadequacies in their mental development. One of the most eloquent advocates of anarchism, the French writer Jean Grave, also admitted the case for degeneracy, but with a different argument and a concomitant justification. In an address to industrialists whom he felt had degraded the labour of working men, Grave wrote:

> As you took to task the destruction of races, not inferior . . . but only backward, you similarly intend to destroy the class of workers that you also qualify as inferior. You search

every day to eliminate the workshop labourer and replace him by machines. Your triumph will be the end of humanity because little by little you will return the faculties that you have acquired by the need of struggle to the most rudimentary ancestral forms, and human beings will have no other ideal than that which is associated with their digestive system.[6]

To Grave, it was the bourgeois institutions themselves, rather than inexorable biological forces, that were responsible for 'atavistic' individuals in contemporary society.

Anarchist violence was a focus for many detractors, but they also saw degeneration in anarchist egalitarianism. The biologist T.H. Huxley wrote 'the doctrine that all men are, in any sense, or have been, at any time, free and equal is an utterly baseless fiction',[7] and he and others believed that there was a natural hierarchy of society, the destruction of which would result in the collapse of civilization. The philosophy of equality disclaimed the theories of differentiation that proliferated in the wake of Darwin, as differentiation – rather than homogeneity – was seen to be the effect of natural selection. Others also claimed that equality would lead to mass action, and indeed, the concept of the unruly 'masses' was very much a preoccupation of the late nineteenth century. The growth of movements such as anti-Semitism, Zionism and nationalism confirmed the opinion of Le Bon and other sociologists that universal freedom was an anathema to civilization:

> To-day the claims of the masses are becoming more and more sharply defined and amount to nothing less than a determination to utterly destroy society as it now exists, with a view to making it hark back to that primitive communism which was the normal condition of all human groups before the dawn of civilization.[8]

To Le Bon, 'the advent to power of the masses marks one of the last stages of Western civilization'.[9]

The agitational extremes of conservatives, as well as the incendiary behaviour of some anarchists, were counterbalanced by the growth of socialist ideas which advocated a reformation of society *within* institutions, rather than merely accepting such institutions or obliterating them entirely. Like anarchists, socialists believed in equality, but they felt that this 'natural right' could be obtained best under the aegis of a paternalistic state, which took care of its citizens. This type of 'evolutionary', as opposed to 'revolutionary', socialism had led Karl Marx in 1864 to form the International Working Men's Association, which sought to unite disparate groups of European workers and thereby to educate the working classes in a greater understanding of their social conditions and political function. Indeed, by the 1870s the opposition between 'evolutionists' and 'revolutionists' resulted in a division in the ranks of the International – the former faction siding with Marx and the latter with the Russian Mikhail Bakunin. After the dissolution of the International in 1876, the Left polarized even further: legalized trade unions and socialist parties such as the Parti Ouvrier Belge (POB) and the Social Democratic Party (SDP) in Germany attempted to find a political solution to class inequalities, while the anarchists intensified their campaign of violence and conspiracy.

Both anarchist and socialist ideas encompassed art, as advocates of both philosophies saw the potential for art in their ideal societies. Art was seen to be serving evolutionary and revolutionary anarchist aims through its subject-matter and style; it was claimed to be a means of regenerating a sick society, and its educational purposes were extolled. Even as early as 1848,

the French painter Gustave Courbet threw open the political possibilities of art in his challenging paintings, The Burial at Ornans (Figure 21) and The Stonebreakers (Figure 22). Courbet was an avid supporter of the 1848 revolutions – attempts throughout Europe to overthrow the power of an entrenched class system. Courbet's professedly 'realist' style was intended to undercut social hierarchies. The Burial at Ornans is a vast painting, but all the individuals within it – regardless of their status in society – were given equal treatment. In the wake of the 1848 revolutions, this 'equalizing' was seen as subversive, and Courbet himself called his own work 'democratic'.[10] Ideas of democracy and, by extension, equality, were at that time associated with socialism, and subsequently anarcho-communism. Courbet himself was later a supporter of the Commune established in Paris in 1871 in the wake of the Franco-Prussian War.

Courbet also admired the work of the anarchist writer Pierre-Joseph Proudhon, whose seminal Du Principe de l'art et sa destination sociale (1865) claimed that art could serve a moral purpose by showing the poor the realities of life. Like many later anarchists, Proudhon believed in the abolition of property, to which end art could serve: if the poor were made aware of their condition, Proudhon felt, they could and would seek to ameliorate it. This idea was later stated more eloquently by Kropotkin, whose Paroles d'un révolté (1885) extolled the propagandist purposes of art. In a rhetorical address to contemporary artists, Kropotkin wrote:

> Painters, poets, musicians, if you have understood your real mission and the interests of art itself, come then put your pen, your brush, your burin in the service of revolution. Tell us in your vivid style or in your thrilling pictures the titanic struggle of the people against their oppressors; inflame young hearts with the beautiful revolutionary breath which inspired our ancestors; tell the wife of the beauty in the action of her husband if he gives his life in the great cause of social emancipation. Show the people the ugliness of real life, and make us understand the cause of this ugliness; tell us what a rational life could have been, if it had not been blocked by the ineptness and ignominies of the existing social order.[11]

Art was seen to foster and incite revolutionary activities among the repressed classes of society.

But art was not only to be a means of propaganda; it was also felt to have the potential to uplift 'ordinary men'. This theme was constantly put forward in the 1880s and 1890s, when more and more visions of ideal anarcho-communist societies began appearing in pamphlets and journals throughout Europe and America. For example, Grave's ideal society embraced art as a necessary component. Aesthetic satisfaction, like hunger, was a genuine human need that should be fulfilled:

> For this transformation to endure, it is necessary that the revolution which is accomplished has enough awareness not to brush past the evolution of the individual. The starving do not acquire the possibility of satisfying their physical needs unless they have conditions that can equally satisfy their artistic and intellectual needs.[12]

Grave's attitude was affirmed by his friend, the anarchist art critic Félix Fénéon, whose political activities may have included planting a bomb in an elegant Parisian café in 1894, although he was acquitted from this charge. Fénéon too felt that art could bring about social regeneration, and he looked forward to the day when 'art will be part of the life of ordinary men . . . when it does the artist won't look down at the worker from his celluloid collar: the two of them will be a single one'.[13]

The central importance of art to anarchist doctrine was confirmed by the formation of societies

in France and Belgium devoted to the aesthetic education of the working classes In Brussels the 'Maison du Peuple' was sponsored by the POB, and artists such as Fernand Khnopff (see Chapter 5) were involved with its art section. Each meeting of the 'Section d'Art' consisted of informal speeches, music and readings of literature or poetry. In France, a similar organization, the Groupe de l'Art Social, devoted itself to the education of the working classes. Although both societies were sponsoring art education in its widest sense, painting and sculpture also came within their briefs. In a pamphlet called *Art et socialisme* (1896), Jules Destrée summed up the arguments for state support of the arts. He claimed that it was 'a deplorable error to consider art to be the frivolous leisure of rich people', as art was 'one of the most noble social forces'. To Destrée, revolution ought not simply to be economic, but 'scientific, aesthetic and moral , and art would help to bring about this condition.[14] Destrée's pamphlet was socialist, rather than anarchist, and his orientation was therefore interventionist: according to him, the state should actively encourage artists through commissions and financial recompense, although artists should have 'absolute independence' in their choice of subject and style.[15]

The independence of the artist was another important factor stressed by socialist and anarchist sympathizers, although in many respects this insistence upon independence excused artists from the necessity of painting propagandist images. According to this line of thought, an artist could and should do whatever he wished, just as each individual in the perfect anarchist society should have freedom of action and expression. Oscar Wilde put forth this theory in his controversial essay 'The Soul of Man Under Socialism' (1890), in which he adapted Kropotkin's ideas to fit his own aesthetic obsessions in typical epigrammatic style: 'The form of government that is most suitable to the artist is no government at all.'[16] Through such assertions as this, artists who rebelled against institutions or invented new styles could be seen as anarchists, in the broadest sense of the term, because they were not constrained by tradition, but were instead exhibiting their right to free individual expression. The subject-matter and style of artists throughout Europe thus became politicized by the 1890s, to the point that one French article could refer casually to the distinction between 'artistes conservateurs' and 'artistes révolutionnaires'.[17] Far from being divorced from the political sphere, the choices of artists were firmly entrenched within it.

Anarchist ideologies thus became blended into artistic ideologies, and the practice of the artists themselves could be presented or perceived as a manifestation of political circumstances. Artistic responses to political anarchism fell broadly into the two categories of propagandism and individualism outlined above. The first, following the ideas of Kropotkin, suggested that art had a propagandist, educative purpose. Art should reveal social problems and illuminate the life of the lower classes. The second category of thought was more élitist, but paradoxically more popular among artists with genuine anarchist affiliations. According to the principles of Wilde and others, artists should give full rein to their creative instincts and produce beautiful works which would serve to uplift the 'masses' and help inspire them with hope for a better future. Although these categories were not mutually exclusive, they influenced art in different ways. Those who believed that art could serve the purposes of propaganda often followed Courbet in perpetuating a realist style, where their innovation was often confined to their subject-matter. Artists who advocated the doctrine of individualism were primarily stylistic innovators, who saw their function as revolutionaries more in the realm of form and colour than in subject-matter. Whether or not the artist intended the association, the nature of *fin de siècle* art was political and, in many senses, anarchic.

Realist art appeared throughout Europe from the 1840s, increasingly treating the subject of country peasants or the urban working class. In France, England, Italy, Spain and Russia, the proliferation of such subject-matter coincided with the growing force of socialist and anarchist ideas. Nordau saw the increase in depictions of the lower class as indicative of declining values, and he attacked the ugliness and negativism of modern art:

> The aim of the creative arts in former ages was the reproduction of the beautiful . . . The art of to-day . . . examines nature with a frowning brow and a keen, malicious eye, skilled in discovering faults and blemishes . . . Courbet's ugly Stonebreaker (sic) is as far removed from absolute truth, as Lionardi's (sic) lovely Mona Lisa.[18]

Nordau's emphasis on *The Stonebreakers* reveals the orientation of his attack: it is the socialistic critique of modern society that he found difficult to accept, even though he called for a future world 'when even the humblest man will find his individual life merged into the fuller life of the community, and his isolated, circumscribed horizon broadened by means of festivals of poetry, music, art, thought and humanity'.[19] Like the contemporary political philosophy of Lorenz von Stein, Nordau advocated a form of paternalistic communalism, which allowed for social inequalities while protecting the well-being of all citizens. In such a compromise society, Nordau saw art as playing a role, but an art which looked to higher things, such as beauty, rather than emphasizing the degraded state of a large portion of the population. Nordau's idea that images of the working class had a negative effect was counteracted by Kropotkin's assertion that representations of the poor served an educative purpose. Kropotkin felt that if the poor could be reminded of the hardships they were forced to endure, and the wealthy could be enlightened about the inequalities in society, the anarchist cause would be furthered. However, a third approach to images of the poor formed a bridge between the ideas of Nordau and Kropotkin. Followers of the French painter Jean-François Millet saw the poor as noble and heroic, and the seamier side of life – particularly in paintings of rural scenes – was often avoided in favour of sanitized and aesthetically attractive images.

In Spain, Italy and England paintings of the urban and rural poor reveal the contradictions within and the problems contingent upon realist or socially critical images. Even works ostensibly demonstrating new styles were often shackled to social realist subject-matter which responded more to the needs of politics than art. For example, Picasso's 'Blue Period' paintings are usually classified as 'Symbolist' because of their melancholy mood. However, as Patricia Leighten has recently argued, he was most likely responding to the concerns of anarchist friends and acquaintances in Barcelona and Madrid, such as the painter Isidre Nonell and the novelist Pío Baroja.[20] Picasso's visions of blind beggars, old men, prostitutes and starving families were based upon the poor conditions in urban society which anarchists blamed on the evils of the capitalist system. Els Quatre Gats, the Barcelona café where anarchist intellectuals met, was a favourite haunt of Picasso, and he was one of several artists who signed a petition in 1900 demanding the release of imprisoned anarchists.

Just as Picasso's 'Symbolist' style did little to conceal a social realist approach, so the Italian painter Alessandro Morbelli tackled social problems in a progressive Neo-Impressionist style, which used juxtapositions of primary colours to create a dazzling, shimmering effect. Morbelli's *For Eighty Cents* (1895, Vercelli, Civico Museo Antonio Borgogna) shows peasants labouring in rice-fields, and alludes to a crisis in Italian agricultural communities of the 1890s. His decision to

paint such a controversial subject was commensurate with the socialist and anarchist orientation of a number of his Divisionist colleagues, such as Vittore Grubicy de Dragon, who claimed that the artist should become involved in the 'ideas and aspirations influencing the disinherited classes'.[21] Morbelli's work, despite the superficial beauty of the composition, thus revealed a condition which anarchists hoped to change, and thereby conformed to Kropotkin's idea that works of art should expose the bleaker side of social reality.

A similar orientation colours the work of the English artist Hubert von Herkomer, whose *Hard Times* (Figure 23) and *On Strike* (1891, London, Royal Academy of Arts) offer more ambiguous readings of contemporary social circumstances. *Hard Times* shows an unemployed man with his wife and children resting by a roadside, and it alludes to the effects of an economic depression of the 1880s. The work was meant to evoke the desperation of the family, but it also conveyed the heroism of the father, who is not allowing weariness to weaken his resolve. Herkomer's work illustrated a social problem of the time, but his interest in the subject was less in the hardships of the poor family than in the realist style in which the scene is painted. In a comment to one of his students, Herkomer revealed an almost casual indifference to the fate of the rural poor; he instructed her 'to get real tramps and pose them under a hedge, and a sick child, and put them in several positions',[22] in order to enhance the realistic effect of the scene.

On Strike tackles the contemporary issue of legalized labour unions and strikes, a growing phenomenon throughout Europe in the 1880s and 1890s. Here again Herkomer domesticates the scene: he does not show the strikers acting in unison, but instead reveals the effect of the strike on family life. If there is a message in this painting, it is an ambiguous one: the wife and child are suffering, but utterly reliant on the man who is the immediate cause of their suffering. Whether Herkomer was attacking social conditions here or merely representing an interesting contemporary subject is difficult to say, but certainly the reviewers at the time saw *On Strike* in terms of topicality as much as social criticism:

> Nobody will deny that in these days of labour disputes and acute social questions such a subject is appropriate to art; and in his figure of the gaunt, dogged and surly labourer, of his unhappy wife and half-famished children, Mr. Herkomer has given us a summary of one side, and a very important side, of modern civilisation.[23]

This analysis reveals two of the inherent problems of social realism. First of all, the extent to which such paintings were political statements or merely fashionable novelties is unclear. Secondly, critics writing about images of the poor often read political issues where none existed, or conversely, they obscured important political intentions. Although one could find social criticism in Herkomer's work, it is very difficult to detect any social comment whatsoever in, for example, the paintings of the English artist George Clausen, whose prettified views of the rural poor (as in *The Stone Pickers*, 1866–1867, Newcastle-upon-Tyne, Laing Art Gallery) deny hardship and glorify poverty as picturesque. Such scenes were common throughout Europe in the last part of the nineteenth century; rural poverty was packaged into sentimental and escapist visions of country life. However, not all artists who presented such glorified views of the poor were glossing over social problems; some hoped to ennoble the peasant or proletariat by this means. Nevertheless, their intentions could be easily misconstrued, as was the case in the work of the Italian Giovanni Segantini, whose political motives for painting 'pretty' images of the rural poor were misrepresented in a contemporary monograph:

His peasants feel that they are born to that life of ceaseless toil, and regard the fact merely as a hard necessity. There is no idea of revolt or anger against those who are better off than themselves; for if they are poor, at least nature is a kindly mother to them, and supplies their modest wants. There is not in them that sordid and degrading poverty which we see in some of Millet's French peasants.[24]

This view of Segantini's work acknowledges his glorification of the peasant, but denies the potential for revolt inspired by their hardship. The author thus implies that Segantini himself felt that the peasant's way of life was the best one.

Indeed, this attitude was widely held by middle-class anarchists who desired a rural communal life without strife or conflict. Although some sanitized images of peasants merely eschewed the problems of contemporary society, others were intended to glorify the underclass. The Italian artist, Giuseppe Pellizza da Volpedo's *The Fourth Estate* (Figure 24) is a large painting which gives full attention to the subject of rural uprising. The impoverished agricultural labourers of this painting are presented as heroic and courageous, as well as defiant, and it is no surprise that the work was deemed inspirational by socialist newspapers.[25] The idealism of such paintings was seen by many to be commensurate with anarchist sentimentality; Pellizza's contemporary, the criminologist Enrico Ferri, claimed that anarchists were more attracted by sentiments than abstract political ideals.[26]

The above examples reveal the ways in which scenes of the rural poor and the urban proletariat could be interpreted in terms of anarchist or socialist politics. The realist style of many of these works often created a false sense of accessibility: the subjects seemed uncomplicated or unambiguous, even though they were inevitably laden with political implications. In Russia, peasants were looked upon by nationalist sympathizers as exemplary of the Russian race. By the end of the nineteenth century, peasant culture in Russia became synonymous with Russianness, an association which was perpetuated by middle-class intellectuals who wanted Russia to divorce herself from 'western' cultural influence. The source of this tendency in art was the foundation of the Wanderers (*Peredvizhniki*) – a group of artists who seceded from the Petersburg Academy in 1863, and set up a series of travelling exhibitions in 1871. The initial purpose of the Wanderers was to bring art 'to the people', although their own class and intellectual affiliations tended to be liberal-bourgeois.

The simple realist style and peasant subjects characteristic of the Wanderers' work were also advocated by Leo Tolstoy, in his socialist aesthetic treatise, 'What is Art?' (1898). In this tract, Tolstoy condemned modern art, which he claimed was not only incomprehensible to the masses, but was also based upon the sweat and toil of the working man. True art was more than a simple pleasure or diversion; instead it was 'one of the conditions of human life . . . one of the means of intercourse between man and man'.[27] Tolstoy thought that an artist who expressed genuine feelings could inspire those feelings in an observer, but that the commercialization of the art world had deadened true artistic inspiration. His assessment of an art for the masses was ultimately utopian: 'Art . . . is a means of union among men joining them together in the same feelings and indispensable for the life and progress towards well-being of individuals and humanity'.[28] Tolstoy wanted an accessible and comprehensible art, and his desires were, to an extent, answered by the early work of the Wanderers. Paintings such as Ilya Repin's *They Did Not Await Him* (1884–1888, Moscow, Tretiakov Gallery), concerning the return of a political exile, and Vasili Maksimov's *Lady Morosova* (visualizing a historic peasant rebellion) seemed to answer the needs of 'the masses'.

However, critics from the 1880s began to construe such works as exemplary of Russian folk culture.[29] In the wake of the assassination of Tsar Alexander II in 1881, the 'democratic' nature of peasant subjects was superseded by an essentially nationalist focus, as Alexander's well-meaning reformist efforts were engulfed by an intensification of repressive conservatism and Panslavism. Art *for* the people became, in political terms, art *about* the Russian nation.

Indeed socialist art often functioned more directly as political propaganda, and artists discovered various ways of making their own political commentary effective. In France, Eugène Carrière, despite his professed socialist sympathies, avoided direct statements in his paintings. His hazy views of life, death, sickness and maternity (see also Chapter 6) in many ways paralleled Tolstoy's desire for a universal art which would have appeal for all people. Carrière hoped to convey his message through poetic generalization. At a speech given in the London Museum of Natural History in 1901, Carrière extended his socialist ideas to a discussion of human anatomy:

> None of the members [of the body] is a burden for the others: the arms are what they must be for grasping, the legs for walking. The head blossoms from the spine, slight in comparison to the rest of the body: from there is a sensation of general equilibrium, of ease.[30]

Carrière's description of the beauty of the human body could also pertain to a perfect society, where all members work together towards a common goal, and no one is forced to live off the charity of anyone else.

Carrière's genuinely held socialist convictions were not always borne out by his painting, which, despite his best intentions, appealed largely to a middle-class art-buying public and would have seemed unusual, or even obscure, to anyone who did not already have a sound knowledge of academic art. The same cannot be said of Käthe Kollwitz, whose own political convictions were embodied in a realist style and a socially critical subject-matter. Although Kollwitz continually denied political affiliation, her father and husband were both socialist sympathizers, and she professed a life-long dedication to the problems of the working class. One of her earliest works was a cycle of etchings based on Gerhardt Hauptmann's play *The Weavers* (1892), which had been banned from public performance. Kollwitz saw the play in a private production of 1893, and she was impressed with its revelations about the life of the working class. Her cycle *A Weavers' Uprising* was selected for a gold medal when it was shown in Berlin in 1898, but the intervention of Kaiser Wilhelm II prevented Kollwitz from receiving the award. The Kaiser's refusal to grant her this prize is significant, as the decision was not made on the basis of the work's quality, but on its subject-matter. Robert Bosse, the Kulturminister of Berlin, admitted:

> In view of the subject of the work, and of its naturalistic execution, entirely lacking in mitigating or conciliatory elements, I do not believe I can recommend it for explicit recognition by the state.[31]

In works such as this one, as well as in her *Peasants' War* (Figure 25), Kollwitz sought to expose social problems, and to make those problems accessible to a wide audience, but her approach contradicted the aims both of the aesthetic vanguard and the conservative elements surrounding the Kaiser himself. The aesthetic critic Hermann Bahr condemned Kollwitz's work as 'too literary' and went on:

We are spoiled: if one paints a revolution, it should come to us through storm-tossed, distorted trees with branches stretched out lustfully, or through the wrath of the weather-beaten sea – in short, the artist should make a revolution through lines and colours . . . not through anecdotes of revolt.[32]

The realism which offended Bahr's sensibilities also went against the Kaiser's desire for an art which was 'uplifting'. Ironically, the Kaiser himself used socialist language and sentiments in his address on the unveiling of new monumental sculpture which took place in the Berlin Siegesallee in 1901. But his form of socialism – unlike the humanitarian concerns of Kollwitz and Carrière – was paternalistic and patronizing:

Art should provide an influence on the people by giving the lower classes the possibility of fresh heart after hard toil and work. We, the German people, have maintained the great ideal of lasting goodness, while other peoples were more or less lost. Only the German people remain who are, in the first place, appointed to tend this great ideal which belongs to them, so that the working, toiling classes are given the possibility of raising themselves and their thoughts up to the beautiful.

Even if art, as it now happens again and again, shows us misery, made out to be as hideous as it is in reality, then it sins against the German people. The care of the ideal is the great work of culture, and if we are a model to other peoples, and hope to remain so, the whole population must work together to reach that goal. If culture is to fulfil its task, then it must penetrate the lowest levels of the people. It can only do that if art raises itself up, rather than descending into the gutter.[33]

Wilhelm acknowledged the power of art, but he of course wanted art to assuage mass discontent, rather than stimulate it. His appropriation of the socialist idea that art should educate the masses rested in his advocacy of an idealizing art which denied poverty, misery and degradation.

Both anarchists and socialists also realized the potential propagandist purposes of art, and the need to gain a wider audience for that propaganda. This aim was furthered by the growth of anarchist journals in the 1880s and early 1890s, some of which included illustrations by artists with anarchist sympathies. From the early 1890s, the violent strain of anarchy led to greater suppression of press freedom, as governments in France and Spain in particular began to pass laws preventing the publication of anarchist propaganda. Several methods were used to facilitate the distribution of literature in light of repressive legislation. First of all, pamphlets were often given names designed to fool the vigilant police force. For example, the title of Félix Dubois's Le Péril anarchiste (1894) implied a condemnation of anarchist activity, and indeed the first few pages are devoted to a catalogue of anarchist violence. But in reality the work was a polemic for the anarchist cause designed to slip past the police. Secondly, journals were distributed through unorthodox means. 'Comrades' with some spare cash were encouraged to buy extra copies of journals and then

leave them wherever they will be picked up and opened – in the staircases of houses, for instance, and in the baskets which women carry with them when marketing. A good plan would be to give the packets to children in the street, telling them to take them home to their parents.[34]

Finally, journals often had to change editors or relocate, and London – with its more lenient laws – came to be known as the base for suppressed journals and political refugees.

Despite the fact that they were ostensibly designed to reach a mass audience, many of these journals were actually intended for a literate middle-class public, and they consequently contained reviews, excerpts from literature and sometimes illustrations. Even the deliberately 'working class' *Père Peinard* – a journal written totally in Parisian dialect – contained relatively sophisticated critiques of modern society which would have simultaneously appealed to an educated audience. In fact, *Père Peinard* was one of the first periodicals to publish anarchist caricatures, and its editor Émile Pouget employed such well-known artists as Camille Pissarro, Théophile Steinlen, Maximilien Luce and Félix Vallotton to produce attacks on the institutions of contemporary society. The efficacy of visual propaganda was apparent to many anarchists, just as it was to conservative leaders such as Kaiser Wilhelm. In his book on crowd behaviour, Le Bon highlighted the visual image as one of the strongest weapons in the hands of a political faction: 'To-day the majority of the great men who have swayed men's minds no longer have altars, but they have statues, or their portraits are in the hands of their admirers'.[35]

But for anarchists, a problem arose from the fact that in many cases artists were unwilling to acknowledge their potentially incriminating contributions to journals. In 1894, Luce was arrested for his involvement with anarchist publications, and according to the subsequent police report, 'the arrest of Luce has planted terror in the hearts of all the illustrators, sculptors and painters of Montmartre; even the most moderate of the anarchists talk of fleeing'.[36] Consequently, Camille Pissarro's most potent attack on industrial capitalism, *Turpitudes Sociales* (1889, private collection), was actually a private work, designed for the consumption only of his two nieces. The danger of being directly involved with polemical anarchist literature led other artists to compromise by contributing illustrations to reviews which had anarchist sympathies, but were not openly agitational. Literary and artistic periodicals such as *La Revue blanche* and *Mercure de France* were punctuated with excellent illustrations, and among other subjects, articles on anarchy formed part of their issues. In cases such as this, the works of art reproduced were rarely of the rural or urban poor, and if they did represent such subjects, the stylistic innovation which they evinced detracted attention from the subject-matter. Art historians have tried, with varying degrees of success, to explain the fact that 'anarchist' artists tended to produce works which were 'anarchist' only in stylistic terms; the issue of stylistic innovation in terms of art with anarchist sympathies is indeed problematic.

One of the most notable figures of the Parisian literary scene, Félix Fénéon, was both an aesthete and an anarchist. Paul Signac's portrait of him (1890, private collection) highlights the effete aspects of the critic's character, and its style links Fénéon with the Neo-Impressionist movement he praised in his art criticism. Fénéon was also a practising anarchist, and he was arrested in 1894 for planting a bomb in the Foyot restaurant in Paris. The so-called 'Trial of the Thirty', at which Fénéon and others were questioned, distinguished him as an eloquent wit, and a man capable of amazing daring in the face of potential conviction. Fénéon's lively repartee during the trial undermined the seriousness of his charge, turning the courtroom into a cabaret, and it ultimately resulted in his acquittal:

Judge. It has been established that you surrounded yourself with Cohen and Ortiz.
Fénéon (smiling). One can hardly be surrounded by two persons; you need at least three.
(Explosion of laughter) . . .

Judge: You were seen speaking with them behind a lamp-post.

Fénéon. Can you tell me, Your Honour, where behind a lamp-post is?[37]

This combination of stylish self-expression and potential for violence was one of the strangest aspects of *fin-de-siècle* anarchy, and one that is the most difficult for us to understand today. Advocates of decadence in poetry, and artists who turned away from realism or institutional affiliation were, in effect, rebelling against repressive social systems, just as political anarchists were denying the validity of governments and social hierarchies.

The individualist strand in anarchist philosophy had its roots in Nietzsche's idea of an 'Übermensch' – an ideal, aristocratic male who would be superior to the degenerate conditions of modern civilization. Like Nietzsche, the German philosopher Max Stirner enjoyed a renewed readership in the 1890s, when his *Der Einzige und sein Eigentum* (1845) was rediscovered after many years of obscurity. Both Nietzsche and Stirner glorified individualism over the 'herd instinct'; to Stirner, the individual was the only human reality. Individualism was also a strong component in anarchist thinking. In an ideal anarchist society, each individual should have the right to express himself freely, without being restricted by laws, and without being required to answer to any commercial or other external requirements. Artists and writers were drawn to the belief that self-expression was more important than conformity, and they made frequent statements to this effect throughout the 1880s and 1890s.

At times, the quality of such statements seemed to contradict the essential humanitarianism of anarchy itself. Thus, Oscar Wilde's defence of anarchy, 'The Soul of Man Under Socialism', contained a number of egoistical and judgemental aphorisms, such as 'Socialism would relieve us from that sordid necessity of living for others', and 'Art should never try to be popular. The public should try to make itself artistic.'[38] To some writers and artists, then, anarchy became another form of élitism. Félicien Rops, for example, voiced contempt for both the masses and the bourgeoisie: 'Art does not have to be democratic, social, socialist or popular. I think, contrary to people who believe that a novel or a sketch has a mission to save society and to instruct the masses, that art always was and always will be under penalty to be no more than a druidism.'[39] He also asserted, 'The bourgeoisie is the most corrupt, the most foolish, the most cruel, the most egoistical and the most educated of the classes of nineteenth-century society.'[40] Rops and many of his 'progressive' contemporaries thus implicitly advocated a form of artistic aristocracy, which was in many ways alien to anarchist ideology. The élitism of the aesthetes was attacked by the anarchist writer A. Hamon in his pamphlet on the anarchist character:

The aesthetes often present this aggregate of mental characteristics and nevertheless are not socialist/anarchists . . . Therefore, some individuals who possess the aggregate of psychic characteristics, determined by our analysis, have a profound contempt for the masses. They contemplate them from a serene height where they hover and where the vile multitude will never reach. They believe themselves and assert themselves to be superior to the mass of humanity. They are libertarians for themselves and authoritarians for others.[41]

Despite Hamon's critical remarks, aesthetic individualism was one component of the anarchist movement. Artists and writers put themselves above commercial considerations and broke away from institutional control. In this way, new movements and styles in art began to be seen as manifestations of anarchy, in obvious opposition to conservative thought which saw rebellion

against the established institutions of society in negative terms. Matthew Arnold's essay *Culture and Anarchy* (1869) was one of the first works to attack systematically a type of free-for-all liberty that led easily to nonconformity. Although his essay dealt specifically with religious controversy, he also objected to rebellion in general and claimed that societies needed culture and authority to counteract anarchy. To Arnold, anarchy was synonymous with chaos: 'In our eyes, the very framework and exterior order of the State, whoever may administer the State, is sacred; and culture is the most resolute enemy of anarchy, because of the great hopes and designs for the State which culture teaches us to nourish.'[42] Arnold's association of culture with stable forces of society was affirmed in the 1890s by Le Bon, who claimed that a race's stability was based on 'the inherited groundwork of its thoughts'; Le Bon's view of new styles of art dismissed their rebellion as superficial:

> When an artist imagines he is shaking off the burden of the past, he is in reality only returning to more ancient forms . . . replacing, for example, one colour by another, the pink of the face by green, or abandoning himself to all those fantasies, the spectacle of which we have been afforded by our recent annual exhibitions.[43]

But observers such as Le Bon also saw rebellious artists as leading a campaign to undermine society's institutions. By breaking away from traditions and academies, artists could be seen to be guilty of acts of aesthetic terrorism. Anarchist individualism manifested itself variously in the German and Austrian Secessions, the French Neo-Impressionist style and in the escapist medievalism of William Morris in England. Each of these tendencies represented a strand of anarchist belief that concentrated on the need for artistic self-expression as a component of individualism.

The Secession movements in Vienna, Munich and Berlin were seen by many traditionalists as examples of this species of anarchy. In each case, a group of artists separated themselves from the established academic system, and set up their own exhibition societies which functioned outside the government of the Academy. Whether the works produced by Secessionist artists were conventional or progressive, the very fact that these artists had broken away was seen as a form of anarchist rebellion. In terms of *fin de siècle* thought, this interpretation was fed by the language in which these artists presented themselves, and the ways in which their actions were construed in the critical press. For example, the Vienna Secession building contained an inscription over its door, '*Die Zeit ihre Kunst, Die Kunst ihre Freiheit*' ('To each time its art, to art its freedom'), which explicitly politicized the artists' activities by linking their rebellion with the concept of 'freedom'. The first version of their journal, *Ver Sacrum*, extended this notion by suggesting that their individualist ideals would ultimately serve the aesthetic needs of the 'masses':

> We want to bring foreign art to Vienna not just for the sake of artists, academics and collectors, but in order to create a great mass of people receptive to art, to awaken the desire which lies dormant in the breast of every man for beauty and freedom of thought and feeling.[44]

However, the interests of the 'masses' were of little concern to the artists of the Berlin Secession, whose rebellion against the Verein Berliner Künstler was wholly in the name of artistic freedom. Here, however, anarchist individualism was seen to be in direct opposition to the attitude fostered by Kaiser Wilhelm II and the chairman of the Verein, Anton von Werner.[45] In this case, artistic style came to be seen as politically significant. The artists of the Berlin Secession, including the

chairman, Max Liebermann (Figure 26) advocated a *plein air* style derived from the French Impressionists. Such a style was construed as 'foreign' by the Kaiser's arts functionaries, and it was therefore presented as blatantly anti-German. Given Germany's long rivalry with France, and in the aftermath of the Franco-Prussian War, this sentiment was particularly significant. The Verein encouraged a classical, idealist style and nationalist subject-matter designed to glorify the German nation. The Kaiser's own attitude towards art was, as we have seen, more concerned with its impact on the 'masses'; whereas the artists of the Berlin Secession were very much painting for an educated and cultured audience who could appreciate what were then considered the obscurities of French Impressionism. The Berlin Secessionists were the 'anarchist' individualists, who saw free self-expression to be the highest aim of the artistic community.

The actions of the Munich Secession were also seen in political terms, but here the relationship between 'democratic' and 'élitist' art was complicated by the political situation in Bavaria. The artists who formed the Munich Secession in 1892 were reacting against the activities of the Munich branch of the Allgemeine Deutsche Künstlergenossenschaft, whose exhibitions were based upon rigidly democratic principles, which allowed each participating artist to show a maximum of three works, regardless of quality. A gradual change in the Genossenschaft's policy led to actions which were construed as positively discriminating in favour of mediocre art, rather than encouraging the talents of Germany's more gifted artists. The announcement of the formation of the Verein Bildender Künstler Münchens (which later became the Munich Secession) outlined these grievances:

> Colleagues! The recent events in the Munich Künstlergenossenschaft are no doubt familiar to you all, for they were such as to require that each member take a stand. The simmering pot has now boiled over and led to a rupture that was unavoidable and is also irreparable. The battle that had been waged secretly for years has now been publicly declared with bitterness. It is the battle of the discontented and offended mediocrity against artistic greatness, of the reactionary against the progressive.[46]

However, despite the membership of Impressionists such as Liebermann, the Munich Secession did not at first foster the stylistic innovation of the Berlin Secession. In fact, many Secessionist artists were advocates of social realism, and their exhibitions were dominated by proletarian subjects. The very nature of these subjects was abhorrent to the conservative Catholic Centre party whose strong presence in the Bavarian government gave it a substantial influence over artistic affairs. For example, members of the party were particularly offended by Fritz von Uhde's *Difficult Path* (*c.* 1890, Munich, Bayerische Staatsgemäldesammlungen), which was originally entitled *The Trip to Bethlehem* and depicted Mary and Joseph as homeless paupers. Equally unwelcome to them (as to the Kaiser), were works which presented a pessimistic view of reality. Leopold von Kalckreuth's triptych *The Days of Our Years Are Threescore and Ten* (1898, Munich, Bayerische Staatsgemäldesammlungen) is one such gloomy work. Here, the ages of life are presented in the form of a peasant woman: on the left panel, a child who is too young to work gathers grain; on the right is a young mother carrying a basket, and the central panel shows an old woman, whose despair is indicated by her action of tracing patterns in the ground with her stick. The hopelessness of rural poverty is reinforced here by a quotation from Psalm 90: 'The days of our years are threescore years and ten; and if by reason of strength they be fourscore years, yet is their strength labour and sorrow; for it is soon cut off, and we fly away.'

The individualism of Secession artists constituted a form of anarchy, but the artists themselves were not necessarily anarchists in the political sense; the perceived subversiveness of the Impressionist style and peasant subject-matter may be attributable to the fact that Germany lagged behind France in new artistic developments. It was, indeed, in France that artistic anarchy and political anarchy came together in the work of the Neo-Impressionists, Seurat, Signac, Camille and Lucien Pissarro, Luce and Henri Cross. Apart from Seurat – whose political affiliations remain obscure – each of these artists expressed open sympathy for the anarchist cause, and they were all friendly with anarchist thinkers such as Grave and Fénéon. The Neo-Impressionist style, which they all practised, originated with Seurat's use of the optical theories of Ogden Rood, Charles Blanc and Michel-Eugène Chevreul. Neo-Impressionism was a more 'scientific' form of Impressionism, based on complicated colour relationships and optical colour mixtures. The style was a rebellion against the perceived triviality of Impressionism, which these artists felt conveyed only the fleeting moment, rather than the more permanent realities of nature. The anarchist qualities of the Neo-Impressionist art consisted of stylistic individualism, criticism of bourgeois society and presentation of a utopian rural harmony.

Although artists such as Camille Pissarro and Signac were strong supporters of anarchism, their critics accused them of 'art for art's sake', and anarchist sympathizers berated them for not following Kropotkin's suggestion that artists should depict the sufferings of the poor. Pissarro was obviously sensitive about such accusations, and after reading Kropotkin's *Conquest of Bread* (1892), he wrote to Octave Mirbeau:

So Kropotkin thinks that one must live as a peasant fully to understand them: it seems to me that one must be committed to one's subject to represent it well, but is it necessary to be a peasant? Let's be artists, above all, and we'll have the faculty to feel everything, even a landscape, without being a peasant.[47]

Pissarro's son, Lucien, also responded to the criticisms of detractors. In a letter to the editor of *Temps nouveaux* of 1895, Lucien wrote:

The distinction that you establish between 'art for art's sake' and art with a social tendency does not exist. Each production which is truly a work of art is social (whether the author wishes it or not).[48]

Finally, in notes for a lecture to be delivered to a workers' association, Signac linked artistic rebellion with anarchist individualism: 'The anarchist painter is not he who produces anarchist paintings but he who, without caring for money, without desire for recompense, will struggle with all his individuality against bourgeois and official conventions.'[49] Although they were essentially concerned with style, the anarchic Neo-Impressionists saw their stylistic innovation as a stamp of individualism.

However, their subject-matter, too, was often directly related to those issues which concerned their fellow anarchists. Seurat's earliest experiments with colour theory in *Une Baignade, Asnières* (Figure 27) and *A Sunday Afternoon on the Island of 'La Grande Jatte'* (Figure 28) were concerned with contemporary social life. In recent years, art historians have devoted a great deal of attention to the subject of these works, and although there is much disagreement as to Seurat's exact intention, many see both paintings as comments on bourgeois society.[50] Both are scenes of leisure and

modernity: *Une Baignade* shows workers bathing, while a smoking factory chimney in the background attests to the productivity of the working class; *La Grande Jatte* represents a mixture of classes on an island in the Seine which was used by both the working class and the bourgeoisie as a Sunday retreat. In both paintings, Seurat was representing a contemporary social scene, and it is possible that his view of class difference was intended to be critical of the effects of French industrial society.

Other artists in Seurat's circle avoided the urban scene completely, and concentrated instead on a utopian vision of rural harmony. By the 1880s Pissarro, for example, spent a great deal of time outside Paris in order to paint the rural peasantry. His *Peasant Women Haymaking* (Figure 29) is only one of many works which used the Neo-Impressionist style to create a pleasant rural idyll in which peasants work together in harmony. Although such representations may seem at first to be merely escapist fantasies, they were also in keeping with the anarchist desire for a return to rural communalism. The ideal anarchist society was not an urban one, but involved a nostalgic vision of the country. In fact, in the last two decades of the nineteenth century, parts of the French countryside, as in Italy, were undergoing an agricultural crisis as the effects of the Industrial Revolution and the concomitant economic changes began to take root. Pissarro's visions of rural life were therefore a product of his own anarchist ideals, rather than directly responsive to the realities of country life.

Escapism was also characteristic of the anarchist utopianism of William Morris in England. Although Morris's affiliations were primarily socialist, and he sometimes used the word 'anarchy' as a term of abuse, many of his ideas coincided with anarchist philosophy. In an essay on 'Art and Socialism', Morris decried the dominance of the machine in modern society:

> The wonderful machines which in the hands of just and foreseeing men would have been used to minimise repulsive labour and to give pleasure – or in other words added life – to the human race, have been so used on the contrary that they have driven all men into more frantic haste and hurry, thereby destroying pleasure, that is life, on all hands: they have instead of lightening the labour of the workmen, intensified it, and thereby added more weariness yet to the burden which the poor have to carry.[51]

Morris's answer to the degrading effects of urbanization was to provide all levels of society with art and beauty, which he felt would erode the nasty impact of speed, smoke and noise. In his utopian novel, *News from Nowhere* (1890), Morris's protagonist is transported magically into a future society which has no industry, no currency, no property and no institutions. Nor are there any schools; children left to their own devices naturally educate themselves. Morris's ideal society is replete with beauty and art, and most citizens have some kind of artistic ability. Morris's *News from Nowhere* is essentially an anarchist critique on the ugliness of modern life, which he felt resulted from industry, competition and capitalism.

To counteract this ugliness, Morris attempted to revive medieval notions of handicraft, and through his company, Morris & Co., he produced wallpaper, upholstery and items of furniture. His productions were admired throughout Europe, and his principles were taken up by a number of artists, including the Belgian Henry van de Velde. Van de Velde, like Morris, wanted art and beauty to be a regular part of everyone's daily life, and to facilitate this ideal, he designed his own house, Bloemenwert, as a total work of art, including in his designs even the clothes of the house's inhabitants. In this way, human beings became part of the beautiful environment. The irony of Morris's and Van de Velde's efforts has been pointed out many times: the time and care required for

cuality manufacture was impossible to sustain in a world where speedy mass production was possible. It was not the poor who benefited from Morris's beautiful objects, but the wealthy who could afford to buy them. Anarchist individualism ultimately favoured the artist and the work of art, rather than the exploited classes of society, and rather than ameliorating the conditions of life, anarchist art was often separated from the social problems it sought to address.

NOTES

1. Gustave Le Bon, *The Psychology of Socialism*, Eng. trans. (London, 1899), 299.
2. David Ritchie, *Darwinism and Politics* (London, 1889), 12.
3. Cesare Lombroso, *Gli anarchici* (Turin, 1894), 30.
4. Ibid., 11, 20.
5. Enrico Ferri, *Socialismo e criminalità* (Rome, 1883), 9.
6. Jean Grave, *La Société mourante et l'anarchie* (Paris, 1893), 182.
7. T.H. Huxley, 'On the Natural Inequality of Men', *Nineteenth Century*, 27, no. 155 (January 1890) 13.
8. Gustave Le Bon, *The Crowd*, Eng. trans. (London, 1896), xvii.
9. Ibid., xix.
10. See T.J. Clark, *Image of the People: Gustave Courbet and the 1848 Revolution* (London, 1973).
11. Peter Kropotkin, *Paroles d'un révolté* (Paris, 1885), 66–7.
12. Jean Grave, *L'Anarchie: son but – ses moyens* (Paris, 1899), 41.
13. Félix Fénéon, *Le Symboliste* (Paris, 1886), quoted in Robert Goldwater, *Symbolism* (London, 1979), 71.
14. Jules Destrée, *Art et socialisme* (Brussels, 1896), 3–4.
15. Ibid., 9.
16. Oscar Wilde, 'The Soul of Man Under Socialism' (1890), in Russell Fraser, ed., *Selected Writings of Oscar Wilde* (Boston, 1969), 358.
17. 'A Propos de peintures', *La Revue blanche*, 20 (June 1893), 457–8.
18. Max Nordau, *The Conventional Lies of Our Civilization*, Eng. trans. (Chicago, 1884), 11.
19. Ibid., 59.
20. Patricia Leighten, *Re-ordering the Universe: Picasso and Anarchism 1897–1914* (Princeton, 1989).
21. Vittore Grubicy de Dragon, 'Il Socialismo in Italia secondo le Osservazioni di un'Artista', *La riforma*, 27 July 1889, quoted in *Post-Impressionism*, exhibition catalogue, Royal Academy of Arts (London, 1979), 221.
22. From the diary of Mary Godsal, Clwyd Co. Council Library, 3 May 1884, quoted in Julian Treuhertz, ed., *Hard Times*, exhibition catalogue, Manchester Art Gallery (Manchester, 1987), 96.
23. *The Times* (1 May 1891), 8.
24. L. Villari, *Giovanni Segantini* (London, 1901), 36.
25. See *Post-Impressionism*, 246.
26. Ferri, *Socialismo*, 14–15.
27. Leo Tolstoy, *What is Art? and Essays on Art*, Eng. trans. (Oxford, [1930]), 120.
28. Ibid., 123.
29. This point is argued well by Elizabeth Valkenier, *Russian Realist Art* (Ann Arbor, MI, 1977).
30. Eugène Carrière, *Ecrits et lettres choisies* (Paris, 1907), 33–4.
31. Letter from Bosse to the Kaiser, 12 June 1898, quoted in Peter Paret, *The Berlin Secession: Modernism and its Enemies in Imperial Germany* (Cambridge, MA, 1980), 21.
32. Hermann Bahr, *Tagebuch* (Berlin, 1909), 122.
33. Speech of 18 December 1901 in Johannes Penzler, ed., *Die Reden Kaiser Wilhelms II*, 4 vols. (Leipzig, 1907), 3:61–2.
34. Félix Dubois, *The Anarchist Peril*, Eng. trans. (London, 1894).
35. Le Bon, *Crowd*, 66.
36. Paris Police Archives BA/79, no. 500, 27 July 1894, quoted in Jean Ungersma Halperin, *Félix Fénéon: Aesthete and Anarchist in Fin-de-Siècle Paris* (New Haven, 1988), 285.
37. Ibid., 289–90, quoting from contemporary newspaper accounts.
38. Wilde, 336, 349.
39. Letter of 1887, quoted in Guy Cuvelier, *Félicien Rops* (Brussels, [1987]), 8.
40. Letter of 1878, quoted in Robert Delevoy, Gilbert Lascault, Jean-Pierre Verhoggen and Guy Cuvelier, *Félicien Rops* (Lausanne, [1985]), 27–8.
41. A. Hamon, *Psychologie de l'anarchiste-socialiste* (Paris, 1895), 124.
42. Matthew Arnold, *Culture and Anarchy* (London, 1869), 259.
43. Le Bon, *Crowd*, xiv, 75.
44. *Ver Sacrum*, 1 (1898), 6.
45. A full discussion of these political complexities is presented in Peter Paret's excellent *The Berlin Secession*, cited above.
46. Quoted in Maria Makela, *The Munich Secession: Art and Artists in Turn-of-the-Century Munich* (Princeton, 1990), 143.
47. J. Bailly-Herzberg, ed., *Correspondance de Camille Pissarro* (Paris, 1988), 3:217.
48. Quoted in Robert L. Herbert and Eugenia W. Herbert, 'Artists and Anarchism: Unpublished Letters of Pissaro, Signac and Others – I', *Burlington Magazine*, 102 (November 1960), 479.
49. Ibid.
50. See, for example, John House, 'Meaning in Seurat's Figure Painting', *Art History*, 3 (1980), 345–56, and Richard Thomson, *Seurat* (Oxford, 1985).
51. William Morris, 'Art and Socialism', in *Selected Writings*, ed. G.H. Cole (London, 1934), 625.

CHAPTER 4
ANXIETY

William Morris's model for an anarchist society was not simply a blueprint for a reformed political system. As in many utopian fictions, *News From Nowhere* offered an attack on a contemporary way of life, rather than a genuine attempt to suggest an alternative for it. By positing a return to the culture of the Middle Ages, Morris was explicitly rejecting modern urban society, and indeed, in other tracts and lectures, he reiterated his loathing for the growing cities of Europe. His expression of distaste was not moderate: 'Apart from the desire to produce beautiful things, the leading passion of my life has been and is hatred of modern civilization.'[1] His hatred centred upon the unnaturalness of urban life, and the social inequalities which resulted from urban industrial capitalism:

> Think of the spreading sore of London swallowing up with its loathsomeness field and wood and health without mercy and without hope, mocking our feeble efforts to deal even with its minor evils of smoke-laden sky and befouled river: the black horror and reckless squalor of our manufacturing districts, so dreadful to the senses which are unused to them that it is ominous for the future of the race that any man can live among it in tolerable cheerfulness.[2]

The polarity Morris saw between the healthy country and the sick city had a long history in English literature, but his use of this age-old dichotomy took on a special meaning in the late nineteenth century.[3] Cities in Europe were expanding with frightening rapidity, gradually draining the countryside of its population and traditions. These new large cities were places where poverty and disease were rife, and conditions were only slowly ameliorated by various sanitary reforms and legislation. Despite the fact that the very existence of large cities was a result of industrial progress, they were also regarded as seats of moral degeneration, where 'natural' goodness could be easily corrupted or subverted by artificial desires or neurotic obsessions. The intensity of urban living thus became a major part of the argument that society was mentally 'sick': the urban experience was one of anxiety and isolation.

The extent of the change from rural to urban society should not be underestimated. England was the first nation whose urban population outnumbered its rural by the mid-nineteenth century, and Raymond Williams's decisive assessment that this was 'the first time in human history that this had ever been so, anywhere'[5] indicates just how momentous this fact actually was. In 1870, there were only about 70 cities in Europe with populations of over 100,000, but after 1900, this number had grown to 200 – an increase of nearly 200% in 30 years[6]. Not only were there more cities, but quantity and distribution of urban population also changed dramatically. Berlin, for example, grew from 826,000 in 1871 to 2,000,000 by 1905,[7] and the population of Budapest tripled between 1867 and 1900.[8] In London and Paris, urban redevelopments gradually

8

drove the poor into slums or industrial suburbs, and the middle class was also dispersed by the prohibitive cost of living in the city's more convenient centres.[9] The extent and rapidity of these changes heightened fears that growth would be endless and destructive. As one journal article put it:

> To look at our enormous cities, expanding day by day and almost hour by hour, engulfing year by year fresh colonies of immigrants, and running out their suckers, like giant octopuses into the surrounding country, one feels a sort of shudder come over one, as if in presence of a symptom of some strange social malady.[10]

Although this writer, Elisée Reclus, was using a Darwinian argument to prove that cities were the result of a positive 'evolution', he was also responding to a prevalent contemporary attitude. Cities were seen to be growing too fast and consuming a way of life that had dominated Europe for hundreds of years. Inevitably, such expansion and its concomitant problems led to a sense that the new urban regions would eventually collapse under the weight of disease, poverty and immorality – as Ancient Rome had done. One author, Brooks Adams, saw exact parallels between modern urban culture and the ancient Roman empire:

> For many years farming land has fallen throughout the West as it fell in Italy in the time of Pliny. Everywhere, as under Trajan, the peasantry are distressed; everywhere they migrate to the cities, as they did when Rome repudiated the denarius.[11]

The theory of urban degeneration fed this cultural disquiet.

But the anxiety provoked by city living had artistic, as well as a political and sociological, dimension. Not only were artists increasingly turning to urban themes, but their response to this manifestation of modern life represented a more general ambivalence towards urban living. Regardless of where they were born, artists tended to migrate to cities in order to gain recognition through exhibitions, to meet other artists who were experimenting with new ideas, and to make contact with art dealers and patrons. It is significant that anarchist utopians such as Pissarro had to divide their time between sojourns in the country and periods in Paris, and Van Gogh's attempt to create an artists' colony in Arles was a dismal failure. Although some rural artists' communities – such as those in Brittany and Worpswede (see Chapter 8) – were successful, most artists were dependent on the city for their livelihood. A rejection of the city was a deliberate statement, but equally, when an artist did tackle urban themes, this treatment was replete with ambivalence. Cities were seen as threatening, exploitative, degenerate, isolating, or, alternatively, as exciting or hauntingly beautiful. The intense and novel experience of living in a city attracted and repelled artists, but underlying all these manifestations of urban life was uncertainty towards the present or anxiety about the future. The idea of the crowd, the inequalities of wealth, the sense of the city as progressive and the image of urban decadence all found their place in *fin de siècle* art, and in this art, the external environment that elicited these phenomena were frequently related to the psychological state of the artist. However, this blending of psychology and society should not be taken as evidence of an individual artist's 'genius' or madness; instead, through the media of art, the external, urban world, and the inner world of neurosis and anxiety each found a means of expression.

These 'external' and 'internal' discourses intersected in a painting by the Belgian artist James

Ensor, *The Entry of Christ into Brussels, 1888* (1889, Collection of Colonel Louis Frank, London). Ensor's work represents a large and somewhat threatening crowd which is celebrating Mardi Gras in Brussels before the onset of Lenten austerity. The air of celebration is artificial and almost hysterical, and the celebrants are masked and frenzied. Art historians have suggested that the figure of Christ, who emerges from this carnivalesque throng, is in fact a representation of Ensor himself.[12] In this interpretation, Ensor becomes the rejected Christ figure, who is forced to face an overwhelming mass of potential opposition and misunderstanding. Certainly Ensor was something of a recluse, and he suffered from paranoia, particularly when his works were rejected by the jury of the Belgian avant-garde society, Les XX.

However, to read the work as an allegory of Ensor's own experience would be to ignore its urban and political themes. As Diane Lesko has pointed out, Ensor's *Christ* was painted in response to the 1887 exhibition in Brussels of Seurat's *La Grande Jatte*, which inspired Belgian artists to adopt his new Divisionist technique, based on the optical experiments of such scientists as Ogden Rood and Charles Henry. But Lesko's assertion that Ensor's *Christ* was a pessimistic response to Seurat's optimistic view of a 'classless utopia' disregards the bitingly satirical undercurrents in Seurat's own work (see Chapter 3).[13] If Ensor's painting was a response to Seurat, it was more an extension, than a rejection, of Seurat's essential cynicism about the condition of modern urban society. The difference lay more in points of emphasis: Seurat distinguished the different classes present on La Grande Jatte, whereas in Ensor's Brussels, they were blended and concealed behind an array of carnival masks.

In Ensor's painting, a large banner with the words 'Vive la sociale' figures prominently amidst the throng, thus relating Ensor's crowd directly with the potential threat of an anarchist uprising. Like may other cities in Europe, Brussels housed a committed anarchist underground, and Ensor himself was connected with anarchist sympathizers. However, his message seems ambivalent about the movement itself, as the crowd appears to be as much a threat as a welcome sign of revolution. From at least the time of Morel's *Traité des degenerescences* (1857), crowded urban areas came to be associated with crime, violence, alcoholism and insanity.[14] Anarchist violence – ironically committed to a future rural communist utopia – was considered one manifestation of this urban sickness. Ensor's inclusion of an anarchist reference in his *Entry of Christ into Brussels* is therefore not without some ambiguity. The role of religion in such an unbridled gathering is just as equivocal, and this complexity appeared again in Ensor's etching *The Cathedral* (1886, London, British Museum). In both works, Ensor created an urban dystopia with an uncontrolled, morally degenerate crowd acting out a parody of religious celebration. Through these allusions to class, anarchy and religion, Ensor's painting echoed the concerns of contemporary Belgian society, rather than providing a map of his own mental condition.

Representations of the urban crowd in the late nineteenth century were not always so foreboding, but in some instances, the very absence of menace was significant to the contemporary understanding of the work of art. This was the case in the paintings of music halls produced by the English artist Walter Richard Sickert in the late 1880s. Again, art historians have often concentrated on Sickert's interest in Degas's depictions of the Parisian *cafés concerts*, which certainly did influence Sickert's choice of subject.[15] Formalist comparisons are often made between Degas and Sickert, which stress the aesthetic distinction between their works, and at first glance, Sickert's own comments about his choice of subject seem to bolster this formalist approach to his work. In a much quoted denial of Degas's influence, Sickert said:

It is surely unnecessary to go so far afield as Paris to find an explanation of the fact that a Londoner should seek to render on canvas a familiar and striking scene in the midst of the town in which he lives . . . I found myself one night in the little hall off Islington Green. At a given moment I was intensely impressed by the picture created by the coincidence of a number of fortuitous elements of form and colour.[16]

Although Sickert insisted that he had a purely formal interest in the music hall interior, his very choice of subject was rife with implications for London audiences of the late nineteenth century, as several recent scholars have suggested.[17] In fact, the music hall was one of the few places of entertainment in the East End of London, where it formed the nucleus of leisure life for the working class. The controversy that surrounded music halls lay partly in the fact that the artistes who performed in them were said to incite class discontent, lust, and immorality in the audience: the presence of bars and prostitutes in many music halls fed this exaggerated assumption. However, there were also music halls in the West End of London; venues like the Alhambra mimicked the format of the East End halls, but they were frequented by the middle classes and high society. For his music hall paintings, Sickert deliberately selected the East End – not the West End – and he added to their subversive content by focusing on the working-class audience itself, which was inevitably presented as a blur of anonymous faces. In a painting such as *The Gallery at the Old Bedford* (Figure 30), the audience becomes the sole subject of study, and although the figures are not individualized, Sickert provided enough clues to make their class affiliation obvious. Public distaste for Sickert's early work was not limited to his style, but to what was perceived as the 'vulgarity' of his subject-matter. In reality, Sickert's music hall scenes were subverting expectations, by transforming something considered to be ugly, amoral and impoverished into an image of great beauty and power. Such a dissonance was founded upon the social tensions of modern life, and would not have been missed by Sickert's largely middle-class public.

Art played a varied role in expressing these very real social conflicts, which reached a fever pitch in the cities of the late nineteenth century. The idea of 'class' within the urban discourse of the *fin de siècle* does not simply imply inequalities of birth; with the growth of large industrial centres, wealth became a major factor in creating class distinctions. Throughout Europe, writers pointed to these inequalities, with evidence of the differences between the superior social structure of rural communities and the heartless individualism of capitalist cities. Morris explained the growth of cities in economic terms:

It is profit which draws men into enormous unmanageable aggregations called towns . . . profit which crowds them up when they are there into quarters without gardens or open spaces; profit which won't take the most ordinary precautions against wrapping a whole district in a cloud of sulphurous smoke; which turns beautiful rivers into filthy sewers; which condemns all but the rich to live in houses idiotically cramped and confined at the best, and at the worst in houses for whose wretchedness there is no name.[18]

Morris was concerned with the ugliness of cities, but others found more cause for despair in the undermining of rural communalism. For example, in 1887 the German philosopher Ferdinand Tönnies wrote a tract postulating a distinction between *Gemeinschaft*, or community, and *Gesellschaft*, or society.[19] Although he intended these categories to represent ideal types, they

also constituted a real divide in European culture. *Gemeinschaft* signified nature, the family, the rural peasantry; *Gesellschaft* was mechanism, rationality, science, the urban and the artificial:

> The theory of the Gesellschaft deals with the artificial construction of an aggregate of human beings which superficially resembles the Gemeinschaft in so far as the individuals peacefully live and dwell together. However, in the Gemeinschaft they remain essentially united in spite of all separating factors, whereas in the Gesellschaft they are essentially separated in spite of all uniting factors.[20]

Tönnies also discussed the issue of wealth, which he felt dominated the mechanical, urban society. The desire to work together which characterized rural life was destroyed by the lure of making money. In the view of the French sociologist Gustave Le Bon, further discontent was created when industrial society failed to live up to the new desires that it had engendered by its very existence.[21] Industrial 'progress' not only stimulated a culture based on wages and the exchange of money, but it resulted in more and more products for people to spend their money on. Without money, it was impossible to succeed, or even to be comfortable, in such a society.

The isolation and separation created by the artificial construction of city life was also pinpointed by Peter Kropotkin, who was even more concerned with the implications of division and conflict within cities:

> Today the *united* city has ceased to exist; there is no more communion of ideas. The town is a chance agglomeration of people who do not know one another, who have no common interest, save that of enriching themselves at the expense of one another. . . . What fatherland can the international banker and the ragpicker have in common? Only when cities, territories, nations, or groups of nations, will have renewed their harmonious life, will art be able to draw its inspiration from *ideals held in common*.[22]

In Kropotkin's eyes, art was meant to be something which could have meaning for everyone, and in a society based on conflict, rather than community, this would not be possible. Other writers contributed to the debate about the place of art in industrial society. Brooks Adams in his *Law of Civilization and Decay* described the development of civilization from a state of superstition to that of martial conflict and finally of commercial hegemony. To Adams, the gradual move from emotional to economic concerns stifled the artist who, he felt, 'has become the creature of a commercial market'.[23] However, Robert Vaughan, in his eulogistic *The Age of Great Cities* compared the 'higher culture' of cities with the 'lower culture' of the provinces. To him, cities were places of free commerce, and therefore stimulated freedom of expression and taste for art: commercial prosperity preceded artistic prosperity:

> There is the genius of commerce and the genius of the sword, and all is mediocrity beside. The scattered tillers of the ground, if left to themselves, must always resemble the vegetation of the wild heath, which the eye regards not, and of which the future preserves no memorial. Such is the necessary lot of isolated man, especially when doomed to a narrow round of manual occupation. If men are to become strong, physically or mentally, it must be by association – by the association of war, or by those of cities.[24]

It is important to remember that Vaughan was writing in 1843, at the very outset of the massive urban boom which would completely change the face of Europe by 1900. Many mid-nineteenth-century artistic responses to the city seemed to concur with Vaughan's positive assessment. In France, in the 1870s, the Impressionists celebrated the new boulevards designed by Georges-Eugène Haussmann, which obliterated the medieval look of Paris and turned it into a thoroughly modern city. Renoir, Manet, Monet and Degas also painted the life of the city, responding in part to a call from the poet Charles Baudelaire that the artist should turn his attention to the new themes of modern life. In his apostrophe to the artist Constantine Guys, 'The Painter of Modern Life' (1863), Baudelaire described the city as a place of great beauty – a sort of urban outpost of rural society which represented the best qualities of both:

> He [Guys] marvels at the eternal beauty and amazing harmony of life in the capital cities, a harmony so providentially maintained amid the turmoil of human freedom. He gazes upon the landscapes of the great city – landscapes of stone caressed by the mist or buffeted by the sun.[25]

In England, the vogue for urban themes was started by the success of William Powell Frith's *Railway Station* (Figure 31), a view of Paddington Station which followed earlier crowd scenes, *Ramsgate Sands* (1854) and *Derby Day* (1858). Frith later contended that he had avoided scenes of modern life for many years, fearing they were not 'picturesque':

> I don't think the station at Paddington can be called Picturesque, nor can the clothes of the ordinary traveller be said to offer much attraction to the painter – in short, the difficulties of the subject were very great, and many were the warnings of my friends that I should only be courting failure if I persevered in trying to paint that which was in no sense pictorial.[26]

When Frith finally turned to such themes, he created the picturesque by careful arrangement of figures and a contrived contrast between different levels of society. In Frith's *Railway Station*, rich and poor mingle, but through his eyes, all were merely components of a pleasing picture. By avoiding the full implications of the dissonances between poverty and wealth in the city, Frith made his picture more attractive for his largely middle-class public, just as Baudelaire eschewed the seamier side of urban life through his vivid evocations of the city's 'natural' beauty.

This search for the 'picturesque' in city life was one of the more problematic aspects of artistic representation in the late nineteenth century. Even socially conscious artists were restricted by the expectations and demands of the public as to what they could include in a work of art. This problem becomes apparent in Blanchard Jerrold's guidebook *London: A Pilgrimage* (1872), which was illustrated by Gustave Doré (Figures 32 and 33). This book purports to be a trip around London 'in search of the Picturesque', and Jerrold begins by insisting that London is full of picturesque people and places:

> London an ugly place indeed! We soon discovered that it abounded in delightful nooks and corners: in picturesque scenes and groups; in light and shade of the most attractive character.[27]

Jerrold did not limit his exploration to the fashionable West End, but he also travelled to Whitechapel, where he peeped into the rotting hovels of the very poorest inhabitants of East London. Doré's illustrations enhanced Jerrold's purpose: the pleasant visions of the West are indeed contrasted with the darker corners of the East, but Doré's views of the impoverished East End evoke sublime beauty rather than the unsightly conditions of poverty. Indeed, the introduction to the book speaks of 'Paternoster Row' and 'the hospital waiting room for outpatients: outside the casual ward' as two manifestations of this same quality of the picturesque.[28] In light of *London: A Pilgrimage*, one must look at Luke Fildes's socially conscious *Applicants for Admission to a Casual Ward* (1874, Royal Holloway and Bedford New College) in a different light. Fildes appears to be showing the wretched and hopeless situation of the poor and sick, but to Jerrold and Doré, such bleak visions had aesthetic possibilities. In works such as these, the aesthetic obscured the significance of the social problem, and by placing such works within an artistic context, the artist became a voyeur and an apologist, rather than a polemicist for the improvement of social conditions.

Such aestheticizing of the urban landscape was characteristic of a number of nineteenth-century painters who were influenced in some way by the Impressionist style. Whistler's images of Wapping and Battersea Bridge transformed a heavily industrialized region of the Thames into a dream-like vision. Indeed, a number of landscape painters, including Monet, found the Thames a useful focus for their cityscapes. By concentrating on water and bridges, rather than factories and workers, these artists recalled the eighteenth-century view pictures of Canaletto and thus implicitly denied the machinery, dirt and sweat of contemporary society. In these landscapes, even the smoke and smog produced by factories becomes a sort of *sfumato*, which contributes to the tranquil atmosphere of the urban scene. This is also true in Atkinson Grimshaw's representations of Leeds or Liverpool, which seem to repudiate those cities' reputations as part of the 'ugly industrial north'. Grimshaw achieved this effect by setting his works in the evening – the end of the working day – and by bathing his landscapes in gaslight to enhance the beauty of the image. In such paintings, the urban industrial scene was transformed into images of poetic beauty.

By the 1890s, many observers had become aware of the limitations that artists faced in attempting to convey urban poverty in an honest way. In this respect, it is instructive to compare George Sims's *How the Poor Live* of 1883 with Jerrold and Doré's *London* of eleven years earlier. Sims's work is also something of a guidebook, but he confined his tour to what he called 'Povertyopolis' – his cynical nickname for the East End of London.[29] In what is perhaps a direct allusion to Jerrold's *London*, Sims denied that poverty could be aestheticized or seen as 'picturesque':

The difficulty of getting that element of picturesqueness into these chapters which is so essential to success with a large class of English readers, becomes more and more apparent . . . Rags, dirt, filth, wretchedness, the same figures, the same faces, the same old story of one room unfit for habitation yet inhabited by eight or nine people, the same complaint of a ruinous rent, absorbing three-fourths of the toiler's weekly wage . . . rotten floors, oozing walls, broken windows, crazy staircases, tileless roofs, and in and around the dwelling-place of hundreds of honest citizens the nameless abominations which could only be set forth were we contributing to the *Lancet* instead of the *Pictorial World*.[30]

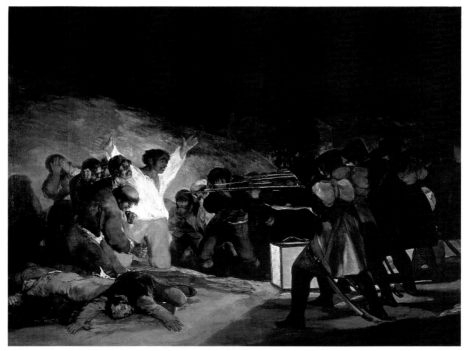

13 Francisco José de Goya y Lucientes, *Execution of the Defenders of Madrid, 3rd May, 1808*, 1814, Prado, Madrid

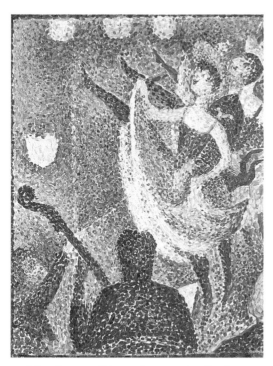

14 George Pierre Seurat, *Le Chahut*, Courtauld Institute Galleries, London

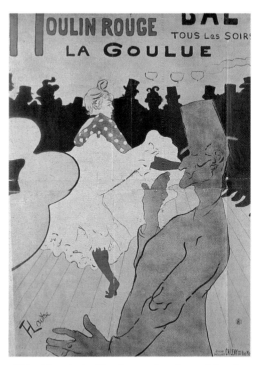

15 Henri de Toulouse-Lautrec, *Moulin Rouge – La Goulue*, Private Collection

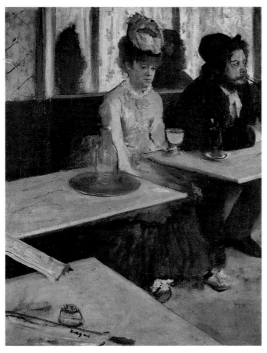

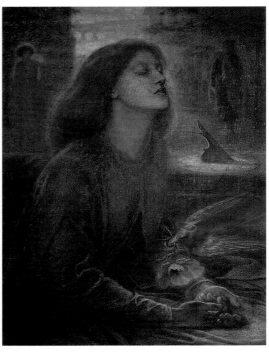

16 Edgar Degas, *At the Cafe*, 1876–7,
Musee d'Orsay, Paris

17 Dante Gabriel Rossetti, *Beata Beatrix*,
*c*1863, Tate Gallery, London

18 Paul Gauguin, '*Where do we come from? What are we? Where are we going?*',
Boston Museum of Fine Arts, Massachusetts

19 Odilon Redon, illustration from
Les Origines, 1883,
British Museum

20 Aubrey Beardsley, 'The
Mysterious Rose Garden' from *The
Yellow Book*, Volume IV, 1895

21 Gustave Courbet, *Burial at Ornans*, 1849–50, Louvre, Paris

22 Gustave Courbet, *The Stone Breakers*,
Staatliche Kunstsammlungen, Dresden

23 Sir Hubert von Herkomer, *Hard Times*, 1885,
Manchester City Art Gallery

24 Giuseppe Pellizza da Volpedo, *The Fourth Estate*, 1898–1901,
Civica Galleria d'Arte Moderna, Milan

25 Käthe Kollwitz, *Peasants War* (plate 2), 1903–8,
British Museum, London

26 Max Liebermann, *Garden Scene*, Christie's, London

27 Georges Pierre Seurat, *Bathers at Asnières*, 1883–4,
National Gallery, London

28 Georges Pierre Seurat, *Sunday Afternoon on the Island of 'La Grande Jatte'*,
1883–6, Art Institute of Chicago, USA

29 Camille Pissarro, *Women Haymaking*, 1887–9,
Dr H.C.E. Dreyfus Foundation, Kunstmuseum, Basel

30 W.R. Sickert, *The Gallery at The Old Bedford*, 1897,
Walker Art Gallery, Liverpool

31 William Powell Frith, *The Railway Station*, 1862,
Royal Holloway and Bedford New College, Surrey

How the Poor Live is also illustrated, and although the crude representations of alcoholics, prostitutes. 'rotten floors' and 'oozing walls' are less sanitized than Doré's sublime, they do not convey fully the extent of the situation that Sims presents in his emotive verbal descriptions of the East End way of life.

During the next twenty years in England, many writers followed Sims in exposing the horrific conditions in the slums of London. These studies range from the statistical to the fictional.[31] But works such as Arthur Morrison's novels *Tales of Mean Streets* and *A Child of the Jago* treated the unhappiness and poverty of the East End with ethnographic detachment, while sensationalizing violence and perpetuating stereotypes. For the purposes of literature, as well as art, the East End was ugly, and either its ugliness had to be avoided, or it had to be translated into some other kind of consumable form. Oscar Wilde's socialist sympathies were very much inspired by what he saw as the essential ugliness of capitalist society; he looked forward to a socialist future where 'there will be no people living in fetid dens and fetid rags, and bringing up unhealthy, hunger-picked children in the midst of impossible, and absolutely repulsive surroundings'.[32]

Artists who wished to depict urban life were therefore faced with a dilemma if they chose to represent the inequality and nastiness characteristic of cities, they had to sacrifice the aesthetic qualities of their art; if they avoided the unpleasant, they misrepresented the realities of modern life. However, even after Impressionism had run its course in many parts of Europe, artists continued to strive for beauty in their representations of the metropolis, although many of these later works presented a compromise between a romanticized version of city life, and one which either revealed the social problems inherent in urban culture or the political commitment of the artist. This more 'positive' visualization of urban life can be seen in the work of the Belgian Symbolists, the French artists Seurat and Delaunay, the Italian Futurists and the German Expressionist painter Ludwig Meidner. Although each of these artists used the city in different ways, they all commented on the urban scene without highlighting its 'ugliness'.

The problems created by urban growth were well known to Belgian artists, but with rare exceptions, they did not represent urban poverty or industry in their work. Instead, they employed a more indirect commentary on contemporary life. This is the case in Fernand Khnopff's paintings, *Abandoned City* (1904, Musées Royaux des Beaux-Arts de Belgique) and *The Secret and the Reflection* (1902, Bruges, Groningenmuseum). In each of these works, Khnopff avoided the details of industry and urban growth and looked back to the fifteenth century, when Bruges was an important artistic centre of the Burgundian Empire. *Abandoned City* represents a desolate row of fifteenth-century Flemish houses standing next to a calm sea. This image creates an eerie sense of isolation: the city is empty and the sea is in a position to move forward and engulf it. *The Secret and the Reflection* evokes Bruges as if through an old photograph. The nostalgic sense of loss that permeates both of these works reveals Khnopff's own perspective on the growing industrialization of Belgian society. Although Bruges itself was never subjected to the urbanizing tendencies of Brussels, there were plans in the late nineteenth century to give Bruges a new commercial *raison d'être*.[33] However, Khnopff's views of Bruges eschewed modernism completely, evoking instead a long lost medieval past when Bruges was a thriving artistic centre. *The Secret and the Reflection* is, in fact, a tribute to the novel *Bruges-la-Morte* (1897) by the Belgian Symbolist, Georges Rodenbach. Like Khnopff, Rodenbach expressed a longing for the medieval past, which carried with it a rejection of modern urban culture and all it stood for. Ironically, Bruges had been a prosperous mercantile city in the fifteenth century, but artists with socialist sympathies saw fit to ignore this aspect of its history. Commercial cities of the past such as Bruges, Venice and Florence had

retained their historical and aesthetic character, and could therefore be used by artists who aspired to an ideal type of city – however ahistorical their own assumptions about these cities might be.

But artists could even look to recent developments in their own city as signs of the possibility of a positive future. In this respect, Seurat's painting of the *Eiffel Tower* (1889, San Francisco, Fine Arts Museum), produced in his Neo-Impressionist style, is particularly significant. As I have already suggested, Seurat expressed his cynical view of modern urban society in several paintings which show the uneasy mix of classes in the context of leisure (see Chapter 3). However, the *Eiffel Tower* appears to carry with it no such cynicism or ambiguity. The Eiffel Tower was erected in 1889 as a symbol for the Paris *Exposition Universelle*, which was held on the centenary year of the French Revolution. Constructed in iron, the Tower was a potent symbol of modern technology, but it was also an icon of revolution, and it therefore formed a central focus of Pissarro's frontispiece to his anarchist *Turpitudes Sociales* (see Chapter 3). By presenting the Eiffel Tower in such an iconic manner, Seurat was paying direct tribute to the *possibilities* – if not the realities – of urban culture. Through the style in which the work was painted, Seurat enhanced, rather than diminished, its beauty. The juxtaposition of lively primary colours was also characteristic of the paintings of Robert Delaunay, an artist of the next generation who also produced views of the Eiffel Tower. Although Delaunay was not using a Neo-Impressionist style, his 'Orphism', based on a prismatic fracturing of primary colours, equally reinforced the aesthetic quality of Paris's major modern landmark.

Seurat's and Delaunay's aesthetic representations of the Eiffel Tower and Khnopff's nostalgia for old Bruges can be placed in the context of *fin de siècle* urban utopianism. Many European and American writers who were critical of the effects of urban life suggested ways in which the city could be reformed so that it would retain its advantages while losing its more destructive aspects. From the late 1880s, writers tried to suggest alternatives to the problematic nature of modern urban living, but Edward Bellamy, Theodor Fritsch, Ebenezer Howard and H.G. Wells did not simply reject the modern city, but presented ways in which it could be reformed. Underlying the arguments of each of these utopians was the idea that a change in the formal and visual structure of urban society would help facilitate an improvement of its living conditions. To these authors, the 'ugliness' of the modern city lay not so much in its physical appearance, but in the pernicious inequalities signified by the urban landscape.

Bellamy was an American journalist, whose utopian novel *Looking Backward* 2000–1887 was published in 1888 and soon found its way to England, France and Germany. Like many polemicists who distrusted urban growth, Bellamy had socialist sympathies, and indeed, he was responsible for the intellectual foundation of the American Nationalist party, which advocated the nationalizing of all industries. In Bellamy's novel, the protagonist, Julian West, is a wealthy, spoiled Bostonian, who despises the working class, but gets his comeuppance when a bout of hypnotism somehow leads to his transportation to the year 2000. The Boston of the year 2000 is a socialist utopia, where all material needs are provided for by the government, allowing people ample time to attend to their spiritual needs and social solidarity. In this utopia, all public places are beautiful, because art is not confined to the private sphere – although Bellamy's chillingly accurate description of a shopping centre may not strike many observers today as a sign of public beauty.[34] Because competition is no longer necessary, beauty is not sacrificed to profit. After sampling utopia, Julian West dreams that he is back in the Boston of 1887, and he is struck immediately by the ugliness of his surroundings, and the relationship of

that ugliness to the commercial function of much urban architecture. 'Stores! Stores! Stores! miles of stores!', West exclaims when he sees Washington Street, and he expresses a similar horror at the number of banks and factories which dominate the urban landscape. While sitting on a bench in Boston Common, he sums up the horror of urban living:

> For thirty years I had lived among them, and yet I seemed to have never noted before how drawn and anxious were their faces, of the rich as of the poor, the refined, acute faces of the educated as well as the dull masks of the ignorant. And well it might be so, for I saw now, as never before I had seen so plainly, that each as he walked constantly turned to catch the whispers of a spectre at his ear, the spectre of Uncertainty. 'Do your work never so well,' the spectre was whispering, – 'rise early and toil till late, rob cunningly or serve faithfully, you shall never know security. Rich you may be now and still come to poverty at last.'[35]

The German writer Theodor Fritsch, in his *Die Stadt der Zukunft* (*The City of the Future*) (1896) constructed a similarly totalitarian urban utopia, but Fritsch carried the idea of a strong state a step further. In his assessment, 'reason' and 'order' were the components of an ideal city, which he felt should be built on a radial pattern with a cultural complex at the nucleus and factories near the outside. But Fritsch's strictly organized urban space was also dominated by a social hierarchy, as his plan involved separating 'private houses of monumental character' from 'workers' residences'. A system of tunnels and railways precluded regular contact between the classes.[36] Fritsch's regimented and hierarchic metropolis, like Bellamy's socialist answer to the problems of urban life, was rejected by many who were suspicious of such extensive organization or government control.

An alternative was provided by Ebenezer Howard whose *Tomorrow: A Peaceful Path to Real Reform* (1898) used a factual, rather than fictional, approach to the urban question. Although his answer to the problem was a 'garden city', or 'a well-planned town, built on an agricultural estate',[37] Howard did not embrace the anarchist values normally associated with such ruralist solutions. Instead, he called for a compromise between government control and free enterprise, which he felt would be best achieved in an urban environment. But Howard's 'garden city' was designed and planned to allow the best possible life for all levels of society: combining the beauty of the country with all the advantages of city life, the garden city had as its nucleus a series of art and leisure complexes – libraries, museums and galleries. The industrial and commercial functions were removed to the outskirts. Howard's solution recognized the alienation and destructive competition that characterized contemporary cities:

> These crowded cities have done their work; they were the best which a society largely based on selfishness and rapacity could construct, but they are in the nature of things entirely unadapted for a society in which the social side of our nature is demanding a larger and larger share of recognition.[38]

It was just this 'social side' that worried H.G. Wells, who also forecasted a type of garden city in his predictive collection of essays, *Anticipations*.[39] But Wells's most potent examination of the urban question was his haunting short story, 'The Time Machine' (1895), which implied that urban life – however alienating – is merely an outgrowth of man's natural impulses. In 'The Time Machine', the Victorian 'Time Traveller' is transported forward to the year 820,701. He finds

himself not in a world of unbridled urban expansion, but in a distinctly rural society, full of the 'ruinous splendour' of once great palaces, where, he realizes, 'The shop, the advertisement, traffic, all that commerce which constitutes the body of our world, was gone.'[40] The beautiful but simple inhabitants of this future world – the Eloi – live in communistic harmony, but their peaceful life is constantly threatened by the existence of the ape-like Morlocks who reside underground amidst the remnants of once-productive machinery. Although Wells cleverly avoids drawing the sort of pointed conclusions that characterize Bellamy's *Looking Backward*, he implies that the life of leisure and culture, and the life of work and competition, are inextricable parts of human character: 'It is a law of nature we overlook, that intellectual versatility is the compensation for change, danger, and trouble . . . There is no intelligence where there is no change and no need of change.'[41] Competition is therefore necessary for progress; without it, degeneration will ensue. The rural society of Wells's 'Time Machine' was therefore regressive and undesirable; whereas the urban – however faulty – was seen to be more characteristic of the essential character of human beings.

After the turn of the nineteenth century, artists too began glorifying the city in their work, but with perhaps less regard for human values than Bellamy or Howard, and with less studied detachment than Wells. The most obvious example of this glorification is the work of the Italian Futurists, who believed that the modern metropolis was a positive development, and that nostalgia for the past was misguided and needed to be obliterated. Following the lead of the poet Filippo Tommaso Marinetti's *Futurist Manifesto* of 1909, Italian artists such as Umberto Boccioni, Carlo Carrà and Gino Severini were inspired by urban themes, through which they expressed their enthusiasm for modern life. Often their attempts to display dynamism, movement and energy in their work were abortive, and their own letters and diaries reveal their continual frustration with the effort to depict movement within the confines of a static, two-dimensional form. Their views of urban life were romanticized, and their expression of modernity inevitably involved a rejection of the kind of human values that could not be sustained in competitive industrial society. For example, in their *Technical Manifesto* of 1910, the Futurists wrote:

> We desire to take our place again in life itself. Today's science, rejecting its past, answers to the material needs of our time; art no less, rejecting its own past, should respond to the intellectual needs of our time. Our new awareness no longer lets us view man as the center of the universal life. For us, a man's pain is interesting no less but no more than that of an electric bulb which, functioning, suffers and endures agonies and cries out in the most lacerating expressions of colour.[42]

This affected indifference to suffering allowed the Futurists to side-step the ambiguity of such themes as those of Boccioni's *The Riot in the Galleria* (1910, Milan, Brera) and *The City Rises* (Figure 34) The *Riot* was originally exhibited in 1911 with the title *Una baruffa* (A Brawl), which rendered the depicted violence specifically urban working class. *The City Rises* was originally called *Il lavoro* (*Work*, or more correctly, *Labour*), and it too therefore represented a sensitive working-class issue. However, neither of these paintings engaged directly with the subjects they displayed. Boccioni was more concerned with the spiritual experience of urban living, which he attempted to convey through fevered washes of distorted colour. In a defence of *The City Rises*, he wrote to a friend:

I do not hesitate to say that a picture of such dimensions, inspired by such a pure purpose as that of erecting a new altar to modern life vibrant with dynamism, one no less pure and exalting than those raised out of religious contemplation of the divine mystery – a picture that attempts this is infinitely superior to any sort of more or less objective reproduction of real life.[43]

Thus Boccioni's allegory of labour was really a glorification of the inner spirit of modern life which avoided its nastier realities.

Spiritual self-indulgence was also characteristic of the art of Ludwig Meidner, who painted a series of city themes involving explosion, destruction and desolation. Meidner was influenced by the Italian Futurists, and he was one of the founding members of a group of Berlin artists and poets called Die Pathetiker, which included poets such as Jakob von Hoddis, who made their reputations by writing paeans to big cities (*Grosstädte*). Meidner's own writings expressed his excitement about the metropolis and special love for Berlin, which was nevertheless tempered with a manic irritation at the conflicting demands of city life. From 1912 he painted 'apocalyptic' views of cities (see Chapter 8), which conveyed the impression of ecstatic frenzy. Although these representations of the city – like Meidner's own poetic revelations – were self-consciously expressionistic, they give a good indication of the kind of anxiety and hysteria the city could inspire. This attitude emerges very well in Meidner's description of the early-morning walks around Berlin which he took with Hoddis:

We used to leave the Café des Westens after midnight and march, straight-backed, quite fast, right ahead through the streets, following our noses . . . We were twenty-eight at that time and had plenty of stamina; first light found us still marching on, not at all tired, and the early sun was well over the rooftops before we asked each other what part of town we were in. Mostly it was the far north or northeast, but the rows of buildings continued, those cheerfully dismal Berlin apartment blocks, with their countless dismally cheerful balconies. Here and there were the first eyewitnesses to the coming Berlin weekday, which in those days, for all its homely plainness, did not seem plain and banal but beautiful, magnificent, unique and even sublime, and inexpressibly delightful. We were so in love with that city.[44]

Meidner's use of oxymoronic descriptions ('dismally cheerful', 'cheerfully dismal') did not deny the ugliness of the city – as the Impressionist's work had done – but instead glorified that very ugliness. However, this glorification in many ways carried with it more disturbing implications. Unlike utopian writers, Meidner and the Futurists did not wish to preserve the advantages of cities while destroying their disadvantages; to them, the city, and everything in it, was the focus of unqualified and indiscriminate approbation. This unyielding moral stance can be seen in Meidner's apocalyptic landscapes, in which images of urban havoc smacked of the enthusiasm he felt for city life. Even destruction could be seen as a positive force.

Meidner's own poetic descriptions of his life and work are indicative of the way in which the urban experience was beginning to be internalized. Of the many perceptions of the city which grew during the *fin de siècle*, one of the most prevalent was the idea that the city was a breeding ground for anxiety, neurosis and madness. Some artists self-consciously expressed this metropolitan psychology, but their choice of subject and treatment was often used after their deaths to evaluate their art in terms of their mental state. This is particularly true of Edvard

Munch who suffered from psychological ailments, and painted works which represented the anxiety of urban living. In order to extricate the myths from the historical context, it is worth considering the issue of urban anxiety in relation to Munch's work. What will become clear is the way in which an artist's subject-matter could be understood and constructed by contemporary observers who were well versed in the psychological controversies of the time. Through their choice of subject, artists played upon these very controversies, and audiences interpreted their works accordingly.

The neurosis of urban living was pinpointed by psychologists, sociologists and interested observers throughout the last two decades of the nineteenth century. The city was seen to be the seat of physical and moral disease, both of which were perceived to result ultimately from some form of psychological malady. The British biologist Harry Campbell related physical degeneration to the topographical spaces of the city itself: 'Residence among the slums of a large city produces distinct physical deterioration, which increases with each generation until family extinction finally ensues.'[45] Charles Richer's *Le Surmenage mental dans la civilisation moderne* (1890) identified the city as an incubator for modern psychological disorders, and Campbell also significantly linked city life with effeminacy: 'That the confinement entailed by town-life exerts an injurious influence on the men, and makes them more like women in their nervous health, is evident to every one who has the opportunity of comparing country with town people.'[46] The idea that the metropolis was somehow emasculating was repeated often by psychologists studying sexual 'deviance' (see Chapter 5). Richard von Krafft-Ebing asserted that 'the number of masochists, especially in large cities, seems to be quite large',[47] and he similarly blamed the city for inciting unnatural lusts in its inhabitants: 'There is no doubt that external, accidental impressions, particularly loitering in the streets of a large city, greatly intensify the desire. The sight of beautiful and imposing female forms, *in nature*, as well as in art, is exciting.'[48] For Krafft-Ebing, the very presence of so many bodies seemed enough to provoke uncontrolled sexual behaviour in the urban population.

Other writers concentrated more on the physical effects of living in the city. In his *Degeneration Amongst Londoners*, James Cantlie attributed 'urbo-morbus' to the destruction of the ozone (referring to 'pure and refreshing air' rather than a specific form of oxygen). The air itself was enough to cause physical, mental and moral disease in the inhabitants of London, and he prescribed exercise and regular trips to the country to counteract the harmful impact of city air.[49] Other authors were more cautious in their assessment of the city's destructive potential. Professor Clifford Allbutt in an article on 'Nervous Diseases and Modern Life' denied that the proliferation of nervous maladies was caused by modern life, and attributed them instead to the fashion-seeking of the upper classes:

> There is some ground, I believe, for the assertion that dwelling exclusively in large cities is tending to dwindle and impoverish the bodily health of the wage-earning, or permanently resident, class; but it is not in this class that the effects of 'brain pressure', of ambitious projects of business competition, of pampered aestheticism are to be sought.[50]

According to Allbutt, a new taxonomy of mental diseases allowed people to identify those maladies that had formerly been ignored, and the bored leisure classes had the time and the hypochondriacal inclination to cultivate illnesses which had formerly not had a name. Allbutt's solution to the problem was commonsensical:

The men and women who, having inherited a fairly stable nervous-system, working their brains so as to get the most out of them, are temperate in meat and drink, and secure their own portion of fresh air . . . and who keep out of railway accidents, may fight their way without making for the doctor.[51]

The most eloquent assessment of urban neurosis appeared long after the turn of the century. Sigmund Freud – who had lived through this period – summed up the situation in his *Civilization and its Discontents* (1930). Freud outlined the causes of human suffering, which he attributed to three factors: the knowledge that nature is superior to man, the feebleness of the human body, and the inadequacy of social relations. He elaborated:

When we start considering this possibility, we come upon a contention which is so astonishing that we must dwell upon it. This contention holds that what we call our civilization is largely responsible for our misery, and that we should be much happier if we gave it up, and returned to primitive conditions.[52]

Calling upon his psychoanalytic theory, Freud suggested that the progress of civilization forced human beings into greater and greater states of repression: the aggression that 'primitive' man was allowed and even required to exhibit had to be sublimated or suppressed in 'civilized' societies. Equally, the unbridled sexuality of 'primitive' man was proscribed by the moral laws of western 'civilization'. Consequently, human beings lived in a state of guilt, experiencing feelings of aggression and sexuality which were not sanctioned by their own social laws, and which consequently had to be suppressed:

Men have gained control over the forces of nature to such an extent that with their help they would have no difficulty in exterminating one another to the last man. They know this, and hence comes a large part of their current unrest, their unhappiness and their mood of anxiety.[53]

To Freud, neurosis resulted from the conflict between primitive instinct and modern life.

Freud's *Civilization and its Discontents* was a psychoanalytic summary of a situation which had been acknowledged in some form for many years before the book was written. The conflict between human instinct and the unspoken repressions of metropolitan existence was an appropriate subject for art from the late nineteenth century. Munch frequently presented urban themes in terms of neurosis and this conflation of external and internal anxiety can be seen by comparing three paintings of Karl Johan Street, the main thoroughfare in Kristiana (Oslo). Each of Munch's paintings of the crowds on Karl Johan Street brought out a different aspect of the relationship between the individuals and their environment. In *Music on Karl Johan Street* (1889, Zurich, Kunsthaus), he showed people gathering to hear a military band, and he presented this view through the cheerful luminosity of Impressionist painting. A slightly later work, *Spring Day on Karl Johan Street* (1890–1891, Bergen, Rasmus Meyers Samlinger), reveals the influence of Divisionism, which gives the painting a sense of lazy lightheartedness in keeping with the pleasurable season it represents. However, when Munch painted *Evening on Karl Johan Street* (Figure 35), he changed his emphasis and his style again to create a pessimistic view of urban neurosis. This work represents a crowd in which individuals are alienated from each other by fear and anxiety. Their faces are mask-like, and their fixity suggests that their minds are lost in private terrors. The problems of urban life

are transposed into the neuroses of individuals: Munch managed to externalize that repression through a calculated use of physiognomy and frigid colours.

Neurosis overtakes the urban setting in Munch's most famous painting, *The Scream* (1893, Oslo, National Gallery) and in the lesser-known *Anxiety* (Figure 36). Neither of these works represents a crowd, but the crowd and the city itself are implicit in the terror of the figures represented. In a famous passage, Munch described how the subject of *The Scream* came about, and in this, he neatly conveyed a prevailing anxiety about urban life:

> One evening I was walking along a path, the city was on one side and the fjord below. I felt tired and ill. I stopped and looked out over the fjord – the sun was setting, and the clouds turning bloodied. I sensed a scream passing through nature; it seemed to me that I heard the scream. I painted this picture, painted the clouds as actual blood.[54]

In Munch's contrived description, the scream is the panicked cry of nature – a nature that is being steadily engulfed by the city. He deliberately polarized the natural and the artificial, in an attempt to convey this impression. In many respects, Munch's attempts to encapsulate mental anxiety in physical spaces falls within Max Nordau's definition of 'Anxiomania' 'an error of consciousness which is filled with presentations of fear, and transfers their cause into the external world, while, as a matter of fact, they are stimulated by pathological processes within the organism.'[55] Indeed, it was paintings such as *The Scream*, and Munch's own comments about them, that led critics to evaluate Munch himself as psychologically disturbed. One Norwegian doctor, Johan Scharffenberg, declared publicly that Munch was suffering from hereditary insanity, and a review of Munch's paintings which appeared in a daily newspaper of 1890 described his art in terms of mental malaise:

> Among our painters, Munch is the one whose entire temperament is formed by the *neurasthenia*. He belongs to the generation of fine, sickly sensitive people that we encounter more and more frequently in the newest art. And not seldom they find a personal satisfaction in calling themselves 'Decadents', the children of a refined, overly civilized age.[56]

By using terms common in contemporary psychological usage, such criticisms served to create a relationship between the 'progressive' artist and insanity, and between that artist's production and the spontaneous outpourings of a disturbed mind. In considering the issue of art and anxiety, it is important to extricate fact from fantasy, and to realize to what extent, if any, an artist's mental state can be determined by his work. In order to do this, an examination of the *fin de siècle* debate about 'genius' and 'insanity' is illuminating, and suggests the extent to which artists and their works were subjected to myth-creating psychological assessments. Such a study gives insight not only to the work of Munch, but to that of artists who were considered to be equally disturbed, Toulouse-Lautrec and Vincent Van Gogh.

The debate about insanity and artistic 'genius' was initiated by the French psychologist Moreau de Tours in *La Psychologie morbide dans ses rapports avec la philosophie de l'histoire* (1859), and was developed further by Cesare Lombroso in his *Genio e follia* (1882) and *L'uomo di genio* (1888). Both Moreau and Lombroso argued that genius was merely a symptom of insanity, although Lombroso later grudgingly renounced his extreme position. Another writer within this school of thought, J.F. Nisbet, summed up this position most succinctly:

> Genius, insanity, idiocy, scrofula, rickets, gout, consumption, and other members of the neuropathic family of disorders, are so many different expressions of a common evil – an instability or want of equilibrium in the nervous system.[57]

Most authors who engaged in this debate neglected to define what 'genius' actually was, but Francis Galton's well-known *Hereditary Genius* gave them a model to follow.[58] Galton drew his selection of geniuses from biographical dictionaries and obituaries of *men* who had distinguished themselves by natural gifts and more than one original act. Galton claimed that only 1 in 4,000 men could be geniuses, and these men were usually judges, statesmen, writers, divines, or artists. Artists were mentioned frequently in the debates about genius, but equally they figured prominently in the argument that geniuses were congenitally mad.

The most extreme position was taken by Lombroso, and echoed by his follower Nordau. In his book L'*Uomo di genio* (*The Man of Genius*), Lombroso devoted a chapter to art; however, here he did not discuss the 'genius' of professional artists, but the art work produced by the insane in mental hospitals. Even so, his examples of work produced by 'mattoids' and 'degenerates' with little grasp on reality bore a striking resemblance to prevailing tendencies in modern art. According to Lombroso, alcoholics tended to paint yellow pictures, whereas melancholics painted skulls; the use of symbolism and hieroglyphics was a sure sign of insanity, while arabesques and ornamentation were symptoms of atavism. Artistic creativity resulted from the compulsive personalities of madmen, and even originality itself was seen to indicate sickness: 'Disease often develops . . . an originality of invention which may also be observed in mattoids, because their imagination, freed from all restraint, allows of creations from which a more calculating mind would shrink, for fear of absurdity.'[59] All of these descriptions could easily have been applied to avant-garde artists, especially the Impressionists, the Neo-Impressionists and the Symbolists. However, Lombroso made only one direct reference to contemporary art: he suggested that in response to the open competition in Rome for a design for a monument to Victor Emmanuel 'mattoids came forward in crowds'.[60] In his eyes, there was little to distinguish the artistic inclinations of the insane from the insane inclinations of artists.

Lombroso's ideas were carried to their logical conclusion by Nordau, whose *Degeneration* actually did point a finger at specific artists and art movements. For example, Nordau explained Impressionist art by attributing to its practitioners the disease of nystagmus, or 'trembling of the eyeball', which he claimed accounted for the blurred images they produced:

> The curious style of certain recent painters – 'impressionists', 'stipplers', or 'mosaists', 'papilloteurs', or 'quiverers', 'roaring' colourists, dyers in gray and faded tints – becomes at once intelligible to us if we keep in view the researches of the Charcot school into the visual derangements in degeneration and hysteria.[61]

He goes on to assert that artists such as Manet, who used a great deal of violet in their work, were suffering from hysteria and melancholia. Nordau felt that artists who really believed they were painting the 'truth', but who produced anything other than the most hackneyed form of academic realism, must have had some sort of psychological disorder.

Not all writers who entered this debate were as extreme in their judgements as Lombroso and Nordau. The Germans Paul Radestock and William Hirsch both presented a more balanced assessment of the genius/insanity issue.[62] Hirsch claimed that there was no sharp demarcation between sanity and insanity, just as there was no distinct divide between genius and normality. To him, the psychological state of artists should be judged not by the work of art itself, which 'expressed the metaphysics of the period', but through the personality of the artist who produced it.[63] In Hirsch's analysis, the 'degenerate' art of the nineteenth century was not the

result of degenerate artists, but grew out of a society burdened by religious scepticism and urban anxiety.

However, it was not Hirsch's, but Nordau's analysis that has survived in history and popular assessment. For example, despite the intelligent arguments of art historians such as Griselda Pollock, Fred Orton and Lesley Stevenson, Vincent Van Gogh and Toulouse-Lautrec are still often considered the 'mad geniuses' of the late nineteenth century, whose works abound with echoes of their psychological disorders.[64] Certainly Van Gogh may have suffered from psychomotor epilepsy, and Toulouse-Lautrec experienced the destructive effects of alcoholism and syphilis. Both artists also spent time in asylums. But despite these factors, their art cannot be seen simply as an unconscious outpouring of their anxiety. Toulouse-Lautrec's scenes of Parisian life are full of the frenzied decadence of the period, but they also represent his own circle of acquaintances in Paris, and his contribution of similar images to advertising posters indicates that there was a popular demand for such 'degenerate' scenes.

Likewise, Van Gogh's self-portraits, which have frequently been read as maps of his psychological state, were instead contrived studies designed to reveal his artistic skill. Given the popular mythology surrounding Van Gogh, many are tempted to read his self-portrait of 1888 (Figure 37) as a sign of his incipient madness and suicide. When shown photographs of this portrait, students today tend to conjure up clinical imagery, pointing to Van Gogh's shaved head as a sign of confinement, and the lurid green background as evidence of his mental disorder. Nordau's legacy has not yet been shaken off. In fact, Van Gogh painted the portrait in order to offer it in exchange with other artists' self-portraits, as part of his desire to form a community of artists in Arles. His depiction of himself as a saint-like ascetic was a stamp of artistic pride, rather than self-destructiveness. Indeed, Van Gogh's letters to his brother contribute to his self-presentation as a misunderstood genius, while Toulouse-Lautrec – during his confinement in an asylum in 1899 – became the subject of the press speculation which fertilized a posthumous myth of his insane genius.

The discourse of neurosis which grew out of late nineteenth-century psychological theory included the productions of 'progressive' artists within its sphere, but the works of those artists and the themes of anxiety which they so often presented cannot now be seen as unproblematic documents of a neurotic society. Issues of anxiety were related to a complex variety of political, social and psychological themes which dominated *fin de siècle* thought. But the divisions between external and internal manifestations of anxiety were not always clear, and art, as well as life, was subjected to emotive and sometimes misleading descriptions.

NOTES

1. William Morris, 'Art and Socialism', in *Selected Writings*, ed. G.H. Cole (London, 1934), 657.
2. Ibid., 638–9.
3. These complications are outlined in Raymond Williams, *The Country and the City* (St. Albans, 1975).
4. This paradox is discussed by Patrick Brantlinger, *Bread and Circuses: Theories of Mass Culture as Social Decay* (Ithaca and London, 1983), 127.
5. Williams, 261.
6. Michael Biddiss, *The Age of the Masses: Ideas and Society in Europe Since 1870* (Harmondsworth, 1977), 30.
7. Malcolm Bradbury and James McFarlane, eds., *Modernism 1890–1930* (Harmondsworth, 1976), 106.
8. See Robert Pynsent, ed., *Decadence and Innovation: Austro-Hungarian Life and Art at the Turn of the Century* (London, 1989), 111–248.
9. For Paris, see T.J. Clark, *The Painting of Modern Life: Paris in the Art of Manet and His Followers* (Princeton, 1984); for London see Donald J. Olsen, 'Victorian London: Specialization, Segregation and Privacy', *Victorian Studies*, 17 (Spring 1974), 265–78.
10. Elisée Reclus, 'The Evolution of Cities', *Contemporary Review* (Feb 1985), 246.

11. Brooks Adams, *The Law of Civilization and Decay: An Essay on History* (London, 1895), 290.
12. See, for example, Paul Haesaerts, *James Ensor* (Brussels, 1973), 111–14.
13. Diane Lesko, *James Ensor: The Creative Years* (Princeton, 1985), 52.
14. See Robert Nye, *Crime, Madness and Politics in Modern France: The Medical Concept of National Decline* (Princeton, 1984).
15. For this view of Sickert, see Wendy Baron, *Sickert* (London, 1973), and Ronald Pickvance, 'The Magic of the Halls and Sickert', *Apollo*, 76 (April 1962), 107–15.
16. Walter Sickert, *The Scotsman*, 24 April 1889.
17. See, for example, John Stokes, *In the 90s* (Hemel Hempstead, 1989); J.S. Bratton, ed., *Music Hall: Performance and Style* (Milton Keynes, 1986); and Shearer West, 'Painting and the Theatre in the 1890s', in Richard Foulkes, ed., *The 1890s: Essays on Drama and the Theatre* (Cambridge, 1992).
18. William Morris, 'How We Live and How We Might Live', in *Selected Writings*, cited above.
19. Ferdinand Tönnies, *Gemeinschaft und Gesellschaft* (1887), Eng. trans. as *Community and Association*, ed. Charles Loomis (London, 1955).
20. Ibid., 74.
21. Gustave Le Bon, *The Psychology of Socialism* (London, 1899), 13.
22. Peter Kropotkin, *The Conquest of Bread*, ed. Paul Avrich (London, 1972), 134.
23. Adams, 294.
24. Robert Vaughan, *The Age of Great Cities* (London, 1843), 86–7.
25. Charles Baudelaire, *The Painter of Modern Life and Other Essays*, ed. Jonathan Mayne (London, 1964), 11.
26. W.P. Frith, *My Autobiography and Reminiscences*, 3 vols. (London, 1887), 1:327.
27. Gustave Doré and Douglas Jerrold, *London: A Pilgrimage* (London, 1872), viii, ix.
28. Ibid., viii.
29. George Sims, *How the Poor Live* (London, 1883), 14.
30. Ibid., 29.
31. For a statistical assessment, see Charles Booth, ed., *Life and Labour*, Vol. 1: *East London* (London, 1889); for fictional representation, see especially Arthur Morrison's novels *A Child of the Jago* (London, 1896), *To London Town* (London, 1899), and *Tales of Mean Streets* (London, 1894).
32. Oscar Wilde, 'The Soul of Man Under Socialism,' in *Selected Writings of Oscar Wilde*, ed. Russell Fraser (Boston, 1969), 337.
33. This argument is well discussed by Jeffrey Howe, *The Symbolist Art of Fernand Khnopff* (Ann Arbor, 1982), 38.
34. Edward Bellamy, *Looking Backward 2000–1887* (Boston, 1888), ed. John L. Thomas (Cambridge, MA., 1967). Julian West describes the shopping centre as follows: 'I was in a vast hall full of light, received not along from the windows on all sides, but from the dome, the point of which was a hundred feet above. Beneath it, in the centre of the hall, a magnificent fountain played, cooling the atmosphere to a delicious freshness with its spray . . . Around the fountain was a space occupied with chairs and sofas, on which many persons were seated conversing' (157).
35. Ibid., 299, 303.
36. Theodor Fritsch, *Die Stadt der Zukunft* (Leipzig, 1896), especially 4, 8–9.
37. Ebenezer Howard, *Tomorrow: A Peaceful Path to Real Reform* (London, 1898), 51.
38. Ibid., 134–5.
39. H.G. Wells, *Anticipations of the Reaction of Mechanical and Scientific Progress Upon Human Life and Thought*, 6th ed. (London, 1902).
40. H.G. Wells, 'The Time Machine', in *The Complete Short Stories of H.G. Wells* (London, 1927, rev. ed., 1974), 33, 36.
41. Ibid., 79.
42. Quoted in Ester Coen, *Umberto Boccioni*, exhibition catalogue, Metropolitan Museum of Art (New York, 1988), 93.
43. Quoted in Ibid., 96 (letter of 19 May 1911).
44. Quoted in Carol Eliel, *The Apocalyptic Landscapes of Ludwig Meidner* (Munich, 1989), 75–77.
45. Harry Campbell, *Differences in the Nervous Organisation of Man and Woman: Physiological and Pathological* (London, 1891), 78.
46. Ibid., 87–8.
47. Richard von Krafft-Ebing, *Psychopathia Sexualis*, Eng. trans. (Philadelphia and London, 1892), 107.
48. Ibid., 109.
49. James Cantlie, *Degeneration Amongst Londoners* (London, [1885]).
50. Clifford Allbutt, 'Nervous Diseases and Modern Life', *Contemporary Review* (February 1895), 219.
51. Ibid., 220.
52. Sigmund Freud, *Civilization and its Discontents*, ed. James Strachey (London, 1979), 23.
53. Ibid., 82.
54. Quoted in J.P. Hodin, *Edvard Munch* (London, 1972, reprint 1977), 48.
55. Max Nordau, *Degeneration*, Eng. trans. (London, 1895), 226.
56. Andreas Auberg, 'Høstudstillingen: Aarsarbeidet IV; Edvard Munch', *Dagbladet*, 355 (5 Nov 1890), 2–3, quoted in Reinhold Heller, *Munch: His Life and Work* (London, 1984), 69.
57. J.F. Nisbet, *The Insanity of Genius and the General Inequality of the Human Faculty Physiologically Considered* (London, 1891), 57.
58. Francis Galton, *Hereditary Genius* (London, 1869).
59. Cesare Lombroso, *The Man of Genius*, Eng. trans. (London, 1891), 184.
60. Ibid., 230.
61. Nordau, 27.
62. See Paul Radestock, *Genie und Wahnsinn* (Breslau, 1884) and William Hirsch, *Genius and Degeneration*, Eng. trans. (London, 1897).
63. Hirsch, 320.
64. Griselda Pollock and Fred Orton, *Vincent Van Gogh: Artist of His Time* (Oxford, 1978) and Lesley Stevenson, *Toulouse-Lautrec* (London, 1991).

CHAPTER 5
ANDROGYNY

I n 1897, the British psychologist Havelock Ellis isolated a crucial concern for his own and other western cultures:

> Now that the problem of religions has practically been settled, and that the problem of labour has at least been placed on a practical foundation, the question of sex – with the racial questions that rest on it – stands before the coming generation as the chief problem for solution.[1]

Although Ellis's optimism about the resolution of social problems was unfounded, his focus on sex was both topical and appropriate. From the 1880s onwards, psychologists began turning their attention directly to the question of how the sexuality of human beings developed and how this development could be altered or 'perverted' by heredity or environment. In England, the socialist Edward Carpenter had to publish his tracts on free love privately, but in Germany Carl Ulrichs openly declared his homosexuality, while Richard von Krafft-Ebing and Albert Moll analysed sexual 'deviation' through scientific case study and literature. In France, Russia and Italy, studies of sexual behaviour also began to appear, and many of these were translated into several languages and circulated throughout Europe. This interest both predated and influenced Sigmund Freud, whose own theories were often imaginative extensions of existing ideas. As Krafft-Ebing put it,

> Sexuality is the most powerful factor in individual and social existence; the strongest incentive to the exertion of strength and acquisition of property, to the foundation of a home, and to the awakening of altruistic feelings, first for a person of the opposite sex, then for the offspring, and, in a wider sense, for all humanity.[2]

Krafft-Ebing's homiletic remarks represent the typical apologia that preceded such studies. While professing to maintain a conventional and established social order, psychologists, anthropologists and sexologists exposed what they felt to be deviations from that order. In the beginning, the new 'science of sex' was designed to maintain the status quo.

The explosion of literature on sexual behaviour seemingly resulted in a greater openness about sexual questions, but this openness was circumscribed by the lingering conventions of nineteenth-century bourgeois society. The new public interest in men and women, and how they related to each other, was continually accompanied by polemics of moral outrage which demanded that the study of sexuality be reserved for doctors, psychologists and policemen. However, once sex had entered the public forum, it was very difficult to drive it away, and

novelists and poets in particular began filling their work with surprisingly graphic speculations or fictions about physical love. This supposedly excessive emphasis on sex led one exasperated journalist to exclaim, 'To represent men and women as merely or mainly conduits of sexual emotion, is as luridly inartistic as it is to paint a face as a flat, featureless plain, from which the nose rises as a lonely eminence.'[3] To prevent fictional accounts of sexual behaviour was difficult, but artistic representations were effectively confined to the private productions of pornographers. Art was too immediate and too limited by its public place in exhibitions and academies to respond overtly to the findings of the new sexual science. However, artists did absorb the concerns of their society, and works of art could be interpreted as participating in the complex debates about gender which dominated sexual studies. Any painting of human beings – whether historical, literary, contemporary or imaginary – can be seen to contribute to the confusion of images about women and men which accompanied this growing study of sexuality. As stable and limited objects, works of art also reinforced the stereotypes that emerged from these wide-ranging European debates.

Essentially, studies of sex began with one or two assertions about masculinity and femininity: either men and women had opposite qualities, or each sex had some qualities of the opposite sex within it. Such a deceptively simple polarization underlay several decades of intense debate about the roles of men and women in society. Many sexologists began and ended with the question of love, and it is instructive to look at several images of love to see how art works could embody conflicting social attitudes and confusions. Gustav Klimt's earliest version of *The Kiss* (1895, Vienna, Historisches Museum der Stadt Wien) represents a theme that he returned to a number of times in his career. Unlike his later decorative and rather daring interpretations, this early work is both sentimental and in some respects conventional. Klimt's loving couple are both dressed in contemporary clothes and embrace each other amidst a haze, which adds an aura of soft-focus unreality to their contact. Contemporary notions of romantic love were frequently rooted in the idea that men and women had totally distinct yet complementary qualities. Sociologists such as Herbert Spencer saw this differentiation as the stamp of cultural advancement.[4] As Darwin had argued, evolution involves divergence into separate species, or, moving from a homogeneous state to a heterogeneous state. The growing separation between the characters of men and women revealed the 'advanced' stage of their evolution and made them indispensable complements of each other. Romantic love, such as that depicted by Klimt, was seen to be a prelude to their eventual union, which itself was geared wholly toward the production of healthy offspring.

The dangers inherent in this assertion were manifold: again and again scientists and psychologists used the differentiation theory as a means of arguing against change. If men became more 'manly' and women more 'womanly', the progress of society was assured; if men became more like women and women more like men, they were both experiencing an atavistic regression to a state of primitive homogeneity or hermaphroditism. We can misread today writers such as Paolo Mantegazza, Professor of Anthropology in Florence. Mantegazza's casual exposition of the sexual habits of South American Indians, and his consequent stress on the value of free love, present him as an open-minded thinker in his own time. However, Mantegazza also saw men, women and their relationships in conventional terms:

> Love is a chemical affinity; and its composition is proportionately stronger the more widely different are the elements in the combination. The ideal of perfect marriage is the combination of a man thoroughly a man, *exceedingly so*, and a woman thoroughly a

woman, *exceedingly so*. Whenever a man acquires a feminine tendency of character and a woman a virile one the chemical affinity diminishes in intensity.[5]

Such statements required that the very definitions of masculinity and femininity be subjected to greater scrutiny. What was seen by some as complementarity was seen by others as irreconcilability. Using largely the evidence of slugs, birds and sea anemones, Darwin and his followers asserted that men were katabolic (or energetic), while women were anabolic (or lazy); men had a strong sexual instinct, while women had little or none; men were egotistical, while women were altruistic:

> The female not only possesses complicated organs for building up large ova . . . but is further endowed with the necessary instincts for hatching the eggs, and looking after the young brood . . . The male in a similar way, is endowed with a strong instinct for seeking out and fertilising the female – the almost universal law being that the male shall be the seeker – and, furthermore he is equipped with many secondary sexual characteristics which will enable him to secure her; such as extra strength, and weapons of offence and defence for conquering male rivals; odoriferous glands, and external beauty.[6]

Although the author here was not writing expressly about human beings, he easily extended the analogy. Some scientists felt that there could be little argument against the assertion that mental and physical differences between men and women were the givens of progress and evolution, or that the open struggle for women's emancipation or the more cautious campaigns for homosexual rights were futile attempts to change the course of human history: 'What was decided among the prehistoric Protozoa cannot be annulled by Act of Parliament.'[7]

Thus love, which had long been a concern of artists and writers, was 'Darwinized', and observers frequently turned their attention away from natural selection and towards the question of sexual selection, or how members of the same sex compete with each other to win a mate. It would be simplistic to suggest that artists merely illustrated scientific theories, but their works are full of imagery which had resonances for contemporary audiences. For example, Klimt's vision of inevitable romantic union contrasts graphically with representations of struggle which dominate the fairy-tale mysticism of Burne-Jones's paintings. Burne-Jones's *The Depths of the Sea* (1887, Cambridge, MA, Fogg Art Gallery) and *Phyllis and Demophoön* (1870, Birmingham Art Gallery) reveal love as conflict. In *The Depths of the Sea*, a mermaid carries off her victim, while the mythological Phyllis, in the shape of an almond tree, attempts to trap Demophoön, who does not love her. In both cases, the woman has stepped out of her conventional role and asserted her right to the man. In both cases again, the woman is a half-evolved hybrid: a fish-woman and a tree-woman; and in both cases the man succumbs unwillingly to the woman's seductions. Burne-Jones's pessimistic love-fantasies provides solace for neither man nor woman. The image of conflict which dominated much painting of males and females in the late nineteenth century was as starkly uncompromising as that of uncomplicated romantic love. Neither Klimt nor Burne-Jones suggested a solution to the differences between the sexes; but through art, both asserted established ideas about love and gender difference.

In contrast to these images of dissonance or complementarity, some artists stressed the unity of the sexes, and through these works a very different kind of solution to the 'battle of the sexes' emerged. *The Love of Souls* (1900, Brussels, Musée d'Ixelles) by the Belgian painter Jean Delville was

only one of many such paintings which presented love as a fusion of two beings who do not appear to be radically different from each other. In Delville's work, love is not a coming together of opposites, but a reconciliation of similar types; we could see Delville's creatures as man and woman, but their nudity does not sharply distinguish them. To Delville, love is the fusion of compatible or like souls: love was manifested in the image of the androgyne.

The androgyne, or human with the qualities of both man and woman, was a crucial image in late nineteenth-century art. It stood as a metaphor for the confusion stimulated by the 'battle of the sexes', an oblique icon for homosexual love, and a symptom of a larger crisis in the construction of male identity at the turn of the century. Although in essence, the androgyne was both sexes, the figure was most often represented as a feminized male. The image can be best understood by examining it in its theoretical, social and artistic manifestations. The scientific theory of 'unisexuality' and of the 'criminal' nature of homosexuality; the concealment of homosexual subtexts beneath aesthetic theories and mysticism; and finally the ultimately narcissistic nature of androgyny must all be considered. Artistic images and theories of androgyny suggested 'solutions' to a number of the modern problems which emerged with the greater openness about human sexual behaviour.

The term 'androgyny' has often been used interchangeably with 'hermaphrodite', but although the two are related, androgyny came to be more important for the arts, whereas hermaphroditism took on a more biological association. According to Darwinian theory, hermaphrodites existed only among the lower animals, such as earthworms and snails; by extension, the hermaphrodite state was a primitive one which represented a very early stage in evolution: 'As at present existing, hermaphroditism may be interpreted as a persistence of the primitive state, or as a reversion to it.'[8] The idea that differentiation was the stamp of civilization was a fairly new one in the nineteenth century. As Thomas Laqueur has pointed out, before the Industrial Revolution many physicians and theologians held that men and women were essentially the same species and that woman was 'undeveloped man'.[9] Although Laqueur claims that this 'one-sex' theory was eclipsed by the middle of the nineteenth century, it began to reemerge in a new form by the 1890s.

Most psychologists and sexologists felt that the true hermaphrodite (a human being with both male and female sexual organs) was rare, but they identified a state which they called 'psychosexual hermaphroditism' or 'psychical hermaphroditism'.[10] This was a condition in which one sex felt strongly that they were more like the opposite sex, despite the incontrovertible evidence of their genital organs. Thus, through this theory, men who liked to cook and sew, or women who smoked cigars and rode bicycles, could equally be seen to have qualities of psychosexual hermaphroditism. The German homosexual psychologist Carl Ulrichs went so far as to define and classify gradations of the sexual perspective. Speaking only of men, he called 'normal' men Dionings, and 'abnormal' men Urnings, subdividing the latter category into Mannlings (men who appeared manly but loved other men), Weiblings (effeminate men who loved older, rougher men), and Zwischen Urnings (an intermediate category of men who loved young men).[11] The term 'Urning' was borrowed from ancient mythology, and referred to the goddess Aphrodite, who was born from the genitals of the god Uranos. In the late nineteenth century, 'Urning' became a widely used euphemism for homosexual, as it stressed the more positive side of homosexual love.

The idea that human sexuality could be graded in such a way was widely adopted by sexologists, but such a taxonomy was laden with potential value judgements. Thus, psychologists could argue that any divergence from the sexual norms of manhood and womanhood was

deviation or degeneration, but they first had to clarify what those 'norms' were. On the other hand, the belief in the possibility of gender ambiguity inspired the socialist homosexual, Edward Carpenter, to write a eulogy for the new 'intermediate sex'. According to Carpenter, the 'Soul material' in men and women does not always correspond with their outer body appearance, but he saw this concept through utopian eyes: 'Sometimes it seems possible that a new sex is on the make – like the feminine neuters of Ants and Bees.'[12] The belief that men could feel like women and women could feel like men was advocated in an extreme form by the Austrian philosopher, Otto Weininger, who claimed that both sexes were really a mixture of man and woman. Weininger wrote his massive *Sex and Character* when only 21, and he committed suicide two years later. The book is a mixture of fanaticism, misogyny and Darwinism, but underlying Weininger's extreme approach is an important conception of gender homogeneity. Weininger claimed that no human being could really be totally manly or totally womanly. Using 'M' to represent the ideal of masculinity, and 'W' to indicate the ideal of femininity, Weininger constructed a series of algebraic formulae to explain human sexual attraction. According to him, the perfect couple could be represented numerically: for example, a man who was 3/4 M and 1/4 W would perfectly complement a woman who was 1/4 M and 3/4 W. Weininger expanded this theory to absurd extremes:

$$\text{If } \chi \left\{ \begin{matrix} \alpha M \\ \alpha' W \end{matrix} \right. \text{ and } \gamma \left\{ \begin{matrix} \beta W \\ \beta' M \end{matrix} \right.$$

(where α, α' and β' are greater than 0 and less than unity) define the sexual constitutions of any two living beings between which there is an attraction, then the strength of the attraction may be expressed thus:

$$A = \frac{K}{\alpha - \beta} f^t$$

where f^t is an empirical or analytical function of the period during which it is possible for individuals to act upon one another, what may be called the 'reaction-time'; whilst K is the variable factor in which are placed all the known and unknown laws of sexual affinity, and which also varies with the degree of specific, racial and family relationships, and with the health and absence of deformity, in the two individuals.[13]

Weininger's convoluted formulation merely indicates that attraction between men and women depends upon their masculinity or femininity, the amount of time they have known each other and their race, class and health. To express such an indefinable state in these terms could only contribute to the rigidity that characterized much thinking about sexual behaviour.

The theories of Ulrichs, Carpenter and Weininger were coloured by the differing motivations and biases of the writers concerned, but all three contributed to the growing awareness that the Darwinian polarization of men and women was not a wholly appropriate model. The idea of a third sex that combined the qualities of the other two created a receptive atmosphere for the appearance in art of gender ambiguity, which often served a specific theoretical or practical purpose. From the 1860s, European paintings began to include images of women and men whose gender qualities were indeterminate. The root of this tendency can be traced to the work of the English artist Dante Gabriel Rossetti, even though his own paintings unmistakably represented women. Rossetti's imaginative paintings of women, such as *Astarte Syriaca* (Figure 38),

were all based on familiar models, whom he used frequently. Although he himself painted these sensuous women to satisfy a market demand and keep up his income, he was inadvertently contributing to the later nineteenth-century fascination with androgyny. *Astarte Syriaca* represents Jane Morris, one of Rossetti's favourite models. Although Morris was reportedly kind and uncomplicated, Rossetti imposed upon her image the character of a heady, sensual and sexually threatening woman. According to one view of womanhood prevalent at the time, women had little or no sexual desire (see Chapter 6), but *Astarte* as exhibited by Rossetti could be interpreted as a desirous and demanding being. Rossetti, therefore, endowed his woman with qualities which were not normally associated with women at this time. Not only did he represent women as essentially 'unwomanly', but his repeated use of a few models gave many of his paintings a superficial similarity to each other. Jane Morris, for example, appeared in a number of classical and biblical guises. Although Rossetti repeated such themes largely in order to 'mass produce' his popular subjects for avid patrons, this repetition served to fuse his many images of women into one image. Thus, his women approached men in their appearance, and they began to become indistinguishable. Rather than painting 'women', Rossetti began to paint 'Woman', but 'Woman' which had at least some qualities normally associated with a man.

Rossetti's subjects were not explicitly androgynous, but some of his followers carried the implication of his innovations a step further. The most notable of these was the Belgian painter Fernand Khnopff, who, like Rossetti, used the same model for many of his works. Khnopff's painting I *Lock the Door Upon Myself* (1891, Munich, Bayerische Staatsgemäldesammlungen) was based on a poem by Rossetti's sister, Christina. Khnopff's strange treatment of the subject mirrored the poem's own obscurity, but he reinforced the poem's glorification of isolation:

> All others are outside myself;
> I lock the door and bar them out,
> The turmoil, tedium, gad-about.
>
> I lock the door upon myself,
> And bar them out; but who shall wall
> Self from myself, most loathed of all?[14]

The isolated figure in this case was based on Khnopff's sister, Marguerite, whose appearance in many of his works has led some art historians to suggest (without sufficient evidence) that he had an incestuous relationship with her. In reality, Marguerite became to Khnopff what Jane Morris was to Rossetti – an embodiment of an ideal. However, Khnopff went much further than Rossetti in stressing the androgynous qualities of his model. Although still primarily woman, Marguerite's sexuality is more ambiguous than that of Rossetti's models. Khnopff's fellow Belgian, Delville, isolated this feminized androgyny as the dominant quality of Khnopff's art:

> Khnopff has created a type of ideal woman. Are they really women? Are they not rather imaginary femininities? They partake, at the same time, of the Idol, of the Chimera, of the Sphinx and of the Saint. They are rather plastic androgynes, subtle symbols, conceived according to an abstract idea and rendered visible.[15]

Khnopff emphasized this abstraction particularly in his most famous painting, variously titled *L'Art*, *Des Caresses* and *Le Sphinx* (1896, Brussels, Musées Royaux des Beaux-Arts de Belgique), in which sexual ambiguity becomes outright androgyny. This painting plays upon the myth of Oedipus and the Sphinx, but rather than being the victorious solver of the Sphinx's riddle, this 'Oedipus' is a bewildered loser, who is subjected to the most overt sexual advances by the Sphinx. Marguerite makes her appearance again in the features of the Sphinx, which itself was a conglomerate of several different animals. The idea of fusion is one of the basic principles of androgyny, but here the Sphinx is not just a union of sexes, but also a union of man and beast. It is hardly surprising that the figure of the man is also androgynous.

So far, these images of 'unisexuality' are based primarily upon female models, but the theory of androgyny, as applied to works of art, rarely assumed such a female aspect. Even images ostensibly representing 'female' androgynes could in fact be metaphors of male anxiety, as was the case in Aubrey Beardsley's illustrations for Oscar Wilde's play *Salome*, in which the image of a sensual woman is transposed into an androgynous symbol of male identity crisis. The biblical character of Salome was a popular subject in nineteenth-century literature and art: her responsibility for the beheading of John the Baptist allowed writers and artists to play upon themes of violence and conflicts between sensuality and spirituality. In the Bible, Salome is the daughter of Herodias, who seeks revenge on John the Baptist when he preaches against her marriage to her brother-in-law, Herod. To convince Herod to kill John the Baptist, Herodias asks Salome to dance for her step-father and incite his lust. After the dance, Herod grants Salome anything she wants, and, on her mother's instruction, she asks for the head of John the Baptist on a platter. Flaubert's *Salammbô* and Mallarmé's poem 'Hérodiade' both used the character of Salome to express this sexuality and violence. As she appeared in art during the second half of the nineteenth century, the character of Salome was equivalent to the sexual anti-heroines of Rossetti's paintings, and like them, she assumed some qualities normally associated with men. This aspect of Salome's character was identified by the novelist J.-K. Huysmans, whose fictional Des Esseintes purchases Gustave Moreau's paintings of the biblical murderess. Des Esseintes's description of the paintings stresses those aspects that undercut Salome's femininity:

> Des Esseintes finally realized this Salome, superhuman and strange, of whom he had dreamed. She was no longer solely the dancer who, by a depraved twisting of her loins, tore a cry of desire from an old man; who broke in two the foundation of a King's will by the swirl of breasts, the shake of belly, the shudder of thigh; she became, in some manner, the symbolic Deity of indestructible Luxury, the goddess of immortal Hysteria, the cursed Beauty, . . . the monstrous, indifferent insensible, Beast, who, like Helen of Troy, poisons all that approach her, all that see her and all that touch her.[16]

Salome is both beautiful and monstrous; sexual and heartless.

When Oscar Wilde wrote his play *Salome* in 1891, he too stressed these qualities, but the conflicts between asceticism and lasciviousness and the idea of a powerful and destructive woman took on further implications. These subtexts are hinted at in Beardsley's strange illustrations for the play, which was denied a licence by the Lord Chamberlain, and was not performed until 1896, when it premiered in Paris. Beardsley's illustrations are full of androgynous figures who do not actually represent characters in the play (Figure 39), nor do they necessarily reflect Wilde's own perceptions of Salome. Beardsley's *J'ai baisé ta bouche* shows a masculinized

Salome revelling in the chance to kiss the severed head of John the Baptist, and his *Toilet of Salome* (Figure 40) includes a collection of androgynes who wait upon her. According to Eliot Gilbert, Beardsley's images were intended to expose Wilde's own ambivalent response to the roles of men and women in a patriarchal society.[17] By giving Salome masculine features and by desexualizing her servants, Beardsley alluded to the debates about unisexuality which were beginning to emerge in late Victorian society. Equally, he revealed Wilde's own place within these debates. Although when *Salome* was written, Wilde was a famous, if controversial, public figure, by the time it was first performed in Paris, his homosexuality had been publicly exposed, and he was languishing in Reading Gaol.

Attitudes to homosexuality in the late nineteenth century offer a partial explanation for the popularity of androgynous themes in art. Homosexuality certainly existed before the 1870s, but it was only then that the term began to be commonly used, and it was at first exclusively applied to male same-sex love. Although the issue of *male* homosexuality was beginning to be discussed openly, this sexual preference was still considered to be an abnormality and was often referred to in alarmist terms. Mantegazza's reaction was not untypical: 'Love between males,' he wrote, 'is one of the most terrifying facts to be met with in human psychology'.[18] Krafft-Ebing classified male prostitution as 'the darkest stain on the history of humanity', and Max Nordau's predictions of a futuristic nightmare included a provision for homosexuals to be legally married.[19] The overt horror expressed by these writers was partially the result of the popular equation of homosexuality with sodomy or pederasty. Sodomy was considered an act 'against nature' because – whether performed on men or women – it was directly contrary to the propagation of the species; it was often therefore represented as immoral, a flagrant violation of both human and religious laws:

> In urnings morally perverse and potent, quod erectionem, the sexual desire is satisfied by pederasty, an act, however, which is repugnant to perverted individuals that are not defective morally, much in the same way as it is to normal men.[20]

Some psychologists and sexologists argued against this emphasis on sodomy. Marc-André Raffalovich, for instance, listed everything that two men could do together, including platonic love, kissing like brothers, mutual masturbation and coitus without penetration (between the legs or the cheeks of the buttocks).[21] His purpose was to show that homosexual men were not confined to sodomy in their expressions of sexual affection – an assertion that was also defended by other writers in England and Germany.[22] However, these studies did little to dissipate popular prejudice about homosexuality, which was enhanced by the public exposure of Wilde's activities in 1895.

Ironically a greater openness about homosexuality stimulated greater legislation against all kinds of homosexual act. In Germany, article 175 criminalized any 'coupling against nature between men', which was a clear prohibition against sodomy.[23] In Britain, the 1885 Amendment to the Criminal Law Act stated that 'Any male person who, in public or private commits, or is party to the commission of, or procures or attempts to procure, the commission by any male person of any act of gross indecency with another male person, shall be guilty of a misdemeanour.'[24] The vagueness of the term 'gross indecency' was intended to allow policemen to be suspicious of any overt form of male affection. But greater vigilance about homosexuality preceded the passing of these laws, and one of the victims of this attentiveness was the

English artist Simeon Solomon, who was arrested in a public urinal in 1873. Solomon was accused of sodomy, but he escaped with a light sentence, as no specific act could be proven.

Solomon's arrest ruined his career as an artist, but long before he came under public suspicion, his paintings and drawings were filled with homosexual subtexts. These themes were inevitably embodied in the image of the androgyne. Like Khnopff, Solomon was inspired by the work of Rossetti, and equally like his Belgian counterpart, Solomon took Rossetti's example a step further. Influenced by his Jewish heritage, Solomon began producing scenes from the Old Testament, such as his drawing David Playing to King Saul (1859, Birmingham Museum and Art Gallery), but Solomon's interpretation of the Bible stressed the androgynous nature of the figures, rather than any sense of moral purpose normally characteristic of contemporary exhibition painting. Although Solomon's theme here was not overtly homosexual, his representation of David stressed sexual ambiguity, as the critic Arthur Symons noted:

> The same face, varied a little in mood, scarcely in feature, serves for Christ and the two Marys, for Sleep and for Lust. The lips are scarcely roughened to indicate a man, the throats scarcely lengthened to indicate a woman. These faces are without sex; they have brooded among ghosts of passions till they have become the ghosts of themselves; the energy of virtue or of sin has gone out of them, and they hang in space, dry rattling, the husks of desire.[25]

Solomon's watercolour Sappho and Erinna at the Garden of Mytelene (1864, London, Tate Gallery) has an explicitly homosexual theme, but given the historical justification of the subject, it cloaks, rather than highlights, this meaning. The fact that lesbian love was largely ignored at the time, and many did not believe in its existence, would have made such a subject doubly acceptable, despite its hidden implications.

Solomon did not confine his explorations of androgyny to art: in 1871 he published A Vision of Love Revealed in Sleep — an allegorical examination of love, in which his own soul appears as a woman. This work may seem innocuous to readers today, but he was forced to have it privately printed at the time, due to the subversive nature of its underlying theme. Equally, although many of his contemporaries felt that Solomon was an artist of immense ability, even positive comments were often coloured with some uneasiness about his use of androgynous figures. Robert Browning, for instance, confessed in a letter:

> Simeon Solomon invited me the other day to see his pictures, but I could not give the time: full of talent, they are too affected and effeminate. One great picture-show at the Academy — the old masters' exhibition, — ought to act as a tonic on these girlish boys and boyish girls, with their Heavenly Bridegrooms and such like.[26]

The use of androgynous figures in art allowed a tolerance for implicitly homosexual themes, but it did not entirely mask those themes. Androgyny thus became an acceptable code for homosexual expression, but it also came to be used to undermine the idea that homosexuality and sodomy were equivalent states. In fact, the use of androgyny in art became a means of expressing a new aesthetic and an idealist philosophy in which love between men was seen as a higher form of experience than heterosexual love. Although homosexuality was publicly considered both an aberration and a crime, writers and artists began to use the androgyne as a code for the exalted

nature of homosexual union. Through the image of the androgyne, a condition considered 'primitive' by Darwinian theorists was held to be the highest and most spiritual state of human existence. Through aesthetics, androgyny was stripped of all sexual connotations, and through mystical and occult theories, it was given a spiritual rationalization.

Solomon was one of the first artists to make use of androgyny as an aesthetic expression. His inspiration came from two sources: the work of the English writer Walter Pater, and the paintings of the early Renaissance, which he had seen when he visited Italy in 1867. Pater himself was fascinated by Renaissance painting, and through his *Studies in the Renaissance* (1873), he explored androgynous themes in the work of Leonardo da Vinci. Pater felt that the greatness of Leonardo's *Mona Lisa* and *St John the Baptist* (Figure 41) rested partly in their mysterious sexual ambiguity. His descriptions helped inspire a continued interest in early Renaissance art among English painters in the last quarter of the nineteenth century. Artists such as Burne-Jones could therefore exhibit paintings which deliberately represented androgynous figures, but these very figures could be explained by recourse to the influence of Italian painters, particularly Leonardo and Botticelli. Equally Gustave Moreau's early works, such as his *Oedipus and the Sphinx* (1864, New York, Museum of Modern Art), reveal his debt to early Renaissance painting, and also explored the implications of androgyny. Moreau's own notebooks make this association explicit. Claiming that the 'primitive' painting of the Early Renaissance is close to the modern soul, he continues:

> Look at the heads of the primitives, Giotto, Masaccio, Filippo Lippi, even Botticelli, who is a sensual painter, and you will understand to what extent these physiognomic expressions, these heads with character are made much more for the modern soul than the types created by Raphael, Correggio and Michelangelo. What gravity, what sadness, what mystery in nature, and (perhaps because of that) the ideal is not merely plastic . . . The Soul – that hyphen between man and God – this refound virginity is truly very beautiful.[27]

The relationship between androgyny and Italian Renaissance art was also stressed by the French novelist Joséphin Péladan and the German poet Hugo von Hofmannsthal. Through such a long association with the Renaissance, androgyny to an extent received a respectable art-historical justification.

Pater also studied the writings of the eighteenth-century historian, Johann Joachim Winckelmann, whose own homosexual yearnings were expressed in his descriptions of ancient Greek statues. In an essay on Winckelmann, Pater considered the idea of male beauty in ancient sculpture, and isolated what he felt to be its salient quality:

> The beauty of the Greek statues was a sexless beauty; the statues of the gods had the least traces of sex. Here, there is a moral sexlessness, a kind of impotence, an ineffectual wholeness of nature, yet with a divine beauty and significance of its own.[28]

Pater's emphasis is important. Like Symons's assessment of Solomon's paintings, Pater's description of Greek statues stressed their *sexlessness*. The nude male body was thus desexualized, and its beauty was seen to lie in its perfect form, rather than in its sensual associations. Following Pater's example, Carpenter also insisted on the sexlessness of ancient sculpture, but his argument had a much more obviously polemical purpose:

The whole vista of Greek statuary shows the male passion of beauty in a high degree. Yet though the statues of men and youths (by male sculptors) preponderate probably considerably, both in actual number and in devotedness of execution, over the statues of female figures, it is . . . remarkable that in all the range of the former there are hardly two or three that show a base or licentious expression, such as is not so very uncommon in the female statues.[29]

Carpenter was trying to undermine the common association of homosexuality with the act of sodomy, by suggesting that homosexual desire was really an aesthetic expression. But Carpenter's defence was undercut by a number of contemporary sexual case studies which equated the awakening of homosexual love with a viewing of nude male bodies. Havelock Ellis presented one such case study whose appreciation of men was primarily visual: 'Aesthetically, he thought them [women] far less beautiful than men. Statues and pictures of naked women had no attraction for him, while all objects of art which represented handsome males deeply stirred him.'[30] Another of Ellis's cases 'became familiar with pictures, admired the male figures of Indian martyrs, and the full, rich forms of the Antinous', and yet another turned himself into the very object he admired: 'His body is excessively smooth and white, the hips and buttocks rounded . . . He is much preoccupied with personal appearance and fond of admiration; on one occasion he was photographed naked as Bacchus.'[31] Such case studies served to undermine those apologists who claimed that the love of male nudity was an exalted and sexless admiration, but even the scientists admitted that many homosexuals had an 'artistic' temperament, or were admirers of music, painting and literature. Raffalovich, for example, distinguished homosexuals who had a genuine love of male beauty from those who had an obscene curiosity.[32]

Nevertheless, despite the best intentions, the use of male nudity in art – even when it appeared in the form of a sexless androgyne – aroused suspicion and misunderstanding. The English monthly magazine, The Artist, which later became The Artist and Journal of Home Culture, was only one of many publications that suffered from prejudices against homosexuality. It began as a progressive art journal, opposed to the monopoly of the Royal Academy, but by the late 1880s its articles, poems and polemics had thinly disguised homosexual themes. Certain reputedly homosexual individuals both past and present, including Oscar Wilde and Michelangelo, were given great prominence; poems about androgynous figures in sculpture and painting, such as Antinous and St Sebastian, and articles on male nudity and male beauty began to appear in every issue. For example, in 1891, an article called 'Art and Athletics' argued for the co-operation of artists and male athletes: according to this study, athletes should submit themselves to artists as free models, and the artist should not charge for the resulting painting, being content with the simple act of representing male beauty.[33] The pseudononymous author of the article claimed that this practice was common among the ancient Greeks, and indeed, the Greeks were frequently called upon to justify male love. One notable defence was an article entitled 'The New Chivalry', which was perhaps the most overt and assertive apology for male love in the journal. The article argued that in the past, men had been forced to have sexual relationships with women by a need to propagate the species. Now that Britain was as populous as its sometime enemies, France and Germany, it would be possible to turn away from such a 'practical' form of love and towards a more spiritual one – a 'new chivalry':

Wherefore just as the flower of the early and imperfect civilization was in what we may call the Old Chivalry, or the exaltation of the youthful feminine ideal, so the flower of the adult

and perfect civilization will be found in the New Chivalry or the exaltation of the youthful masculine idea . . . The New Chivalry then is also the new necessity. Happily it is already with us. The advanced – the more spiritual types of English manhood already look to beauty first. In the past the beauty has been conditioned and confined to such beauty as could be found in some fair being *capable of increasing the population*.[34]

The 'new chivalry' encompassed the attentions which older men bestowed upon younger boys. Like many defences of homosexuality, the stress was on the platonic aspect of the relationship, rather than the sexual one, which was dismissed as either disgusting or unnecessary.

This platonic emphasis is important for both the theory of androgyny and the ideal image of the androgyne in late nineteenth-century painting. From the time of the Renaissance, defenders of homosexual love had often used the evidence of Plato's dialogue, *The Symposium*, to prove that homosexuality was the highest form of love among the ancient Greeks. In the *Symposium*, Aristophanes, one of Socrates's guests at dinner, presents a theory of creation which suggests that human beings were once joined together. They were subsequently split in two, and thus all human beings wander around the universe looking for their 'other half'. The yearning for union of like souls was the basis of androgyny. Equally, Plato's *Symposium* suggested that the ideal love was a spiritual relationship between an older and younger man, in which the older man was the lover and the younger one the loved. The defence of male same-sex love was thus discussed in philosophical, mystical and idealist terms, which were borrowed by psychologists, novelists and artists to elevate the idea of homosexuality in the eyes of the public.

Krafft-Ebing was scornful of the possibilities of platonic love. He called it 'an impossibility, a self-deception, a false designation for related feelings', and he claimed that those who practised it did so 'with the risk, however, of becoming nervous (neurasthenic), and insane, as a result of this enforced abstinence'.[35] However, other 'scientific' writers were more sympathetic to the possibility. Albert Moll admitted that it was difficult to define platonic love, but acknowledged that it was something more than friendship and less than sexual activity.[36] Carpenter also took this attitude in his defence of homosexuality, and went further by claiming that male 'comradeship' would not only result in the democratic levelling of society, but that the love of men for other men engendered philanthropic and socially beneficial feelings.[37] Raffalovich was the most forthcoming in his assessment. Using literature as his defence and following Plato's ideas, he begins by allowing platonic love to have a 'physical' aspect:

The physical satisfaction of platonic love is the sharing of the bed of affection. In philosophical love, this physical intimacy allows all caresses except sexual ones; in honourable love, it allows the allurement of sexual pleasures, at long intervals, and as little as possible, and it is necessary that these pleasures are equally obtained, searched for, desired, dear, equally the expression, ill-chosen perhaps, of immaterial virtues and tenderness.[38]

However, he goes on to argue for the superiority of this form of affection. Distinguishing 'the great difference between platonic unisexual love and conjugal or chaste heterosexual love', Raffalovich claims:

The man who would like to shape the woman in accordance with his god, in accordance with him, will be a wretch and a madman. The woman cannot become a man morally,

intellectually, psychically. There is no point of sufficient place in heterosexual love for love of the similar ideal. It is there that uranism finds its superior, metaphysical explanation.[39]

Platonic union could be seen as an exalted form of human experience, superior in every way to heterosexual affinity.

In art, the glorification of platonic love reinforced the spiritual purity of ideal union, and in some cases, androgynous figures were used to stress this spirituality. One of the most notable examples is Delville's *School of Plato* (Figure 42), which shows a group of young, nude but androgynous men surrounding the great philosopher, who sits like a god on a throne to educate them. The association of Plato with androgyny was deliberate, although Delville's interpretation of platonic love was part of a larger mystical/idealist philosophy. Delville himself was a respected academic painter. He moved to Scotland to become Professor at the Glasgow School of Art from 1900 until 1907, when he returned to Brussels to become Professor of Design at the Académie des Beaux-Arts. Like Solomon and Burne-Jones, he admired the work of early Renaissance artists, but he carried that admiration beyond a simple appreciation of beauty by developing a system of art based on classical principles of order and harmony, advocated in his book *La Mission de l'art* (1900). Like Richard Wagner, whose music and philosophy he admired, Delville saw art as having a spiritual purpose, which would ultimately result in the regeneration of degenerate man (see Chapter 8). To Delville, beauty and order were the basis of art:

> All beauty is an expression of universal order. All ugliness expresses the disorder of life. That one speaks of 'classicism' or 'academicism', of what import! But when it transpires that the beauty of the form never enters the preoccupation of the artist, his work becomes confused and chaotic. And each time that the art separates itself from this conception of universal order, it degenerates. If the art of the ancient Greeks, after thousands of years, continues to amaze us and to dazzle us by its supreme eurythmics, it is that the architects, sculptors and painters penetrated a divine vision of the world, and that the men of State of this epic were disciples and philosophers.[40]

Delville believed that formal harmony in art encouraged social harmony, which he claimed was the highest public virtue.[41] He expressed these ideas in art through both his mystical themes and through the sexless figure of the androgyne, which represented to him an icon of spiritual purity and harmony. In Delville's art, Platonic philosophy was revived, and the ideal androgyne is removed from its associations with any kind of earthly love. Although homosexual sub-texts can still be read into Delville's paintings, he moved well beyond any earthly consideration to a more exalted spiritual one. Delville was a member of the Belgian exhibition society, the Salon de la Rose + Croix, which, between 1892 and 1898, showed paintings based upon similarly mystical or idealist philosophies, often with a religious text as well. Other exhibitors at the Salon, including William Degouve de Nuncques, also used the figure of the androgyne for similar purposes. Nuncques's *Angels in the Night* (1894, Otterlo, Rijksmuseum Kröller-Müller) is a particularly significant example, as angels were commonly considered to be spiritual and sexless.

As a representation of spiritual harmony, the androgyne not only had a precedent in the work of Plato, but also in both Indian philosophy and the Old Testament Book of Genesis. All of these factors contributed to the increasing appearance of the androgyne in art, as organizations such as the Salon de la Rose + Croix were interested in the application of

religious or occult ideas to art (see Chapter 7). In Hinduism, the gods Siva and Sakti were understood to be combined in the androgynous Ardhanarisvara, and Hindu philosophy interpreted androgyny as the union of opposite parts of the soul. A painting such as František Kupka's watercolour *Lotus Soul* (1898, Prague, Narodni Gallery) reveals this new interest in Eastern religion, combined with an understanding of the spiritual nature of the androgyne. Furthermore, in Jewish legend, the original Adam of Genesis was an androgynous being – a combination of heart and soul. The separation of Adam through the creation of Eve resulted in a divisive universe. This concept underlies one of Chagall's most interesting paintings, the *Homage to Apollinaire* (1911–12, Eindhoven, Van Abbemuseum). In the centre of the work, the figures of Adam and Eve (holding the apple) are represented as a single hermaphrodite. In the lower right-hand corner, Chagall acknowledges several poets and critics who had encouraged him in Paris: Guillaume Apollinaire, Herwarth Walden, Blaise Cendrars and Canudo. The names of each of these men can be read as a cipher for one of the four elements: the *aire* of Apollinaire; the *Wald* (German for wood/earth) of Walden the *cendres* (fire) of Cendrars and the *d'eau* (water) of Canudo.[42] This alludes to the Jewish idea that the four elements had originally been united, and this theme is reinforced by the fact that Eve does not emerge from Adam's rib, but shares a common body with him. In this painting, Chagall refers to the wisdom of the Cabbala, which takes the reunification of diverse elements into a single form as the goal of mankind. This reunification could only take place through the agency of love, which would act as a kind of spiritual alchemy to put an end to conflict and division.

Ironically, the spiritual image of the androgyne could be used to reinforce the divisions between men and women, and when the image moved away from being merely a veiled homosexual allusion and towards a defence of pure or platonic love, the 'maleness' of the androgyne often came to be emphasized above the 'femaleness'. This is most obviously the case in the fictional writings of Joséph Péladan, who called himself 'Joséphin' to stress his commitment to the androgynous cause. Péladan was associated with the artists of the Salon de la Rose + Croix, and like them, he advocated the idea of platonic love as the ultimate form of spiritual expression. However, despite his emphasis on spirituality, Péladan's controversial novels such as *Le Vice suprême*, were filled with characters who behaved in anything but a platonic way. To Péladan, the road to pure platonism was a transcendence of earthly sexual temptation, but he described that earthly temptation in graphic detail in order to underline his point. In its most extreme form, Péladan's theory was blatantly misogynistic, although his novel *L'Androgyne* (1891) adopted a more conventional interpretation of the subject:

> Esoterically, he [the androgyne] represents the initial state of man, which is identical to his final state. He assigns to him the principle of evolution and the secret of success . . . and this secret decodes itself easily through the word 'love' which, heraldically, consists in the rapprochement of the beard and the breast of androgynous passions The sphinx incarnates the complete theology with the solution of origins and finalities . . . The sphinx smiles at his divine enlightenment; he will reconstitute a day of his original unity, because he is man and god, in the same measure of involution and evolution.[43]

Péladan's emphasis on the sphinx complements a common artistic obsession at the time: painters such as Khnopff equally used the sphinx both to stress the spiritual significance of androgyny and to link that with religion and mysticism. However, unlike Khnopff, who presented

the sphinx in a female guise, Péladan's sphinx, like his androgyne, is identified as male through its masculine pronoun, 'il'. Péladan's reasons for emphasizing this association become clearer in his book *Le Gynandre* (1891), where he develops his theory of androgyny. A group of lesbians, who are derided for their false efforts at androgyny, are trained by a real androgyne, Tammuz, to worship the phallus. Tammuz makes the essential masculinity of the androgyne clear:

> The androgyne is the virginal adolescent male, still somewhat feminine, while the gynander can only be the woman who strives for male characteristics, the sexual usurper: the feminine aping the masculine . . . The first originates in the Bible and designates the initial stage of human development; the Graeco-Catholic tradition has consecrated its use, whereas I have taken the other from botany, and with it I baptise not the sodomite but any tendency on the part of woman to take on the role of man.[44]

Péladan recalled the Hebrew legend of Adam as the original androgyne, and claimed that the only return to androgyny would be through the purity and spirituality of male abstinence and chastity. Péladan put his ideas in apocalyptic terms by suggesting that the rediscovery of androgyny would herald the reign of the Holy Spirit and thus the millennium. Women were identified as a hindrance to this spiritual advancement.

Although not always as deliberately misogynist as Péladan, Raffalovich also denied women's role in platonic love. In his defence of homosexuality, Raffalovich claimed that the male 'invert' takes on more qualities of the woman than the female 'invert' does of the man. He justified this by recourse to some conventional beliefs about the characters of men and women:

> If he [the man] is capable of all the vices of woman, he is also capable of displaying her virtues . . . but his physical constitution gives him more strength; he is even more different than the woman because it is the intelligence that differentiates more than the feeling. The woman copies the man, reflects him more than she resembles him. One pretends that lesbians are not solely of virile demeanour, but also of virile character; it is an illusion rather than a reality.[45]

Raffalovich was not the only one to feel that women did not have the strength of character to take on a significant number of male attributes; Weininger also insisted upon this theory, to the point of asserting that the only way of understanding the psychology of a woman is through the explanations of homosexual men, because only *men* could sufficiently articulate their own psychological state.[46] The idea that women defined themselves psychologically in terms of men also underlay Freud's theory that women's neurosis could be explained by penis envy: the woman thus spends her life coping with the fact that she is not a man.

Freud's theories of human sexuality did not become established until after the turn of the century, but many of his ideas grew from the research of his predecessors and contemporaries. One of Freud's major contributions to the theory of sexuality was his attempt to explain the development of human character through sexual development, but his work also indicated the complexities that arose from the opening up of sexual study. Freud's androgyne was the baby, who was all id, or sensation, but who learned to differentiate itself sexually through experience. As the child developed an ego, so did it learn to think of itself as he or she. Confusions of identity at crucial early stages could result in later sexual 'abnormalities'. Freud's ultimate study was not sex, but identity.

Identity – especially male identity – is an issue which permeates the uses of androgyny at the

turn of the century. As psychologists and anthropologists were exposing the plethora of sexual possibilities through scientific study, traditionalists were emphasizing long-established clichés of masculinity. Even while the androgyne was becoming a significant image in art and literature, adventure novels and paintings of heroic classical gods were becoming increasingly popular. Men were being told to pursue the ideals of male love, even while they were being encouraged to develop military prowess and 'manly' self-denial. It is instructive here to examine the 'cures' for male homosexuality employed by psychologists such as Krafft-Ebing, who depended largely upon hypnotic suggestions to reinforce male heterosexual love. Krafft-Ebing's patients, under hypnosis, had to repeat assurances that they would not masturbate ('I can not, must not and will not masturbate again'; 'I abhor onanism, because it makes me sick and miserable'); that they would think of same-sex love as disgusting ('I abhor the love for my own sex, and shall never again think men handsome'; 'I no longer have inclination toward man; for love of men is against religion, nature and law'); and that they would fall in love with a nice, feminine woman and live happily ever after ('I shall and will become well again, fall in love with a virtuous woman, be happy, and make her happy'; 'I feel an inclination toward women; for woman is lovely and desirable, and created for man').[47] Krafft-Ebing's form of hypnotism stimulated what Carpenter called 'an overfed masculinity in the males'.[48] The type of man that Krafft-Ebing's hypnotism was trying to create was a conventionally masculine one.

 Such a divergence of role models indicates an uncertainty about male identity in Europe at the turn of the century, and representations of the androgyne to an extent attest to this confusion and conflict of interests. In central European art, this confusion and self-examination also manifested itself in the growth of Expressionist painting, which encouraged personal exploration. It is significant that Expressionist art in Germany and especially in Austria, continued to make use of the portrait, and the self-portrait, long after the genre had been marginalized by 'progressive' artists in other countries. The male self-portrait manifested the ultimate conflict in masculine gender identity, and although men did not often paint themselves as androgynes, the narcissistic obsessions that dominated the theories of androgyny were also characteristic of these works.

Ernst Ludwig Kirchner's *Self-Portrait as a Soldier* (1915, Oberlin College, Allen Memorial Art Museum), for example, was painted during the First World War. Kirchner presented himself in the 'masculine' role of a fighting man in military dress, with a cigarette dangling casually from his mouth. The image reinforced the masculine stereotype of a soldier that had long been a Prussian obsession and was certainly consolidated by the war itself. However, Kirchner did not fight in the war; in fact, his mental state made him unfit for active service. Therefore, the painting, which was produced when he was recuperating in an asylum, can be read as ironic. In what Harry Campbell referred to as an effeminate society,[49] the insistence upon vigorous masculinity could only create confusion, and Kirchner embodied that confusion in his own self-image.

The most notable artist to explore the theme of male identity was Egon Schiele, whose paintings and drawings were variations on the theme of himself. Schiele's *Self-Portrait Nude Facing Front* (Figure 43) and his *Self-Portrait Masturbating* (1911, Vienna, Albertina) are examples of how he used his own nude body to explore the problems of sexuality and self-expression. In each case, Schiele presented himself as ugly and painfully thin; in each case he displayed himself publically in a way which would otherwise have been considered private: he was showing off his sexuality, and exhibiting shame in the process. Schiele was a self-conscious individual, and through his letters, handwriting and paintings, he presented himself in a series of different guises. At times, he would foreground his own poverty; at other times, he would play the martyr. In these self-portraits he explored the idea of

shame, although his letters and life-style suggest that shame was not the most familiar feeling to him. In these works, he presented his nudity as deformity, and he admitted to masturbation – the root of all sexual abnormality, according to many contemporary psychologists. Schiele's self-portraits are the visual embodiment of Freud's emphasis on the 'inner self'; they are a session in psychoanalysis, but equally they are an admission of confusion. Schiele attempted to present his soul for the sake of the viewer, but the soul as seen through the body and through the body's sexuality. The androgyny in Schiele's self-portraits does not lie in homosexuality, nor in a desire for an ideal union of souls, but in his love-affair with himself. Like Rossetti's or Khnopff's monotonous use of the same models, Schiele used himself to represent an ideal.

The image of androgyny was multi-faceted and could just as easily embody the tensions between the sexes as it could stand as a metaphor for homosexual love. But in many cases, the uses of the androgyne in art – like the theories of unisexuality in science and literature – were based upon a *male* identity crisis that itself arose with the growing openness about sexuality. Social attitudes contributed to the construction of an ideal masculine identity, but the models of literature and art served to undercut these constructions and offer different options in their place. The crisis in male identity was due in no small part to the changing role of women in society, and it is that new role, and the images which it engendered, which will be explored in the next chapter.

NOTES

1. Havelock Ellis and John Addington Symonds, *Studies in the Psychology of Sex, Volume I: Sexual Inversion* (London, 1897), x.
2. Richard von Krafft-Ebing, *Psychopathia Sexualis*, Eng. trans. (Philadelphia and London, 1892), 1.
3. James Ashcroft Noble, 'The Fiction of Sexuality', *Contemporary Review* (April 1895), 494.
4. Herbert Spencer, *The Principles of Sociology*, 3 vols. (London, 1876–96).
5. Paolo Mantegazza, *The Art of Taking a Wife*, Eng. trans. (London, 1894), 161.
6. Harry Campbell, *Differences in the Nervous Organization of Man and Woman* (London, 1891), 33.
7. Patrick Geddes and J. Arthur Thomson, *The Evolution of Sex* (London, 1898), 267.
8. Ibid., 78.
9. Thomas Laquer, *Making Sex: Body and Gender from the Greeks to Freud* (Cambridge, MA, 1990).
10. See Ellis and Krafft-Ebing, cited above.
11. An English summary of Ulrichs's theory is given in the Appendix of Edward Carpenter, *The Intermediate Sex: A Study of Some Transitional Types of Men and Women* (London, 1908).
12. Carpenter, *Intermediate Sex*, 10, and his *Love's Coming of Age* (Manchester, 1890).
13. Otto Weininger, *Sex and Character*, Eng. trans. (London, 1906), 37–8.
14. Christina Rossetti, 'Who Shall Deliver Me?', in *The Poetical Works of Christina Rossetti* (London, 1904), 238.
15. Jean Delville, from *Annuaire de l'Académie* (Brussels, 1921), 19, quoted in Jeffery W. Howe, *The Symbolist Art of Fernand Khnopff* (Ann Arbor, 1982), 48.
16. J.-K. Huysmans, *A Rebours* (Paris, 1978), 106.
17. Elliot Gilbert, ' ''Tumult of Images'': Wilde, Beardsley and *Salome*', *Victorian Studies*, 26, no. 2 (Winter 1983), 135–59.
18. Paolo Mantegazza, *The Sexual Relations of Mankind* (1885), Eng. trans. (New York, 1935), 85.
19. Krafft-Ebing, 418, and Max Nordau, *Degeneration*, Eng. trans. (London, 1895), 538–9.
20. Krafft-Ebing, 229.
21. Marc-André Raffalovich, *Uranisme et unisexualité* (Paris, 1896), 119–20.
22. See Ellis, and also Albert Moll, *Les Perversions de l'instinct génital*, French trans. of *Die conträre Sexualempfindung* (1891) (Paris, 1893); subsequent references are to the French edition.
23. Moll, 292.
24. Quoted in Jeffrey Weeks, *Coming Out: Homosexual Politics in Britain from the Nineteenth Century to the Present* (London, 1977), 14.
25. Arthur Symons, *Studies in Seven Arts* (London, 1906), 61.
26. Edward McAleer, ed., *Dearest Isa, Robert Browning's Letters to Isabella Blagden* (Austin, 1951), 331 (letter of 24 February 1870).
27. From Gustave Moreau's Notebooks, which are located in the Moreau Museum, Paris; quoted in Julius Kaplan, *The Art of Gustave Moreau* (Ann Arbor, 1972), 14.
28. Walter Pater, 'Winckelmann', in *Studies in the History of the Renaissance* (London, 1873), 194.
29. Edward Carpenter, *Homogenic Love, and its Place in a Free Society* (Manchester, 1894), 11.
30. Ellis, 60.
31. Ibid., 64, 76.
32. Raffalovich, 182. See also Carpenter, *Intermediate*; Krafft-Ebing; Moll, 83.
33. Harmodius, 'Art and Athletics', *The Artist and Journal of Home Culture* (1 October 1891), 291–3.

34. P.C., 'The New Chivalry', *The Artist and Journal of Home Culture* (2 April 1894), 102–4.
35. Krafft-Ebing, 12, 229.
36. Moll, 110–11.
37. See especially Carpenter, *Love's Coming*.
38. See Raffalovich, 127.
39. Ibid., 107.
40. These are manuscript notes for the book, quoted by Olivier Delville, *Jean Delville, peintre* 1867–1953 (Brussels, 1984), 41–3. The full text of Delville's treatise is published in English: *The New Mission of Art*, Eng. trans. (London, 1910).
41. Jean Delville, *New Mission*, 122.
42. Susan Compton, *Chagall*, exhibition catalogue, Royal Academy of Arts (London, 1985).
43. Joséphin Péladan, L'*Androgyne* (Paris, 1910), 16–17.
44. Joséphin Péladan, *Le Gynandre* (Paris, 1891), quoted in Howe, 219 (translation mine).
45. Raffalovich, *Perversions*, 216–17.
46. Krafft-Ebing, 85.
47. Ibid., 327, 329, 341.
48. Carpenter, *Love's Coming*, 74.
49. Campbell, 47.

CHAPTER 6
ICONS OF
WOMANHOOD

The crisis of male identity which stimulated the popularity of androgynous images in art was matched by, and indeed, was partly the result of, a concomitant change in perceptions of female identity. The important attention given recently to the long and difficult campaign for women's suffrage has highlighted the fact that women were beginning to make their mark on society, despite the almost insurmountable obstacles that were put in their way. The 'New Woman' – in effect a creation of English literature – embodied the growing freedoms that women were gaining. Although some of these new freedoms (such as smoking and riding bicycles) may seem rather trivial to us, the fact that women were controlling their own property, attending universities (although often not able to take degrees) and participating in local politics represented a major shift of their position in society. The 1890s was a period of transition and disruption for women, and attitudes about women, which appeared in journalism, literature and art, inevitably gravitated towards the extreme ends of a complex debate. Even while women were improving their position in society, scientists were using Darwinian theory to prove that women were stupid, or evil, or passive. The issue of womanhood had entered the public forum, and polemicists on both sides of the 'woman question' used any means at their disposal to assert the 'truth' of their ideas.

Within this often heated debate, art had the dubious role of fixing images of women in the public mind. In a period in which any representation of women was loaded with connotations, artists could play upon contemporary ideas, or their works could participate in reinforcing those ideas. In this respect, art could be a dangerous weapon for consolidating negative stereotypes of women, but equally (although less often), it could present a more positive facet of womanhood. Generally, each work of art appeared to present a single, unambiguous image which defined and circumscribed the role of women in terms of mythological or biblical characters. Some recent authors have attempted to read all representations of women in the later nineteenth century as a manifestation of misogyny: according to these historians, no matter who the artist was, or in what guise he (or even she!) presented a woman, the representations evinced male hatred or fear.[1] Although this misogyny cannot be denied, the representations of women in the late nineteenth century are actually more complex than these authors suggest. If the prolific images of women are compared with each other, it becomes apparent that there were many different attitudes towards women embodied in art, and that these stereotypes were often mutually exclusive. The icons of womanhood in *fin de siècle* art do not add up to a single image of woman but, as Valeria Babini has indicated, they present a collage of opinion, misunderstanding and fear.[2] It is important to consider different ideas about woman in the late nineteenth century to understand how such attitudes were encoded in art, and how these often contradictory icons merely added to the confusion that suffused the current crisis in female identity.

One of the most famous 'icons of womanhood' of the *fin de siècle*, John Singer Sargent's portrait of the actress Ellen Terry as Lady Macbeth (1889, London, Tate Gallery), demonstrates the strength of this ambiguity. Sargent's portrait emphasizes the evil power of the Lady Macbeth who 'unsex'd' herself in order to encourage her husband's fatal ambition. The portrait, in effect, shows us the new 'strong' woman that men were beginning to fear or dislike, a hidden text that was made obvious by a *Punch* cartoon showing Terry as Lady Macbeth with large metal chains around her neck and weights over her arms, lifting a steel bar above her head. The caption to this engraving, 'Athletics. Strong woman performing her *tour de force*' makes the link between Lady Macbeth and the athletically minded 'new woman' explicit.[3] However, an earlier article in *Punch* and an earlier study by Sargent both indicate a rather different approach to Terry's performance. Far from playing Lady Macbeth as a frightening powerhouse, Terry repeatedly emphasized her devotion to her husband:

> Miss Ellen Terry's reasoning about her impersonation of *Lady Macbeth* seems to have been this – 'The grim Tragedy Queen with whom we have been accustomed to associate *Lady Macbeth*, could never have been the woman to whom Macbeth was so devoted that he writes to her whenever he has a moment's leisure'.[4]

The domesticity of Terry's Lady Macbeth is, to an extent, confirmed by Sargent's original oil study for the painting, which shows Lady Macbeth rushing out of Duncan's castle to welcome her husband as he arrives. The contradictions between the final artistic representation and the reality of Terry's performance suggest that Sargent was deliberately creating an image of Terry that corresponded with prevailing ideas about womanhood. He was not showing the actress in a character as she performed it, but he allowed one prevailing female stereotype to subsume the personality and performance of the actress. The complexity of significance behind this portrait can be matched by many other paintings of women in the same period.

Confusion about women's role in society was ubiquitous. In terms of education and the fight for suffrage, the 'woman question' was becoming a public issue, but even while women were gaining ground, attitudes of dismayed scepticism flourished. The idea that women were incapable of undergoing the 'ordeal' of education was prevalent. Nietzsche said, 'When a woman has scholarly inclinations there is usually something wrong with her sexuality',[5] and Mantegazza, who admitted to having female literary friends, nevertheless claimed,

> The only people who dedicate themselves to higher learning in one way or another are the ugly, hysterical, or very poor . . . Look around without leaving Italy and tell me how many *normal* women, how many healthy and perfect women, there are in our literary circle.[6]

Education was felt to destroy women's ability to have children, and to intensify the possibility of nervous disorders. Even when women's superior exam performance became an uncontestable fact, the biologist Harry Campbell in 1891 could use this as evidence that women were capable only of memorizing and could not aspire to the exalted realms of abstract thinking:

> The . . . reasons enumerated appear to show that the fact of women standing as well as, or higher than, men in examination lists is not inconsistent with their intellectual inferiority.[7]

Women's desire for suffrage met with even greater opposition. Alarmists predicted that the rise of women's power would result in the collapse of social order, and because of the intensifying militancy of the suffrage movement, many felt that women would naturally advocate socialism or even anarchy. In countries such as France, where republican sympathies were challenging the long hegemony of Catholicism and monarchism, anti-suffragists claimed that women would support the return of Catholic domination, thus reinforcing the power of the élite and the Church.[8] The emotive, even hysterical, terms in which such arguments were made indicate desperation and manipulation on the part of their authors. If women gained political power, one writer argued, 'the whole of the States, governed by ultramontane ministers (under Roman rule), would combine to form one power, which would be sufficient to ensure the gradual triumph of papacy over the whole earth'.[9]

The 'New Woman' was seen as an aberration. Even the supposedly enlightened writer Edward Carpenter described the modern woman as essentially un-womanly: she was indifferent to men, 'brain-cultured', bored with children and inclined to lesbianism.[10] Similar judgements were put forth by the Italian criminologist, Cesare Lombroso, whose classification of the 'criminal woman', not coincidentally, matches many qualities normally associated with emancipated women:

> In general the moral physiognomy of the born female criminal approximates strongly to that of the male. The atavistic diminution of secondary sexual characteristics which is to be observed in the anthropology of the subject, shows itself once again in the psychology of the female criminal, who is excessively erotic, weak in maternal feeling, inclined to dissipation, astute and audacious, and dominates weaker beings sometimes by suggestion, at others by muscular force; while her love of violent exercise, her vices, and even her dress, increase her resemblance to the sterner sex.[11]

The implication of a link between criminality and emancipation would not have been lost on Lombroso's readers, despite the fact that this judgement is submerged in his ostensibly 'objective' scientific study. Otto Weininger claimed that women's emancipation was a misguided movement consisting of a few strong-minded women 'with masculine dispositions' who started a 'fashion'. The majority of women (whom Weininger judged as weak and imitative) then followed this fashion, without having the intelligence or the discrimination to realise that they were incapable of carrying its implications through.[12]

Such judgements of women proliferated in the second half of the nineteenth century, but the prevalence of contrasting opinions has been ignored by many historians of the period. Even while Lombroso was equating emancipation with criminality, and Weininger was attributing it to female stupidity, a (male) writer in the *Contemporary Review* saw women's new role as a stamp of progress:

> Women especially seem to be changed for the better. Freedom to live their own lives, and the enfranchisement of their faculties in a liberal education, which, physically put, means the development of their brains and nerves, so far from making women more whimsical or languorous, seems not only to have given them new charms and fresher and wider interests in life, but also to have promoted in them a more rapid and continuous flow of nervous spirits, and to have warmed and animated them with a new vitality, both of body and mind.[13]

Views of women's inferiority were widespread, but not inevitable; even those who advocated such theories showed an overt fascination with women and their place in modern society.

32 Gustave Doré, *Over London by Rail*

33 Gustave Doré, *The Devil's Acre, Westminster*

34 Umberto Boccioni, *The City Rises*, 1911,
Collection Jesi, Milan

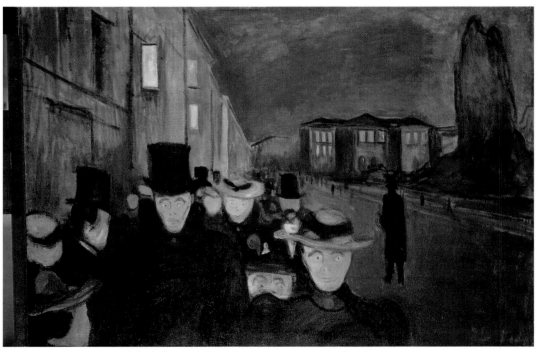

35 Edvard Munch, *Spring Evening in Karl-Johann Street*,
Oslo, 1892, Bildegalerie, Bergen

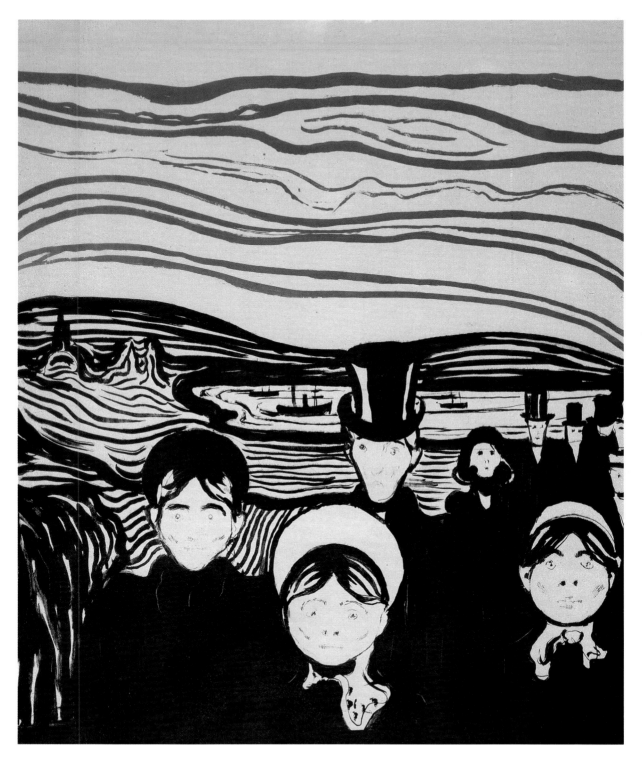

36 Edvard Munch, *Anxiety*, Christie's, London

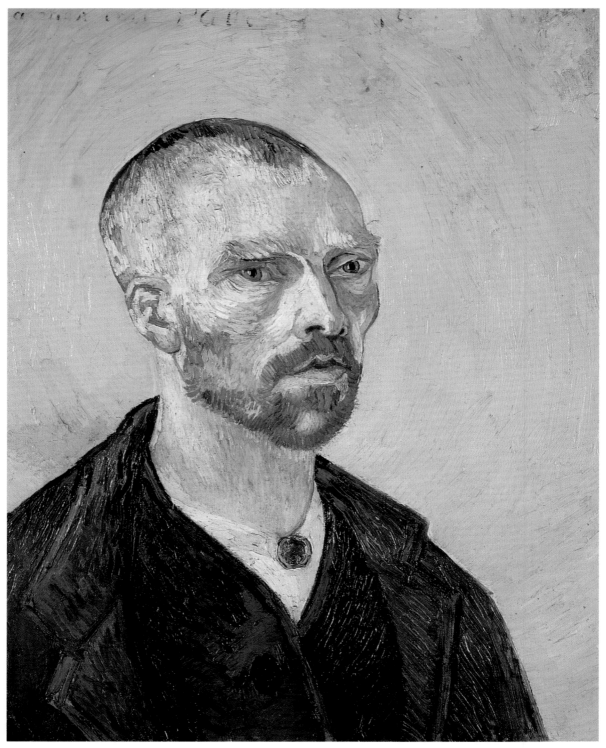

37 Vincent van Gogh, *Self Portrait*, 1888, Fogg Art Museum, Harvard University, Cambridge, MA

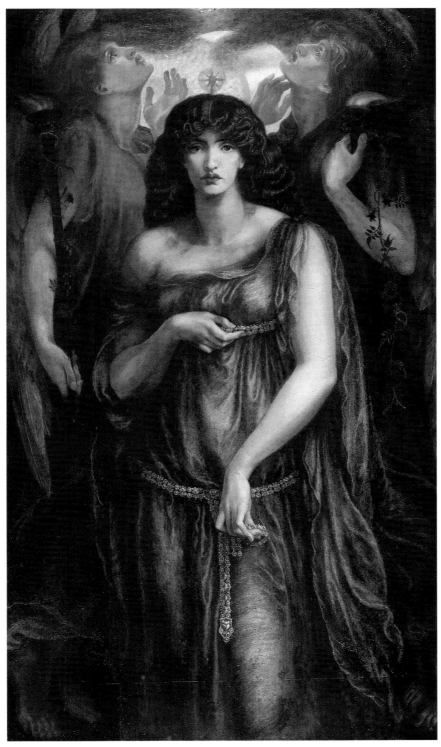

38 Dante Gabriel Rossetti, *Astarte Syriaca*, 1877, Manchester City Art Gallery

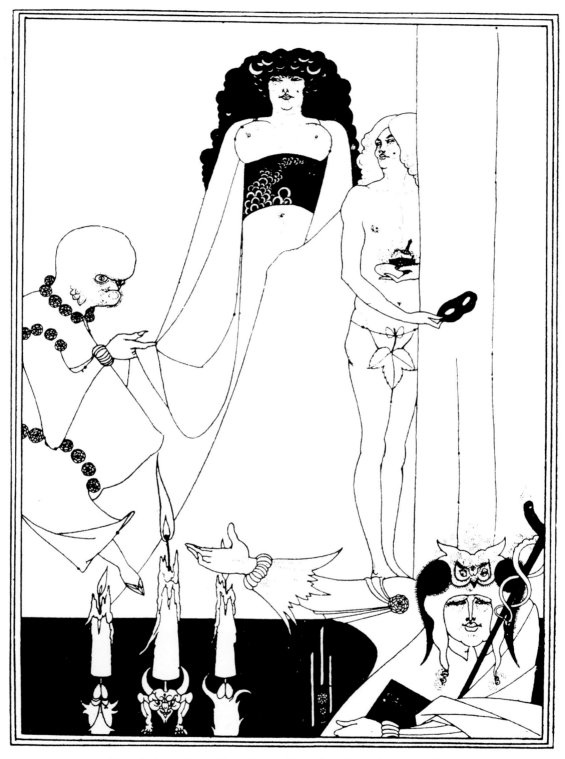

39 Aubrey Beardsley, 'Enter Herodias' from *Salome*, 1894

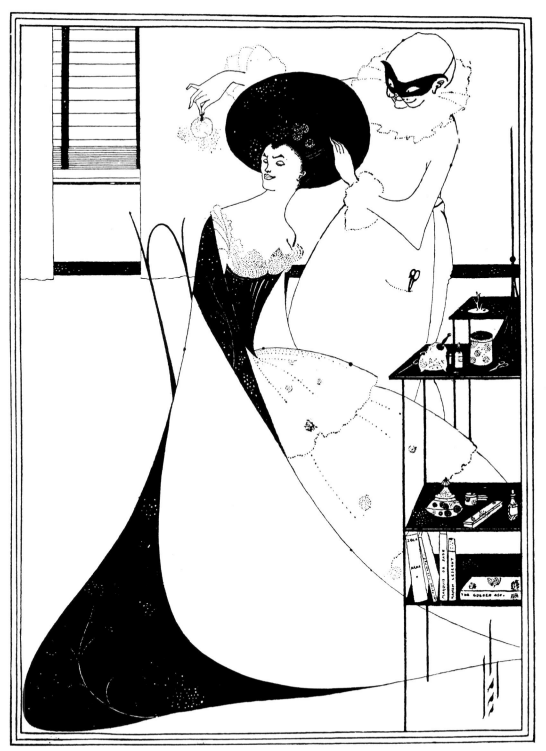

40 Aubrey Beardsley, 'The Toilet of Salome' from *Salome*, 1894

41 Leonardo da Vinci, *St John the Baptist*, 1509,
Louvre, Paris

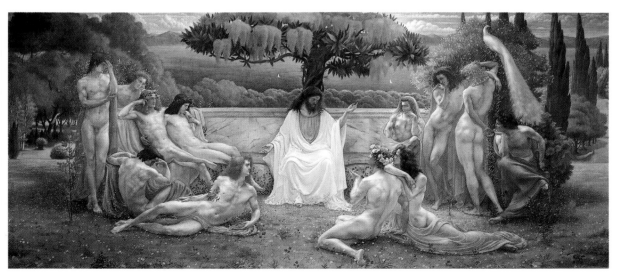

42 Jean Delville, *The School of Plato*, 1898,
Musee d'Orsay, Paris

Artists who contributed to the construction of these images of womanhood also revealed confusions. By forcing women to fit a series of painterly roles, artists presented what appeared to be monolithic icons which often reinforced prevailing stereotypes. However, the need to represent women, and to circumscribe them in this way, resulted in an over-simplification which obscured the more complex reality. For example, Dante Gabriel Rossetti painted numerous images of his lover, and later wife, Elizabeth Siddal as melancholy, languorous and passive (Figure 17). According to contemporary accounts, Siddal was actually high-spirited and a practical joker, attributes which are obscured in Rossetti's pictorial recreation of her.[14] The confusions between art and life could result in descriptions of women in terms of painting, and particularly Pre-Raphaelite painting; one of Munch's favourite models, Dagny Przbyszewsky, was described in such a way and compared to figures in the work of Botticelli and Leonardo, and Maria Delville, wife of the Belgian painter, was said to look like a model out of a painting by Rossetti or Burne-Jones.[15] The women themselves were lost within the image.

The diverse images of women which emerged during the period of increasing emancipation can be classified, but with reservations. Women, as seen in art, tended to fall into the categories of passive, sexual, evil[16] or maternal, and these same divisions functioned in the debates for and against female equality. However, such divisions should not be accepted uncritically. Artists were certainly responding to contemporary attitudes, and were presenting what appear to be unambiguous responses. Taken together, these images merely reinforce the prevailing confusion, and often contradiction, that permeated critical debate about women in the last years of the nineteenth century and the early years of the twentieth. Artists also wrapped up their images of women in the visual language of classical culture or biblical anecdote. Although artists since the Renaissance had been painting scenes of Medusa, Leda and the Swan, Judith and Holofernes and Salome, the use of such themes in nineteenth-century art has been interpreted in terms of sexual politics. Certainly, each work of art must be understood within the context of its own time, but there is a danger of disregarding the importance of artistic tradition, the demands of the market-place and the simple tendency to imitate. All of these factors affected artists and were responsible for the icons of womanhood which emerged.

The idea that women were passive and languid was a commonly repeated tag of Darwinian theory. Their passivity was seen to emerge from the fact that they were 'anabolic' beings, rather than 'katabolic' ones, and this differentiation was interpreted as a necessary stage in evolution. Women's anabolic nature prepared them for the tiring role of motherhood and gave them greater potential to recover from disease:

> The fact that women bear rest well, and also rapidly store up energy, *i.e.*, increase in weight, enables us frequently to produce striking effects merely by putting them to bed and feeding them up.[17]

Women were defined in terms of men, and were seen to be helpless and purposeless outside their relationships with men. George Elgar Hicks's excruciating trilogy of paintings, *Woman's Mission* (1860s, London, Tate Gallery), represents the ideal woman as *Guide to Childhood*, *Companion to Manhood* and *Comfort of Old Age* – all of which define woman solely in terms of her relationship with others. Although women were obviously seen as a necessary support for men, they were also believed to be hopelessly dependent on them. In this respect, they were compared to children. According to Harry Campbell, and later August Strindberg, women were lacking in will-power, imitative, highly

emotional, had short attention spans, were incapable of thinking abstractly, wanted sympathy, lacked courage, were dependent, liked animals, had active imaginations and told many lies – just like children.[18] Even the positive qualities of children – such as intuition – were attributed to women only with reservation or in terms of their relationship with men. One theorist argued that women's intuition resulted from their instinct for survival in primitive society: 'those who were quickest to detect the signs of rising wrath in their husbands . . . would escape the vengeful blow which dashed out the brains of the stupider woman.'[19] Darwinians acknowledged the fact that primitive women had had a greater role in the working life of society, but postulated that 'progress' meant that they no longer had to work. Although medical men and psychologists worried about the detrimental effect of the passive and indoor lifestyle of many middle-class women, they reinforced such a lifestyle by their continued insistence that women were physiologically incapable of action. The stereotype of passivity easily merged into the label of 'languid'.

Passive and languid women were also common subjects in European art in the second half of the nineteenth century, but usually these images were justified by the painting's subject. Works such as Alma Tadema's In the Tepidarium (Figure 44) show women in a state of leisure, reclining, or sleeping. Such paintings were very common in England, where women would share the canvas space with flowers, plants, feathers or other heady symbols which reinforced the general feeling of ennui in the works. It would be simplistic to suggest that artists were indoctrinated with the Darwinian clichés of the late nineteenth century, and that their paintings were little more than illustrations of scientific prejudices. Indeed, depictions of passive women had a long artistic genesis, and more than one artist was influenced by Italian Renaissance paintings such as Titian's Venus of Urbino. However, the reception of such images was undoubtedly facilitated by the proliferation of Darwinian theories, and the images themselves were often thinly disguised erotica which played upon contemporary beliefs for their effect. Tadema's Tepidarium is hardly an innocent work. The languid woman prepares to scrape herself clean with a strigil, and although these details could be justified by recourse to their 'archaeological' accuracy, the moist gleam of the woman's skin, and the comically phallic shape of the strigil itself, turn a 'historical' subject into an erotic one.

Many images of passivity thus transformed women into erotic objects presenting themselves for the gaze of male viewers, even while such works ostensibly reinforced the theory that women were sexless beings. Campbell's contention that 'there is not the slightest doubt that a large proportion of women do not experience the slightest desire before marriage'[20] was commonly affirmed in contemporary scientific literature. The idea that men had a large sexual appetite which women did not share led some writers to assert that female indifference to sex was a necessary component of civilized society: as Krafft-Ebing put it, 'If she [a woman] is normally developed mentally, and well bred, her sexual desire is small. If this were not so the whole world would become a brothel.'[21] Women's passivity was seen to be coextensive with their sexual frigidity. Although perceived to be without sexual desire themselves, nude women posed in a languid or passive way could be made the objects of sexual desire. By this means, even respected academic painting could contain barely disguised erotic undertones.

However, although some scientists, psychologists and polemicists argued that women were totally without sexual passion, others paradoxically contended that women were nothing but sexuality – that their lives were ruled by their sexual instincts. Just as paintings such as Tadema's Tepidarium could turn the sexually passive woman into an erotic object, so Giovanni Segantini's The Punishment of Lasciviousness (Figure 45) could de-eroticize women by showing them as sexually active beings. Segantini's women are subjected to a punishment not unlike those meted out in Dante's

Inferno: they are floating endlessly in an arctic landscape in atonement for their lustful desires. The frigidity and aridity of their surroundings offers a contrast to the sybaritic nature of their crimes. Segantini, like Krafft-Ebing, obviously saw women's sexual desire as potentially dangerous and destructive. In addition to the destructive nature of female sexuality, psychologists and doctors stressed the connection between the female body and nervous disease: conditions such as neurosis, hysteria, migraine headaches, even epilepsy were seen to be the result of malfunctions in women's ovaries, clitoris or menstrual cycle. The increase in sexual 'examinations' during the second part of the nineteenth century, and the occasional use of such operations as clitor- idectomy and ovariotomy indicated the attentions that were beginning to be paid to women's internal functioning. As several recent writers have pointed out, doctors began to concentrate disproportionately on the sex organs of women to explain conditions which were more within the domain of psychology.[22]

The relationship between women's psychology, sexuality and disease can be seen in Edvard Munch's *Puberty* (*c* 1893, Oslo, National Gallery), which highlighted an important theme in contemporary scientific literature about sex. Psychologists and anthropologists stressed the essential place of puberty in a woman's life, and Mantegazza studied the puberty rituals in primitive societies to indicate the importance of this time of life to the process of birth.[23] However, Weininger dismissed the importance of puberty to men, seeing it rather in terms of women's psychology:

> [The woman] is not disturbed by the onset of puberty . . . The male, as a youth, has no
> longing for the onset of sexual maturity; the female, from the time when she is still quite a
> young girl, looks forward to that time as one from which everything is to be expected.[24]

If women were considered totally sexual beings, their period of fertility could be seen as the most important one in their lives; indeed, Mantegazza claimed that a woman after the age of 45 or 50 'is no longer a woman, and the reproductive faculty is entirely destroyed'.[25] But far from stressing the joys of puberty asserted by Weininger, or the welcome inevitability of reproduction stressed by Mantegazza, puberty in Munch's painting is shown accompanied by anxiety, shame and fear. He represented an adolescent girl naked and vulnerable, her posture defensive and protective. She does not welcome the onset of puberty and sexuality, but fears it, as one would fear an illness. Indeed, Munch's vision of the anxieties surrounding sex are not unrelated to his paintings of sickrooms and the tensions which accompany disease and death. Puberty might be the onset of a woman's fertile years, but according to some contemporary ideas about sexuality, it also heralded a period of possible anxiety and neurosis.

The association of women's sexuality with disease took several different forms. Middle-class women were seen to develop menstrual and nervous problems because of their inactivity, and the indoor life recommended by so many doctors was felt to encourage such disorders. On the other hand, working-class women – especially prostitutes – came to be associated with the widespread malady of syphilis. The unbridled sexuality of prostitutes was seen to be the breeding-ground of disease, and in England the Contagious Diseases Acts of 1864, 1866 and 1869 regulated prostitution by forcing women suspected of soliciting to undergo medical examination and rehabilitation. In Italy, Lombroso distinguished between 'female offenders' who were criminal and those who were prostitutes, seeing the latter as a more 'natural' category of criminality for women to fall into: 'they [prostitutes] show fewer of the anomalies which

produce ugliness'.[26] But despite Lombroso's insistence that 'beautiful' criminals tended to be prostitutes, others emphasized the association of prostitution with the ugliness of syphilitic scars. Félicien Rops's *Mors Syphilitica* (private collection) made this connection explicit by allegorizing syphilis as a woman/skeleton carrying the scythe of the grim reaper. Despite the obvious contribution of men to the spread of venereal disease, women were seen to be the carriers of it, and the manifestation of the disease itself: among the icons of womanhood, sexuality and sickness were often partnered.

Just as the image of the passive woman could become an erotic object, so the image of the sexual woman could be manipulated for erotic purposes, and in this respect, Félicien Rops also contributed to the prevailing stereotypes of woman's sexuality. Rops's drawings of women could be considered pornographic, and indeed many of them today are still in inaccessible private collections. Unlike artists such as Tadema who concealed eroticism in the guise of a classical subject, Rops intended to glorify the nudity of modern woman:

> For studies of the modern nude, it is not necessary to make the classical nude, but indeed the nude of today, which has its particular character and form resembling no other. It is not necessary to make the breast of the Venus de Milo, rather the breast of Tata [a contemporary prostitute], which is less beautiful, but is more the breast of the day.[27]

By showing 'modern' nudity, rather than idealizing or disguising it within a fictional subject, Rops was challenging the conventions of academic art, but he was equally repeating the belief that women were sexual beings. The pornographic nature of his images of woman is reinforced by his drawing *Pornokrates* (private collection), which represents the spirit of pornography, a blindfolded woman with a pet pig on a lead. The growing market for pornography was later exploited by Schiele, who had a captive audience for his drawings of nude pubescent girls, and whose pornographic drawings were partly responsible for his arrest for indecency in Neulenbach in 1912. His watercolour *Nude Black-Haired Girl* (1911, Vienna, Albertina) drew its effect from the combination of the undeveloped sexuality of the model, and her knowing, even inviting, gaze. The pornographic nature of this drawing can be shown further by comparing it to a painting by a female artist, Paula Modersohn-Becker, whose charcoal and paste *Standing Girl* (1900/1906, Bremen, Ludwig-Roselius Sammlung, Böttcherstrasse) is another adolescent with prominent genitalia. Modersohn-Becker does not provide a contrast between nudity and expression, and her work thus appears to be a less problematic study than that of Schiele. Pornography was effectively confined to the depiction of the female body, as male nudity was more frequently idealized. Again, the woman became an embodiment of sexuality and hence a delight to the lascivious male gaze.

In 1907, Edouard Fuchs's *Geschichte der erotischen Kunst* brought the issues of erotic and pornographic imagery into the public forum. Fuchs's book is a curious mixture of long-winded Marxist rhetoric and sumptuous illustrations of erotic art past and present. The publication of this book indicates that the subject of erotic art had finally become open enough to earn such a major study, but Fuchs's approach reveals that erotica could be viewed as much for what it represented as for its own sake. To him, sensuality (*Sinnlichkeit*) was the highest and noblest purpose of art, whose ultimate aim was to delight, rather than to instruct. However, he significantly distinguished between 'good' erotica and 'perverted' erotica, and confined erotica to normal sexual activities performed by husband and wife.[28] Fuchs cast this argument into a Marxist perspective: periods in which erotica were 'healthy' were those of equality and peace,

whereas those periods in which erotica were 'perverted' were those of class strife and tension. Through his analysis, erotic art came to be read as historical documentation.

Fuchs's attacks on prudery and his (relatively) balanced approach to the subject of erotica were not shared by those who saw the pornographic representations of women as symptoms of social degeneracy. Max Nordau, among others, attacked writers and artists who were disproportionately interested in women and sex,[29] although the women themselves were often treated as incitements to sexual desire. This idea that the woman – by her very existence – was inciting men to sexual desire led many who were opposed to women's equality to represent women as evil and insatiable creatures. The icons of the 'evil woman' were among the most prevalent in art of the *fin de siècle*, for they are often the most arresting images. They certainly support a view commonly held today, that men at the end of the nineteenth century were afraid of women and that they saw women as 'the enemy'. Although such an attitude was not all-encompassing, it was certainly one of many approaches to the 'woman question', and it is worth considering the 'evil woman' and her image in art to see how that attitude was manifested.

In the last years of the nineteenth century and the early years of the twentieth, paintings exhibited throughout Europe began more and more frequently to represent women from mythology, the Bible and history. However, if a survey is made of these subjects – which includes Salome, Judith, Eve, Medusa, the Sphinx, Circe and Medea – it becomes apparent that the most popular female subjects were not the most pleasant of historical examples (Figure 46). Within the European academy system, artists were encouraged to paint 'history pictures', or scenes which had a literary or historical justification, but the shifts in historical focus at the end of the nineteenth century equally imply a shift in perception and fashion. For example, the German artist Franz von Stuck was a respectable academic painter and one of the major proponents of the Jugendstil – or German art nouveau – style. However, his most popular subjects were those of fatal women, such as the typical *Sin* (1895, Munich, Bayerische Staatsgemäldsammlungen) which shows a woman holding a snake and staring out of the canvas in a direct and challenging manner. 'Sin' is obviously the embodiment of Eve, or the perpetrator of Original Sin; 'Sin' is also a beautiful woman. The association of woman with evil was not lost on contemporary observers. One turn-of-the-century writer recognized that this painting could be read as a symbolic comment on the battle of the sexes, but his own assessment of it was in terms of women's evil:

> It will be said that this painting denies profundity because it does not reveal the 'unfathomability of the womanly soul', nor does it proclaim the furious 'War of the Sexes', which according to the testimony of wise men, has raged since the beginning of time. Of this, again, is the Stuckian paganism guilty – this world view of a laughing philosopher which is so crazy as to see no unfathomability before pure beauty. One must promptly peruse Strindberg or the smaller Church fathers on the subject of women in order to breathe the deep smoke of knowledge after this ordinary atmosphere of beauty. Oh yes! This species of painting is a bad temptation. It derives surely from the snake, whose head a more honest man should crush underfoot.[30]

Another article entitled 'The Devil in Fine Art', which appeared in the journal *Kunst unsere Zeit*, made the connection obvious:

> Notice that in our art of today one sees sin only in the woman! – does the woman question come to play in this? – or is it the fear of the woman? And how is it, that the sexual question also prevails in the theme of the devil? . . . To us, it suffices that the ethical force and condemnation which comes to expression in the new devil's painting is greater than ever.[31]

In an increasingly secular society, religious images were being utilized to circumscribe the position of woman; indeed, biblical women began to take a more and more prominent place in exhibited painting from the mid-nineteenth century. The heroines and villainesses of violent Old Testament stories were particularly popular among academic as well as 'progressive' artists. Klimt, for example, used the story of Judith and Holofernes as an excuse to show a cruelly sensual woman clutching the decapitated head of her enemy in a decidedly erotic way (*Judith and Holofernes*, 1901, Vienna, Österreichisches Galerie). Rossetti probed beyond the Old Testament itself to the story of Lilith – an evil woman from Hebrew legend who supposedly led Adam astray even before the appearance of Eve and the snake on the scene. Rossetti's *Lady Lilith* (1868, Wilmington, Delaware Art Museum) represents one of the artist's familiar models in the guise of the original seductress. Again, contemporary observers made the connection between a biblical character and the modern women's movement. In a letter to Rossetti, Ponsonby Lyons noted: 'Lilith . . . was evidently the first strong-minded woman and the original advocate of women's rights.' According to Lyons, after God created Lilith, 'They [Lilith and Adam] at once began to dispute. Lilith refused to obey Adam, saying they were both quite equal, for they were made from the same earth.'[32] The fact that this 'original advocate of woman's rights' was also technically responsible for the downfall of mankind would not have been lost upon this particular observer, nor upon Rossetti.

The implicit relationship between images of evil women and the 'New Woman' can be further illuminated by examining psychological and anthropological literature on cruel women. Lombroso's observations about the female criminal indicate that she could be beautiful, although her beauty was sometimes more 'virile' than feminine, and that she was capable of 'refined, diabolical cruelty' and was totally oblivious to any sense of morality.[33] Her cruelty manifested itself in vengefulness, passion, greed and lack of maternal instinct – all of which were attributes emphasized in the *fin de siècle* icons of the 'cruel woman'. Indeed, Lombroso's descriptions of the criminal woman could just as easily apply to any number of paintings which were shown at major European exhibitions during his life-time. The fact that historical or mythological evil could share such obvious characteristics with a contemporary idea of feminine crime shows the extent to which images of past and present could interpenetrate. Lombroso's writings were widely read and quoted throughout Europe, just as paintings of cruel women became increasingly popular. Lombroso also felt that women's crimes were distinguished from men's in that they were more concerned with passion or love. When the Austrian artist Oskar Kokoschka created illuminations and posters for his controversial (and largely unperformable) play, *Murder, Hope of Woman*, he made the link between criminality, evil and women explicit. This early Expressionist drama concerns a passionate woman who holds a man prisoner, until the man escapes from the prison and murders her. Ironically, the criminality of the play rests largely in the actions of the man, rather than the woman, but the man is 'driven' to this crime by the woman's unreasonable behaviour, and although Kokoschka was not attempting to present a traditional moral, it is possible to read into the play his endorsement of the man's actions in light of the woman's suffocating passion. Whether or not Kokoschka knew the work of Lombroso, his play represented one manifestation of the 'evil woman'.

However, the image of the cruel woman should not be seen simply as a manifestation of

misogyny or an implicit attack on female emancipation. According to contemporary psychologists, truly cruel women were relatively rare. In his vast study on sexual aberration, Krafft-Ebing cites only two cases of female sadism – one of which was a blood-sucking vampire/woman.[34] According to Krafft-Ebing, sadism is essentially unfeminine; what is more common is the phenomenon of male masochists. In one autobiographical case study, the interests of the male masochists become clear: 'I revelled in the sight of pictures of commanding women,' the patient explains, 'particularly if, like queens, they wore furs.'[35] Krafft-Ebing elaborated on this theme later in the book, where he wrote, 'For the masochist the principal thing is subjection to the woman; the punishment is only the expression of this relation.'[36] This is not to suggest that every painting of a cruel woman at the end of the nineteenth century was merely an erotic icon for the pleasure of a race of masochistic males. Instead, Krafft-Ebing's analysis suggests that the *idea* of a cruel woman – however rare a reality this may be – could serve erotic purposes of a masochistic nature. The images of cruel women at the turn of the century thus had their own fascination for the men who painted them and the men who observed them, whether that fascination was based on repulsion, arousal or even cautious approval.

To a point, such a view of women became as much a cliché as a reality. Bram Dijkstra's exhaustive study *Idols of Perversity* (1987) reproduces and discusses a vast range of examples of such images, but one wonders whether *every* artist who painted Eves or Circes or Salomes hated or feared women with an equal degree of feeling. When the art critic Hermann Bahr published one of his regular exhibition reviews in 1894, he sighed at the sameness of all the images, despite the fact that he had attended shows in Belgium, Holland, France and Germany.[37] Once the icon had been established, there were many artists ready and willing to follow suit, and critics stimulated the popularity of the evil woman by their use of language and the focus of their critiques. Even portraits of real women could be seen in terms of seduction, vampirism and cruelty. For example, J.-K. Huysmans describes Whistler's portraits of women as 'these phantom-portraits which appear to retreat, want to penetrate in the wall, with their enigmatic eyes and their ghoulish mouths of red ice', and of Whistler's *Lady Archibald Campbell* he writes:

> From the otterskin fur of the sombre, gloomy coat, gushes forth the supreme elegance of Lady Campbell, whose narrow laced body palpitates, whose mysterious face leans forward, with invitation in her haughty and inciting eye, and repulsion in her unpolished red mouth. Once again, the artist has drawn from the flesh an indefinite expression of the soul, and he has moulded his model into a restless sphinx.[38]

Here, Huysmans quite self-consciously transformed Whistler's portraits of specific women into abstract images of female cruelty.

Because the images are so inherently interesting, the icon of the 'evil woman' has attracted a great deal of attention in recent years among art historians, but so much focus on this one idea has obscured the fact that contrasting icons of womanhood also existed and were equally popular. Jan Toorop's *The Three Brides* (1893, Otterlo, Rijksmuseum Kröller-Müller) attempts to encapsulate in one canvas the contrasting views of woman as both cruel and pure. Toorop called the bride in the middle of the painting 'a perfumed, hardly blossomed flower which hides under its veil both things: the pure aroma of tenderness and the burning gift of sensual pleasure', but this combination of purity and sensuality is carried to extremes by the nun, who represents 'ardour filled with gruesome asceticism', and the whore, 'a hungry, insatiable sphinx'.[39] To Toorop, there

was very little between the whore and the nun, but as I have emphasized already, artists were, to an extent, confined by their medium when they attempted to make universal statements about womanhood. The 'virgin or whore' contrast, which has rightly been the focus of much feminist critique in recent years, is actually a more problematic dichotomy than it first appears. Just as the cruel seductress could represent woman's power or man's fear, so the image of the woman as virgin or mother could show both man's desire for a pure, uncorrupted woman, or it could represent the insistence upon chastity advocated by some of the more radical suffragists. In addition to these layers of connotation, representations of motherhood at the turn of the century can be seen as important symbols in relation both to the European crisis in Catholicism and the debate about childbirth and population which proliferated with the growth of the eugenics movement. It is also important to examine the images of motherhood painted by *female* artists to understand that man's view of woman and womanhood was not the only available one at the turn of the century.

One of the strongest focal points of early feminism was the idea that women should be in control of their own bodies. To some male observers, the practices of dowry and divorce were seen as little more than legalized prostitution. Mantegazza attacked the emphasis placed on dowries in marriage, and Carpenter made explicit the link between the 'enslavement' of women and the commercial greed of men in industrial society:

> In many respects the newer Women and the Workmen resemble each other. Both have been bullied and set upon from time immemorial, and are beginning to revolt; both are good at detailed and set or customary work, both are bad at organisation; both are stronger on the emotional than on the intellectual side; and both have an ideal of better things, but do not quite see their way to carry it out.[40]

He elaborated this point in his assertion, 'The sense of Private Property, arising and joining with the "angel and idiot" theory, turned Women more and more – especially of course among the possessing classes – into an emblem of possession – a mere doll, an empty idol, a brag of the man's exclusive right in the sex.'[41] As a committed socialist, Carpenter could see the subjugation of women in terms of economic inequalities, and variations of this same theme were taken up by women writers as well. Eleanor Marx's *The Woman Question* (written with Edward Aveling, 1887) extended Carpenter's assertion by suggesting that the abolition of private property would lead to greater equality and freedom in love relationships.[42] Women also shifted the emphasis from the question of marriage to the issue of woman in the workplace. Lily Braun, for example, in her *Frauenfrage*, saw women's position in the workplace as a necessary component of capitalist culture, but in her Marxist terms, bourgeois society was undermining its own morality, and the continuity of the species, by insisting that women work. Braun's viewpoint was ultimately conventional: she saw the 'highest destiny' of women as motherhood, and she condemned the conditions under which some women were forced to work. However, she also saw the co-operation of men and women in the workplace as the ultimate weapon against capitalism: by encouraging such practices, capitalism was nurturing the seeds of its own destruction.[43]

Many women saw socialism as a means of achieving their desired aims, although male socialists did not always wholeheartedly support the feminist cause. To an extent circumscribed by their conventional roles as wives and mothers, women began representing the family as the definitive social institution. Women who wished to have political power could use a combination

of socialist rhetoric and familial loyalty to insist upon their rights and fitness to govern. In his misogynistic *Sex and Character*, Weininger needed to address the idea of the family as a microcosm of society in order to 'prove' his extreme points about the inferiority of women. His refutation reveals the weakness of his own argument:

> Woman has no faculty for the affairs of State or politics, as she has no social inclinations
> . . . The family itself is not really a social structure; it is essentially unsocial and men who
> give up their clubs and societies after marriage soon rejoin them.[44]

Because women had had very little opportunity to prove themselves in a public sphere, they needed to turn to their traditional familial roles to assert their fitness for public life.

However, another response from women came in the form of rejection of men, or spinsterhood. From the mid-eighteenth century, women began infiltrating politics on the local level by becoming involved in purity campaigns. Although these campaigns were designed to ameliorate the conditions in cities and to show compassion for the poor, they were also fuelled by an essentially Christian philosophy. Through purity societies, for example, women were able to expose the hypocrisy of men who derided prostitutes, even while paying for them; the ultimate tone of purity movements was that of moral righteousness. Growing out of such philanthropic endeavours was a sense that sexual love was not necessary, and that marriage, as it currently existed, was to be avoided. As Sheila Jeffreys has pointed out, women combined participation in local politics with rejection of marriage, and it was these women who paved the way for later suffrage reforms.[45]

The way these reforms and changes fed into art is not easy to classify. With its frequent emphasis on nudity or sexuality, painting in particular rarely seemed to relate to the contemporary alterations in women's position, and where it does, it can often be read as rejecting or misinterpreting these changes. However, Aubrey Beardsley's illustrations for Leonard Smithers's edition of Aristophanes's *Lysistrata* (1896) can be understood in part as a humorous response to the political power of spinsterhood of the 1890s. The ancient Greek comedy, *Lysistrata*, takes as its theme the intervention of women in city politics. The Athenian women, tired of the continual war being waged by the men, try to redirect the course of events by refusing their husbands 'conjugal rights'. Women's right to deny their husbands sexual favours was an important issue in the late nineteenth century, when the concept of marital rape effectively did not exist. Beardsley's illustrations for *Lysistrata* ridiculed the men, whose gigantic erections attest to their frustration. Although women's power was thus seen to lie in their sexuality, that sexuality could be employed politically, as a means of exercising an influence which was otherwise outside their reach. In many ways, *Lysistrata* was an allegory of the times, and Beardsley's illustrations mockingly unveil these subtexts.

The changing position of women within the political system created a number of divisions in conventionally male politics. In France, particularly, socialists disagreed about women's emancipation. Some felt that their emphasis on natural equality meant that women should also be considered equal; others feared that the traditional association of women with Catholicism would undermine the efficient running of the state. Socialists shifted their focus from the political spectrum to the issue of woman as mother, and the concept of maternity became an increasingly important one in Catholic countries, just as in art and literature, Virgins and Madonnas became significant images among avant-garde artists.

In France the most notable proponent of the 'motherhood' icon was Eugène Carrière, whose academic respectability was enhanced by his paintings of mothers and children from the 1880s. In

works such as Maternity (1892, New York, Museum of Modern Art), Carrière used his own wife and children as models, but he depersonalized them by wrapping them in an obscuring haze. Art historians have interpreted Carrière's works as universal, and have seen his distinctive style and subject-matter as attempts to get beyond the specific, to the general 'truth' of life. Carrière's own writings have contributed to this interpretation. In a letter of December 1904, he wrote, 'They [women] are so different from us, so great is their collaboration in the complete life, and their heroism at every moment can be compared only to the force of nature itself', and 'Time does not change the nature of beings, and the modern Woman always appears to us as the symbol of creation'.[46]

However, Carrière's emphasis on universality needs to be read within the context of French political attitudes towards maternity at the turn of the century. One of the reasons that socialists in France became so concerned with motherhood rested in fears that the population was declining. Unlike England, where feminism became increasingly militant, the French women's movement – as Karen Offen has shown – was dominated by 'familial feminism', which focused on 'reforms' for women such as new cooking schools and crèches. Again feminism and socialism were linked, but socialists saw women's role within the family as their most important contribution to the social order. Even radical socialists concentrated their attentions on the idea of birth control, which they saw as a weapon to be used to undermine a country anxious about its birth rate.[47] The use of birth control for the purposes of political subversion became one way in which feminists could contribute to political events, but its acceptance was a pyrrhic victory for them, and did little to change entrenched attitudes. Carrière's socialist sympathies could also be understood within this debate about women, and his 'universal' paintings of mothers and children simply reinforced the idea that motherhood was woman's highest aim; Maternity was commissioned by the state to be added to a national collection of contemporary art at the Luxembourg. Carrière's views of maternity may have been universal, but they were also specifically important to his own time and place.

Given the role of the women's movement within the wider context of socialism, and given the emphasis placed on women's role as mother, it is no surprise that images of the Virgin and Child also began to appear at the turn of the century – particularly in countries with a large Catholic population. Although obviously the Madonna had a long tradition in western art, her increasing importance in the second half of the nineteenth century cannot be attributed solely to an interest in the conventions of Renaissance painting. In Italy, the Madonna was a favourite subject of the artist Gaetano Previati, whose Madonna of the Lilies (1893–1894, Milan, Civica Galleria d'Arte) was one of several such subjects he produced at the time. Like Carrière, Previati had socialist sympathies, and he cast these ideas into a mystical or idealist context. Also like Carrière, his socialist ideas seemed to encapsulate the understanding that woman's most important function in society was her role as mother. In his Madonna, the mother herself functions as the source of light, which emphasizes her sacred importance. The Madonna was seen in both her maternal and virginal personae, but rather confusingly, even she could be seen as an object of sexual desire. A number of writers in France, such as Mallarmé and Moréas de Tailhade, wrote poetry which extolled the virtue of the Madonna, even while representing her as a stimulus to desire. As the Madonna, Mary's maternal aspect was extolled, even while her role as the unsullied virgin became a focus of attention. Some of the most overtly lustful literary representations of the Virgin came from the pen of Huysmans, after a rather belated conversion to Catholicism. As Jennifer Birkett has pointed out, Huysmans was one of a number of 'progressive' French writers whose loyalties really rested with the conservative patriarchy of the Catholic church.[48] The confusing

relationship between religious belief and women's role within society came to the fore in one of Krafft-Ebing's many case studies of sexual perversion. One patient who earned a place in the *Psychopathia Sexualis* had a rather peculiar art collection: 'Among his effects were found copies of objects of art and obscene pictures, painted by himself, of Mary's conception, and of the ''congealed thought of God'' in the lap of the Virgin.'[49] Whatever form this 'congealed thought' took in the work of this patient, it undoubtedly highlighted his association of sexuality with religion through the intermediary of woman.

The images of woman as mother obviously had complex and paradoxical referents – not all of which added up to a coherent view of *fin de siècle* maternity. Aside from the socialist belief in the mother as bastion of the familial social order, and the Catholic ambiguity about the presence and nature of the Virgin, issues surrounding the maternal role also became the focus of the eugenics movement – which flourished just before the First World War. Following the ideas of Spencer and other post-Darwinian investigators, eugenicists believed that controlled reproduction would lead to a gradual improvement of the race and would counteract social degeneracy. Throughout Europe and in America, eugenics gradually became consolidated and institutionalized as eugenics laboratories were set up and even eugenics publishing houses began printing significant works in the field. Suddenly, women's role as mother became not only of social importance, but of crucial significance for the survival of the race. To a certain extent, eugenicists redirected the focus of the women's movement by highlighting the value of women's traditional role as mother, which in itself meant a shift of emphasis from their potential political function. Eugenics could be a powerful weapon for the anti-suffragists because it did not *attack* women, but neither did it allow women to extend themselves beyond their capacity as wives and mothers.

The emphasis on controlled reproduction was particularly popular in Italy, where woman's function as a mother was seen as her 'mission'. This was the idea of Muzio Pazzi, a professor at the University of Bologna, who claimed that women needed to sacrifice themselves, not just for the future of the race, but for the rejuvenation of Catholicism. This combination of eugenics and Catholic polemic was unusual, but Pazzi carried it a step further in his study of women whose maternal instinct was 'deficient'. Like several other criminologists of the period, Pazzi was fascinated by the phenomenon of infanticide, which he saw as particularly heinous, given women's 'natural' maternal role. Pazzi proposed special '*sanatori materni*' for those guilty of this crime, where they would be instructed in how to be proper mothers.[50] It is certainly no coincidence that the Italian artist Giovanni Segantini produced a work which hinted at the unnaturalness of 'deficient' maternal instinct. Segantini's *Evil Mothers* (1894, Vienna, Kunsthistorisches Museum), like his *Punishment of Lasciviousness* (Figure 45), shows a punishment of evil women, but this time the crimes of the women were seen in terms of their failure as mothers. A monograph on Segantini, which appeared in 1901, makes this focus clear in its description of the painter's ideal of motherhood:

> In his work motherly love is not only the love of the mother for her child, or that of the sheep for her lamb, but it extends further, to the love of the shepherdess for her sheep, and to the higher love of Providence for all the creatures of the earth.[51]

The sentimentality of this description is commensurate with the fabulations of the eugenicists, who represented mother-love as an exalted and universal function. Segantini drew his inspiration for both paintings partly from a Hindu myth, in which women's negligence of their children is punished by barrenness. The snow itself emphasizes the sterility of the whole scene. The message

is clear: unnatural mothers who abandon or murder their children will be met with a metaphysical punishment to fit the crime – a perpetual sterility of body and mind.

An even nastier image of perverted motherhood came from the brush of Munch, who was never averse to tackling contemporary issues directly. His *Madonna* (Figure 47) is the exact opposite of Previati's utopian *Madonna of the Lilies*. She is not idealized; she does not represent the exalted condition of motherhood. Instead, she is a purely sexual being, rather than a maternal one, and her 'child' is a detached foetus floating in a sea of sperm. The image is horrible, but in many ways it is a more honest revelation of contemporary anxieties. Women were seen as maternal and sensual, as altruistic and selfish, as kind and cruel. Every crime was attributed to them, even while every praise was given for their 'virtue' and maternal compassion. These contradictions are clearly expressed in Munch's controversial work. Motherhood itself was no longer a simple issue.

Aside from its use by socialists, eugenicists and Catholics, the image of maternity was, most importantly, a significant one for women and for women artists. Eugenicists may have kidnapped the issue of maternity for their own (often suspect) purposes, but equally, feminists could point to woman's ability to bear children as a stamp of her superiority. This idea was a leitmotif in the work of the English feminist, Frances Swiney, who turned Darwinism on its head in order to prove that women were, in fact, superior to men. Her use of evolutionary theory and mysticism not only reinforced her important polemical point, but it equally highlighted the absurdity of many former writings in which male superiority was proven using the same set of principles. Swiney claimed that modern degeneration was constantly being attributed to every cause but the right one:

> Persons, totally ignorant of physiology, write diatribes on the declining birth-rate; and equally hysterical effusions on the fearful mortality of infants fill magazines, reviews, and papers, the onus in each case being thrown on the incapable and ignorant mothers of the race, who are, first blamed for not producing more infants, and secondly, upbraided with the loss of those produced.[52]

According to Swiney, the 'real cause' of degeneration was the fact that men insisted upon making love to women too often – particularly when they were pregnant, menstruating or breast-feeding. The male sperm 'poisons' the womb:

> They [children] are often conceived in iniquity, of drunken, lustful parents; and, developed in the rankest poison, they become stunted, malformed, diseased, and prematurely old before they see the light.[53]

In Swiney's view, women should be left alone by men, except when absolutely necessary for conception, and mothers should limit the number of children they conceive to a maximum of four. In another work, she totally overturned the assertions of scientists who insisted upon male superiority: Eve was not the perpetrator of Original Sin, but 'the Mother of all Living'; 'life is female', rather than male; and the male sex organs are the female organs 'placed outside the body', rather than the female organs being undeveloped versions of male genitalia.[54] Swiney's view of women and motherhood was premonitory and apocalyptic: 'If the civilisation of the West is not to go down into the depths, the mothers of mankind must insist upon a return to the Natural Law, to a recognition of the supremacy of motherhood, the divine mission of womanhood.'[55]

Swiney's 'divine mission' was not totally unrelated to Pazzi's emphasis on the 'mission' of mothers, but the fact that these ideas were presented with different gender and political biases is important. There were no women artists who created icons of motherhood to match the icons of unnatural motherhood produced by Segantini and Munch, but several women artists did concentrate on the image of mother and child as a positive one. These images did not gain their power from religious or political bias, but from the important human values which were emphasized by the subjects. The American Impressionist Mary Cassatt turned to paintings of mother and children throughout her career. Her *The Bath* (1892, Chicago, Art Institute) is only one of many images of mothers involved with their children. Cassatt's vision may have been circumscribed within a female domestic world, but it shows that world as significant in its own right. Her contribution to the Impressionist concern with 'modern life' subjects was to highlight the importance of modern mothers, rather than to demean or ignore them, as much contemporary work had done.

The most striking images of mothers and children, and those which approach most closely Swiney's mystical glorification of motherhood, are the paintings of the German artist Paula Modersohn-Becker (Figure 48). She was a member of the Worpswede artists' colony at the turn of the century, and like other artists in the group, she concentrated on painting the peasants and local life of the tiny village where she lived. Although Modersohn-Becker spent a great deal of time in Paris, and certainly knew of contemporary artistic developments, she was most strongly influenced by the quality of primitivism in the work of Gauguin and others. Her *Kneeling Mother and Child* (1907, Bremen, Ludwig-Roselins Sammlung, Böttcherstrasse) is one of many paintings which reveal her sympathy for, and attraction to, woman's maternal role. Speaking of one model, Modersohn-Becker wrote in her diary:

> I've drawn a young mother with her child at her breast sitting in their smoky hut . . . She was suckling her big one-year-old bambino . . . the woman gives her life and her youth and her strength to the child in complete simplicity, unaware of being heroic.[56]

But Modersohn-Becker also related the maternal role to her own status as a woman, and like her near contemporary Schiele, her self-portraits reveal some confusion about her identity and an attempt to examine her own personality and desires within a turbulent modern world. Her *Self-Portrait on Her Sixth Wedding Day* (1906, Bremen, Ludwig-Roselius Sammlung, Böttcherstrasse) shows her pregnant before she had had any children, or had yet conceived the child whose birth would lead to her own death. Modersohn-Becker's own enthusiasm for women and motherhood did not accompany a wholehearted support of the woman's movement. In a letter of 10 January 1897, she wrote home to her family from Berlin about a lecture on emancipation. Her response to the ideas presented was dismissive and frustrated:

> I can discuss the woman question. I'm quite familiar with the catchwords. After life-drawing Friday I went to a lecture, 'Goethe and the Emancipation of Women'. The lecturer, Fräulein von Milde, spoke clearly and well, also very reasonably. Except that modern women have a pitifully sarcastic way of speaking about men as if they were greedy children, which immediately puts me on the male side. I had all but signed the petition against the new civil code [barring women from public meetings] when Kurt [her younger brother] snapped furiously at me. He supports my original opinion to let the important men handle the issue and to believe in their judgement.[57]

Modersohn-Becker, like Schiele, was subject to the conflicting signals surrounding the construction of gender identity at the turn of the century. The various icons of womanhood discussed in this chapter reveal more than anything else that men and women were searching for a way of understanding each other and were relying on stereotype, prejudice or wilful misrepresentation when the 'answer' did not immediately present itself. Women may have been passive or sexual or evil or maternal; they may have been all of these things, or none of them. Art appeared to offer solutions, but in reality, it merely contributed to the confusion.

NOTES

1. See especially Bram Dijkstra, *Idols of Perversity: Fantasies of Feminine Evil in Fin-de-siècle Culture* (Oxford, 1986), and Joseph Kestner, *Mythology and Misogyny: The Social Discourse of Nineteenth-Century Subject Painting* (Madison, Wisconsin, 1989).
2. Valeria Babini, Fernanda Minuz and Annamaria Tagliavini, *La donna nelle scienze dell'uomo: imagini del femminile nella cultura scientifica* (Milan, 1986).
3. *Punch* (25 May 1889), 254.
4. *Punch* (12 January 1889), 15–16.
5. Friedrich Nietzsche, *Beyond Good and Evil* (Harmondsworth, 1990), 101.
6. Paolo Mantegazza, *The Art of Taking a Wife*, Eng. trans. (London, 1894), 157, 164.
7. Harry Campbell, *Differences in the Nervous Organisation of Man and Woman* (London, 1891), 171.
8. See Steven Hause and Anne Kenney, *Women's Suffrage and Social Politics in the French Third Republic* (Princeton, 1984).
9. Edward von Hartmann, *The Sexes Compared: and Other Essays*, Eng. trans. (London, 1895), 4.
10. Edward Carpenter, *Love's Coming of Age* (Manchester, 1890), 66–7.
11. Cesare Lombroso, *The Female Offender*, Eng. trans. (London, 1895), 11.
12. Otto Weininger, *Sex and Character*, Eng. trans. (London, 1906), 70–71.
13. Professor Clifford Allbutt, 'Nervous Diseases and Modern Life', *Contemporary Review* (February 1895), 210–31.
14. See especially Jan Marsh, *Pre-Raphaelite Sisterhood* (London, 1987).
15. For Przybyszewska, see Mary Kay Norseng, *Dagny: Dagny Juel Przybyszewska: the Woman and the Myth* (Seattle, Washington, 1991); for Delville, see Oliver Delville, *Jean Delville peintre 1867–1953* (Brussels, 1984).
16. It will be noted that in this chapter I have avoided the use of the term 'femme fatale', even though it was an ubiquitous description of 'evil' women in the *fin de siècle*. I have done this not simply to be perverse, but because the frequent use of the term *since* the 1890s has served to cloud its original meaning and impact. In attempting to isolate constructed icons of womanhood, I do not wish to recreate or perpetuate those icons myself. I hope I will be forgiven for this deliberate omission.
17. Campbell, 119.
18. Ibid., 157–62 and August Strindberg, 'De l'infériorité de la femme', *La Revue blanche* (January 1895), 1–10.
19. Campbell, 52.
20. Ibid., 200–201.
21. Richard von Krafft-Ebing, *Psychopathia Sexualis*, Eng. trans. (Philadelphia and London, 1892), 13.
22. See, most notably, Sara Delamont and Lorna Duffin, eds., *The Nineteenth-Century Woman: Her Cultural and Physical World* (London, 1978), and 'Sexuality and the Social Body in the Nineteenth Century', *Representations*, 14 (special issue, Spring 1986).
23. Paolo Mantegazza, *The Sexual Relations of Mankind*, Eng. trans. of *Gli amori degli uomini* (1885) (New York, 1935).
24. Weininger, 90.
25. Mantegazza, *Art*, 89.
26. Lombroso, 85.
27. Quoted in Robert Delevoy, Gilbert Lascault, Jean-Pierre Verheggen and Guy Cuvelier, *Félicien Rops* (Lausanne and Paris, 1983), 26.
28. Eduard Fuchs, *Geschichte der erotischen Kunst* (Munich, 1908).
29. Max Nordau, *Degeneration*, Eng. trans. (London, 1895), 167–8.
30. Otto Bierbaum, *Stuck* (Bielefeld and Leipzig, 1901), 76.
31. This article is quoted in Heinrich Voss, *Franz von Stuck 1863–1928* (Munich, 1973), 26.
32. William Michael Rossetti, *Rossetti Papers 1862 to 1870* (London, 1903), 484.
33. Lombroso, 93, 148.
34. Krafft-Ebing, 88.
35. Ibid., 91–2.
36. Ibid., 99.
37. Hermann Bahr, 'Malerei 1894', in *Renaissance: Neue Studien zur Kritik der Moderne* (Berlin, 1897), 175–6.
38. J.-K. Huysmans, *Certains* (Paris, 1904), 69–70.
39. From Toorop's letter to A. Markus, 24 June 1894. These phrases are quoted from Robert Goldwater, *Symbolism* (London, 1979), 51. The majority of the letter (in Dutch) is reprinted in J. Th. Toorop, *De jaren 1885 tot 1910*, exhibition catalogue, Rijksmuseum Kröller-Muller (Otterlo, 1979), 41.
40. Carpenter, *Love's Coming*, 33.
41. Ibid.
42. Eleanor Marx and Edward Aveling, *The Woman Question* (London, 1887).

43. Lily Braun, *Die Frauenfrage: ihre geschichtliche Entwicklung und wirtschaftliche Seite* (Leipzig, 1901), 556–7.
44. Weininger, 205.
45. Sheila Jeffreys, *The Spinster and Her Enemies: Feminism and Sexuality 1880–1930* (London, 1985).
46. Eugène Carrière, *Ecrits et lettres choisies* (Paris, 1907), 310–11.
47. Karen Offen, 'Depopulation, Nationalism and Feminism in Fin-de-Siècle France', *American Historical Review*, 89, no. 3 (June 1984), 648–76.
48. See Jennifer Birkett, *The Sins of the Fathers: Decadence in France 1870–1914* (London, 1986), 93–6.
49. Krafft-Ebing, 73.
50. This is discussed in Babini et al., op. cit. See Muzio Pazzi, 'Misure preventive contro l'aborto criminoso e l'infanticidio', *Rassegna d'ostetrica e ginocologia* (Naples, 1913).
51. L. Villari, *Giovanni Segantini* (London, 1901), 33.
52. Francis Swiney, *The Bar of Isis: the Law of the Mother* (London, 1907), 17.
53. Ibid., 26.
54. Frances Swiney, *Woman and Natural Law* (London, 1912), 9, 10, 23.
55. Ibid., 48.
56. J. Diane Radycki, trans., *The Letters and Journals of Paula Modersohn-Becker* (Metuchen, NJ and London, 1980), 73 (entry dated 29 October 1898).
57. Ibid., 15–16.

CHAPTER 7
THE INNER LIFE

The crisis in gender identity and the mapping of the body which took place in the late nineteenth century indicates an age obsessed with the physical, practical side of human existence. Medicine, psychology, anthropology and other taxonomic disciplines regarded human beings through a microscope, and all of life came to be interpreted within the domain of science. To a certain extent, science also reached into the depths of the inner life of mankind: psychology, for example, was built upon an attempt to identify and classify personalities – particularly pathological ones. However, such introspective concerns increasingly broke away from the fetters of scientific analysis. As Freud was later to realize, 'It is not easy to deal scientifically with feelings'.[1] The life of the 'spirit' or the 'soul' came to be regarded as an antidote to the material pursuits of *fin de siècle* science, and the active adoption of such spiritual alternatives came to be construed as a political act. Increasingly, the goals of positivism were held to be synonymous with liberal parliamentary governments throughout Europe, which advocated the value of competition and industrialization. These goals were seen to be limiting, and even evil, while the value of the 'inner life' was exalted as a means of personal and national development, a tendency with great appeal for artists, whose own productions turned against the imitation of nature and towards new means of depicting this inner life. The role of art in this development is complicated, and even while some artists were advocating the principles of new spiritual movements through innovations in style and subject-matter, others continued to imitate nature for the same reasons. In order to investigate the role of art within this discourse of the spirit, it is necessary to consider several different manifestations of the reaction against positivism in the late nineteenth century: spiritualism; dream psychology; new religious sects, such as the Theosophical Society; and finally, the role of music as an agent for spiritual expression. In each of these important social developments, art had a significant – if problematic – role.

The conflict between science and religion (in its widest sense) is one of the clichés of our image of the nineteenth century. However, an extension of this dichotomy can be made if the concept of 'religion' is replaced by that of 'art'. In its critique of Nordau's *Degeneration*, the anonymous *Regeneration* presented the opposition between science and religion in largely aesthetic terms. The author indicated that science and religion represent 'two different faiths', and he equated the latter with the uplifting potential of visual and aural beauty:

> To turn our back upon emotions and to take our place at the table of science means to ignore all that is beautiful, lovable, ennobling and hopeful, to shut our eyes to the charms of form, colour, motion, and our ears to music, and to concentrate our attention upon the repast spread on the table of science: the pleasure of discovering bacteria in human tissue,

the curiosity of counting the throbs of a frog's heart after being torn from the living body, the sensation of ascertaining the effects of the gastric juices of the foot of a living rabbit inserted into a living dog's stomach.[2]

The author's anti-vivisectionist disgust conflated the pursuits of science with the rejection of beauty, and implied that science had become a pointless and somewhat distasteful discipline. Art, on the other hand, came to be seen as a means of subverting science, and it was thus identified with religious feeling. At the beginning of his monograph on the artist Arnold Böcklin, Johannes Manskopf made this parallel explicit:

> The Golden Age of the machine has begun to turn in on itself, causing us to reflect that man is not a machine, that the life worth living is not that which expresses itself in statistics – that materialistic nature-history perspective of the soul which yields stones instead of bread.[3]

Art could be considered as synonymous with religious inspiration, or, at least, as a suitable substitute for it.

From the late 1880s, artists began to respond directly to this new demand for inner succour, and throughout Europe (and indeed the world), an art movement known as Symbolism increasingly dominated exhibitions and the art market. From England, where Burne-Jones's medieval fantasies rejected the ugly appearance of the modern industrial city, to Australia, where the mythological subjects of Rupert Bunny offered a mild diversion from the strains of everyday life, artists turned away from their own physical environment in order to evoke a lost world or a spiritual arcadia. Not all Symbolist paintings were as consciously representational as the works of Bunny and Burne-Jones, but many Symbolist artists did seek to imitate reality as much as possible – whether or not that 'reality' consisted of fictive maidens or imaginary gods. For example, Pierre Puvis de Chavannes, one of the most admired of the European Symbolists, produced simplified figures, but they were nevertheless figures based on life. In works such as *The Poor Fisherman* (1881, Paris, Louvre), the Symbolist intent lay not in a rejection of representation, but in the lack of meaning behind this representation. Critics responded to *The Poor Fisherman* in a variety of ways, but the simplification of form and seeming timelessness of the subject led most of them to see the painting as more than a straightforward imitation of life. The 'symbol' in Symbolism is not a one to one correspondence between the signifier and the signified, but rather a rejection of such correspondence. Symbolist paintings were often intentionally meaningless, but by avoiding clear-cut interpretations, artists hoped to answer the ill-defined needs of the spirit which were increasingly the subject of public scrutiny in newspapers and books. This compromise between imitation and spiritual evocation irritated a number of observers, including the Naturalist author Émile Zola, who condemned the absurdity of Symbolist art:

> For pity's sake, no painting of the soul! Nothing is more tiresome than the depiction of ideas. That an artist place a thought inside a head, yes! but that the head be there, solidly painted and in such a way that it will defy the passage of centuries. Only life speaks of life, from beauty and truth emerges only living nature.[4]

But Zola's insistence that ideas were more 'tiresome' than life was not shared by others who felt that the endless attempts to observe, classify and interpret the modern world were in themselves exhausting and limiting. Somehow, the inner life was being left behind.

The most succinct definition of Symbolist art appeared in an article by Albert Aurier from the *Mercure de France* in 1890. Later broadened into a long discussion of Gauguin (published 1891), Aurier's 'Symbolism in Painting' ironically subjected Symbolism to a sort of scientific classification system, as he identified a number of qualities which characterized the new art. According to Aurier, Symbolist art was:

1. *Ideist*, for its unique ideal will be the expression of the Idea.
2. *Symbolist*, for it will express this Idea by forms.
3. *Synthetist*, for it will present these forms, these signs, according to a method which is generally comprehensible.
4. *Subjective*, for the object will never be considered as an object, but as the sign of an idea perceived by the subject.
5. (As a consequence) *decorative* – for decorative painting, in its proper sense, as understood by the Egyptians and, very probably, the Greeks and the Primitives, is nothing other than a manifestation of art at once subjective, synthetic, symbolist and ideist.[5]

Aurier felt that by following these principles, Symbolists would find a plastic means to explore the vagaries of the inner life.

Artists throughout Europe settled upon a similar comparison between representational and 'ideational' art. For example, the Russian Pavel Varfolomeevich Kuznetsov used 'spiritual' colours such as deep blue, and evocative images, such as foetuses and fountains, to evoke the interior life of the ages of man. Kuznetsov's fountains were not meant to be seen as specific symbols of the 'fountain of life', but were intended to portray inner realities of life by transcending such obvious pairing of object and significance. Similarly, the Belgian Carlos Schwabe avoided narrative tricks to convey the sensations of *Grief* (1893, Geneva, Musée d'art et d'histoire), choosing instead to signify his meaning through an emaciated and black-clad inverted Madonna figure standing in a field of flowers. Kuznetsov and Schwabe were dealing with the inevitable facts of birth and death, but they avoided a factual representation in favour of a vague and evocative one. Even works which had a symbolic clarity, such as Böcklin's *Self-Portrait with Death* (Figure 49) could be interpreted in metaphysical terms. Although Böcklin's work was painted before the Symbolist movement began, later observers saw its function as essentially Symbolist. Böcklin borrowed the motif of death playing the fiddle from earlier German art, such as Holbein's *Dance of Death* series and *Portrait of Brian Tuke*, but despite this, his achievement could be perceived as something distinct from that of his predecessors:

In most other paintings of related subjects, the figure of death appears only as one of the portrait's assigned external symbols. However, here the deep ensoulment [*Beseelung*], the inner relationship between the two figures, is vividly portrayed. Brush and palette in hand, the head slightly tilted to the side, the artist turns inward to listen to the melody which Death plays for him.[6]

The claim that Böcklin's work was more poetic and lyrical than that of his sources ignored the fact that Böcklin was self-consciously associating himself with Holbein, the great German artist who spent a number of years in Basle – Böcklin's own place of birth. This attempt to obscure the meaning of Böcklin's rather old-fashioned allegory indicates the epistemological problems that a generation of Symbolist art caused for historians in the early twentieth century. The fact that it is almost impossible to describe or convey the meaning of Symbolist works even today is not a failure on the part of art historians, but rather a result of the obscurantist intentions of the artists who produced them.

From the very inception of Symbolist painting, detractors associated its vagueness and spiritual emphasis with various spiritualist or occult movements which had become increasingly popular in Europe from mid-century. Indeed, such a pejorative interpretation of Symbolist art condemned it as doing nothing to answer the genuine spiritual needs of Europe. For example, the German philosopher Julius Langbehn (see Chapter 8) derided spiritualism for reflecting only the temporary needs of a materialist society: 'Possibly it [spiritualism] will only remain as long as it takes our materialistic age to convert itself from spiritualism to spiritism.'[7] To him the vogue for spiritualism was a temporary fashion which would eventually be replaced by something more fundamental. Although their motives were very different, Langbehn's criticisms of spiritualism matched Zola's attack on Symbolist art: the art was seen to be ultimately lacking in substance and genuine exploration of contemporary concerns. Indeed spiritualism and the occult were increasingly associated with charlatans and entertainers, although the initial impetus of the movement had been concerned with the amelioration of social conditions and a satisfaction of spiritual needs.

Spiritual séances were brought to Europe from America in the 1850s, and by the 1870s the popularity of spiritualism was indicated by a number of societies and periodicals devoted solely to the practice of communicating with the dead.[8] Séances were either publicly advertised or held in private drawing rooms. Through the officiating 'medium,' spirits of the dead were alleged to speak or even act. Common manifestations of spiritual presence included table rappings, automatic writing and objects which moved by themselves. Often participants claimed to see the spirits of their deceased relatives or to hear the voices of the dead coming through the mouth of the medium. The fact that many of the mediums were attractive working-class women added a frisson of sexuality to the spiritual communication, while paradoxically they were endowed with a power and authority that subverted the gender and class stereotypes of nineteenth-century society.[9] Furthermore, because spiritualism appealed to the less material side of human nature, it was embraced by a large portion of the working class who saw in it some answer to their increasingly unsatisfactory lives:

> No great poet, artist, or musician ever lived, probably, who was not conscious of spiritual influx . . . Foremost among those who have opposed slavery, vice, intemperance, the legal and moral subjection of women, and the tyranny of narrow creeds, – who have advocated prison reform, education, and the maintenance of peace, have been, to their honour, a whole army of the despised spiritualists.[10]

But such positive associations were not dominant, and although many who practised spiritualism had a sincere belief in its edifying potential, others were deceivers capitalizing on an appealing fad. Spiritualists were frequently discredited publicly and subjected to numerous tests of their

validity. Furthermore, in the wake of Charcot's studies of hysteria, it is not surprising that spiritualists – like women generally, artists, writers and anarchists – were labelled as insane. In their psychological-artistic study, *Les Démoniaques dans l'art*, Charcot and Charles Richer used religious art from the past to 'prove' that what had been construed previously as possession by demons was actually an example of hysteria.[11] By pairing artistic representations of demonic possession and religious ecstasy with descriptions of hysterical patients at Sâlpetrière, Charcot and Richer implicitly dismissed any spiritual explanations, and indeed revealed their own anti-clerical biases.[12] The ecstasy of spiritualists was considered to be the modern equivalent of demonic possession, which was equally discredited by scientists. Artists of the *fin de siècle* who represented demons or monsters were implicitly embracing the rhetoric of spiritualism, while rejecting scientific explanations of such phenomena. Although few artists represented séances, the themes of spiritualism and possession found their way into a number of Symbolist paintings by artists such as Vrubel, Munch, Ensor and Gauguin.

Mikhail Aleksandrovich Vrubel was a Russian who abandoned a potential career in law to study art. He was inspired by Venetian and Byzantine art of the Middle Ages, and through his work on the restoration of wall paintings in St Cyril in Kiev, he became interested in the decorative and spiritual potential of medieval art. Vrubel was one of many *fin de siècle* artists who was committed to an insane asylum (see Chapter 4), and undoubtedly his eventual insanity served to enhance the significance of his work for his successors – the Russian Blue Rose group who exhibited together in Moscow from 1907. Vrubel's obsessions with mythical and imaginary subjects must have contributed to his posthumous reputation, and one of his most repeated themes was *The Demon*. Although based on a poem by Lermontov, Vrubel's 'demons' were not just Romantic literary illustrations, but they had both spiritual and spiritualist significance in the light of his own interest in medieval art. The demon was a spiritual figure, evoked in a 'decorative' anti-realist style, and signifying not the positive side of spiritual life, but rather its antithesis. One of the greatest objections to spiritualism in Europe came from clerics, who related the practice of raising spirits to devil-worship and who warned the proponents of spiritualism of the likely consequences of such communion with evil powers. Although spiritualists refuted such a negative construction of their belief, many Symbolist artists actively evoked the Satanic implications of spiritualist communion. The demon became not simply an agent from the 'devil', but the evil within man; demonic possession became secularized.

This secularization of the demon can be seen in the works of both Munch (Figure 50) and Ensor. Munch's famous painting, *The Vampire* (1893–1894, Oslo, Munch Museum) was originally given the title 'Love and Suffering' by August Strindberg, whose interpretations were generally well in line with Munch's own ideas.[13] Munch was therefore not presenting a literal rendering of a folk myth, but a symbolic representation of the painful and evil aspects of love. *The Vampire* predates the publication in England of Bram Stoker's *Dracula* (1897), although in many ways the two works represent the same blending of spiritualist superstition and subtextual commentary on modern life – indeed, part of the efficacy of *Dracula* is its contemporary setting. Stoker took pains to lull his readers into a sense of familiarity by constant reference to recent controversies, inventions and scientific discoveries: phonographs, blood transfusions, typewriters and Charcot's theories of hysteria all appear in *Dracula*, but this comfortably familiar world of scientific progress is threatened by the appearance of the vampire himself. One of the novel's protagonists, the sensitive Jonathan Harker, visits Dracula in his Transylvanian castle and discovers the vampire asleep in his lair:

There was a mocking smile on the bloated face which seemed to drive me mad. This was the being I was helping to transfer to London, where, perhaps for centuries to come, he might, amongst its teeming millions, satiate his lust for blood, and create a new and ever widening circle of semi-demons to batten on the helpless.[14]

Throughout *Dracula*, the pestilence of the vampire and his creation of a race of 'semi-demons' become metaphors for the corruption of modern society. It is significant that Dracula himself has recognizably Jewish characteristics, and that the female vampires of the novel are explicitly equated with the 'New Woman'. Superstition is seen as both a reinforcement of racial and social anxieties and an antidote to materialism. As the wise Dr Van Helsing states,

All we have to go upon are traditions and superstitions . . . Yet must we be satisfied; in the first place because we have to be − no other means is at our control − and secondly, because, after all, these things − tradition and superstition − are everything Does not the belief in vampires rest for others − though not, alas! for us − on them? A year ago which of us would have received such a possibility in the midst of our scientific, sceptical, matter-of-fact nineteenth century?[15]

Similarly, *The Vampire* represents Munch's own perspective on the agonies of modern love, and it reveals his construction of women as demons who possess and engulf the men who love them. The demon thus becomes the harbinger not only of evil, but of modernity.

A similar interpretation can be placed on the paintings of James Ensor, whose many depictions of masked figures and skeletons conflate universal themes of death and damnation with a very specific commentary on the evil and artificiality of bourgeois society. In works such as *Intrigue* (1890, Antwerp, Koninklijk Museum), Ensor replaced the real features of the characters he represented by masks which appear leering, lunatic or corrupt; the masks effectively indicate the spiritual corrosion of their wearers, whose real faces may not betray this internal decay. Ensor's work indicates a sort of 'possession', but through the medium of masks, he externalized this internal state. Perhaps for the same reason, Ensor was attracted to the works of the American writer Edgar Allan Poe, some of which he illustrated. Many artists found the spiritualist interests of Poe conducive to visual representation, and others used Poe's ideas without specifically illustrating his many short stories. This is the case in Gauguin's Tahitian painting *Nevermore* (1897, London, Courtauld Institute of Art), the title of which makes a direct allusion to Poe's poem, 'The Raven'. The Raven is a harbinger of doom and disaster, and Gauguin's allusion suggests that his own depiction of Tahitian superstition is intended to have similar foreboding connotations. Poe provided artists with a repertoire of images which represented the spiritualist conflicts between good and evil. But Poe was also known for his skilful evocation of dream imagery, and after spiritualism, dreams were the second major source for *fin de siècle* artists who wished to represent the inner life.

The French artist, Odilon Redon, was the first of his generation to use dream imagery as the basis for his art. Redon's first major series of lithographs, *Dans le Rêve*, and his second, *A Edgar Poe*, both make use of the psychology of dream states, including the tendency to juxtapose unusual objects, and to imagine monsters. Although Redon spent his early years in obscurity, he was 'discovered' by Symbolist artists and praised by Huysmans in 1889 for his skilful representations of monsters.[16] In many ways, the Symbolist glorification of Redon contradicted his own stated

purpose: 'All my originality consists then of making improbable beings come to life humanly according to the laws of the probable, putting, as far as possible, the logic of the visible at the service of the invisible.'[17] Redon's 'monsters' were constructed with the principles of science in mind, and he benefited from the tutelage of his botanist friend Armand Clavaud. Redon's smiling spiders and floating eyeballs were provided with a sort of Darwinian justification (see Chapter 2), and their association with dream imagery further distanced them from the imaginary monsters of occultist belief. To an extent, Redon set the agenda for the artistic use of dream imagery, but his scientific approach and the nature of his images are more easily understood if examined in the context of contemporary dream psychology.

The change in attitudes to dream psychology in the late nineteenth century and its effect on art can be demonstrated by comparing Redon's illustrations of dreams with Oskar Kokoschka's illustrated poem, *Die Träumenden Knaben* (*The Dreaming Boys*) of 1908 (Figure 51). In complete contrast to Redon's 'scientific' explanation for his oneiric monsters, Kokoschka explained such visions in metaphysical terms, In an article 'On the Nature of Visions' (1912), Kokoschka extolled the primacy of the imagination, and the imagination's ability to transform the dull phenomena of everyday life: 'If we will surrender our closed personalities, so full of tension, we are in a position to accept this magical principle of living, whether in thought, intuition, or in our relationships.'[18] Kokoschka realized this theory in *The Dreaming Boys*, in which the poetic text bears little relationship to the lyrical illustrations. Kokoschka effectively 'translated' the text of his poem into a vision which bore a spiritual, rather than a literal, affinity to it. Both Redon's empirical view of dreams and Kokoschka's metaphysical view can be reconciled with a long debate about the nature of dreams which began in the 1870s when Redon was first producing *Dans le Rêve*. This debate not only considered the relationship between dreams and waking life, but also compared dream states to both hypnotism and insanity.

Some earlier dream researchers, such as Professor Heinrich Spitta in Germany, dismissed dreams as manifestations of weakened brain power. Spitta isolated the different phases of sleep, but his conclusions suggested that only waking life was really valuable:

> Those who praise the condition of sleep claim that this state induces the soul to appear as something different than it does in waking life – something majestic, free, divine, which it can never actually be, – only during the waking state, in fully independent activity, in free and rational association of the objective and subjective world, only then can the soul fully and wholly unfold itself, only then at the high point of its self-conscious development can it reach its mystical vision.[19]

Spitta postulated a state between sleeping and waking, which he called 'middle sleep' (*Mittelschlaf*), or 'artificial (*künstliche*) sleep', within which he included drunkenness, narcotic hallucination and delusive insanity. Spitta's association of the lapsed consciousness of sleep with psychological disorders relegated dreams to an inferior position in the life of 'normal' human beings. To a certain extent, Spitta's conclusions were shared by Redon's contemporary P.-Max Simon, whose *Le Monde des rêves* (1888) also compared dreams to hallucinations. Both Simon and Spitta suggested that the dreams of 'normal' individuals were often caused by disturbances in the digestive tract, respiratory ailments or heart problems, thus indicating that dreams were reflexive responses to the physical environment, rather than any real indicator of the soul's activity.[20] But amongst his discussion of pathological hallucination, Simon also considered the relationship

between dreams and artistic creation, and he claimed that dream imagery was often dependent upon art, just as art drew upon dream imagery: in religious hallucinations, images of God and the Virgin Mary 'ordinarily conform to the types adopted by painters and sculptors',[21] and even in sane individuals, dreaming could lead to artistic creativity. If Redon's own dream subjects are considered in light of this debate, they could be seen as playful pastiches of dream imagery, divested of any significant content, or conversely as indicative of pathological states. The insistence that dreams were somehow pathological was reinforced by the French psychologist Moreau de Tours, who claimed that there was 'an absolute identity between the state of dreaming and insanity',[22] whilst Charcot drew similar conclusions about hypnotism, which he claimed could only be enacted upon insane individuals.

However, these dismissive views of dream psychology did not remain dominant. As early as 1879, the German psychologist Paul Radestock had written a book on dreams in which he argued for 'the great significance of dreams in folk psychology', and he developed a positive assessment of the prevailing spiritual power during sleep.[23] Although Radestock also equated dreams with states of madness and hallucination, he put a greater emphasis on the metaphysics of dream psychology. To Radestock, the dreamer was not simply lowered into a weakened state of consciousness, but rather benefited from a heightened spiritual state. This interest in the power of the dream state was shared by the French psychologist Hippolyte Bernheim, who employed hypnotism as a curative, rather than a demonstration of pathology. Bernheim used the term 'ideodynamism' to indicate the energetic spiritual condition that characterized both hypnotism and dreaming.[24] Bernheim's belief in the spiritual energy of dreams – like Radestock's metaphysical view of dream psychology – was later taken up and transformed by Freud.

Freud's *The Interpretation of Dreams* (1899) overturned much traditional understanding of dream psychology, and its impact helps explain the difference between Kokoschka's and Redon's approaches to the illustration of dreams. One of the earliest major works by Freud, *The Interpretation of Dreams* subtly argued for the significance of the unconscious, and the function of dreams as a mediator between conscious and unconscious states. According to Freud, dreams function as wish fulfilment by translating hidden desires into symbolic form. Dreams break down the barriers between the conscious and the unconscious and allow the psychopathological fears and passions which are submerged by the drudgery of daily life to enter the consciousness in an acceptable form.[25] Freud was more concerned with the 'latent' content of dreams than he was with their 'manifest' content, as he felt that the latent content revealed the dream's true meaning in the context of the individual's psychical life. To an extent, Freud's Viennese contemporary Kokoschka made use of these dream 'techniques' in his *Dreaming Boys*. By translating the ideas of the poem into vague, spiritual symbols, he could evoke the 'latent' content of the poem, without reproducing its 'manifest' imagery. Quite apart from the literal dream realizations of Redon, Kokoschka's representations of dreams offered a more subtle interpretation of the vagaries of the inner life.

Between Redon's biological fantasies and Kokoschka's spiritual realities, several artists tackled the subject of dreams as manifestations of personal anxiety. The most famous of these images is *Night* (1896, Berne, Kunstmuseum) by the Swiss painter Ferdinand Hodler. Hodler's work shows a group of people asleep in what appears to be a nature camp outing, but one of these individuals is being disturbed by an anonymous robed figure who rises up to terrorize him. The fearful observer has his eyes open, but everyone else around him continues to sleep. It is significant that the screaming figure is a self-portrait of Hodler, while among the sleeping women are his former

wife and his mistress.[26] Hodler may or may not have been making a statement about himself and his own difficult personal circumstances, but his painting does relate the personal fears of an individual to the nightmare imagery of dreams. The looming robed figure could be death, or some other private terror, but it invades the sleeping consciousness in a concrete form.

Hodler externalized a nightmare terror, and Gauguin tackled a similar theme in his Tahitian painting Le Rêve (Te Rerioa) of 1897, although Gauguin's fearful Tahitian woman is not simply witnessing a manifestation of her own neurotic personality. Gauguin played on his vague knowledge of Polynesian culture to equate the 'dream' with a vision. Although he could rationalize this depiction as a representation of real Tahitian superstition, such an equation of dreams and visions had more to do with western understanding of the spiritual life of 'other' cultures. Radestock himself tackled this theme in his examination of 'Völkerpsychologie'. He claimed that native cultures could not distinguish between dreams and objective reality; their 'visions' were actually the visions of dreams: 'The Negro in South-Guinea interprets all his dreams as visits of the spirits of his departed friends.'[27]

Gauguin's interest in religious and spiritual life dominated his paintings of the late 1880s. Indeed, it is through a new evaluation of the worth of religion in contemporary society that Symbolist art found its most fruitful source of inspiration. Interest in spiritualism and dreams were part of a more general growing obsession with extreme forms of Catholicism, the religions of the East, and the new 'religion' of theosophy. These religious manifestations of the inner life affected not only Gauguin and his followers, but the Nabi group and the artists who exhibited at the Salon de la Rose + Croix.

The crisis in belief which characterized the latter part of the nineteenth century cannot be overestimated, and has already been considered in this chapter. However, it would be simplistic to suggest that people in nineteenth-century Europe fell easily within the two opposing camps of those who adhered to traditional religious faiths and those 'atheists' who had surrendered their belief to the supremacy of science. The pull of religion was still very popular, but its power manifested itself in different ways. First of all, in Belgium, France, Germany and Austria, Catholicism became politicized by right-wing traditionalists in the upsurge of such movements as ultramontanism in France and the creation of Catholic political parties such as the Centre Party in Germany. In many instances, such politicized Christianity not only opposed the half-measures of liberal governments, but fostered anti-semitic, monarchic and jingoistic sentiments among its followers. A second, and opposing, development in the religious life of Europe led people to search for alternatives to traditional Christianity, and eastern religions – including Judaism – were seen as more effective responses to spiritual needs.

The extremist responses to religious crisis in Europe provided inspiration for Symbolist painting. When Gauguin went to Pont Aven for the first time in 1886, he was only one of many artists who travelled there in the hopes of finding an undisturbed, 'primitive' and picturesque landscape to paint. Certainly, Brittany had been a popular subject with a number of realist artists such as Dagnan Bouveret. However, Gauguin's eventual involvement with other artists, including the perceptive Émile Bernard, led to a re-evaluation of the folk culture of Brittany in terms of its religious and spiritual significance. Bernard's interest in the philosophy of Plato and Schopenhauer, and in the mysticism of the eighteenth-century Swede Emanuel Sweden-borg influenced Gauguin's own understanding of the simple religious piety of the Breton peasants, and Bernard's stylistic experiments – which involved a use of flat patches of unmixed colour – had an impact on Gauguin's simplification of form. When Gauguin painted

The Yellow Christ (Figure 52), he based the representation on a wooden crucifix at a chapel near Pont Aven, and his Vision After the Sermon (Figure 53) interpreted the imagination of Breton women who literally see the subject of their sermon – Jacob wrestling with the angel – before their eyes. The stylistic innovation in Vision After the Sermon can also be attributed to Gauguin's growing interest in the formal structure and perspectival simplicity of Japanese prints, which he used in order to attempt to create a metaphor for the spiritual life: in his art the 'exotic' Japanese became easily equated with the 'exotic' Breton peasants, and by extension the spiritual life of the East was used as a metaphor for the simpler state of piety in 'backward' western societies.

Several of Gauguin's followers embraced this religious pluralism more fully only to step aside from it and wholeheartedly adopt the Catholic faith. This is not only true of Jan Verkade, who became a monk, but also of the Danish artist Mogens Ballin who renounced his Judaism to join the lay order of St Francis. Verkade was one of the members of an artistic group called the Nabis, whose very name rather archly reflected its pseudo-religious function. Nabi is in fact Hebrew for 'Prophet', and the Nabis felt that they served this ancient religious function through their art. To a great extent, the Nabi movement involved cultish role playing, most notably exemplified by Alexandre Séon's portrait of Paul Élie Ranson wearing fancy dress, holding a sceptre and reading from a 'sacred book'. The group had its own secret ceremonies, met regularly in a 'Temple' and called each other 'Brother'. Both their art and their writing revealed their interest in the doctrines and parables of non-Christian religions, including Buddhism, Zoroastrianism and ancient mythology. Ranson's painting Christ and Buddha (1890; private collection) juxtaposed the crucified Christ with a conventional Buddha figure, a Hindu lotus and an Arabic inscription. A similar sort of pluralism appears in Maurice Denis's statement about the purpose of art in an article which appeared in Art et Critique (1890). Defining this new tendency in art as 'Neo-Traditionism', Denis praised the decorative spiritualism of past religious art:

> In the beginning, pure arabesque, as little trompe l'oeil as possible; a wall is empty: then filled with symmetrical patches of form, harmonies of colours (stained-glass, Egyptian paintings, Byzantine mosaics, kakemonos).
> Then comes the painted bas-reliefs (the metopes of Greek temples, the church of the Middle Ages).[28]

And he continued, 'Great art, which is called decorative, of Hindus, of Assyrians, of Egyptians, of Greeks, the art of the Middle Ages and of the Renaissance, and works decidedly superior to modern art, what is it? other than the dressing up of vulgar sensations – of natural objects – in sacred, hermetic, imposing icons.'[29] Denis's approach respected the artistic production of non-western and early Christian cultures while implicitly condemning the areligious positivism that lay behind much contemporary realist and Impressionist art.

Denis's evaluation also needs to be understood in relation to the growing influence throughout Europe of the Theosophical Society, a pseudo-religious movement which encouraged receptivity to non-western religions, and provided a fruitful source and inspiration for artists. To an extent the Theosophical Society itself was a reaction to the new scrutiny given to comparative religions and myths from the 1860s. Like many such spiritual manifestations, eastern religions were subjected to the kind of scientific classification that was being applied to all branches of society. The Professor of Comparative Philology at Oxford, Friedrich Max Müller,

for example, published a number of works in which he attributed the myths of ancient and primitive societies to various linguistic mistakes which had somehow been perpetuated through the ages. Müller's rational interpretation of irrational mythology did not satisfy some anthropologists who saw the basis of myth in primitive responses to nature, rather than in etymological confusions. One of the most notable of these objectors was Andrew Lang, whose *Myth, Ritual and Religion* (1887) attacked Müller's philological methodology. Lang suggested that a linguistic interpretation of myths was inadequate because different cultures with different languages produced similar mythologies. Lang suggested an evolutionary theory of myth-making which developed from man's initial response to nature: 'Comparative Anthropology studies the development of law out of custom; the development of weapons from the stick or stone to the latest repeating rifle; the development of society from the horde to the nation.'[30] In a later work, Lang made his evolutionary theory of myth explicit: 'The archaeologist and the student of Institutions . . . demonstrate that our weapons and tools, and our laws and manners, have been slowly evolved out of lower conditions, even out of savage conditions.'[31] This interpretation indicated that evolution was not simply an adaptation of physical form to the environment, but an adaptation of the mental life of mankind as well: 'We [anthropologists] argue . . . that religious and mythical faiths and rituals which, among Greeks and Indians are inexplicably incongruous have lived on from an age in which they were natural and inevitable, an age of savagery.'[32]

The theories of Lang and his circle made an impact on both art and architectural theory. In order to understand a work such as Gustave Moreau's *Jupiter and Semele* (1896, Paris, Musée Gustave Moreau), it is important to remember the anthropological debates that were being conducted in Europe at the time. In representing a mythological subject, Moreau was in many ways producing a work belonging to a genre of European history painting traditionally advocated by educated patrons. However, Moreau's work was not simply a straightforward representation of a mythological story. By his own testimony, he intended this myth of the god who reveals his full holy glory to a mortal woman and thereby destroys her to have a wider symbolic function.[33] While producing this work, Moreau was immersed in the study of comparative religions, and was especially interested in Manichaeism, a third-century philosophy which suggested that the universe existed as a diametrical opposition between dark and light, and that religion's purpose was to release the light which had been stolen from the world by Satan. Moreau's loose interpretation of Manichaeism in *Jupiter and Semele* encompassed these principles in the oppositions of good and evil, man and woman, power and weakness, but his own explanation of the work was so bound up in eastern mysticism that it is almost impossible to see this apparent oppositional clarity. Indeed, Moreau seemed to obscure his meaning deliberately, making the observer fight to recover his complex spiritual intention.

Although Moreau was not directly influenced by Lang's work, the English architect William Lethaby developed a theory based explicitly on Lang's findings. Lethaby's *Architecture, Mysticism and Myth* (1892) tried to trace the origins of architectural forms to primitive understanding of the universe. In Lethaby's view, architecture was originally seen to be a microcosm of the universe, where the sky was the 'ceiling', the golden gate of heaven was the 'door', and the sea was the 'pavement'. Lethaby referred directly to Müller and Lang, although he slightly misunderstood their divergence on the topic of myths: 'Mr Max Müller, Mr Andrew Lang, and Dr Taylor are certainly agreed that to a large extent what is now mythology was once an explanation of nature.'[34] In his introduction, Lethaby claimed to be setting out universal 'esoteric' principles of

architecture, rather than presenting a utilitarian history.[35] His reference to 'esoteric' principles was a conscious allusion to the teachings of the Theosophical Society.

In many respects, the Theosophical Society itself filled a gap left by the scientific approach of Müller, and even the less rigid evolutionary theory of Lang. The Society had its origins in a lecture delivered in New York in September 1875 on 'The Lost Canon of Proportion of the Egyptians, Greeks and Romans'. This lecture was attended by Helena Petrovna Blavatsky who, from this point onwards, began to consider the hidden meanings inherent in non-western religions and founded the Theosophical Society on the basis of their teachings. In 1879, Blavatsky travelled to India with Colonel Olcott, and continued to conduct her explorations into the life of the spirit. Her theories were systematically attacked by Müller, who derided them as 'Esoteric Buddhism'[36] for what he saw as their consistent inaccuracy, but Blavatsky's version of theosophy had a world-wide popular following which took the study of comparative religions out of the hands of academics, and placed it very firmly within the public domain.

The most lucid explanation of theosophy is contained in Blavatsky's own book, *The Key to Theosophy* (1889), which professed to be a handbook for the ignorant beginner.[37] The *Key* was cleverly conceived as a long question and answer session, in which a nameless sceptic queries 'The Theosophist' about the goals and intentions of the Society, and its achievements. Although this work is very wide-ranging, several recurring motifs indicate what Blavatsky felt was significant about the movement: the quest for secret knowledge, the achievement of self-improvement, and humanitarianism. The first of these – the quest for secret knowledge – is actually suggested by the very name 'theosophy' which means 'divine knowledge or science'; this 'divine knowledge' was presented as universal, rather than specific to any particular religion or country. Indeed, Blavatsky praised the open-mindedness of the theosophists who would accept (almost) anyone within their organization:

> The Fellows [of the Theosophical Society] may be Christians or Mussulmen, Jews or Parsees, Buddhists or Brahmins, Spiritualists or Materialists, it does not matter; but every member must be either a philanthropist, or a scholar, a searcher into Aryan and other old literature, or a psychic student.[38]

The divine knowledge which the theosophists sought was not the 'exoteric', or public, form of religious worship, but the 'esoteric', or secret, doctrines. Within this sphere, the teachings of Confucius, Zoroaster, Buddha, Christ, Socrates and Plato were all considered significant. The second major lure of theosophy was its emphasis on individual development. Using a modified version of Buddhist teaching, Blavatsky proposed seven spheres of human existence, four of which (Rupa or Sthula-Sarira, Prana, Linga Sharira, Kama Rupa) were physical or lower beings, and three of which (Manas, Buddhi and Atma) were higher or spiritual beings. When a person died, he would shed his outer body, and depending on how he had led his life, he could ascend to a higher spiritual plane, or descend to become reincarnated in a new earthly body. The law of Karma (fate or retribution) suggested that the reincarnated spirit would suffer on earth for the sins of the previous life. In order for the individual spirit to become united with the world spirit and attain Nirvana, self-improvement in earthly life had to be sought. This improvement was attained by renouncing egoistical goals in favour of humanitarian ones, and it is this humanitarianism which comprised the third major attraction of theosophy. Indeed, theosophy was aggressively anti-materialist, and its rejection of capitalist society was hardly less explicit:

We, Theosophists, say that your vaunted progress and civilization are no better than a host of will-o'-the-wisps, flickering over a marsh which exhales a poisonous and deadly miasma. This, because we see selfishness, crime, immorality, and all the evils imaginable, pouncing upon unfortunate mankind from this Pandora's box which you call an age of progress . . . At such a price, better the inertia and inactivity of Buddhist countries, which have arisen only as a consequence of ages of political slavery.[39]

Many theosophists were committed socialists, and Blavatsky herself wrote of them as 'practical altruists – preaching most unmistakable Socialism of the highest type'.[40] This combination of hermeticism, personal development and social consciousness appealed to many people who were disillusioned with contemporary society. Theosophy served both political and social needs, and it retained just enough mystery and controversy to provide an additional allure to its various proponents.

The widespread appeal of theosophy among artists was certainly due to such attractions, but artists also found much in theosophy that contributed to their own experiments with both style and subject-matter. First of all, theosophy provided the more traditional artists with new subjects for illustration, as its exposure of eastern religious practices appealed to the voyeuristic curiosity that many Europeans and Americans felt for exotic cultures (see Chapter 8). Buddhas were a particularly popular subject. but other works could refer more vaguely to the mysteries of foreign religious practices. For example, the British sculptor George Frampton produced a work which he called *Mysteriarch* (1892, Liverpool, Walker Art Gallery) – alluding vaguely to esoteric mysteries of existence. Frampton's work was an example of the 'new sculpture' movement, which attempted to bring into sculpture some of the idealism normally associated with easel painting.[41] The 'new sculpture' was not intended to be unequivocal, and by evoking theosophical mysteries, the meaning of the sculptured form could be extended.

Secondly, theosophy's exploration of the soul inspired a number of artists in their attempt to paint the state of the soul. This is particularly true of the work of the American artist Elihu Vedder, who spent most of his career in Italy and was strongly influenced by the Pre-Raphaelites and their followers. Vedder is best known for his illustrations to Edward Fitzgerald's translation of the *Rubáiyát* of the early twelfth-century Persian poet Omar Khayam – an example of one of several exotic texts that were being rediscovered in the nineteenth century. Through the influence of Fitzgerald, English art and theosophy, Vedder turned to depictions of the soul, including *The Soul in Bondage*, and *The Sorrowing Soul Between Doubt and Faith* (Figure 54). This interest in the quest of the soul related directly to the theosophical idea that the soul 'decides' after death whether to pursue the upward path towards Atma, or to return back to earth to be reincarnated within a physical body. Vedder's interest in theosophical ideas can also be seen in another work which he produced in the same period – *The Keeper of the Threshold* – (1898, Pittsburgh, Museum of Art, Carnegie Institute). The word 'threshold' was a theosophical metaphor for the divide between the physical and spiritual spheres, and Vedder underlined this implication by placing the painted figure in the pose of Buddha.

Aside from such specific borrowings of theosophical ideas, artists drew on theosophy in other ways. In attempting to create an art which expressed something beyond itself, Symbolists could turn to theosophy as an example: subject-matter became the 'exoteric' material which concealed the 'esoteric' meaning. The very vagueness and lack of definition in Symbolist art could be taken as a clue to the initiated. The Nabi group capitalized on such mystification and used it to their own advantage as a rationalization of their experiments with style and subject-matter. When such

works as Séon's portrait of Ranson are considered in this light, the obscure significance of the fancy dress begins to become clearer. However, Denis himself reacted rather ambivalently to the theosophical tendency of the Nabi group. He was not a theosophist himself, but a devout Catholic, who hoped to revive religious subject-matter through works such as his *Catholic Mysteries* (1890, Alençon, J.F. Denis Collection). Denis's painting is a modification of the traditional Annunciation scene. The Virgin sits submissively in a chair, while the angel Gabriel enters the room preceded by two young boys with candles. The work combines a sense of ritual with the conventional iconography of this Christian scene. The relationship between theosophy and Catholicism is a problematic one, as theosophists did not reject Catholics, although Catholicism rejected theosophists. However, this relationship was further complicated by the various political associations of the two divergent tendencies. While theosophists had democratic, even socialist, sympathies, Catholics in Europe were increasingly associated with the traditionalist political Right. The importance of Roman Catholicism to the Symbolist movement was widely acknowledged at the time, as artists such as Denis and writers such as Huysmans either converted to Catholicism or intensified their Catholic sentiments to reinforce their aesthetic tendencies.

Catholicism and esoteric cults converged in the Salons de la Rose + Croix one of the most bizarre artistic groupings of the late nineteenth century. The Salons originated as the Ordre Kabbalistique de la Rose + Croix, first founded in 1889. This 'Order' was soon to lapse, but was revived in 1892 by its adherent, Joséphin Péladan, as a specifically artistic organization. Péladan's advocacy of a neo-Platonic cult of androgyny has already been discussed (Chapter 5), but his more general involvement in the Rose + Croix indicates the confusions that arose in religious beliefs of the *fin de siècle*. The very title 'Rose + Croix' was a deliberate reference to the Rosicrucian cults of sixteenth-century Germany. These so-called 'secret societies' actually originated from the sixteenth-century writings of J.V. Andreae, whose Lutheran satires on Catholicism included a story about 'Christian Rosenkreutz' who founded a secret society based on the mysteries of Arabic religions. Although this work was intended to be a satire, readers at the time believed its pronouncements, and a series of real secret societies slowly emerged throughout Europe. It is ironic that Péladan, himself a militant Catholic, should have turned for inspiration to a society based originally on the writings of a Lutheran, but such apparent contradictions are typical of the religious climate of the late nineteenth century.

The first exhibition of the Rose + Croix took place in Paris in March 1892. To underline the religious nature of the group, the exhibition was opened by a mass at St Germain l'Auxerrois. Six further salons followed, attracting such artists as Jean Delville, Fernand Khnopff and Jan Toorop, although several artists favoured by Péladan, such as Puvis, Burne-Jones and Moreau, refused to be involved. Péladan's aim was to abolish the influence of realism in art, and to replace it not simply with a Symbolist religiosity, but with a specifically Catholic form of mysticism. Péladan adopted the title of the Sâr, or Magus, and even after his exhibitions ceased, he continued to parade his aesthetic ideas through a series of unreadable novels produced in the late 1890s. Péladan's Catholicism was linked with the traditionalist ideals of powerful European right-wing movements. He stated, 'I believe in Ideal, Tradition and Hierarchy',[42] and in so doing he inherited the sentiments of his father who favoured not only Catholicism, but aristocracy and monarchy. It was partly due to Péladan and his imitators that Nordau was to associate Symbolism with Catholicism. Of Symbolist works, Nordau claimed, 'They are vague . . . and they are pious', and he linked them with the Jesuits, who, he claimed, 'invented the phrase ''bankruptcy of science'' '.[43]

Péladan's inspiration for the revived order of the Rose + Croix came when he visited Bayreuth in 1888 in order to witness performances of Wagner's operas in the composer's own Festspiel-haus. Although Wagner himself had died in 1883, it was only after his death that his work became a powerful influence on the European Symbolist movement. Among the various manifestations of the inner life which were influential on art of the *fin de siècle* – including spiritualism, dreams and the fragmentation of religion – music was the most elusive, but in many ways the most persistent, and Wagner's own theoretical and creative contribution offered a paradigm for the other arts.

The relationship between art and music is obviously a complex one. As long as art was based upon an imitation of reality, its affinity with music was less apparent than its links with literature. However, the reactions against realist art in the late nineteenth century led to a rejection of the literary analogies in favour of the more abstract, musical associations. One of the earliest painters to articulate this analogy was James MacNeill Whistler, whose various 'Nocturnes' and 'Symphonies' avoided the narrative associations of most contemporary painting. Whistler's works evoked a mood, rather than told a story, and it was the power of music to arouse such inner sensations that led artists to be attracted to its principles in the 1890s. A similar evocation of mood characterized Max Klinger's *Brahmsphantasie* – an album of fourteen etchings which the artist presented to Brahms on the occasion of his 60th birthday. Klinger classified his etchings in opus numbers, and his individual illustrations were intended to evoke the mood of Brahms's *lieder*, rather than illustrate their imagery. Klinger's artistic theory, *Malerei und Zeichnung* (*Painting and Drawing*) (1871) had extolled drawing and engraving as a more appropriate expression of feeling than painting: the feeling, according to Klinger, was aroused through the power of the design itself.

Although both Whistler and Klinger attempted to find a way to convey musical expression through visual imagery, many artists who were inspired by music were frustrated in their attempts to carry the artistic analogies to any satisfactory conclusion. Often paintings with musical associations were little more than illustrations of the stories of opera. Of the many artists who admired Wagner, few of them found a means of conveying their admiration apart from rather straightforward illustrations of his various operas. The paintings of scenes from such works as *The Flying Dutchman* and *The Ring of the Niebelung* by the American Albert Pinkham Ryder, Henri Fantin-Latour and Jean Delville are really narrative pictures, despite the attempts of Delville and Ryder to convey mood through soft-focus effects. The admiration for Wagner among Symbolist artists found a stronger expression through the adoption of his musical theory, especially his idea of the *Gesamtkunstwerk*, or total art work.

Wagner's theories of art were translated into several languages and had a large readership in the 1890s. Wagner believed in the regenerative power of art (see Chapter 8), but he also saw art – in its broadest sense – as a substitute for the failing religion of the modern age:

> One might say that where Religion becomes artificial, it is reserved for Art to save the spirit of religion by recognizing the figurative value of the mythic symbols which the former would have us believe in their literal sense, and revealing their deep and hidden truth through an ideal presentation.[44]

The religious nature of art was reiterated in another essay 'The Art-Work of the Future', which proposed a reunification of the arts of music, painting, dance and poetry that Wagner claimed had been separated over the centuries.[45] This idea was seized upon by artists in the last years of

the nineteenth century and the early years of the twentieth. In Russia, for example, the World of Art group, which included Sergei Diaghilev, Léon Bakst and Alexander Benois, were instrumental in the founding of the Ballet Russe, whose first performance took place in Paris in 1909; the original productions of Stravinsky's *Firebird* (1910), *Petrushka* (1911) and *The Rite of Spring* (1913) were among its achievements. In each of these ballets, new forms of choreography were combined with innovations in set design and music to create a sort of *Gesamtkunstwerk*, and certainly the productions represented one of the most successful attempts to unify the arts in the wake of Wagner.

However, some artists took the idea of the *Gesamtkunstwerk* a step further and attempted to transcend mere unity to achieve synthesis. These descendants of Wagner sought not just to link the arts together in an artificial way, but to create synaesthesia, or the evocation of one sense organ by appeal to a different sense organ. Synaesthesia implies that colours have noise, or smells have visual qualities. This was much more difficult for artists to achieve than a mere *Gesamtkunstwerk*, but the Russian composer, Scriabin, attempted to do so in his musical composition 'Mysterium', which used not only music and dancing, but lighting, chanting and incense.[46] Another advocate of synaesthesia was the artist Vassily Kandinsky, whose unproducable play *The Yellow Noise* included in its cast of characters 'Five Giants, Vague Creatures, Tenor (Backstage), A Child, A Man, People in Flowing Robes, People in Tights, Chorus (Backstage)',[47] and conveyed its effects through colours, sounds and movement, rather than language. Kandinsky was influenced by the philosophy of Rudolf Steiner, whose 'anthroposophy' was a modification of Blavatsky's theosophy, which placed mankind, rather than the Godhead, at its centre. Kandinsky and Scriabin were both attempting to use music and the union of the arts to reach new spiritual depths, but were both hindered by the limitations of the media in which they were working.

Perhaps the most successful union of music, art and spiritual significance was achieved at the fourteenth Vienna Secession exhibition (1902), which was dedicated to Beethoven. The artists of the Vienna Secession chose this theme because they hoped to turn the exhibition itself into a sort of *Gesamtkunstwerk*, in which observers would enter to worship at the shrine of Beethoven. For the exhibition, the interior of the Secession building was indeed designed like a shrine, which had echoes of a Mycenaean palace, an Etruscan tomb or an early Christian basilica. At the centre of this shrine was Max Klinger's statue of Beethoven sitting semi-nude on a throne and facing an eagle. The visitor to the exhibition could not reach this statue directly, but had to walk around a demarcated passageway through which the statue could be occasionally glimpsed. According to one contemporary account, the visitor was made to feel as if he or she was engaged in an act of devotion.[48]

One of the most interesting parts of the exhibition was a frieze by Klimt, which covered the wall of the first corridor. This frieze was broken into three parts, and Klimt explained their significance in the exhibition catalogue:

The three painted walls form a coherent sequence. First long wall, opposite the entrance: longing for happiness. The sufferings of Weak Humanity, who beseech the Knight in Armour as external, Pity and Ambition as internal, driving powers, who move the former to undertake the struggle for happiness. Narrow wall: the Hostile Powers. The giant Typhoon, against whom even the Gods battle in vain; his daughters, the three Gorgons, Sickness, Mania, Death. Desire and Impurity. Excess. Nagging Care. The longing and

desires of mankind fly above and beyond them. Second long wall: longing for happiness finds repose in Poetry, the Arts lead us into the Kingdom of the Ideal, where alone we can find pure joy, pure happiness, pure love. Choir of Heavenly Angels, 'Freude Schöner Götterfunke' 'Diesen Kuss der ganzen Welt'.[49]

It is possible to follow the frieze through with reference to Klimt's explanation, but the allegorical figures and the progression from suffering to joy is made clearer by Klimt's quotations from the choral movement of Beethoven's Ninth Symphony with which he ends his description. In fact, the interpretation of the Ninth Symphony in terms of a movement from despair to joy was first articulated by Wagner in his draft programme for a performance of the Symphony in Dresden in 1846. In these notes, Wagner wrote that the Ninth represented 'A struggle, in the most magnificent sense of the word, of the soul fighting for happiness against the oppression of that hostile power who interposes himself between us and earthly happiness.'[50] In his later essay on Beethoven, Wagner reiterated his interpretation of the Ninth Symphony:

> The C-Minor Symphony appeals to us as one of those rarer conceptions of the masters in which a stress of bitter passion, the fundamental note of the commencement, mounts rung by rung through consolation, exaltation, till it breaks into the joy of conscious victory.[51]

To Wagner, Beethoven revealed the goodness of mankind in the face of the world's sorrows; he described the choral section of the symphony as an antidote to a nightmare:

> This unprecedented stroke of art resembles nothing but the sudden waking from a dream, and we feel its comforting effect upon the tortured dreamer; for never had a musician led us through the torment of the world so relentlessly and without end.[52]

This vision of joy and sorrow epitomizes the tensions which characterized the spiritual concerns of *fin de siècle* Europe. While the disillusioned population sought escape from a materialistic world, artists fed that need of escape through their use of music, spiritualism, dreams and religion. But an escape from degenerate society did not provide a cure for that society's sickness. The perceived agents of cultural regeneration were much more drastic and even painful than other-worldly spiritual balms.

NOTES

1. Sigmund Freud, *Civilization and its Discontents*, ed. James Strachey (London, 1979), 2.
2. *Regeneration* (London, 1895), 122, 97.
3. Johannes Manskopf, *Böcklins Kunst und die Religion* (Munich, 1905), 1.
4. *Le Figaro*, 2 May 1896, quoted in Richard J. Wattenmaker, *Puvis de Chavannes and the Modern Tradition*, exhibition catalogue, Art Gallery of Ontario (Toronto, 1975), 4–5.
5. G.-Albert Aurier, 'Le Symbolisme en peinture: Paul Gauguin', in *Oeuvres posthumes* (Paris, 1893), 215–16.
6. Manskopf, 15.
7. Julius Langbehn, *Rembrandt als Erzieher* (Leipzig, 1890), 86.
8. See especially, Janet Oppenheim, *The Other World: Spiritualism and Psychical Research in England 1850–1914* (Cambridge, 1985), and for a more general account, see Derek Jarrett, *The Sleep of Reason: Fantasy and Reality from the Victorian Age to the First World War* (London, 1988).
9. This is discussed in Alex Owen, *The Darkened Room: Women, Power and Spiritualism in Late Victorian England* (London, 1989).
10. S.E. Gay, *Spiritualistic Sanity: A Reply to Dr Forbes Winslow's 'Spiritualistic Madness'* (London, 1879), 32–3.
11. J.-M. Charcot and Paul Richet, *Les Démoniaques dans l'art* (Paris, 1887).
12. See Jan Goldstein, 'The Hysteria Diagnosis and the Politics of Anticlericalism in Late Nineteenth-Century France',

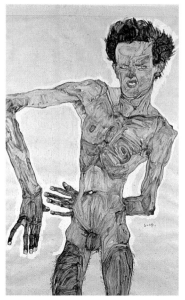

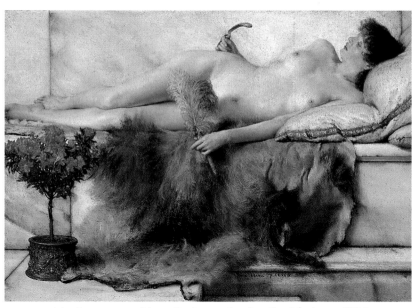

43 Egon Schiele, *Standing Nude, facing front* (self-portrait), 1910, Vienna

44 Lawrence Alma Tadema, *In the Tepidarium*, 1881, Lady Lever Art Gallery, Liverpool

45 Giovanni Segantini, *The Punishment of Lasciviousness*, 1891, Walker Art Gallery, Liverpool

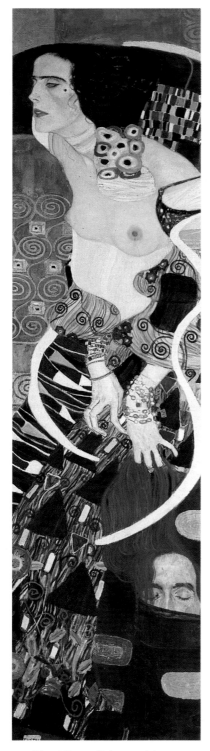

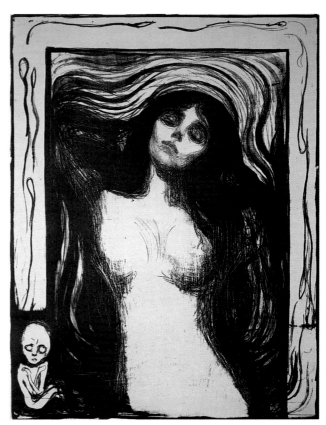

47 Edvard Munch, *Madonna, Loving Woman*,
Christie's, London

46 Klimt, *Salome*, Museo
d'Arte Moderna, Venice

48 Paula Modersohn-Becker, *Little Girl Pushing a
Pram*, 1904, Worpsweder Kunsthalle, Stade

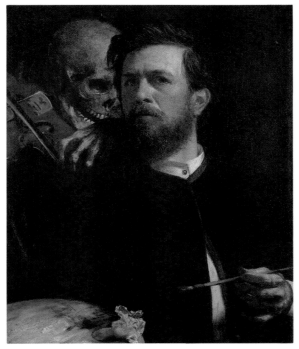

49 Arnold Böcklin, *Self-Portrait with Death*, 1872,
Staatliche Museen zu Berlin, Germany

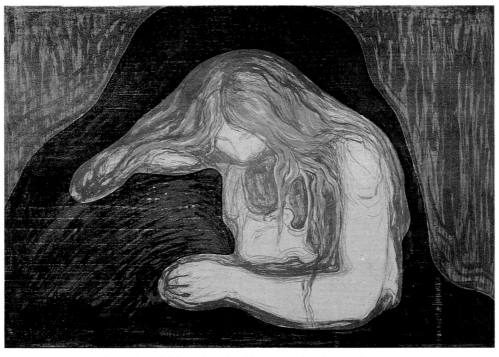

50 Edvard Munch, *The Vampire*, Christie's, London

51 Oskar Kokoschka, *Die Traumenden Knaben*, 1908,
British Museum, London

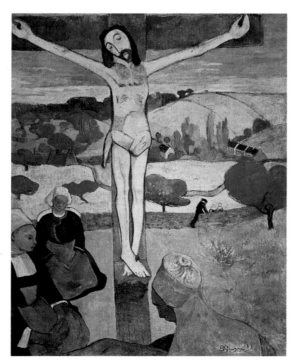

52 Paul Gauguin, *The Yellow Christ*, 1889,
Albright-Knox Art Gallery, Buffalo, New York

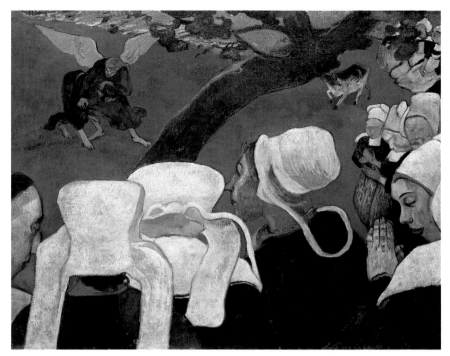

53 Paul Gauguin, *The Vision after the Sermon: Jacob Wrestling with the Angel*, 1888, National Gallery of Scotland, Edinburgh

54 Elihu Vedder, *The Sorrowing Soul Between Doubt and Faith*, c1887, Herbert F. Johnson Museum of Art, Cornell University, Ithaca, New York

55 Claude Monet, *Haystacks at Giverny*,
Private Collection

56 Akseli Gallen-Kallela, *The Story of Kullervo*, 1899,
Ateneum Helsinki

57 Pekka Halonen, *Winter's Day in Karelen*, 1896,
National Museum, Stockholm

58 Ceiling of the Gueli Crypt in the Sagrada Familia
Cathedral, Barcelona, designed by Antonio Gaudi

59 Paul Gauguin, *Ta Matete*, 1892, Kunstmuseum, Basel

60 Franz Marc, *Fate of the Animals*, 1913,
Offentliche Kunstsammlung, Basel

Journal of Modern History, 54 (1982), 209–39.
13. See Reider Dittmann, *Strindberg and Munch in the 1890s* (Epping, 1982).
14. Bram Stoker, *Dracula* (1897) (Oxford, 1983), 51.
15. Ibid., 237–8.
16. J.-K. Huysmans, *Certains*, 2nd ed. (Paris, 1904).
17. Odilon Redon, À *soi-même*, 2nd ed. (Paris, 1961), 26–7.
18. Oskar Kokoschka, 'Von der Natur der Gesichte', in *Schriften 1907–55* (Munich, 1956), 339, quoted in Hereschel B. Chipp, *Theories of Modern Art* (Berkeley and LA, 1968).
19. Heinrich Spitta, *Die Schalf- und Traumzustände der menschlichen Seele* (Tübingen, 1878), 9.
20. P.-Max Simon, *Le Monde des rêves* (Paris, 1888), 40.
21. Ibid., 78.
22. Moreau de Tours, 'De l'identité de l'état de rêve et de la folie', *Annales médico-psychologique*, 3rd series, 1 (1855), 302, quoted in Ruth Harris, *Murders and Madness: Medicine, Law and Society in the Fin de Siècle* (Oxford, 1989), 48.
23. Paul Radestock, *Schlaf und Traum: eine physiologisch-psychologische Untersuchung* (Leipzig, 1879), ix.
24. See Hippolyte Bernheim, *Hypnotisme, suggestion, psychothérapie* (Paris, 1891), 23–4.
25. Sigmund Freud, *The Interpretation of Dreams* (1899), in *The Complete Psychological Works of Sigmund Freud* (London, 1958).
26. See Sharon Hirsh, *Ferdinand Hodler* (London, 1982).
27. Radestock, 8.
28. Maurice Denis, 'Definition du Néo-Traditionism', in *Théories par Maurice Denis 1890–1910*, 4th ed. (Paris, 1920), 7.
29. Ibid., 12.
30. Andrew Lang, *Myth, Ritual and Religion* (London, 1887), 28.
31. Andrew Lang, *Modern Mythology* (London, 1897), viii.
32. Ibid., ix.
33. For a discussion of this painting and Moreau's comments on it, see Julius Kaplan, *The Art of Gustave Moreau* (Ann Arbor, 1972).
34. William Lethaby, *Architecture, Mysticism and Myth* (London, 1892), 32–3.
35. Ibid., 1.
36. Max Müller, 'Esoteric Buddhism', *Nineteenth Century* (33 May 1893), 767–88.
37. H.P. Blavatsky, *The Key to Theosophy* (London, 1889).
38. Ibid., 19.
39. Ibid., 246–7.
40. Ibid., 79.
41. For other examples, see Susan Beattie, *The New Sculpture* (New Haven, 1983).
42. Joséphin Péladan, *L'Art ochlocratique* (Paris, 1888), 45, quoted by Jennifer Birkett, 'Fin-de-siècle Painting', in Mikuláš Teich and Roy Porter, eds., *Fin de Siècle and its Legacy* (Cambridge, 1990), 155.
43. Max Nordau, *Degeneration*, Eng. trans. (London, 1895), 104, 114.
44. Richard Wagner, 'Religion and Art', in *Richard Wagner's Prose Works*, Eng. trans., 8 vols. (London, 1892), 6:213.
45. Richard Wagner, 'The Art-Work of the Future', in *Works*, 1:69–213.
46. See M. Cooper, 'Scriabin's Mystical Beliefs', *Music and Letters*, 16 (1935), 110–11.
47. *The Blaue Reiter Almanac* (1912), Eng. trans. (London, 1974).
48. From an account in the *Neue Freie Presse*, discussed in Jean Paul Bouillon, *Klimt-Beethoven* (Geneva, 1987), 18.
49. Quoted in Peter Vergo, *Art in Vienna 1898–1918* (Oxford, 1986), 71–2. The quotations from Schiller may be translated as 'Joy, beautiful spark of God' and 'This kiss of the whole world'.
50. These programme notes were not published until 1871; they are quoted in Bouillon, 26.
51. Wagner, 'Beethoven', in *Works*, 5:100.
52. Ibid., 5:101.

CHAPTER 8
REGENERATION

Wagner's ideas did more than provide inspiration for artists and musicians who wished to reform their own practice. By the end of the nineteenth century, Wagner's theories came to be seen as a way forward for those who wished to regenerate 'decadent' European culture. Throughout this book, the theme of degeneration in society, politics, gender relations and religion has indicated the pessimistic spirit with which Europeans faced the dawning of a new century. However, amidst such prophecies of doom and decay were a number of alternative predictions and panaceas. Unfortunately, many of these 'cures' were more dangerous than the disease they sought to remedy. The themes of nationalism, primitivism and apocalypse which emerged in art, philosophy and politics in the last years of the nineteenth century were intended to represent positive antidotes for contemporary cultural pessimism. But each of these proposed solutions contained within itself a quality of desperation and, ultimately, the idea that the only regeneration for a dying culture was through its total destruction.

Art – especially landscape painting – proved to be a very significant part of European nationalism in the *fin de siècle*, but the ways in which it contributed to the nationalist agitations in different European countries were complicated. To put it simply, nationalism was one of several mass responses to the failure of European parliamentary liberalism, and to the aggressive imperialist aspirations of countries such as Germany and Russia.[1] Nationalism was particularly strong in eastern Europe and Scandinavia, although most countries experienced some degree of nationalist agitation. In France, for example, the prosecution of the Jewish artillery officer Alfred Dreyfus (who was alleged to have betrayed military secrets to Germany) stimulated nationalist anti-Semitism; in Germany the Pan-Germanic movement had strong political affiliations, and in England nationalism and imperialist ideology went hand-in-hand. In each of these countries, art responded to nationalist sentiments, not necessarily by overt propaganda, but largely by specific reference to the landscape of the country represented. When we look at a nineteenth-century landscape painting today, it is perhaps difficult for us to understand what kind of meaning that landscape would have had for a contemporary observer. In order to elucidate the nationalist implications of landscape painting it is first necessary to consider the body of theory which underlay many depictions of nature at the turn of the century: Wagner's belief in the regenerative power of art; the philosophy of monism; and finally, the nature-worship stimulated by the publication of Julius Langbehn's *Rembrandt als Erzieher* (*Rembrandt as Educator*). Each of these sources contributes to our understanding of the perceived power of art at the time and the almost reverent respect for the landscape itself.

Wagner's own belief in the regenerative power of art was unequivocal. His essay 'Art and Revolution' (1849) linked art and politics by suggesting that a social revolution needed to precede

a regeneration of the spirit. This notion of regeneration reappeared in 'The Art-Work of the Future', where Nature becomes the means by which mankind can achieve this revolutionary spiritual renewal. At the beginning of his tract, Wagner asserted that error began when man broke away from nature:

> The real Man will therefore never be forthcoming, until true Human Nature and not the arbitrary statutes of the State, shall model and ordain his Life; while real Art will never live, until its embodiments need be subject only to the laws of Nature, and not to the despotic whims of Mode.[2]

In essence, this statement encapsulates Wagner's rejection of positivistic science in favour of the spiritual life which he felt was lacking in the modern world. However, his implication that modernity cancelled out nature indicates the importance of returning to a more natural state, which he felt was embodied in the spirit of the *Volk*. Wagner's glorification of nature led him to advocate everything from a renunciation of egotism to militant vegetarianism.[3] but his theories also produced some notable comments on painting. Wagner admitted that 'Modern *Natural Science* and *Landscape-Painting* are the only outcomes of the Present which, either from an artistic or a scientific point of view, offer us the smallest consolation in our impotence, or refuge from our madness',[4] and he claimed that his 'art work of the future' would use landscape painting as the stage background for his *Gesamtkunstwerk*:

> That which the landscape-painter in his struggle to impart what he had seen and fathomed, had erstwhile forced into the narrow frames of panel-pictures, – what he had hung up on the egoist's secluded chamber-walls, or had made away to the inconsequent, distracting medley of a picture-barn, – *therewith* will he henceforth fill the ample framework of the Tragic stage, calling upon the whole expanse of scene as witness to his power of recreating Nature.[5]

Wagner's enthusiasm for 'natural' landscape painting is particularly significant, given his rejection of other forms of empirical science throughout his work, and he saw the landscape as possessing the spiritual means of regeneration. Wagner's theories were widely known throughout Europe, and in several countries periodicals were produced which were devoted to his ideas and his music. The most famous of these, the *Revue wagnérienne* of France, was dominated by Symbolist writers, and there and elsewhere, Wagner's 'revolutionary' theories were interpreted as a stimulus for supporters of the Left. However, in Germany, Wagner's ideas were appropriated by sympathizers on the Right, particularly those with nationalist inclinations. For example, one German writer of the 1880s claimed that the regeneration of Germany would be brought about by following Wagner's nationalistic theories of art and Bismarck's militarism.[6] These ideas were also adopted by Wagner's avid supporter, the art historian Henry Thode, who attacked contemporary art as anti-German, and advocated a return to traditionalism. In Thode's eyes, the landscapes and seascapes of Arnold Böcklin and Hans Thoma represented a positive alternative to the foreignness of French Impressionism – despite the ironic fact that many of Böcklin's landscapes were based on his visits to Italy, and Thoma was influenced by the French Barbizon painters.[7]

Other writers on Böcklin also saw him as an appropriate example of the Wagnerian idea of

regeneration through nature. Manskopf's monograph of 1905 did not mention Wagner, but Wagnerian ideas lay behind his linking of art with religion. Manskopf attempted to reconcile the seeming contradictions in Wagner's view of landscape painting, by asserting that it was possible for an artist to paint a 'real' landscape which nevertheless had a spiritual purpose.[8] To Manskopf, religion needed to be deeply rooted in life to avoid total dissolution, and Böcklin – by revealing the religious spirit within nature – somehow managed to bridge this gap. Böcklin was seen to be responsible for an 'ensouling of matter' (*Beseelung der Materie*), rather than a materializing of the soul:

> His trees, his flower-strewn meadows, his seas are symbols of the inner essence of Nature. He paints the idea of the autumn, of the spring, and actually the 'Idea' in the platonic sense of the word, or in the sense that Christians speak of artistic creativity as a related development to the creative power of God.[9]

The presence of mythological figures within these 'natural' landscapes could only serve to reinforce the Wagnerian interpretation of Böcklin's work. Thode and Manskopf were not so much concerned with the power of nature *per se*, but with the power of a specifically German nature; through such extensions of Wagner's ideas, the relationship between landscape painting and nationalism was cemented.[10]

With Wagner's ideas as reinforcement, the philosophy of monism and, ultimately, the vitalist theories of Henri Bergson also provided fuel for nationalist interpretations of landscape. Monism is a complicated idea with an ancient origin. Proponents of monism, such as the biologist Ernst Haeckel, rejected the dualism of soul and body and argued for a universal reality which encompassed all living things.[11] Monists were not pantheists, but in their view, inanimate objects were as much a part of reality as living human beings. Monism inspired one of the most influential philosophers of the early twentieth century, Henri Bergson, a professor at the Collège de France. Bergson's difficult books – including the important *Creative Evolution* – attempted to tackle the question of the life force (*élan vital*) which lay at the root of all human action. His metaphorical means of explanation is often hard to follow, but his task was no less daunting: he attempted to develop a theory of the evolution of the consciousness, which he claimed was in a constant state of flux. He contrasted the dynamic nature of human consciousness with the static nature of scientific study:

> Matter or mind, reality has appeared to us as a perpetual becoming . . . But preoccupied before everything with the necessities of action, the intellect, like the senses, is limited to taking, at intervals, views that are instantaneous. . . . Thus we pluck out of duration those moments that interest us.[12]

Bergson criticized scientific empiricism, and postulated intuition as the more important of the two internal states: 'while intelligence treats everything mechanically,' he wrote, 'instinct proceeds, so to speak, organically'.[13] The organic analogy was very important to Bergson, as it was to other monists: the individual's body and soul were related to nature and the universe, and such a relationship refuted the often asserted superiority of 'man' over 'nature'. Nature came to take its place beside man as part of the same universal oneness.

Before Bergson's writings worked out the full, metaphysical implications of monism, the artist Ferdinand Hodler presented monist theories of nature in his own published lecture, *The Mission of the Artist* (1897). Hodler developed an equally complex theory of 'parallelism', which indicated the

unity of nature and the achievement of this unity through repetition of natural forms in art. Hodler thought that all of nature was united by an underlying order, and he too saw nature as offering more than met the eye:

> When the artist makes a picture, he borrows elements from the pre-existing world he lives in. The more imaginative artist is guided by nature; she is the greatest source of facts; it is she who stimulates the imagination. The deeper one probes into the mind of nature, the more complete is the notion of it one renders.[14]

Hodler considered the work of art as particularly important in conveying this unity, and his own Symbolist paintings *Eurythmy* (1895, Berne, Kunstmuseum) and *The Consecrated One* (1893–4, Berne, Kunstmuseum) exemplified this theory of parallelism in a quite literal way. However, Hodler's works were not place-specific and therefore did not contain within them any implicit or explicit nationalist content. Although the theory of monism was not used by artists in such a direct way, it supplied a theoretical framework to support the idea that the landscape somehow had a universal significance, and that landscape painting represented more than the imitation of nature.

A third major intellectual factor in the creation of a relationship between landscape painting and nationalism was the publication in Germany of Julius Langbehn's *Rembrandt as Educator* in 1890. Langbehn was a student at the University of Munich, but did not pursue a career after graduating. Instead, he began a series of *Wanderjahre* – travelling around Germany collecting ideas and information for a book which he claimed would change the face of contemporary German society. Langbehn's book took a long time to emerge, and during this period of collation his eccentricities became widely known. Suffering from what seems to have been paranoid delusions, Langbehn saw himself as a sort of Messiah, and demanded absolute devotion from his gradually dwindling circle of friends. In 1889 he managed to gain an introduction to Nietzsche, who was at that time in an asylum, and he attempted to convince Nietzsche's mother to revoke her responsibilities for her son in order to allow Langbehn himself to foster his recovery. Nietzsche's mother refused.[15] When it finally did appear, *Rembrandt als Erzieher* was astonishingly popular and went to 39 editions within two years. Langbehn made constant adjustments to the text, so that each edition is slightly different. Although muddled, pretentious and at times virtually unreadable, *Rembrandt* contained a great deal of sentiment which appealed to the prejudices and fears of contemporary society. Langbehn – like Wagner before him – attacked modern culture and called for an age of art to replace that of science. But Langbehn's idea of a *Kunstpolitik* (an art-politics) went beyond Wagner's call for spiritual regeneration through art, as Langbehn's aestheticization of political life did not marginalize art within a spiritual sphere. Like Wagner too, Langbehn was interested in the power of the *Volk* from whose needs (*Bedürfnis*) true art arose. The *Volk* was the essential meeting point of art and politics. In Langbehn's eyes, Rembrandt was one of the most individualistic 'German' artist, and he justified Rembrandt's 'Germanness' by reference to the idea of the 'Niederdeutsch', or the north-eastern German peasant tradition: 'Rembrandt is the prototype of the German artist; he and only he therefore completely corresponds to the wishes and needs of the German folk of today.'[16] Langbehn's interest in the *Volk* and the regenerative power of art was complemented by his anti-urban emphasis. He linked the spiritual corruption of modern society with the city, and eulogized the countryside as a place of refuge and spiritual nurture. Like Wagner's follower Thode, Langbehn was an admirer and friend of the landscape

painter Hans Thoma, and his own ruralist interests were undoubtedly bolstered by this connection.

Langbehn's attitude to the countryside must be understood in the context of his theories of the *Volk* and the political significance of art. His book helped inspire a series of youth clubs and agrarian colonies in Germany over the next twenty years in which the rural interest was laden with politics. Some of these colonies – such as the Vegetarian and Fruit Tree Colony of Eden, north of Berlin (founded in 1893) – were intended to be escapist utopias providing a refuge from the horrors of modern urban life. Others, such as the *Wandervogel* (founded in 1901), advocated nature walks and abstinence from alcohol, but their ultimate purpose was to promote purity of mind and body.[17] This process of purification through nature came to be linked with both nationalism and anti-Semitism. The German countryside was seen to symbolize the roots of German culture; and a rejection of modern life embodied a rejection of both urban sophistication and the capitalist system that so many Europeans associated with the financial acumen of the Jews. In Germany particularly, the foundation of nature colonies was not without a political agenda, and even artistic groupings such as that at Worpswede, near Bremen, cannot be accepted as unproblematic. The artists who gathered there from 1889 included Paula Modersohn-Becker, Otto Modersohn, Heinrich Vogeler and Fritz Mackesen. These artists claimed that they were modelling themselves on the French Barbizon group, who also left the city in order to pursue *plein air* painting in surroundings which offered an infinite number of potential subjects. However, the original landscape emphasis was gradually superseded by an interest in the peasant culture of Worpswede, and Modersohn and Modersohn-Becker in particular were responsible for producing portraits of the local poor sometimes located within the landscape itself. Although it would be wrong to attribute this shift of emphasis solely to Langbehn's influence, the widespread awareness of his ideas would have made it difficult for contemporaries to see these works as simply pleasant views of the German countryside. Through the lens of Langbehn, the peasant was the essential German and the countryside was the true character of the German nation. Paintings of specifically German peasants and recognizably German landscapes after the publication of *Rembrandt* would have been seen as part of this nationalist discourse – whether or not the artist intended such a reading.

The ideas of Langbehn were not as widely disseminated as those of Wagner and monism, but all three helped confirm the relationship of the national landscape to the nation itself. In France, Spain, Scandinavia and eastern Europe, artists' colonies or even individual artists began to produce landscape paintings which fed this growing nationalist sentiment. The landscape was seen to be synonymous with the spirit of the nation, and through reference to the landscape, artists hoped to foster the spiritual regeneration of decadent society. However, landscape painting was not the only manifestation of nature which had this nationalist significance; the decorative designs of art nouveau – many of which were based on organic forms – also came to have associations with the particular countries in which they were produced. However, just as nationalism differed from nation to nation, so did landscape painting and art nouveau vary in different parts of Europe.

In order to show how this association worked, it is instructive to begin with an artist whose paintings are not usually considered within such interpretive structures. Claude Monet's contribution to the Impressionist group, and his continual experiments with light and the 'fleeting moment' long after the Impressionist circle had broken apart, have led many observers to see his later works as examples of his obsession with somewhat outdated Impressionist ideas.

However, as Paul Tucker has recently shown, Monet's late works, especially the series paintings, were seen at the time as important representations of the character of the French countryside, and Impressionism itself was viewed as an essentially French contribution to European culture.[18] A series such as the *Haystacks* (Figure 55) could be construed as inherently French, and indeed Monet's very repetition of such subjects indicates their rich potential and importance for the artist. Tucker traces the changing patterns in Monet's reputation, and argues convincingly that the artist's acclaim rose when he turned from urban to rural imagery. One critic called Monet 'our great national painter', and made explicit the association between Monet's work and nationalist sentiment:

> He knows elements of beauty, harmonious or contradictory, of our countryside: the red pine trees against the blue sea, definite and hot; the contours of the cliffs effaced by the mist, the water running under the fresh foliage, the haystacks standing on the naked plain; he has expressed everything of that which forms the soul of our race.[19]

Such a romanticized reading of Monet's works indicates how easily a nationalist premise could be drawn from a simple depiction of nature. Monet's icons of rural France served as reassuring and acceptable representations of a nation which was torn with internal strife. During the 1890s, while Monet painted his series works, the French republican government was suffering a period of instability which it tried to correct by absorbing both the socialist Left and the nationalist Right into its own ideological structure, thus neutralizing their power. This attempt at compromise served to intensify extremism within the government and the country as a whole. The republican solidarists used every means at their disposal to reassure the country, and Monet's calm images of the French countryside were among those cultural weapons which served to distract attention from the real conflicts in contemporary French society.

Other countries also gave Impressionism a political reading: in Germany, reactions against Impressionism were seen to be evidence of national solidarity, while Spain tried to claim that its own Impressionist painters, such as Joaquín Sorolla, had developed independently from the French and were producing works of a specifically Spanish character.[20] However, the strongest associations between nationalism and landscape painting occurred in Scandinavia and eastern Europe, where national identity was not as secure as it was in France or even Spain. Artists' colonies similar to that at Worpswede in Germany were popular in Denmark, Norway and Finland. In each case, the artists chose the most remote possible location, attempting to find a 'characteristic' portion of their native landscape. One colony was founded in the Jutland fishing village of Skagen in Denmark, and another at a farm at Fleskum, near Oslo. Significantly, the Fleskum colony included a number of women, and indeed women seemed to play a greater role in these ruralist groups, as the very nature of the colonies put them outside the public urban domain of exhibitions and art academies, from which women were conventionally excluded.

The landscapes produced under these circumstances were not devoid of political significance. In the latter part of the nineteenth century, several Scandinavian countries were undergoing a crisis of identity. Norway did not break free from Swedish control until 1905, and Finland did not separate itself from Russian domination until the Russian Revolution in 1917. Finland was in a particularly difficult situation: in the first part of the nineteenth century, Russia had relaxed some of its stricter controls, but towards the end of the century there was an intensification of political interference, and many Finnish people felt that their own cultural identity was being suppressed.

To complicate the problem further, some Finnish intellectuals had sympathies with Sweden, and dismissed the nationalist yearnings of those who wanted an independent nation. Amidst these cultural conflicts, landscape painting played a particularly important role.

The Scandinavian style of landscape painting dominant in the last years of the nineteenth century has been aptly referred to as 'National Romanticism'.[21] The 'Romantic' aspects of such painting can be seen in works by the Norwegian Harald Sohlberg, whose Night Glow (1893, Oslo, National Gallery) evokes a mood, rather than representing the specific details of a particular scene. Indeed, many landscape painters consciously turned away from realism; in social realist pictures, the individuals had been given prominence, but fin de siècle landscape painters tended to minimize or discard the human element by concentrating instead on the spiritual resonances of the landscape itself. In some instances, these artists were influenced by mystical and occult ideas, but in many cases, these ideas were blended with their own enthusiastic sympathy for their native landscape.

This mingling of the mystical and the political is even more pronounced in some Finnish landscape painting, which was self-consciously nationalistic. The Finns drew primarily from two sources in an attempt to imbue their works with patriotic significance. The first of these was the epic poem the Kalevala, compiled by Elias Lönnrott between 1802 and 1884 from songs in the Finnish oral tradition. The artist Akseli Gallen-Kallela – a fervent nationalist – illustrated the Kalevala (Figure 56) as part of a campaign to make Finns aware of their own spiritual and cultural heritage. The second source of Finnish nationalist landscape was the landscape itself, particularly the Karelia, a remote and sparsely populated part of eastern Finland which the long hand of Russian bureaucracy had not managed to penetrate. This region was a place of pilgrimage for Gallen-Kallela and other artists such as Pekka Halonen, whose Wilderness (1899, Turun taide-museo, Turku) indicates the attraction of this largely uninhabited part of the country. In Karelia, the artists felt that the pure essence of Finland remained uncorrupted, and the very absence of population was seen to give this territory a special spiritual power. The Karelian landscapes (Figure 57) thus blended spiritualism and nationalism in an uneasy but effective mix. The difficulty of travelling within, and painting, such a desolate area indicates just how intensely many artists felt about the national issue. In the same year he painted Wilderness, Halonen wrote to a friend on the increasing problem of Russian domination:

We no longer exist! The Finnish people are as tough as juniper; we can't be beaten by so little. The land and the nation will live! We are God's chosen people who have a mission to mankind.[22]

In many cases, Finnish artists had a commitment to landscape painting which coincided with their concern for their country's future. In these instances, National Romantic painting could be seen as deliberate propaganda, constructed on the principles of Symbolism, but intending to embody a very specific political message. This deliberation contrasts with the motivations of an artist like Monet, who did not express nationalist intentions, but whose works were construed as such by their French audiences. However, if the nationalism within Monet's views of the French countryside was not explicit, neither was that of the Scandinavian artists – whatever their ultimate goals may have been. On the other hand, in eastern Europe, some landscape painters used Symbolism as a means to make critical statements about national identity and freedom from domination, and their works thus served a polemical purpose, rather than being purely aesthetic objects with political undercurrents.

Such propagandist intent can certainly be attributed to the Polish artist Jacek Malczewski, whose responses to the Polish conflicts with Russia, Austria and Prussia can be mapped through his eccentric paintings. Malczewski was his own favourite subject, and his face appears as a *leitmotif* throughout his work. He saw himself as a representative of the Polish people, although his own privileged education and the benefits of living in the more 'enlightened' Austrian section of Poland gave him advantages that the majority of Polish people did not share.[23] Malczewski's apparently unbridled egotism was combined with a passionate love for Poland and an equally passionate hatred of its subjugation. His despair at the failure of the 1863–4 Polish uprising was matched only by his reaction to the abortive 1905 revolution in Russia – an event he commemorated symbolically in his painting *The Year 1905* (1905–1906, Warsaw, Mirosław Gardecki). Many Poles hoped that this revolution would overturn the Russian *ancien régime*, and would ultimately lead to freedom for the Polish nation. The collapse of the revolution led Malczewski to symbolize Polish frustration through his image of himself, backed by Polonia and Pegasus, unable to move forward due to the intervention of two harpies. The 'harpies' – possibly Austria and Prussia – indicate the evil powers that continued to dominate Poland.[24] Malczewski also painted a number of Polish landscapes with a similarly polemical function. However, unlike the Scandinavian artists, works such as *In the Dust Cloud* (1893–1894, Poznań, National Museum) did not rely on the landscape itself to convey its own meaning, but included allegorical figures which contributed to the nationalist impact his works were intended to have. This work represents a group of mothers and children chained together in a cyclonic whirl before a stark landscape background; their entrapment represents the symbolic enslavement of Poland, while the landscape becomes a shorthand for the nation itself.

The power of the landscape to convey ideas of nationhood was not simply confined to *fin de siècle* Europe. As far afield as Australia, artists were also beginning to form themselves into colonies ostensibly based on the French Barbizon school. For example, artists' camps near Sydney and Melbourne were places where painters would come literally to pitch their tents and paint in the open air. Unlike European artists' colonies, women were often excluded from these camps, as the ambience of the camp was one of austere, 'masculine' adventure. Whether or not such works grew out of national pride, they certainly are unlike any landscapes produced in Europe at the same time: paintings such as John Mather's view of *Mosman's Bay* (1899, Sydney, Art Gallery of New South Wales) reveal a particularly intense sunlight and give a dazzling impression of the beauty of the Australian landscape. Although many of the Mosman's Bay artists had spent time in Europe and confronted the techniques of Impressionism, their contribution in Australia was unique, and reinforced the essential distinction between the Australian and the French landscape.[25]

Despite the differences in artistic intention, style and public response, the examples presented in this chapter so far each indicate the growing power of landscape painting to convey a meaning beyond itself, to tug at the roots of national feeling and stimulate extra-aesthetic, even political, sympathies. However, the landscape was not the only aspect of nature that was imbued with this additional connotative power. Decorative art also underwent a 'naturalizing' process in the 1890s and it too was subject to new interpretations and implications. Until recently art nouveau was seen by art historians as one step on the inevitable road to twentieth-century abstraction. The arabesques and organic sources of art nouveau decoration were praised for their ahistoricism and for the priority of style over subject-matter. This teleological reading of art as progressing towards the 'final cause' of abstraction has thankfully been overturned, but what is left behind is a

much more complicated picture which places art nouveau firmly within nationalist and vitalist discourses.

This association has been pointed out most eloquently by Debra Silverman, whose *Art Nouveau in Fin-de-Siècle France* shows how the domestic and organic natures of art nouveau were used to reinforce French solidarist sentiments in the late nineteenth century.[26] Silverman argues that the rococo revival – one of the sources for art nouveau – was itself a stamp of French nationalism, and that the domestic interior – where the decorative nature of art nouveau found its most appropriate place – was conceived as a refuge from the sordid metropolis. The interior became a locus of escape, and the art nouveau decorations by artists such as Émile Gallé endowed this space with rural associations. The art nouveau interior was not a landscape, but it nevertheless gave simple objects, such as lamps, chairs and jewellery, the forms of natural life.

The anti-urban connotations of art nouveau decorative forms had a particularly ironic resonance when such forms were placed within an urban setting. Works such as Victor Horta's Tassel Staircase in Brussels, Joseph Olbrich's Vienna Secession building, Antonio Gaudi's Sagrada Familia in Barcelona (Figure 58) and the bizarre main gate and elephant house at Budapest Zoo by Kornél Neuschloss-Knüsli all located an ostensibly natural environment within the heart of a major city. Horta's staircase evokes naturalist analogies; its forms resemble the snaking growth of garden weeds or jungle plants. Both the Vienna Secession building and the Budapest Zoo include representations of real animals as part of their decorative schemes. The turtles and owls on the Secession building are matched in the zoo by monkeys, elephants and polar bears. The country, or – in the case of the zoo – the jungle, is imposed on the city and does much to negate the modern sophistication of urban life. Such ironic subversions offer an interesting commentary on the failures of the modern metropolis to meet the essential needs of its inhabitants (see Chapter 4). Gaudi's Sagrada Familia presents a more complicated problem. On the one hand, Gaudi was influenced by the decorative fantasies of art nouveau, but more generally, the church itself recalls the forms of both Gothic and Moorish architecture. Located in the middle of Barcelona, this massive church was effectively a reassertion of Catholic faith in the midst of the industrial challenges of the late nineteenth century. The association of organic form with traditional religious practices gives Gaudi's church the same sort of resonances that Émile Gallé's lamps had in France. References to both nature and the national past contained in the forms of art nouveau involved a rejection of modernity as well as an implicit endorsement of the regenerating power of the nation.

The theme of regeneration, when applied to the productions of art nouveau, carried with it strongly vitalist connotations. The German version of art nouveau, Jugendstil, was associated with the zoological theories of Ernst Haeckel, whose *Riddle of the Universe at the Close of the Nineteenth Century* stressed the regenerative potential contained within natural forms:

> The remarkable expansion of our knowledge of nature, and the discovery of countless beautiful forms of life, which it includes, have awakened quite a new aesthetic sense in our generation and thus given a new tone to painting and sculpture.[27]

Haeckel sought to expose the power of organic form, and published a series of illustrations of nature, *Kunstformen der Natur*, which was strongly influential on the 'founder' of the Jugendstil movement, Hermann Obrist.[28] But Haeckel did not simply praise the beauty of organic form: he used monist principles to suggest that the forms of plants and animals represented the invisible

life force which governed the universe. To Haeckel, an arabesque was not just a pretty design, but it stood for the tendrils of plant life, which themselves embodied the essential dynamic life force. By representing a form which recalled animal or plant life, art nouveau artists could tap this universal principle, and, by association, give power and significance to their work. The combination of organic, vitalist reference and nationalist traditionalism contained in art nouveau decoration gave it a significance beyond that of a merely stylistic reform. Art nouveau itself could be construed as a manifestation of European nationalist sentiments of the *fin de siècle*.

The regenerative power of nationalism was perceived to be one counteractive force to the degeneration of culture in the late nineteenth century, but its relationship with art is complex and problematic. A second source of regeneration – primitivism – had a more direct impact on artistic practice, as artists themselves consciously sought to achieve what they felt was a 'primitive' simplicity. Both nationalism and the search for the primitive were tied up with the desire for spiritual sustenance which characterized European society. Observers could look to the failures of modernity and seek solutions in various alternatives. Both nationalism and primitivism were forms of escapism, but nationalism looked to the future of the nation itself and moved towards political alternatives, whereas primitivism led its adherents away from European society completely to seek the answer in 'other' less sophisticated cultures. While the sentiments of nationalism were complicated by disturbing isolationist tendencies, the interest in primitivism was bound up with imperialist attitudes and romantic misconceptions of the life of the 'savage'. This ambiguity is apparent in the work of Gauguin and the German Expressionist artists, whose works reveal a great deal about European attitudes to 'primitive' cultures.

The term 'primitive' had shifting meanings in the late nineteenth century. In artistic discourse, it was often applied to pre-Renaissance western art, but came to have a more direct association with past and present societies which lacked the industrial sophistication of modern Europe.[29] Attitudes towards the primitive were directed and complicated by several factors. First of all, a combination of European imperialism and mass communication led to a greater dissemination of knowledge about non-European cultures. Secondly, and related to this, the growth of anthropology as a discipline, and Darwin's own ideas about the evolution of man from the savage to the civilized, contributed to a curiosity about the progenitors of modern man. This academic interest ranged from the voyeuristic to the patronizing, and anthropological debate was inevitably complicated by the expectations and assumptions of the Europeans who conducted such studies. Finally, the increasing knowledge of 'other' cultures led to the opening of ethnographic museums, such as the Musée d'Ethnographie du Trocadéro (founded 1882) in Paris, which were devoted to displaying the artefacts of non-western culture. By exhibiting objects which were used as part of the daily life and worship of tribal cultures, Europeans aestheticized the primitive and thereby signalled their own detachment from the real conditions of tribal life.

This tendency to look upon primitive societies as something to be studied or analysed had its antithesis in a more romantic view of the noble innocence of tribal culture, which was drawn from Jean-Jacques Rousseau's eighteenth-century theory of the 'Noble Savage'. Both the scientific and the romantic constructions of the primitive were laden with imperialistic assumptions, but the latter perspective saw a return to primitivism as a means of regenerating the over-civilized culture of western Europe. The romanticized primitive society was seen to be one which was without the mental and physical degeneration and the moral ambiguity that had emerged from western urbanization (see Chapter 2). Advocates of a return to the primitive saw a means of erasing the growing complexities of modern life, but their escapist perspective

neither came to terms with real problems nor involved a true understanding of the cultures they professed to admire.

This combination of romanticizing and aestheticizing the primitive is most obvious in the works of Gauguin. As part of a long campaign of self-promotion, Gauguin left his wife and family in 1891 to travel to Tahiti, having already attempted to pursue his primitivist ideas in Brittany and Martinique. Tahiti had become a French colony in 1881, and Gauguin's first few months there were spent among French pseudo-sophisticates who had set up their own little Europe amidst the natives of Tahiti. Although Gauguin eventually moved into a bamboo hut and committed the bigamous act of taking a Tahitian wife, his own romantic attitudes towards this primitive lifestyle were hardly eroded. His declarations were intended to give the best impression of himself and his motives to the Europeans who would ultimately buy his pictures, as Gauguin initially had no intention of remaining in Tahiti, and kept regular contact with European patrons and critics. When he wrote to Strindberg of 'a clash between your civilisation and my barbarism . . . A civilisation from which you are suffering: a barbarism which spells rejuvenation for me',[30] and when he later published his autobiographical adulation, Noa Noa (1924), Gauguin was not so much revealing a genuine sympathy with Polynesian society as he was constructing a mythology of himself. Indeed when Gauguin returned to Europe in 1893, the attraction of his Tahitian paintings was often based more upon the prurient interest in the sexuality of Tahitian women than in any genuine understanding or affinity with tribal culture. Furthermore, although he claimed to immerse himself in the Tahitian society, Gauguin's paintings were often constructed from photographs of Egyptian, Persian, Cambodian and Javanese art that he brought with him to Tahiti. A painting such as Ta Matete (We Shall Not Go to Market Today) (Figure 59) is designed like an Egyptian frieze and was based on a photograph of a Theban tomb in the British Museum. Such an overlaying of different non-European cultures could have been a manifestation of Gauguin's own theosophical interests, but his eclecticism predated his theosophy, so the latter may have been used to justify the former. Gauguin's return to Tahiti in 1895 has been seen as the culmination of his own self-promotion and escapist attitudes,[31] and those works he left behind did little to enlighten Europeans about the primitive alternatives many of them claimed to extol.

A similar ambiguity of intention and result characterized the work of the Brücke group in Germany, although their interest in primitivism was less egocentric and more directly connected with a desire for social regeneration. The artists were influenced by work they had seen in the Dresden Ethnographic Museum, and many of them collected tribal artefacts. However, their own work was not without ambiguity, as Jill Lloyd has shown.[32] The desire for regeneration which stimulated the rhetoric of the Brücke artists presented a disruption of contemporary society, but the use of primitivism within an artistic context served to reinforce imperialistic stereotypes about 'primitive' societies. The attitude of Emile Nolde typifies this confusion. Nolde's travels in the South Seas and his responses to them seem to indicate his admiration of primitive cultures:

The natives here certainly eat human flesh . . . Are we so-called cultivated people then really much better than the people here? Here a few individuals will die in feuds; in Europe, thousands die in war. And are the corrupt city people, who daily and nightly hinder and destroy the fruits of their love, not more filthy and low than the native people, who bear many children with which they make themselves strong by having more men than the neighbouring tribe?[33]

But Nolde's appreciation of such 'noble savagery' was belied by his own racialist assertions, which eventually led to his association with the National Socialist Party. It was the energy of primitive societies – rather than the societies themselves – that Nolde sought to convey in works such as A *Dance Around the Golden Calf* (1910, Munich, Staatsgalerie Moderner Kunst). In this searching for the primitive spirit the artists of Die Brücke were influenced by the publication of William Worringer's *Abstraction and Empathy* (1908), which suggested that the primitive impulse to produce 'abstract' art was somehow more vital than the western desire to imitate reality. With such a theoretical justification, the artists of Die Brücke could use the forms of primitive masks and sculpture to convey a meaning beyond the mere presence of the objects themselves.

Other artists of Die Brücke juxtaposed tribal artefacts with non-white individuals – thus creating an analogy between the remnants of a primitive culture and the person represented. Many of the paintings of nudes by Kirchner, Erich Heckel and Max Pechstein were based upon adolescent models whose own cultural origins were not purely German. In a work such as *Girl Under a Japanese Umbrella* (1909, Düsseldorf, Kunstsammlung Nordrhein-Westfalen), Kirchner juxtaposed several non-western objects with a model of exotic appearance. The Japanese umbrella, the carved Palau furniture in the background and the features of the model endowed the work with the same sort of seemingly indiscriminate cultural eclecticism that appeared in Gauguin's Tahitian paintings. A similar sort of primitivist *mélange* appears in many Brücke woodcuts, such as those by Pechstein, Schmidt-Rottluff and Heckel. These also frequently represented nude women of exotic appearance, and their simple, crude outlines and sharp edges were intended to equate the model with the primitive energy of the art work itself. By exhibiting the model as one of many primitive 'artefacts', the artists of Die Brücke were in effect reinforcing the cultural stereotypes that their ostensible admiration for primitive cultures sought to subvert. This discrepancy was deepened by their attempts to bring the primitive spirit into their own lives. During the summers, the Brücke artists spent time on the beach in Moritzberg, where they practised nudism as a means of spiritual regeneration. These naturist actions found their way into their paintings, and works such as Kirchner's *Striding into the Sea* (1912, Stuttgart, Staatsgalerie) combine a sense of the exotic with an evocation of primitivist vitalism. But the nature worship in which Brücke artists participated was itself part of the Pan-Germanic purity movement that emerged after the publication of Langbehn's *Rembrandt as Educator*. The 'revolutionary' intentions declared by the group in their early years was thus to an extent undercut by the nationalist and imperialist discourses within which their art was being produced.

The appropriation of ethnographic artefacts for the use of western cultural propaganda was equally problematic in the other major German Expressionist group, the Blaue Reiter. While the Brücke artists practised in Dresden and Berlin, the Blaue Reiter joined together in Munich, although works of both groups were displayed in the two Blaue Reiter exhibitions of 1911 and 1912. The Blaue Reiter was actually a less coherent group than its northern counterpart, and was dominated by the Russian artists Vassily Kandinsky, Alexei von Jawlensky and Marianne von Werefkin, who brought something of Russian spiritual orientation to their interpretation of the primitive. The impact of Russian Symbolism on the Blaue Reiter group was very strong, and it is important to consider this source before moving on to the work of the Blaue Reiter group itself.[34]

Russian artists of the early twentieth century were less interested in the objects of African and Oceanic societies than the folk art of their own country – including icons, *lubki* (folk prints) and decorative arts of the Middle Ages. From the 1870s this self-conscious adoption of folk art had

served to challenge a growing westernization of Russia. The movement began at the Abramtsevo colony near Moscow in the 1870s, where a group of artists attempted to revive medieval styles in their decorative designs. By the 1910s this tendency had gained new impetus through easel painting with the work of David Burliuk, Mikhail Larianov and Natalia Goncharova, whose fervent Russian nationalism led them to use motifs from Russian icons and *lubki* in their deliberately primitivist compositions. Indeed, Goncharova declared that all art except that of Russia was dead and saw the adoption of artefacts from her own culture as a means to a regeneration of art. These artefacts were of an entirely different nature from those used by Gauguin and the Brücke artists, as the primitivist tendencies of *fin de siècle* Russian art grew from a perception of the art of native peasant culture. However, the use of peasant culture by the educated urban artists of early twentieth-century Russia was no less problematic than the French and German use of tribal art, and both were intended to imbue art with a spiritual resonance that was directly opposed to the materialist decay of modern life.

It was within this climate that Kandinsky first decided to abandon a law career to pursue an artistic vocation, and although his first action as an artist was to go to Munich to study in 1897, his early paintings reflect the interests of his Russian Symbolist contemporaries. Especially in his use of fairy tale motifs, Kandinsky showed from the beginning a fascination with the life of the spirit which was to form the basis for the short-lived aspirations of the Blaue Reiter group. The group was formed in 1911, after Kandinsky and other artists had resigned from another Munich exhibition society, the Neue Künstlervereinigung, which had rejected one of Kandinsky's works. Kandinsky and Franz Marc decided to call their new society the Blaue Reiter, or 'blue rider', which had associations with the spiritual nature of the colour blue and the chiliastic symbol of the Four Horsemen of the Apocalypse. Kandinsky and Marc set up two exhibitions, but, more importantly, they produced an Almanac, in which their spiritual beliefs emerged through their use of primitive and fairy-tale motifs. The Almanac is a fascinating document of early twentieth-century art, as it juxtaposes African masks, children's drawings, Bavarian glass painting and the works of the most controversial contemporary artists, such as Henri Rousseau, with articles about art and music:[35] in this way, Kandinsky and Marc sought to highlight the spiritual affinity of the primitive and the modern, and through a return to what they saw as the primitive life of the spirit, these artists thought a spiritual regeneration of society would emerge.

However, regeneration could not simply be achieved by adopting the forms of primitive art. Kandinsky and Marc were among a number of artists, writers and thinkers of the early twentieth century who felt that a full-scale apocalypse was necessary to wipe out the remnants of the decadent European society. Both nationalism and primitivism were subsumed within this apocalyptic discourse, which found expression throughout Europe in the years leading up to the First World War. In attempting to convey the need for a new beginning, artists and writers found methods to present the case for destruction and regeneration in various metaphorical ways. Although some advocates of the apocalypse expressed their belief in the form of a wish for material devastation, others relied on pseudo-religious Symbolist language to express their longing for spiritual renewal. Those who hoped for a new beginning had no aspiration for a reformed version of their own society; instead they called for a complete obliteration of that society, with the chiliastic belief that a new and better society would take the place of the old one.[36] Although the rhetoric of apocalypse and renewal was drawn from millenarian tradition, the new crises of industrial society gave this rhetoric a potent and increasingly dangerous resonance.

This millennial language was built into the cultural criticism of the *fin de siècle*. As early as 1895,

an anonymous critique of Nordau's *Degeneration* refuted Nordau's diagnosis of cultural decline. To this author, what Nordau perceived as cultural degeneration was merely the first step in social renewal:

> The axe must precede the plough, because the forest cannot co-exist with the wheat field. The growing enmity against old dogmas, old authorities, old forms among the educated and artistic classes, the kindling rage of the masses against existing institutions, signal the clearing of the rank jungle and the pestilential swamps prior to cultivation.[37]

This sense of destruction and renewal was often represented in terms of old versus new or youth versus age. When the Austrian art critic Hermann Bahr described Expressionism, he did so with just such analogies in mind. He wrote, 'As long as humanity does not die it renews itself, and no son will ever remain satisfied with the work of his father', and he went on to make the apocalyptic undertones of this comment explicit. Assuming the tone of a sceptical traditionalist, Bahr wrote:

> Do but read the programmes of these modernists. They wallow in manifestos. It is no longer a question of a new art; they paint a new philosophy, a new religion, the dawn of the third realm! Our good, honest, modest Impressionism, dubbed by that maniac Denis as an epoch of ignorance and madness, whereas they are painting the salvation of humanity! Read their Apocalypse![38]

Bahr's own comments were directed to Viennese painters, but he was also aware of the experiments of German Expressionists, whose chiliastic motives he clearly identified.

The origin of such ideas lay largely in the writings of Nietzsche and Wagner. Nietzsche's criticisms of industrial society were constantly tempered with suggestions that such a decadent civilization needed to be destroyed and recreated. In his *Birth of Tragedy* (1872), he contrasted the Apollonian and Dionysiac tendencies, the former an expression of cultural sophistication and the latter a manifestation of primitive unbridled passions.[39] It was in the Dionysian spirit that Nietzsche saw the answer to civilization's problems; it was a spirit that was both destructive and creative, but not frozen in the artificial sterility of modern life. Although Wagner's populist rhetoric eventually alienated Nietzsche, he shared Nietzsche's wish for a spiritual regeneration and believed also that this could only be achieved by some sort of large-scale destruction. In his essay on 'Religion and Art', Wagner wrote: 'The theory of a degeneration of the human race, however much opposed it seems to Constant Progress, is yet the only one that upon serious reflection can afford us any solid hope.'[40] Wagner believed that a race could be enlightened by witnessing the destructive effects of its own evil, and that the power of renewal after destruction would come through art itself. Wagner's and Nietzsche's metaphorical language extolled the advantages of an apocalypse without suggesting how such an apocalypse could be achieved. The language of philosophy thus provided the source for modern artists who felt a vague desire for a similar sort of change.

These motives are apparent in the Blaue Reiter Almanac and in Kandinsky's art treatise, *Concerning the Spiritual in Art* (1912), which was published soon after. Franz Marc's essays in the Almanac made the most explicit use of this apocalyptic rhetoric. Collapsing together the notions of primitivism and modernity, Marc wrote of revolutionary modern artists as 'savages' who were fighting against 'an old established power', and he claimed that these artists intended 'to create out of their work *symbols* for their own time, symbols that belong on the altars of a future spiritual

religion'.[41] The reference to religion and the spirit, and the militaristic metaphor of battle against an old order, were repeated in another of the Almanac essays, in which Marc postulated a coming apocalypse:

> The awareness of this turning point [between materialist and spiritualist art] is not new; its summons was even louder a hundred years ago. At that time, people thought they were very close to a new era, much closer than we believe today. A century intervened, during which a long and exceedingly rapid development took place. Mankind practically raced through the last stage of a millennium that had begun after the fall of the great classical world . . . Today this long development in art and religion is over, but the vast land is still full of ruins . . . The old ideas and creations live on falsely, and we stand helplessly before the Herculean task of banishing them and paving the way for what is new and already standing by . . . It can be sensed that there is a new religion arising in the country, still without a prophet, recognized by no one.[42]

Marc attempted to express the themes of destruction and renewal in his own paintings, which concentrated primarily upon animals as symbols of spiritual strength. Marc's sympathies with the world of animals was part of his disgust at the over-developed sophistication of modern civilization, and the animals became for him representations of the spiritual possibilities of nature. His *Fate of the Animals* (Figure 60) shows these spiritual beings inflicted with a destructive plethora of intersecting lines. Although Marc's own response to animals was more ambivalent by the time he painted *Fate of the Animals*, the work could be seen as exemplifying his belief that the coming apocalypse would threaten not just physical life, but the life of the spirit as well. The power of the spirit to withstand such a threat was asserted by the artistic prophets of the apocalypse. In a rare instance of specificity, Marc's *Unfortunate Land of Tirol* (1913, New York, Solomon R. Guggenheim Museum) used both apocalyptic and animal themes in a direct allusion to the Balkan Wars which contributed to the onset of the First World War. The hint here that war would be the agent of the apocalypse was made explicit by Marc in a later letter to Kandinsky:

> I am not angry at this war; I am grateful to it, from the bottom of my heart. There was no other avenue to the time of the spirit; it was the only way of cleansing the Augean stables of old Europe.[43]

This longing for war was part of the metaphorical, even escapist, language used by those who wished for a new beginning. Indeed, many chiliasts, including Kandinsky, relied heavily on the ideas of Nietzsche and theosophy to give their works a philosophical foundation which eschewed the more practical questions of how the apocalypse would come about and how it could engender spiritual renewal. In his essay, 'On the Question of Form', published in the Blaue Reiter Almanac, Kandinsky expressed a desire for an art that denied the materialism of modern society. He accused some modern artists of being deaf to the spirit, and he used synaesthetic analogies in his call for a tapping of the 'inner sound' in works of art.[44] He did not tackle the problem of how an artist was to achieve this 'inner sound' until the publication of his more developed *Über das Geistige in der Kunst* (*Concerning the Spiritual in Art*) (1912). In this later work, he acknowledged his debt to Nietzsche, theosophy and the anthroposophy of Rudolf Steiner, using the language of a millenarian prophet:

> Our souls, which are only now beginning to awaken after the long reign of materialism, harbor seeds of desperation, unbelief, lack of purpose. The whole nightmare of the materialistic attitude, which has turned the life of the universe into an evil, purposeless game, is not yet over.[45]

Kandinsky asserted that the collapse of religion, science and morality was driving people to turn their gaze inward in order to combat their disillusionment with society; the artist could help foster this new age of the spirit by cultivating an awareness of the spiritual power of colour. Kandinsky's long descriptions endow colour with emotional and psychological properties; for example:

> Passivity is the most characteristic aspect of absolute green, a quality tainted by a suggestion of obese self-satisfaction. Thus, pure green is to the realm of colour what the so-called bourgeoisie is to human society: it is an immobile, complacent element, limited in every respect.[46]

Kandinsky's association of colour with spiritual properties led to a concomitant association of form with materialism, and it was the evolution of this idea that eventually resulted in his purely abstract works. Kandinsky gradually moved away from his representational depictions of apocalyptic themes from Revelation, such as the *Last Judgement* (1912, Munich, Lenbachhaus), to fully abstract works such as *Composition* VII (Moscow, Tretiakov Gallery), although he claimed that the latter work was also a spiritual representation of the apocalypse. By dissolving form, Kandinsky claimed to release the 'inner sound' of the colour and contribute to the spiritual renewal which his writings predicted. However, it is clear that few observers could or would recognize the same spiritual nuances that Kandinsky claimed to be painting. In dispensing with representational clarity, Kandinsky was to an extent avoiding the very issues with which he claimed to be grappling. A work such as *Composition* VII may be apocalyptic, but its abstract obscurity demands, rather than provides, an explanation of how such an apocalypse could or should come about and what its ultimate result would be.

Kandinsky and Marc were both working within the limits provided by Symbolist artists of the 1890s, and the metaphorical nature of their language and the obscurity that surrounded their apocalyptic yearnings could be explained in part by reference to their Symbolist heritage. However, just as Kandinsky and Marc turned away from the particulars of reality to a spiritual alternative, the Futurists embraced modern life as an agent for the destruction which they too welcomed with chilling enthusiasm. In Germany, for example, the Futurist-inspired Ludwig Meidner painted apocalyptic landscapes in which the destruction of the metropolis was represented with manic energy. German apocalyptic poetry provided Meidner with the imagery and inspiration for these landscapes, as much of it looked to the destruction of the city as the beginning of a new millennium. To Meidner and his circle, the city – a product of modern man – had, like Frankenstein's monster, outgrown its creator. Man had created the agency of his own destruction, and the power of the city replaced that previously held by nature. This notion of the urban apocalypse contrasts with Marc's emphasis on nature and Kandinsky's anti-materialist ethos. Within Meidner's work, the destruction itself was seen as the event to be welcomed.

More direct in their destructive impulses were the Italian Futurists, whose manifestos were rife with jingoistic rhetoric. The Futurists extolled the cult of youth, which they associated aggressively with the agencies of apocalyptic destruction. They declared their intentions concisely and provocatively in their 1909 Manifesto:

1. We intend to glorify the love of danger, the custom of energy, the strength of daring.

2. The essential elements of our poetry will be courage, audacity, and revolt . . .

4. We declare that the splendor of the world has been enriched with a new form of beauty, the beauty of speed. A race-automobile which seems to rush over exploding powder is more beautiful than the *Victory of Samothrace* . . .

7. There is no more beauty except in struggle. No masterpiece without the stamp of aggressiveness. Poetry should be a violent assault against unknown forces to summon them to lie down at the feet of man . . .

9. We will glorify war – the only true hygiene of the world – militarism, patriotism, the destructive gesture of anarchist (*sic*), the beautiful Ideas which kill, and the scorn of woman.

10. We will destroy museums, libraries, and fight against moralism, feminism, and all utilitarian cowardice.[47]

The Futurist enthusiasm for scientific progress was shared by other Europeans, who saw new inventions such as the automobile, X-rays and cinematography as a positive way forward for industrial society.[48] This progressivism is contained in such works as Balla's *Racing Car* (1913, Amsterdam, Stedelijk Museum), which attempted to depict the dynamism of new inventions through repetition of forms. However, more prominent was the Futurists' glorification of war and destruction, and their extension of this destructiveness not just to moribund traditions, but to such recent developments as feminism. Unlike the Blaue Reiter artists, the Futurists did not wish to replace materialism with a healthier spiritual alternative; instead they aimed their destructive inclinations at anything that did not fit within their own rather limited view of what the world should be. Other than destruction, their manifesto offered no suggestions as to how such a faulty society could be improved. Destruction was thus seen to be not the precursor of regeneration, but the very symptom of that regeneration.

In a book which began with a teleological theme and ends with the First World War, it would be difficult not to suggest that the apocalypse which some Europeans felt they wanted actually did arrive in 1914. However, it was not prophecy that was responsible for the chiliastic inclinations of European artists before the war, as the tensions between various European countries, and the internal social and political conflicts which resulted from rapid industrialization, were obviously out of control. Indeed, the anonymous critic of Nordau's *Degeneration* blamed the problems of the 1890s on economic competition, and went on to suggest that Germany would be the source of the eventual resolution of social degeneration:

Everything in Germany points to a coming catastrophe . . . The crisis which seems bound to come may be a violent one, arising from below; or it may be a peaceful one, taking its origin from above . . . there will be a momentary social chaos; for all the military and bureaucratic institutions, all systems, theories, prejudices, will be cast in the furnace.[49]

Certainly this author's prediction of a violent catastrophe and social chaos proved true, but the phoenix of a new society which many hoped would arise from the ruins of the old one remained merely a myth. The First World War did not resolve the political, social and cultural tensions of the *fin de siècle*, which continue to haunt us as we approach the millennial year 2000.

NOTES

1. For a clear discussion of these problems, see Enzo Callotti, 'Nationalism, Anti-Semitism, Socialism and Political Catholicism as Expressions of Mass Politics in the Twentieth Century', in Mikuláš Teich and Roy Porter, eds., *Fin de Siècle and its Legacy* (Cambridge, 1990), 80–97.
2. Richard Wagner, 'The Art-Work of the Future', in *Richard Wagner's Prose Works*, Eng. trans., 8 vols. (London, 1892), 1:71.
3. For Wagner's comments on vegetarianism, see 'Religion and Art', in Works, 6:239.
4. Wagner, 'Art-Work', in Works, 1:180.
5. Ibid., 1:186.
6. Moritz Wirth, *Bismarck, Wagner, Robertus: Drei deutsche Meister. Betrachtungen über ihr Wirken und die Zukunft ihre Werke* (Leipzig, 1883).
7. Henry Thode, *Böcklin und Thoma: Acht Vorträge über neudeutsche Malerei* (Heidelberg, 1905).
8. Johannes Manskopf, *Böcklins Kunst und die Religion* (Munich, 1905), 1–2.
9. Ibid., 9.
10. Böcklin's representations of the battle between mythical gods and centaurs have often been interpreted as militaristic, particularly in the wake of the Franco-Prussian war. For a discussion of this, see especially Lutz Tittel, ed., *Arnold Böcklin Leben und Werk in Daten und Bildern* (Frankfurt-am-Main, 1977).
11. See Ernst Haeckel, *Monism, as Connecting Religion and Science* (1893), Eng. trans. (London, 1894).
12. Henri Bergson, *Creative Evolution* (1907), Eng. trans. (London, 1928), 287–8.
13. Ibid., 174.
14. Ferdinand Hodler, *The Mission of the Artist* (1897), quoted in Pierre-Louis Mathieu, *The Symbolist Generation 1870–1910* (New York, 1990), 143.
15. For an excellent discussion of Langbehn, see Fritz Stern, *The Politics of Cultural Despair: A Study in the Rise of the Germanic Ideology* (Berkeley and Los Angeles, 1961).
16. Julius Langbehn, *Rembrandt als Erzieher* (Leipzig, 1890), 9.
17. A good discussion of these nature cults and their relationship to art can be found in Maria Makela, *The Munich Secession: Art and Artists in Turn-of-the-Century Munich* (Princeton, 1990), 123, and Jill Lloyd, *German Expressionism: Primitivism and Modernity* (New Haven, 1991), 102–29.
18. Paul Tucker, *Monet in the '90s; the Series Paintings*, exhibition catalogue, Museum of Fine Arts, Boston, 1989.
19. 'L'Angèle' [Raymond Bouyer], 'Lettre d'Angèle', *L'Ermitage* (10 May 1899), 399.
20. For Germany, see Peter Paret, *The Berlin Secession: Modernism and its Enemies in Imperial Germany* (Cambridge, MA, Harvard University Press, 1980) and for Spain see Francisco Calvo Serraller, 'Dario de Regoyos y el problema del impresionismo español', in *Pintores españoles entre dos fines de siglo (1880–1990)* (Madrid, 1990), 69–75.
21. A full discussion of Scandinavian *fin de siècle* art can be found in *Dreams of a Summer Night*, exhibition catalogue, Hayward Gallery (London, 1986).
22. Quoted ibid., 118.
23. The best source for Polish Symbolism in English is *Malczewski: Vision of Poland*, exhibition catalogue, Barbican Gallery (London, 1990).
24. Ibid., 77.
25. See *Bohemians in the Bush: the Artists' Camps of Mosman*, exhibition catalogue, Art Gallery of New South Wales, 1991.
26. Debra Silverman, *Art Nouveau in Fin-de-Siècle France* (Berkeley and Los Angeles, 1989).
27. Ernst Haeckel, *The Riddle of the Universe at the Close of the Nineteenth Century*, Eng. trans. (London, 1900), 349.
28. See Kurt Bayertz, 'Biology and Beauty: Science and Aesthetics in Fin-de-Siècle Germany', in Teich and Porter, eds., 270–95, and C. Cockerbeck, *Ernst Haeckel's 'Kunstformen der Natur' und ihr Einfluss auf die deutsche bilbende Kunst der Jahrhundertwende* (Frankfurt-am-Main, 1986).
29. The most complete discussion of primitivism and modern art remains William Rubin, ed., *Primitivism in Twentieth-Century Art: Affinity of the Tribal and the Modern*, exhibition catalogue, Museum of Modern Art (New York, 1984).
30. Maurice Malingue, ed., *Gauguin's Letters to his Wife and Friends* (Cleveland, 1949), 197 (undated letter, possibly 5 February 1895).
31. See Belinda Thomson, *Gauguin* (London, 1987), especially 187, and Lesley Stevenson, *Gauguin* (London, 1990).
32. See Lloyd, cited above.
33. Emile Nolde, *Jahre der Kämpfe* (Berlin, 1934), 241.
34. See Armin Zweite, *The Blue Rider in the Lenbachhaus Munich* (Munich, 1989), 11–14.
35. *The Blaue Reiter Almanac* (1912), Eng. trans. (London, 1974).
36. See David Roberts, ' "Menschheitsdämmerung": Ideologie, Utopie, Eschatologie', in Bernard Hüppauf, ed., *Expressionismus und Kulturkrise* (Heidelberg, 1988), 85–103.
37. *Regeneration* (London, 1895), 42.
38. Hermann Bahr, *Expressionism*, Eng. trans. (London, 1925), 19, 27–8; compare his comments in *Renaissance: Neue Studien zur Kritik der Moderne* (Berlin, 1897), 6: 'Die Kunst der Väter tödtet das Leben der Enkel. Sie wollen aus dem Wirklichen flüchten. Wohin? In die Seele? Aber die Seele ist leer, wenn ihr der Stoff der wirklichen Welt fehlt sie wird an ihrer Fülle erst lebendig; nur wer wachte, kann träumen. In Kunst? Aber sie ist doch immer nur gefühltes Leben. Jene todte der Vergangenheit mögen sie in Erinnerungen geniessen; selber können sie seine der Gegenwart schaffen.'
39. Friedrich Nietzsche, *The Birth of Tragedy* (1872), Eng. trans. (New York, 1967).
40. Wagner, 'Religion and Art', in Works, 6:237.
41. Franz Marc, 'The "Savages" of Germany', in Blaue Reiter Almanac, 61, 64.
42. Franz Marc, 'Two Pictures', in Blaue Reiter Almanac, 65–6.
43. Quoted in Zweite, 51.
44. Vassily Kandinsky, 'On the Question of Form', in Blaue Reiter Almanac, 149, 156.
45. Vassily Kandinsky, 'On the Spiritual in Art', in *Complete Writings on Art*, 2 vols. (1982), 1:128.

46. Ibid., 1:183.
47. From 'Futurist Manifesto', first published in *Le Figaro* (20 February 1909), quoted in Herschel B. Chipp, *Theories of Modern Art* (Berkeley and Los Angeles, 1968), 286.
48. This issue is discussed thoroughly in several essays in Teich and Porter, cited above.
49. *Regeneration*, 310–11.

ANNOTATED BIBLIOGRAPHY

The following is a select bibliography of works which I have found helpful or interesting in the process of researching this book. This is by no means comprehensive, and I have concentrated on listing primary sources and recent texts, rather than exhaustively cataloguing research in specific areas. Where English translations are available, I have cited them, except in one or two cases of primary texts which are best appreciated in their original language.

With the exception of Chapter 1, each chapter contains (1) a paragraph of primary sources relating to the theme of the chapter; (2) a paragraph on secondary sources relating to that theme; and (3) a paragraph on relevant art-historical monographs. Paragraph (3) begins with general sources and then catalogues sources on individual artists in alphabetical order by artist. Further references can be found in the footnotes for each chapter.

CHAPTER 1: THE *FIN DE SIÈCLE* PHENOMENON

For general works on the history of millenarianism, see Norman Cohn's important study, *The Pursuit of the Millennium* (London, 1970) and Ernest Lee Tuveson's more theoretical *Millennium and Utopia: A Study in the Background and Idea of Progress* (Gloucester, MA, 1972). For a sociological perspective, see Michael Barkun, *Disaster and the Millennium* (Syracuse, 1986); John Leddy Phelan provides a more focused study in *The Millennial Kingdom of the Franciscans in the New World* (Berkeley and Los Angeles, 1970).

A religious and philosophical perspective for the fifteenth century is provided by J. Huizinga's classic work, *The Waning of the Middle Ages*, Eng. trans. (London, 1987). For Bosch and millenarianism, see William Fränger's eccentric *Hieronymus Bosch* (London, 1989) (to be read with caution). A thorough and readable study of Dürer's work is Peter Strieder's *Dürer. Paintings, Prints, Drawings* (London, 1982). There is a wealth of good material on Botticelli, including Ronald Lightbown's *catalogue raisonné*, *Sandro Botticelli: Life and Work*, 2 vols. (London, 1978). On Botticelli and millenarianism, see Stanley Meltzoff's intellectual but heavy *Botticelli, Signorelli and Savonarola: 'Theologica Poetica' and Painting from Boccaccio to Poliziano* (Florence, 1987) and Donald Weinstein's more accessible *Savonarola and Florence: Prophecy and Patriotism in the Renaissance* (Princeton, 1970). For Filippino Lippi, see Katherine Neilson, *Filippino Lippi* (Westport, CN, 1938, reprint 1972).

The artistic background of the Sack of Rome is provided by André Chastel, *The Sack of Rome 1527*, Eng. trans. (Princeton, 1983), and information on Giulio Romano is best obtained in Frederick Hartt's *catalogue raisonné*, *Giulio Romano*, 2 vols. (New Haven, 1958).

For the relationship between art and politics in the 1790s, see Michael Levey, *Rococo to Revolution* (London, 1966, reprint 1978) and more recently, David Bindman, *Shadow of the Guillotine: Britain and the French Revolution* (London, 1989). Edmund Burke's *Reflections on the Revolution in France* (London, 1790) still provides fascinating insight, as does Simon Schama's *Citizens* (London, 1989), which reads more like a novel than an historical analysis. For Blake's poetry, see Geoffrey Keynes, ed., *Blake: Complete Writings* (Oxford, 1989), and for his art, see David Bindman's thorough *Blake as an Artist* (Oxford, 1977). For Goya and the Spanish political context, see Gwyn Williams, *Goya and the Impossible Revolution* (London, 1976).

CHAPTER 2: DEGENERATION

For an early theory of psychological degeneration, see Bénédict-Augustin Morel, *Traité des dégénerescences physiques, intellectuelles, et morales de l'espèce humaine* (Paris, 1857), and for the origin of much late nineteenth-century pseudo-science, see Charles Darwin's important *On the Origin of Species* (London, 1859) and *The Descent of Man* (London, 1871). Cesare Lombroso's 'Atavism and Evolution', *Contemporary Review* (July 1895), 42, relates Darwinism directly to the theory of degeneration, but the most bizarre contemporary account is Max Nordau's *Degeneration*, Eng. trans. (London, 1895), which, despite its obsessiveness, is a very important work. See also Bernard Shaw's refutation of Nordau, the facetious *Sanity of Art* (New York, 1908). Theories of degeneration occur also in the following works: Havelock Ellis's fascinating utopian critique, *The Nineteenth Century: A Dialogue in Utopia* (London, 1900); Alfred Fouillée's 'Dégénérescence: Le Passé et le present de notre race', *Revue des deux mondes*, 131

(1895), 793–824; Cesare Lombroso, Crime: its Causes and Remedies, Eng. trans. (Boston, 1911); Ernst Haeckel's biologically based The Riddle of the Universe at the Close of the Nineteenth Century, Eng. trans. (London, 1900); John Berry Haycraft's flagrantly eugenic Darwinism and Race Progress (London, 1895); E.S. Talbot's Degeneracy: its Causes, Signs and Results (London, 1899); and Emile Durkheim's pessimistic Suicide (1897), Eng. trans. (London, 1952). The philosophical origin of many theories of degeneration and morality is in Nietzsche's work, especially Jenseits von Gut und Bose, Eng. trans. by R.J. Hollingdale as Beyond Good and Evil (Harmondsworth, 1990). For the idea of decadence, as it relates to the arts, see Holbrook Jackson's classic The Eighteen Nineties (London, 1913), and Arthur Symons's important definition of the term in 'The Decadent Movement in Literature', Harper's New Monthly Magazine, 522 (November 1893), 858–67. For some truly decadent texts, see Charles Baudelaire, Les Fleurs du Mal et autres poèmes (Paris, 1964), and J.-K.Huysmans, A Rebours (Paris, 1978). Huysman's Certains (Paris, 1889) is an interesting example of 'decadent' art criticism. For theories of decadence and degeneracy, and their relationship with art and the history of art, see Konrad Lange's ponderous Das Wesen der Kunst, 2 vols. (Berlin, 1901), which relates art to evolution; John Addington Symonds, 'On the Application of Evolutionary Principles to Art and Literature', Essays Speculative and Suggestive, 2 vols. (London, 1890); Adolf Loos, 'Ornament und Verbrechen', in Die Schriften von Adolf Loos, 2 vols. (Innsbruck, 1932), which uses Lombroso's theories of crimes in an architectural context; and Jean-Martin Charcot and Paul Richer, Les Difformes et les malades dans l'art (Paris, 1889).

There is a wealth of good secondary source material which places the theory of degeneration in its historical and intellectual context, including Klaus Bohnen, ed., Fin de Siècle (Oxford, 1984); John Stokes's useful In the 90s (Hemel Hempstead, 1989); and more recently, Mikulás Teich and Roy Porter's more optimistic view of the period, Fin de Siècle and its Legacy (Cambridge, 1990). For Darwinism in context, see Peter J. Bowler, The Eclipse of Darwinism: Anti-Darwinian Evolution Theories in the Decades Around 1900 (Baltimore, 1983); David Kohn, ed., The Darwinian Heritage (Princeton, 1986); and the recent biography of Darwin by Adrian Desmond and James Moore (London, 1991). In the last few years, several works have tackled theories of degeneration and decadence, and some of these explore the relationships between psychology, the arts and sociology in a helpful and enlightening way. Among the best of these are Daniel Pick, Faces of Degeneration: A European Disorder, c. 1848–1918 (Cambridge, 1989), which is both wide-ranging and methodologically sophisticated, exploring the issue in Italy, France and England. See also the collection of essays edited by Edward Chamberlin and Sander Gilman, Degeneration: The Dark Side of Progress (New York, 1985), and see Jennifer Birkett's well-argued but sometimes a little abstruse The Sins of the Fathers: Decadence in France 1870–1914 (London, 1986). On decadence, see Linda Dowling's annotated bibliography Aestheticism and Decadence (New York, 1977), as well as her convincing article 'The Decadent and the New Woman in the 1890s', Nineteenth-Century Fiction, 33 (March 1979), 434–53, and her penetrating and revealing study of language and imperialism, Language and Decadence in the Victorian Fin de Siècle (Princeton, 1986). Other works on decadence include the explorations of the term by Richard Gilman, Decadence: the Strange Life of an Epithet (New York, 1979), and R.K.R. Thornton, The Decadent Dilemma (London, 1983); the rather tenuous argument for a decadent style of art in John R. Reed's Decadent Style (Athens, OH, 1985); Ian Fletcher's helpful collection of essays, Decadence and the 1890s (Stratford upon Avon, 1979); Jean Pierrot's thematically organized The Decadent Imagination 1880–1900, Eng. trans. (Chicago, 1981); and K.W. Swart's examination of the whole history of decadence in The Sense of Decadence in Nineteenth-Century France (The Hague, 1964). To be avoided is Séverine Jouve's eccentric Les Décadents (Paris, 1989), which tells the story of decadence from a first-person perspective. On decadent literature, see the old-fashioned but still stimulating and comprehensive Mario Praz, The Romantic Agony, Eng. trans. (London, 1970), and the recent 'new historicist' approach to the subject in Christopher Lloyd, J.-K. Huysmans and the Fin-de-Siècle Novel (Edinburgh, 1990). There are also a number of studies concentrating on specific countries. For Austria see Carl Schorske's excellent Fin-de-Siècle Vienna (Cambridge, 1985), and Robert Pynsent's patchy but interesting Decadence and Innovation: Austro-Hungarian Life and Art at the Turn of the Century (London, 1989). Spain is badly served in this subject, but see the helpful general accounts in Ana Maria Arias de Cossio, La pintura del siglo XIX en España (Barcelona, 1989), and Francesco Calvo Serraller, Pintores españoles entre dos fines de siglo (1880–1990) (Madrid, 1990). The more relevant work by Pedro Sainz Rodriguez, Evolucion de las ideas sobre la decadencia espanola y otros estudios (Madrid, 1962), is hard to come by. For France, see Eugen Weber, France, Fin de Siècle (Harvard, 1986), and for Italy, consult the literary anthologies edited by Adelaide Casanova, Scrittori del decadentismo italiano (1989), and the more sophisticated analysis by Carlo Annoni, Il decadentismo (Brescia, 1982). When this book was going to press, History Today (42), (1992) began a series on the fin de siècle which was, unfortunately, published too late for me to use.

Of the artists covered in this chapter, several are the subject of important studies or articles, which avoid a purely biographical perspective. On Degas and decadence, see Theodore Reff's important study, Degas: the Artist's Mind (London, 1976), and Eunice Lipton's feminist approach in Looking into Degas: Uneasy Images of Women and Modern Life (Berkeley and Los Angeles, 1986). For more details, if less analysis, see Henry Loyrette, Degas (Paris, 1991). Of the many books on Munch, the most useful for the context of degeneration are Bente Torjusen, Words and Images of Edvard Munch (London, 1989), Reidar Dittmann, Strindberg and Munch in the 1890s (Epping, 1982), and the more general studies: Anne Eggum, Edvard Munch (London, 1984) and Reinhold Heller, Munch: His Life and Work (London, 1984). For the controversies over Klimt's painting and the context of these controversies, see Hermann Bahr's compilations of criticisms, Rede über Klimt (Vienna, 1901) and Gegen Klimt (Vienna, 1903); Christian Nebehay's Gustav Klimt: Dokumentation (Vienna, 1969); Alice Strobl's documented study, 'Zu den Fakultätsbildern von Gustav Klimt', Albertina Studien, 2 (1964), 138–69; and, more generally, Peter Vergo, Art in Vienna 1898–1918 (Oxford, 1975, reprint 1986). For Picasso's 'Blue Period', the best study is Der junge Picasso, exhibition catalogue, Kunstmuseum (Berne, 1984), but Timothy Hilton's Picasso (London, 1975) also provides a good general introduction, despite its obvious biases. On Rodin, see Albert Elsen, The Gates of Hell (Stanford, 1985), and more generally, Frederic Grunfeld, Rodin: A Biography (London, 1988), and Catherine Lampert, Rodin: Sculpture and Drawings, exhibition

catalogue, Hayward Gallery (London, 1986). Félicien Rops is the subject of exhibition catalogues rather than extensive studies. These include Guy Cuvelier, *Félicien Rops* (Brussels, 1987); R. Delevoy and G. Cuvelier, *Félicien Rops* (Lausanne, 1986); and R. Delevoy, *Félicien Rops* (Paris, 1985). For Watts, see John Gage, *G.F. Watts*, exhibition catalogue, Whitechapel Art Gallery (London, 1974), and for Toulouse-Lautrec, the recent exhibition catalogue, *Toulouse-Lautrec* (New Haven, 1991) is the most exhaustive and balanced source.

CHAPTER 3: ANARCHY

For early statements of the purpose of art in an anarchist society, see Pierre Joseph Proudhon, *Du Principe de l'art et sa destination sociale* (Paris, 1865), and Peter Kropotkin. *Paroles d'un révolté* (Paris, 1885). The clearest polemic for art in the service of the Left is a socialist pamphlet, Jules Destrée, *Art et socialisme* (Brussels, 1896). The best works on anarchy in the 1890s are in French and include Jean Grave's eloquent *La Société mourante et l'anarchie* (Paris, 1893), with a preface by Octave Mirbeau, and the same author's *L'Anarchie: son but – ses moyens* (Paris, 1899). Revealing tracts on anarchy include Félix Dubois, *The Anarchist Peril*, Eng. trans. (London, 1894); A. Hamon's attempt to pinpoint an anarchist character in *Psychologie de l'anarchiste-socialiste* (Paris, 1895); and M. Nettlau's massive *Bibliographie de l'anarchie* (Brussels and Paris, 1897). For a later apology for political violence, see Georges Sorel, *Reflexions sur la violence* (Paris, 1906). Support for anarchy or socialism in other countries often took more literary or sociological forms. In England, see David Ritchie, *Darwinism and Politics* (London, 1889); the impassioned essays by William Morris, *Selected Writings*, ed. G.H. Cole (London, 1934) (which includes *News From Nowhere*); and Oscar Wilde, 'The Soul of Man Under Socialism' (1890), in Russell Fraser, ed., *Selected Writings of Oscar Wilde* (Boston, 1969), 336–64. In Russia, see Tolstoy's examination of the political nature of aesthetics in *What is Art? and Essays on Art*, Eng. trans. (Oxford, [1930]). Opponents of anarchy included Matthew Arnold, who decried any form of rebellion against tradition in *Culture and Anarchy* (London, 1869); and T.H. Huxley in 'On the Natural Inequality of Men', *The Nineteenth Century*, 27, no. 155 (January 1890), 1–23, and 'Government: Anarchy or Regimentation', *Nineteenth Century*, 27 (May 1890), 843–65. As usual, a more extreme reaction can be found in Max Nordau, *The Conventional Lies of Our Civilization*, Eng. trans. (Chicago, 1884), but Cesare Lombroso is somewhat more sympathetic to the anarchist cause, although he derides violence in 'La Physionomie des anarchistes', *Nouvelle Revue* (15 May 1891), 227, and *Gli anarchici* (Turin, 1894). See also the work of Lombroso's pupil, Enrico Ferri. *Socialismo e criminalità* (Rome, 1883). Of all the anarchist periodicals, *Père Peinard* is most interesting from an artistic point of view, although it is very difficult to find, even in copyright libraries. Of the literary reviews which had an anarchist slant, *La Revue blanche* was best served by the Paris artistic community. Finally, the best books on mass culture are Gustave LeBon's early sociological studies, *The Crowd*, Eng. trans. (London, 1896) and *The Psychology of Socialism*, Eng. trans. (London, 1899).

Most relevant information on the history of European anarchism can be obtained in one of three sources: Jean Maitron, *Histoire du mouvement anarchiste en France 1880–1914* (Paris, 1955); James Joll's more accessible *The Anarchists* (London, 1964, 2nd ed. 1979); and the recent exhaustive study by Peter Marshall, *Demanding the Impossible: A History of Anarchism* (London, 1991). A more specific study of a particular case is contained in H. Oliver's workmanlike *The International Anarchist Movement in Late Victorian London* (London, 1983). For mass culture, Michael Biddiss's *The Age of the Masses* (Harmondsworth, 1977) offers a useful introduction to the intellectual history of the period, but see also the interesting argument in favour of popular culture contained in Patrick Brantlinger, *Bread and Circuses. Theories of Mass Culture as Social Decay* (Ithaca, 1983).

The best studies of art and anarchism are Joan Ungersma Halperin, *Félix Fénéon: Aesthete and Anarchist in Fin-de-Siècle Paris* (New Haven, 1988), which contains a full account of Fénéon's trial, and Eugenia Herbert, *The Artist and Social Reform, France and Belgium 1885–98* (New Haven, 1961), which also covers literature. Art and politics is handled more generally in Miriam Levin's somewhat strained examination of the French government's policy on the arts in *Republican Art and Ideology in Late Nineteenth-Century France* (Ann Arbor, 1986). For Belgian art and anarchy, see Jane Block, *Les XX and Belgian Avant-Gardism 1868–1894* (Ann Arbor, 1984). For this chapter and all others, the most comprehensive account of artistic development in the period is *Post-Impressionism*, exhibition catalogue, Royal Academy of Arts (London, 1979). For art and politics in England see Julian Treuhertz's somewhat maligned but informative *Hard Times*, exhibition catalogue, Manchester Art Gallery (Manchester, 1987). For Germany, see the excellent studies by Maria Makela, *The Munich Secession: Art and Artists in Turn-of-the-Century Munich* (Princeton, 1990), and Peter Paret, whose *The Berlin Secession: Modernism and its Enemies in Imperial Germany* (Cambridge, MA, 1980) is both scholarly and gripping. See also Peter Paret and Beth Irwin Lewis, 'Art, Society and Politics in Wilhelmine Germany', *Journal of Modern History*, 57 (1985), 696–710, and Horst Ludwig, *Kunst, Geld und Politik um 1900 in München* (Berlin, 1986), which contains primary documentation relating to art legislation in *fin de siècle* Munich. For Russia, see Theofanis George Stavrou, ed., *Art and Culture in Nineteenth-Century Russia* (Bloomington, 1983). The artists in this chapter include Eugène Carrière, the subject of a sound study by Robert James Bantens, *Eugène Carrière: His Work and Influence* (Ann Arbor, 1983), but see also Carrière's own political beliefs, as revealed in Eugène Carrière, *Ecrits et lettres choisies* (Paris, 1907). For Courbet, see T.J. Clark's challenging *Image of the People: Gustave Courbet and the 1848 Revolution* (London, 1973). For Käthe Kollwitz, see Nina Klein, *Käthe Kollwitz* (New York, 1975); Otto Nagel, *Käthe Kollwitz: Life in Art* (New York, 1975); and the short *Käthe Kollwitz: The Graphic Works*, exhibition catalogue, Kettle's Yard (Cambridge, 1981). Information on Italian artists is confined largely to exhibition catalogues; see *Nomellini e Pascoli*, exhibition catalogue, Palazzo Communale (Barga, 1986); Gianfranco Bruno et al., *Plinio Nomellini* (Florence, 1989); and *Gaetano Previati: Mostra antologica* (Ferrara, 1969). Some good studies of individual artists and their anarchist connections include Patricia Leighten's *Re-ordering the Universe: Picasso and Anarchism, 1897–1914* (Princeton, 1989); Richard Thomson's excellent *Camille Pissarro: Impressionism, Landscape and Rural Labour*, exhibition catalogue, Birmingham Art Gallery and South Bank (London, 1990); and John Hutton's detailed and

scholarly study, 'Camile (*sic*) Pissarro's *Turpitudes Sociales* and Late Nineteenth-century French Anarchist Anti-Feminism', *History Workshop*, 24 (Autumn 1987), 32–61. Richard Thomson has also written an admirable study of Seurat (Oxford, 1985), which tackles both formal qualities and political meaning in his work; and see John House's article, 'Meaning in Seurat's Figure Painting', *Art History*, 3 (1980), 345–56.

CHAPTER 4: ANXIETY

Most of the major primary sources on degeneration also discuss the effects of urbanization; for those, see Chapter 2 above. Arguments against cities which isolate them as seats of crime and anxiety include Cesare Lombroso, *Crime: its Causes and Remedies*, Eng. trans. (Boston, 1911) and Clifford Allbutt, 'Nervous Diseases and Modern Life', *Contemporary Review* (1 February 1895), 210–31,but see also William Morris (cited in Chapter 3 above), who derides the dehumanization of modern urban life. James Cantlie, *Degeneration Amongst Londoners* (London, 1885), isolates a specific city for criticism, and Sigmund Freud's later study, *Civilisation and Its Discontents*, Eng. trans. (London, 1963) consolidates the earlier theories of the city as a seat of neurosis. For conditions in the East End of London, see Charles Booth, ed., *Life and Labour: Volume I: East London* (London, 1889); George Sims, *How the Poor Live* (London, 1883); and for comparison, see Arthur Morrison's various fictional accounts of East End working-class life, including *To London Town* (London, 1899) and *A Child of the Jago* (London, 1896), and Blanchard Jerrold and Gustave Doré's sanitized *London: A Pilgrimage* (London, 1872). A more positive view of the city is contained in Robert Vaughan's *The Age of Great Cities* (London, 1843), and Charles Baudelaire's 'The Painter of Modern Life', in *The Painter of Modern Life and Other Essays*, ed. Jonathan Mayne (London, 1964); and Elisée Reclus's 'The Evolution of Cities', *Contemporary Review* (February 1895), 246–64 sees the rise of cities as evidence of advancement of civilization, as does Brooks Adams, *The Law of Civilization and Decay* (London, 1895). There are a number of utopian studies and plans for cities published in the 1890s; among the most interesting are Edward Bellamy's novel *Looking Backward 2000–1887* (1888), ed. John L. Thomas (Cambridge, 1967); H.G. Wells's 'The Time Machine', in *The Complete Short Stories of H.G. Wells* (London, 1927, rev. ed. 1974) and the same author's *Anticipations of the Reaction of Mechanical and Scientific Progress Upon Human Life and Thought*, 6th ed. (London, 1902); Theodor Fritsch, *Die Stadt der Zukunft* (Leipzig, 1896); and Ebenezer Howard, *Tomorrow: A Peaceful Path to Real Reform* (London, 1898). The contrast between the country and the city is given a philosophical foundation in Ferdinand Tönnies, *Gemeinschaft und Gesellschaft* (1887), Eng. trans. as *Community and Association* (London, 1955). The debate about anxiety, genius and degeneration is carried through several decades in such works as Francis Galton, *Hereditary Genius* (London, 1869); Paul Radestock, *Genie und Wahnsinn* (Breslau, 1884); Cesare Lombroso, *Man of Genius*, Eng, trans, (London, 1891); J.F. Nisbet, *The Insanity of Genius and the General Inequality of the Human Faculty Physiologically Considered* (London, 1891); and William Hirsch, *Genius and Degeneration*, Eng. trans. (London, 1897).

Raymond Williams's *The Country and the City* opened up the theoretical debate about the relationship between rural and urban, for which it provides a good methodological framework. The effects of urbanization are mentioned in a number of secondary sources on the nineteenth century, but the best overall studies include Malcolm Bradbury, 'The Cities of Modernism', in Malcolm Bradbury and James McFarlane, eds., *Modernism 1890–1930* (Harmondsworth, 1976), which gives a perspective on European and American cities of the period. Britain is well represented in H.J. Dyos and M. Wolff's comprehensive two-volume collection of essays, *The Victorian City: Images and Realities* (London, 1973), and in Donald J. Olsen, 'Victorian London: Specialization, Segregation and Privacy', *Victorian Studies*, 17 (Spring 1974), 265–78. For a review which summarizes Dyos and Wolff's book, see Alexander Welsh, 'The Victorian City', *Victorian Studies*, 17 (Spring 1974), 419–29. Germany is the subject of Andrew Lees, 'Debates About the Big City in Germany 1890–1914', *Societas*, 5 (1975), 31–47. More recently, several works have tackled the problem of urban crime in relation to developments in psychology; see especially Robert Nye, *Crime, Madness and Politics in Modern France: the Medical Concept of National Decline* (Princeton, 1984).

For art and nineteenth-century Paris, the best work is T.J. Clark's difficult *The Painting of Modern Life: Paris in the Art of Manet and His Followers* (Princeton, 1984); Belinda Thompson's *The Post-Impressionists* (Oxford, 1983) has an interesting chapter on urbanism. On individual artists see Esther Coen, *Umberto Boccioni*, exhibition catalogue, Metropolitan Museum of Art (New York, 1988). For Ensor, see P.-L. Delevoy, *Ensor* (Antwerp, 1981), and the more comprehensive *James Ensor*, exhibition catalogue, Petit Palais (Paris, 1990). Diane Lesko, *James Ensor: the Creative Years* (Princeton, 1985) considers the influences on Ensor's art, and Frank Whitford contributes an important study of an individual work, 'Ensor's *Entry of Christ into Brussels*', *Studio International*, 183 (September 1971), 936. For Frith, see Mary Cowling, *The Artist as Anthropologist* (Cambridge, 1989), and Shearer West, 'Tom Taylor, William Powell Frith and the British School of Art', *Victorian Studies*, 33 (Winter 1990), 307–26. Despite his posthumous fame, Van Gogh is not well-served in art-historical literature, but for detail, see *Van Gogh à Paris*, exhibition catalogue, Musée d'Orsay (Paris, 1988), and for accessibility, see the interesting discussion in Griselda Pollock, *Vincent van Gogh: Artist of His Time* (Oxford, 1978). Donald Gordon's book on *Kirchner* (Cambridge, MA, 1968) is still the best study in English, although see also Anton Henze, *Ernst Ludwig Kirchner: Leben und Werk* (Stuttgart, 1980). Meidner's work is examined in its cultural context in Carol Eliel, *The Apocalyptic Landscapes of Ludwig Meidner* (Munich, 1989); see also Frank Whitford, 'The Work of Ludwig Meidner', *Studio International*, 183 (February 1972), 54–9 on the theme of the city in Meidner's work. For sources on Munch, see Chapter 2. Although published some years ago, Wendy Baron's *Sickert* (London, 1973) is still the best book on the subject, but for a more recent source, see W.R. *Sickert: Drawing and Painting 1890–1942*, exhibition catalogue, Tate Gallery (Liverpool, 1989). For Toulouse-Lautrec, see Lesley Stevenson, *Toulouse-Lautrec* (London, 1991).

CHAPTER 5: ANDROGYNY

Many of the sources used in this chapter are also relevant for Chapter 6. On Darwinism, the war of the sexes and the mental and physical differences between men and women, see especially Harry Campbell's biologically based, *Differences in the Nervous Organization of Man and Woman* (London, 1891) and the later synthesis by Patrick Geddes and J. Arthur Thomson, *The Evolution of Sex* (London, 1898). For mental differences, see George Romanes, 'Mental Differences Between Men and Women', *Nineteenth Century* (21 May 1887), 654–72, and Alfred Fouillée, 'La Psychologie des sexes et ses fondaments physiologiques', *Revue des deux mondes* (15 September 1938), 397–429. The sexual differences between men and women are examined from an anthropological perspective by Paolo Mantegazza in *Gli amori degli uomini* (1885), Eng. trans. as *The Sexual Relations of Mankind* (New York, 1935), and the same author's *Fisiologia dell'amore* (Milan, 1873). Otto Weininger's *Sex and Character*, Eng. trans. (London, 1906) offers a fascinating, but febrile, assessment of women's 'inferiority' to men. Many of these ideas are placed in a new focus by Sigmund Freud, *Three Essays on the Theory of Sexuality* (London, 1962). More specific works on sexual 'deviation' and androgyny include Richard von Krafft-Ebing, *Psychopathia Sexualis*, Eng. trans. (Philadelphia and London, 1892), and Havelock Ellis and John Addington Symonds, *Studies in the Psychology of Sex Volume I: Sexual Inversion* (London, 1897). There are also many defences of homosexuality from both a psychological and a philosophical perspective. The most sensitive of these are the works of Edward Carpenter, including *Homogenic Love and its Place in a Free Society* (Manchester, 1894); *The Intermediate Sex: a Study of Some Transitional Types of Men and Women* (London, 1908); and *Love's Coming of Age* (Manchester, 1890). Also interesting are Albert Moll's *Die conträre Sexualempfindung* (Berlin, 1891), French trans. as *Les Perversions de l'instinct génital* (Paris, 1893), which uses literary and historical sources – rather than scientific case-studies – as examples, and Marc-André Raffalovich's surprisingly open-minded *Uranisme et unisexualité* (Paris, 1896). The platonic aspects of male friendship, and the relationship between such ideas and art appear in various forms in several works, including the periodical, *The Artist and Journal of Home Culture* (especially 1889–1894); Walter Pater, *Studies in the History of the Renaissance* (London, 1873); Arthur Symons, *Studies in Seven Arts* (London, 1906); and John Addington Symonds, 'A Problem in Greek Ethics', in Ellis, *Sexual Inversion*, cited above. Josephin Péladan's *L'Androgyne* (Paris 1891) and *Le Gynandre* (Paris, 1891) explore these themes, but are virtually unreadable.

There are many challenging works on the history and theory of sexuality, many of which followed in the wake of Michel Foucault's *The History of Sexuality, Volume I: An Introduction*, Eng. trans. (London, 1984). The most relevant studies for this period include Thomas Laqueur's intriguing *Making Sex: Body and Gender from the Greeks to Freud* (Cambridge, MA, 1990); Frank Mort's scholarly *Dangerous Sexualities: Medico-Moral Politics in England Since 1830* (London, 1987); and Elaine Showalter's lively *Sexual Anarchy* (London, 1991). Scholars have also been investigating the history of androgyny, primarily from a literary perspective. General studies include A.J.L. Busst, 'The Image of the Androgyne in the Nineteenth Century', *Romantic Mythologies*, ed. Ian Fletcher (London, 1967), 1–95, and Achim Aurnhammer, *Androgynie: Studien zu einem Motiv in der europäischen Literatur* (Vienna and Cologne, 1986). The use of androgynous figures in art is considered in Bram Dijkstra, 'The Androgyne in Nineteenth-century Art and Literature', *Comparative Literature*, 26 (1974), 62–73, and R. Heller, A Quarrel over Bisexuality', in G.C. Chapple, ed., *The Turn of the Century: German Literature and Art 1890–1915* (Bonn, 1981). For an anthropological study which considers the use of androgynous creatures in eastern religious practice, see Wendy Doniger O'Flaherty, *Women, Androgynes and Other Mystical Beasts* (Chicago, 1980), but avoid Elémire Zolla's unfocused *The Androgyne: Fusion of the Sexes*, Eng. trans. (London, 1981). For the issue of homosexuality in the late nineteenth century, see the series of excellent studies by Jeffrey Weeks, including *Coming Out: Homosexual Politics in Britain from the Nineteenth Century to the Present* (London, 1977); (with co-author Sheila Rowbotham) *Socialism and the New Life: The Personal and Sexual Politics of Carpenter and Ellis* (London, 1977); *Sex, Politics and Society: the Regulation of Sexuality Since 1800* (London, 1981); and *Sexuality and its Discontents, Meanings, Myths and Modern Sexualities* (London, 1985). An interesting, if uneven, collection of essays on the subject is N. Bei, Wolfgang Förster, Hanna Hacker, Manfred Lang, eds., *Das Lila Wien um 1900: zur Ästhetik der Homosexualitäten* (Fulda, 1986); and E. Cooper provides some artistic context in *The Sexual Perspective: Homosexuality and Art in the Last Hundred Years in the West* (London, 1986). For issues of masculinity and the crisis in masculine identity, see Peter Gay, *Freud: A Life for Our Time* (London, 1988); Jacques le Rider, *Modernité viennoise et crises de l'identité* (Paris, 1991); and Annelise Maugue's polemical *L'Identité masculine en crise au tournant du siècle 1871–1914* (Paris, 1987), which attributes male crisis to growing female power.

The androgynous themes of many of the artists considered in this chapter have been explored elsewhere, including the work of Beardsley in Linda Zatlin's brave but not wholly convincing, *Aubrey Beardsley and Victorian Sexual Politics* (Oxford, 1990), and Elliot Gilbert, ' ''Tumult of Images'': Wilde, Beardsley and Salome', *Victorian Studies*, 26, no. 2 (Winter 1983), 135–59. For Burne-Jones, see John Christian, *Burne-Jones*, exhibition catalogue, Arts Council of Great Britain, 1975, and Martin Harrison and Bill Waters, *Burne-Jones* (London, 1973, reprint 1989). The most scholarly work on Chagall is Susan Compton, *Chagall*, exhibition catalogue, Royal Academy of Arts (London, 1985), but see also Shearer West, *Chagall* (London, 1990). Although an interesting artist, Delville is not analysed deeply enough in the, frankly, biased book by Olivier Delville, *Jean Delville, peintre 1867–1953* (Brussels, 1984); more can be discovered from his own words in Jean Delville, *The New Mission of Art*, Eng. trans. (London, 1910). For Khnopff. see R.-L. Delevoy, *Ferdinand Khnopff, Catalogue de l'oeuvre* (Brussels, 1987), and the comprehensive monograph by Jeffrey Howe, *The Symbolist Art of Fernand Khnopff* (Ann Arbor, 1982); for a more specific study of Khnopff's relationship with other European art movements, see *Fernand Khnopff et ses rapports avec la Secession Viennoise*, exhibition catalogue, Musée Royaux des Beaux-Arts Belgique (Brussels, 1987). For Kupka, see Ludmilla Vachtová, *Frank Kupka*, Eng. trans. (London, 1968) and Serge Fauchereau, *Kupka* (Paris, 1988). The best study of Moreau is Julius Kaplan, *The Art of Gustav Moreau* (Ann Arbor, 1982), which makes extensive use of the documentation in the Paris Moreau archive. Schiele is the subject of a number of good studies, including Alessandra Comini's psychological assessment, *Egon Schiele's Portraits* (Berkeley, 1990); Frank Whitford's short and readable monograph, *Egon Schiele* (London, 1981); Klaus Albrecht

Schröder and Harald Szeeman, eds., *Egon Schiele and his Contemporaries* (Munich, 1989) relates Schiele's work to that of other Viennese artists. More insight can be gained by consulting Schiele's own writings, contained in A. Roessler, ed., *Briefe und Prose von Egon Schiele* (Vienna, 1921). There are two good studies on Solomon: Simon Reynolds, *The Vision of Simeon Solomon* (Gloucestershire, 1984) (this includes a reprint of Solomon's allegorical fable, A *Vision*, 1871), and *Solomon: A Family of Painters*, exhibition catalogue, Geffrye Museum (London, 1985).

CHAPTER 6: ICONS OF WOMANHOOD

For further sources, see the bibliography for Chapter 5. A great deal of primary source material about women in the late nineteenth century reinforces a set of stereotypes. Among the literature which speculates about what woman is, and ought to be, is J. Alesson, *Le Monde est aux femmes* (Paris, 1889); Hugh Stuttfield, 'The Psychology of Feminism', *Blackwood's Edinburgh Magazine*, 161 (January 1897), 104–17; Henri Thulié, *La Femme: essai de sociologie physiologique* (Paris, 1885); and Edward von Hartmann's unapologetically misogynistic *The Sexes Compared: and Other Essays*, Eng. trans. (London, 1895). Other prescriptions for women's behaviour appear in books about marriage and marriage handbooks, including Paolo Mantegazza's odd *The Art of Taking a Wife*, Eng. trans. (London, 1894), and the Rev. J.O. Bevan's excruciating *Wooed and Wedded and A'* (London, 1911). Works about the sexuality of women are more varied, and range from S. Icard's theories of female sexuality and hysteria in *La Femme pendant la période menstruelle* (Paris, 1890) to Cesare Lombroso, *La donna delinquente, la prostitua e la donna normale* (1893), Eng. trans. as *The Female Offender* (London, 1895), which considers prostitution. The subject of female eroticism is broached indirectly in Edward Fuchs, *Geschichte der erotischen Kunst*, 3 vols. (Munich, 1908), and James Ashcroft Noble, 'The Fiction of Sexuality', *Contemporary Review* (April 1895), 490–98. The importance of women as mothers is stressed for eugenic purposes in Havelock Ellis, *The Task of Social Hygiene* (London, 1912), although Frances Swiney uses Darwin's theories to favour women and motherhood more positively in *The Bar of Isis: or the Law of the Mother* (London, 1907), and *Women and Natural Law* (London, 1912). Another sympathetic view of women is contained in Edward Carpenter, *Woman and Her Place in a Free Society* (Manchester, 1894), and the issue of working women is tackled in several works, including Eleanor Marx and Edward Aveling, *The Woman Question* (London, 1887), and Lily Braun, *Die Frauenfrage: ihre geschichtliche Entwicklung und wirtschaftliche Seite* (Leipzig, 1901). The New Woman is discussed in many periodical articles, including B.A. Crackenthorpe, 'The Revolt of the Daughters', *Nineteenth Century*, 35 (1894), 23–31.

The use of Social Darwinism to confine women to an inferior role is discussed in a number of excellent recent works, including Cynthia Russell, *Sexual Science: the Victorian Construction of Womanhood* (Cambridge, MA, 1989), which is particularly good for the American perspective; Valeria Babini, Fernanda Minuz and Annamaria Tagliavin, *La donna nelle scienze dell' uomo: imagini del femminile nella cultura scientifica italiana di fine secolo* (Milan, 1986), which considers the rarely studied issues of 1890s infanticide; and Ludmilla Jordanova, *Sexual Visions: Images of Gender in Science and Medicine Between the Eighteenth and Twentieth Centuries* (New York, 1989). The relationship between developments in medicine, psychology and gynecology, and the construction of womanhood, is highlighted in articles from the 'new historicist' journal, *Representations*, special issue 'Sexuality and the Social Body in the Nineteenth Century', 14 (Spring 1986); see also Barbara Ehrenreich and Deidre English, *Complaints and Disorders: the Sexual Politics of Sickness* (New York, 1973); and Sara Delamont and Lorna Duffin, eds., *The Nineteenth-Century Woman: Her Cultural and Physical World* (London, 1978). The myths of woman as 'angel' and 'whore' are exposed in Lynda Nead, *Myths of Sexuality: Representations of Women in Victorian Britain* (Oxford, 1988), which places art firmly within its historical context, and Judith Wallkowitz, *Prostitution and Victorian Society: Women, Class and the State* (Cambridge, 1980). Heinrich Merkl's published thesis, *Ein Kult der Frau und der Schönheit* (Heidelberg, 1981) reinforces the stereotypes of woman as angel. The issue of motherhood, particularly in relation to eugenics and the fall in population, is discussed in several excellent articles, including Karen Offen's exemplary study, 'Depopulation, Nationalism, and Feminism in Fin-de-siècle France', *American Historical Review*, 89, no. 3 (1984), 648–76; Anna Davin, 'Imperialism and Motherhood', *History Workshop*, 5 (1978), 9–65; and Judith Wallkowitz, 'Science, Feminism and Romance: the Men and Women's Club, 1885–1889', *History Workshop* 21 (Spring 1986), 37–59. The problem of population is also addressed in Steven Hause and Anne Kenney, *Women's Suffrage and Social Politics in the French Third Republic* (Princeton, 1984). Suffrage is the subject of Susan Kingsley Kent, *Sex and Suffrage in Britain 1860–1914* (Princeton, 1987); David Rubenstein, *Before the Suffragettes: Women's Emancipation in the 1890s* (Brighton, 1986); and Lisa Tickner, *The Spectacle of Women: Imagery of the Suffrage Campaign 1907–14* (Chicago, 1988), which considers visual responses. On women's rebellion against a male-dominated society, see Sheila Jeffreys, *The Spinster and Her Enemies: Feminism and Sexuality 1880–1930* (London, 1985), and Lillian Faderman, *Surpassing the Love of Men* (New York, 1981), a pioneering work on the history of lesbianism.

For the relationship between art and ideas of sexuality in the late nineteenth century, see Bram Dijkstra's sometimes dangerously one-dimensional *Idols of Perversity* (Oxford, 1986), and for a more balanced view of misogynistic themes in art, see Joseph Kestner, *Mythology and Misogyny: the Social Discourse of Nineteenth-Century British Classical Subject Painting* (Wisconsin, 1989). On Mary Cassatt, see Nancy Mowll Matthews, *Mary Cassatt* (New York, 1987), and the shorter but stimulating book by Griselda Pollock, *Mary Cassatt* (London, 1980). On Klimt, see the bibliography for Chapter 2, but on Klimt and women, see especially Susanna Partsch, *Klimt: Life and Work* (London, 1989). The most interesting way to explore Paula Modersohn-Becker is through her own writing: *The Letters and Journals of Paula Modersohn-Becker*, Eng. trans. (Metuchen, NJ, and London, 1980); but see also the sensible account by Gillian Perry, *Paula Modersohn-Becker: Her Life and Work* (London, 1979). Sargent is generally subjected to the coffee-table treatment in works such as Stanley Olson, *John Singer Sargent: His Portrait* (London, 1986) and Carter Ratcliff, *John Singer Sargent* (Oxford, 1983) – neither of which come to terms with the problem of his representations of women, although they provide useful background. Interesting contemporary monographs on Segantini

include L. Villari, *Giovanni Segantini* (London, 1901) and Marcel Montandon, *Segantini* (Bielefeld and Leipzig, 1904). For a more recent analysis, see A.-P. Quinsac, *Segantini* (Milan, 1982). Equally, Stuck is sometimes best understood through contemporary sources such as Otto Bierbaum, *Stuck* (Bielefeld and Leipzig, 1901), but see also the thorough catalogue, *Franz von Stuck 1863–1928* (Munich, 1973). There is little on Toorop in English; the best source is the Dutch catalogue, J. Th. *Toorop: ee jaren 1885 tot 1910*, exhibition catalogue, Rijksmuseum Kröller Müller (Otterlo, 1979).

CHAPTER 7: THE INNER LIFE

For some early theories of dreams, see Paul Radestock, *Schlaf und Traum* (Leipzig, 1879); Heinrich Spitta, *Die Schlaf- und Traumzusstände der menschlichen Seele* (Tübingen, 1878); and P.-Max Simon, *Le Monde des rêves* (Paris, 1888). Bergson's 'Le Rêve', in *L'Energie spirituelle*, 161st ed. (Paris, 1982) provides an interpretation which accords with his theory of vitalism, and Freud's classic work, *The Interpretation of Dreams* (1899), in *The Complete Psychological Works of Sigmund Freud* (London, 1958), postulates the theory that dreams are an expression of sexual repression. The relationship between dreams and hypnotism is explored in Hippolyte Bernheim, *Hypnotisme, suggestion, psychothérapie* (Paris, 1891). For some insight into contemporary anthropological debates about comparative religion, see Andrew Lang's *Myth, Ritual and Religion* (London, 1887), and *Modern Mythology* (London, 1897); for the application of Lang's theory to the arts, see William Lethaby's strange *Architecture, Mysticism and Myth* (London, 1892). For theosophy, the best original source is H.P. Blavatsky, *The Key to Theosophy* (London, 1889), and the story of the Rosicrucians is told by A.E. Waite in *The Real History of the Rosicrucians* (London, 1887). For a completely different approach to the relationship between myth, religion and the arts, see Richard Wagner's writings. Surprisingly few of his works are translated into English; the only fairly complete edition is a nineteenth-century one: *Richard Wagner's Prose Works*, Eng. trans., 8 vols. (London, 1892). This includes 'The Art-Work of the Future' and 'Religion and Art' among other pieces.

Spiritualism and the occult have attracted academic interest in recent years: see, for example, Janet Oppenheim, *The Other World: Spiritualism and Psychical Research in England 1850–1914* (Cambridge, 1985); Derek Jarrett, *The Sleep of Reason: Fantasy and Reality from the Victorian Age to the First World War* (London, 1988); and Hanna Segal's neo-Freudian investigation, *Dream, Phantasy and Art* (London and New York, 1991). For spiritualism and sexual politics, see Ruth Harris's scholarly and fascinating *Murders and Madness: Medicine, Law and Society in the Fin de Siècle* (Oxford, 1989); Jan Goldstein's 'The Hysteria Diagnosis and the Politics of Anticlericalism in Late Nineteenth-Century France', *Journal of Modern History*, 54 (1982), 209–39; and Alex Owen's exploration of the occult from a feminist perspective, *The Darkened Room: Women, Power and Spiritualism in Late Victorian England* (London, 1989). A number of works have explored the intellectual and philosophical background that gave rise to religious controversies in central Europe. Among these are Allan Janik and Stephen Toulmin, *Wittgenstein's Vienna* (New York, 1973) and William McGrath, *Dionysian Art and Populist Politics in Austria* (New Haven, 1974). For religion generally, the best source is undoubtedly F.L. Cross, ed., *The Oxford Dictionary of the Christian Church*, 2nd ed. (Oxford, 1974). For Wagner's intellectual context, see Jacques Barzun, *Darwin, Marx, Wagner: Critique of a Heritage* (Chicago, 1942), and David C. Large and William Weber, eds., *Wagnerism in European Culture and Politics* (Ithaca, 1984).

Much has been written about the arts movements and tendencies discussed in this chapter. The Rose + Croix is examined in Robert Pincus-Witten, *Occult Symbolism in France: Joséphin Péladan and the Salons de la Rose + Croix* (New York, 1976), and *Belgian Art 1880–1914*, exhibition catalogue, Brooklyn Museum (New York, 1980). Symbolism has received wide coverage as well, including Robert Goldwater's useful introduction, *Symbolism* (London, 1979); Philippe Julian's *Dreamers of Decadence: Symbolist Painters of the 1890s* (London, 1971) and his slightly less substantial *The Symbolists* (London, 1973). The most useful and up-to-date source is Pierre-Louis Mathieu, *The Symbolist Generation 1870–1910* (New York, 1990). For Russian Symbolism, see *The Twilight of the Tsars: Russian Art at the Turn of the Century*, exhibition catalogue, Hayward Gallery (London, 1991); for the Nabis, see Claire Frèches-Thory and Antoine Terrasse, *Les Nabis* (Paris, 1990). Susan Beattie's *The New Sculpture* (New Haven, 1983) is also well worth consulting. Böcklin is the subject of several rather ponderous exhibition catalogues, which were published on the 150th anniversary of his birth. These include Rolf Andree, *Arnold Böcklin: Die Gemälde* (Munich, 1977); *Arnold Böcklin 1827–1901* (Olattbrugg, 1982); and *Arnold Böcklin 1827–1901: Gemälde, Zeichnungen, Platiken* (Basel, 1977); a more useful summary of his life is contained in Lutz Tittel, ed., *Arnold Böcklin Leben und Werk in Daten und Bildern* (Frankfurt-am-Main, 1977). The Australian Rupert Bunny is the subject of a slim catalogue, *Rupert Bunny: an Australian in Paris*, National Gallery of Australia (Sydney, 1991). Hodler is the subject of several exhibition catalogues, including the comprehensive *Ferdinand Hodler*, exhibition catalogue, Petit Palais (Paris, 1983), and *Todesbilder in der zeitgenössischen Kunst: mit einem Rückblick auf Hodler und Munch*, exhibition catalogue, 1983, which places him in his artistic context; see also Sharon L. Hirsch, *Ferdinand Hodler* (London, 1982). Klimt's Beethoven frieze is analysed in minute detail in Jean-Paul Bouillon, *Klimt: Beethoven* (Geneva, 1897). For Puvis, see Richard J. Wattenmaker, *Puvis de Chavannes and the Modern Tradition*, Art Gallery of Ontario (Toronto, 1975). Redon has been the subject of several monographs, including Richard Hobbs, *Odilon Redon* (London, 1977); Michael Wilson, *Nature and Imagination: The Work of Odilon Redon* (Oxford, 1978); Florence Penny's *Mallarmé, Manet and Redon* (Cambridge, 1986) does more than just relate the facts of Redon's career. There is little recent work on Ryder, and so we must rely on L. Goodrich, *Albert Pynkham Ryder* (New York, 1959); the same is true of the American artist Vedder (see *Perceptions and Evocations: The Art of Elihu Vedder*, exhibition catalogue, Smithsonian Museum, Washington, DC, 1979), but see also his autobiography, *The Digression of V.* (Boston and New York, 1910). For Schwabe, see *Carlos Schwabe* (Geneva, 1987). There is one good English source on Vrubel, Aline Isdebsky-Prichard, *The Art of Mikhail Vrubel* (Ann Arbor, 1982), but most works are in Russian.

CHAPTER 8: REGENERATION

See also the bibliography for Chapter 7, much of which is also relevant for this chapter. On the tendency to turn away from the scientific obsessions of modern life and towards a more 'primitive' and spiritual existence, see Julius Langbehn, *Rembrandt als Erzieher* (Leipzig, 1890). This book exists in many editions – a gauge of its contemporary popularity – but it can only be read in small doses. For vitalism, the best primary source is Henri Bergson, *Creative Evolution*, Eng. trans. (London, 1914), and Sigmund Freud's *Civilization and its Discontents*, Eng. trans. (London, 1963) provides a later psychological perspective on the need to reject modern urban society. For an attack on Nordau and an argument for a more spiritual life, see also the anonymous *Regeneration* (London, 1895), which nicely sums up a number of themes of the period. The best artistic evidence of primitivist ideals is contained in the *Blaue Reiter Almanack*, Eng. trans. (London, 1974). For apocalyptic views of society at the turn of the century, see Hermann Bahr's assessment of new movements in art, *Expressionism*, Eng. trans. (London, 1925), and Vassily Kandinsky's *Concerning the Spiritual in Art*, Eng. trans., in *Complete Writings on Art*, 2 vols. (1982).

Langbehn's work is placed in its intellectual context by Fritz Stern, *The Politics of Cultural Despair: A Study in the Rise of the Germanic Ideology* (Berkeley and Los Angeles, 1961), although Stern relies on a linear view of history which sees a direct development from the *völkisch* tendencies of the late nineteenth century to the atrocities of Hitler before and during the Second World War.

The art movements covered in this chapter also receive wide coverage in art-historical literature. The best source for Expressionism is Jill Lloyd, *German Expressionism: Primitivism and Modernity* (New Haven, 1991), but see also Donald Gordon's useful *Expressionism: Art and Idea* (New Haven, 1987), and Bernard Huppauf's edition of collected essays relating to cultural developments in Germany 1910–20, *Expressionismus und Kulturkrise* (Heidelberg, 1988). For Die Brücke's prints, see Reinhold Heller, *Brücke*, exhibition catalogue, Mary and Leigh Block Gallery, Northwestern University, 1988. Unfortunately, *Apocalypse and Utopia: a View of Art in Germany 1910–39*, exhibition catalogue, Fisher Fine Art (London, 1977), does not deliver what its title implies. For the relationship between art and psychology in France, see Debra Silverman's penetrating *Art Nouveau in Fin-de-Siècle France* (Berkeley and Los Angeles, 1989); and C. Cockerbeck's *Ernst Haeckel's 'Kunstformen der Natur' und ihr Einfluss auf die deutsche bildende Kunst der Jahrhundertwende* (Frankfurt-am-Main, 1986). For art nouveau generally, see Kathryn Bloom Hiesinger, ed., *Art Nouveau in Munich* (Munich, 1988), which is particularly useful for decorative arts; Jean-Paul Bouillon, *Art Nouveau 1870–1914* (London, 1985); and Lara-Vinca Masini, *Art Nouveau* (London, 1984), which is organized by country and has a wealth of illustration. A general consideration of Russian art during this period is contained in David Elliot, *New Worlds: Russian Art and Society 1900–37* (London, 1986); Scandinavia has been the subject of a number of recent studies and exhibitions, including *Dreams of a Summer Night*, exhibition catalogue, Hayward Gallery (London, 1986); Neil Kent, *The Triumph of Light and Nature: Nordic Art 1740–1940* (London, 1987); and *Lumières du nord*, exhibition catalogue, Petit Palais (Paris, 1987). For Futurism, see Marjorie Perloff, *The Futurist Movement: Avant-Garde, Avant Guerre, and the Language of Rupture* (Chicago, 1986). For Worpswede, among the few available sources are Manfred Hausmann, *Worpswede, eine deutsche Künstler-Kolonie um 1900* (Fischerhude, 1986); and *Paula Modersohn-Becker*, *Worpswede*, exhibition catalogue, Kunsthalle (Worpswede, 1989). Australian landscape painting is covered well in *Bohemians in the Bush: The Artists' Camps of Mosman*, exhibition catalogue, Art Gallery of New South Wales, 1991. For a good general work on art and primitivism, see William Rubin, ed., *Primitivism in Twentieth-century Art: Affinity of the Tribal and the Modern*, exhibition catalogue, Museum of Modern Art (New York, 1984). For Böcklin and monism, see Johannes Manskopf, *Böcklins Kunst und Religion* (Munich, 1905). The most comprehensive work on Gauguin is *Gauguin*, exhibition catalogue, Grand Palais (Paris, 1989), but see also the interesting discussions in Belinda Thomson, *Gauguin* (London, 1987) and Lesley Stevenson, *Gauguin* (London, 1990). For Kandinsky's early work, see Peg Weiss, *Kandinsky in Munich: the Formative, Jugendstil Years* (Princeton, 1979). Fortunately, there is an exhibition catalogue in English which provides an introduction to Polish Symbolism through the work of Malczewski: *Malczewski: Vision of Poland*, exhibition catalogue, Barbican Gallery (London, 1990). For Marc's ideas about art, see F.S. Levine, *The Apocalyptic Vision: the Art of Franz Marc as German Expressionism* (New York, 1979). The most complete analysis of Monet is contained in John House, *Monet* (New Haven, 1986), but for more specific studies of his later work, see *Claude Monet at the Time of Giverny*, exhibition catalogue, Centre Culturel du Marais (Paris, 1983) and Paul Hayes Tucker, *Monet in the '90s: the Series Paintings*, exhibition catalogue, Museum of Fine Arts, Boston, 1989.

INDEX